Brilliant Beginnings

*The Youthful Works of Great Artists,
Writers, and Composers*

Acknowledgments

We would would like to express our warm thanks to Frédéric d'Agay, Jean-Claude Barat, Patrick Barbier, Pierre Bergé, Édouard and Christian Bernadac, Gilbert Boudar, Éric Bouffetaud, Eugénie de Brancovan, Henri Cartier-Bresson, Valentine de Chillaz, Sylvie Durbet-Giono, Cécile Éluard-Boaretto, Andrée, Henri, and Suzanne Escoffier, Georges Fessy, comte d'Haussonville, Madeleine Foisil, Jean Leclant, Dominique Marny, Jean Mauriac, Laure Murat, Alain Nicolas, Jean Ristat, Jacques Rivière, Christiane Sand, and Bruno Villien.

We would also like to express our gratitude to the many libraries, museums, and other institutions that opened their doors to us, in particular Les Amis de Paris; Bibliothèque Centrale du Musée National d'Histoire Naturelle, Paris; Bibliothèque de Charleville-Mézières; Bibliothèque Historique de la Ville de Paris; Bibliothèque de l'Institut, Paris; Bibliothèque Littéraire Doucet, Paris; Bibliothèque Municipale de Nantes; Bibliothèque Nationale de France, Paris;

British Library, London; Brontë Parsonage Museum, Haworth, Yorkshire; The Britten-Pears Foundation; Carmel de Lisieux; Centre Jean Moulin, Bordeaux; Château de Compiègne; Châteaux de Versailles et de Trianon; Éditions du Cerf.

Éditions Gallimard; Les Enfants des Arts; Joan Miró Foundation, Barcelona; Fondazione Primo Conti, Fiesole; Institut Pasteur, Paris; Maison de Balzac, Paris; Maison Victor Hugo, Paris; Musée des Beaux-Arts, Béziers; Musée de Brou, Bourg-en-Bresse; Musée du Louvre, Paris; Musée Gustave Moreau, Paris; Musée Ingres, Montauban; Musée de Manosque; Musée Marmottan, Paris; Musée d'Orsay, Paris; Picasso Museum, Barcelona; Musée Picasso, Paris; Musée Rodin, Paris;

Musée de Toulouse-Lautrec, Albi; Musée de la Vie Romantique, Paris; National Portrait Gallery, London; Österreichisches Staatsarchiv, Vienna; Estate of Antoine de Saint-Exupéry.

We are also grateful to Jeannine Castoriano, Maryvonne Corrigou, and Benoit Nacci of Éditions de La Martinière; and to Laurent Ungerer, Tiphaine Massari, and Xavier Mercier of c-album, who designed the book, and edited its French edition.

EDITOR, ENGLISH-LANGUAGE EDITION: ELAINE M. STAINTON
DESIGN COORDINATOR, ENGLISH-LANGUAGE EDITION: SIBYLLE VON FISCHER

Library of Congress Cataloging-in-Publication Data

Ayala, Roselyne de.
[Enfance de l'art. English]
Brilliant beginnings / by Roselyne de Ayala and Jean-Pierre Guéno
p. cm.
Includes bibliographical references and index.
ISBN 0-8109-4117-1
1. Child artists. 2. Young artists. 3. Creative ability in children. 4. Creative ability in adolescence. I. Guéno, Jean-Pierre. II. Title.

NX164.C47 A9313 2000
700'.83–dc21 00-31316

Harry N. Abrams, Inc.
100 Fifth Avenue
New York, N.Y. 10011
www.abramsbooks.com

Brilliant Beginnings

The Youthful Works of Great Artists,
Writers, and Composers

Roselyne de Ayala and Jean-Pierre Guéno

Translated from the French by John Goodman

Harry N. Abrams, Inc., Publishers

Contents

Even when one's work has gained in power,

who can resist the occasional nostalgic return to

the simpler creations of first youth . . .

in search of that naive spontaneity,

that inimitable accent,

that now irretrievable

sweetness of a first promise,

a first confession?

MARCEL PROUST

Preface

Even as adults, we all continue to belong to the realm of childhood, a land of vivid sensation, simple pleasure, and exciting discovery, a time when our eyes first saw the world, and when we experienced our first joys, sorrows, and disappointments—a carefree land with no need for either deception or compromise.

In our first years, we unknowingly recapitulate five million years of a particular history, that of writing. Laboriously, we progress from circles to lines, from stick figures to letters, paralleling the human advance from Stone-Age pictographs to vellum manuscripts, to laser printers. As adults, we use these same symbols, composites of curved and straight lines, to record our progress as individuals. Others use them to characterize us, to decide whether we are destined to join a social elite or to be excluded from it, depending—at least partly—on our academic progress, recorded in the form of marks inscribed in these same characters. Thus, writing is—among other things—a tool that either opens or closes options to us. As we evolve, writing also becomes a seismograph of our emotions, a gauge that we use to construct our personalities and record our first experiences. After the passage of twenty or forty years, regardless of our intentions—of whether we have chosen to bury our first youth, to disguise its character behind layers of reconstruction, altered memory, and perhaps even dissimulation—the written traces we left behind will reveal who we were. Perhaps an attentive observer will be able to discern our first joys and miseries behind the curving lines of our vowels and consonants, in the forms of our letters, the size of our capitals, and the slant of our penmanship. Indeed, the handwriting of each individual harbors within it traces of the secrets, of experiential twists and turns in his or her education, traces that remain present long after the onset of adulthood.

For this reason, we felt compelled to return to sources, to seek out the earliest surviving works from the childhoods of a number of people who were later to make their marks as writers, painters,

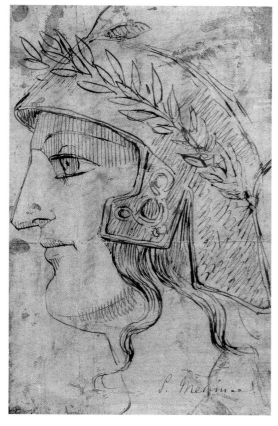

A Warrior in a Helmet, drawn by Prosper Merimée when he was a child

poets, scientists, composers, and inventors. By doing this, we hoped to reconstruct the contexts of these original manuscripts and drawings, and perhaps shed some light on their earliest imaginative beginnings. Some of the men and women we chose to investigate are reference points in Western culture, whose unwitting youthful self-revelations might, for this very reason, be interesting. Others are less well known today, but were important in their own times. Their early works, too, can be fascinating.

Our subjects' childhoods were not always the safe havens that we would like to imagine. The early years of Charlotte Brontë, Stendhal, George Sand, Gustave Moreau, and Salvador Dalí were times not of serenity but of traumatic loss, unhappily dominated by death and human frailty.

Some of these individuals were actual child prodigies, for example, Wolfgang Amadeus Mozart, Albrecht Dürer, Germaine Necker (the future Mme. de Staël), and Jean Auguste Dominique Ingres. Others, while not quite prodigies, showed their gifts at a young age: Michelangelo, Gustave Doré, Franz Liszt, Pablo Picasso, Joan Miró, and Egon Schiele. Others were clearly multitalented. Both Ingres and Eugène Delacroix, for example, were gifted in music as well as in drawing, while Victor Hugo was a fine cabinetmaker and draftsman, in addition to being a great writer.

In many cases, the individuals whose early work we examined emerged from family backgrounds favorable to the development of their gifts, for example, Mozart, Delacroix, Ingres, and Georges Bizet. Others, however, had to break with their pasts. Joseph Mallord William Turner was the son of a wigmaker and the grandson of a butcher; Suzanne Valadon, the daughter of a laundress and an unknown father; Eugène Grindel, better known as Paul Éluard, the son of a common laborer and a dressmaker. Still others, despite being gifted in writing or language, were initially poor students (Stéphane Mallarmé, Marcel Proust, Jean Cocteau), the despair of their parents (Gustave Flaubert, Jean Moulin), or inveterate daydreamers (Antoine de Saint-Exupéry, Claude Monet, Louis Pasteur). Quite a few were ill suited to the educational system in which they found themselves. Auguste Rodin failed the admission examination for the École des Beaux-Arts three times, and if Miró had trusted the judgment of his teachers, he would have become an accountant.

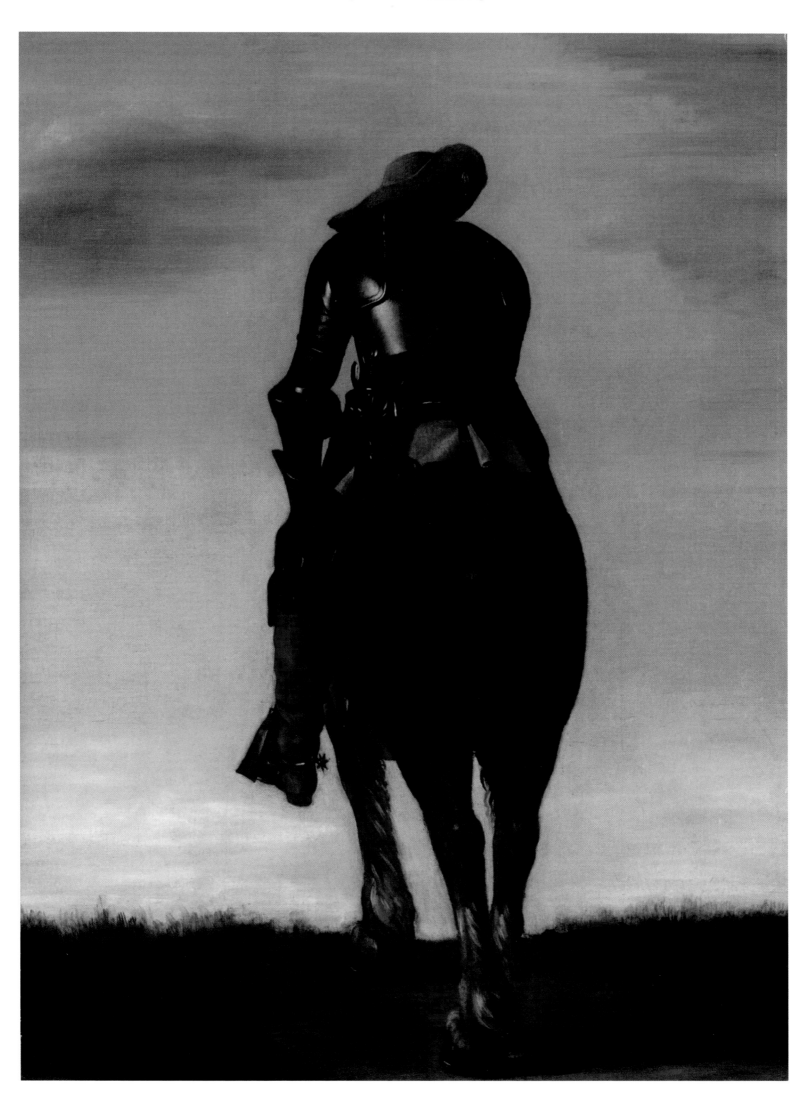

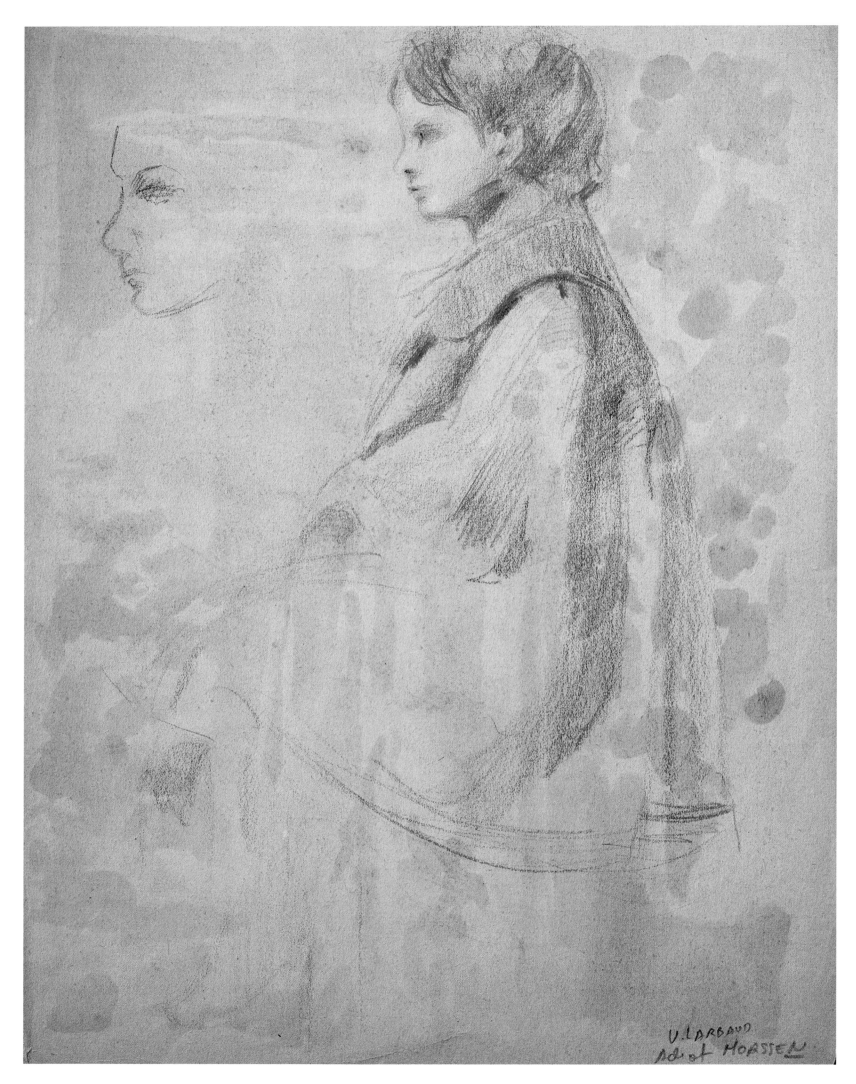

U. LARBAUD
Adiot HOASSEN

12

In fact, many of these individuals have something in common: very early on, either openly or in secret, they began to pursue something that engaged them passionately. Although the results of these early efforts are often awkward, sometimes they are touched with genius.

The manuscripts that reveal these first flashes of insight can be found on scraps of paper, in school notebooks, in private diaries, in letters to parents, or in homework assignments. Other noteworthy traces of childhood and adolescence take the form of graffiti, musical scores, sketches, and self-portraits.

All of these individuals granted themselves the freedom to cultivate their secret gardens, regardless of the cost, regardless of the skepticism and condescension of their teachers, family, and friends. The documents they left behind provide us with a record of successes and failures, but their principal interest lies elsewhere: in the strength of character that underlies such precocious expressions of personality and difference.

Before the exploring spirit within each of us disappears, we should take careful note of the actions of the remarkable people whose early work fills this book, and learn from their examples a rule underlying all creative work, and the truly successful life: hold fast to the freedom to dare, honoring it both in ourselves and in others.

Opposite:
Silhouettes sketched by the young Valéry Larbaud

Below:
Scribbles made by the young Roland Barthes in his exercise book

JEAN-PIERRE GUÉNO
ROSELYNE DE AYALA

The Bible of the Duke of Burgundy

POL AND JEAN DE LIMBOURG
(active early fifteenth century)

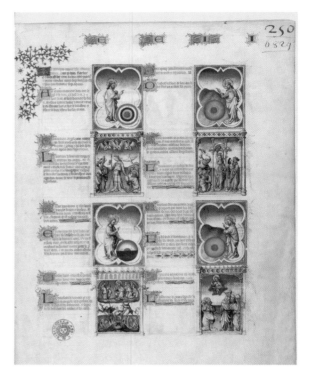

The illuminated manuscript shown here is a late example of a "moralized Bible" (*Bible moralisée* in French), a tradition that began in Paris in the early thirteenth century. Moralized Bibles, originally made for members of the French royal family, were books of short commentaries on passages in the Bible, each of which was also illustrated. Here, each page features eight images arranged in two columns, picturing alternating episodes from the Old and New Testaments, as well as allegorical scenes.

To illustrate this example, Duke Philip the Bold of Burgundy, uncle of King Charles VI of France, in 1402 called upon two young prodigies of fourteen and sixteen, Pol and Jean de Limbourg, natives of the duchy of Gelderland, now in the Netherlands. Unfortunately they were not able to finish the book, for the duke died two years after they began work on it. By then, they had completed the first twenty-four leaves, which together contain 384 of a projected total of 5,000 illustrations. Later the brothers would illuminate the renowned book of hours known today as the *Très Riches Heures,* or "very rich hours" for the Duke of Berry.

The Limbourg brothers' compositions in the Duke of Burgundy's Bible were directly inspired by another moralized Bible commissioned by the duke's father, King John the Good. At some later time, a number of other artists, including some celebrated masters, contributed illustrations to the Duke of Burgundy's Bible, which was finally finished several decades after it had been begun. In the final book, Pol and Jean de Limbourg's illuminations stand out above all the others for their delicate color and refined draftsmanship.

One of the last private owners of the Bible, Aymar de Poitiers, presented it to King Charles VIII of France, after which it remained in the royal collections. It is now one of the most precious and admired manuscripts in the Bibliothèque Nationale in Paris.

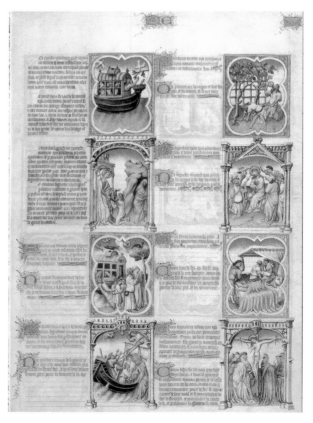

Three pages from the *Bible of the Duke of Burgundy*, exquisitely illustrated by the young prodigies Pol and Jean de Limbourg early in the fifteenth century. Paris, Bibliothèque Nationale de France

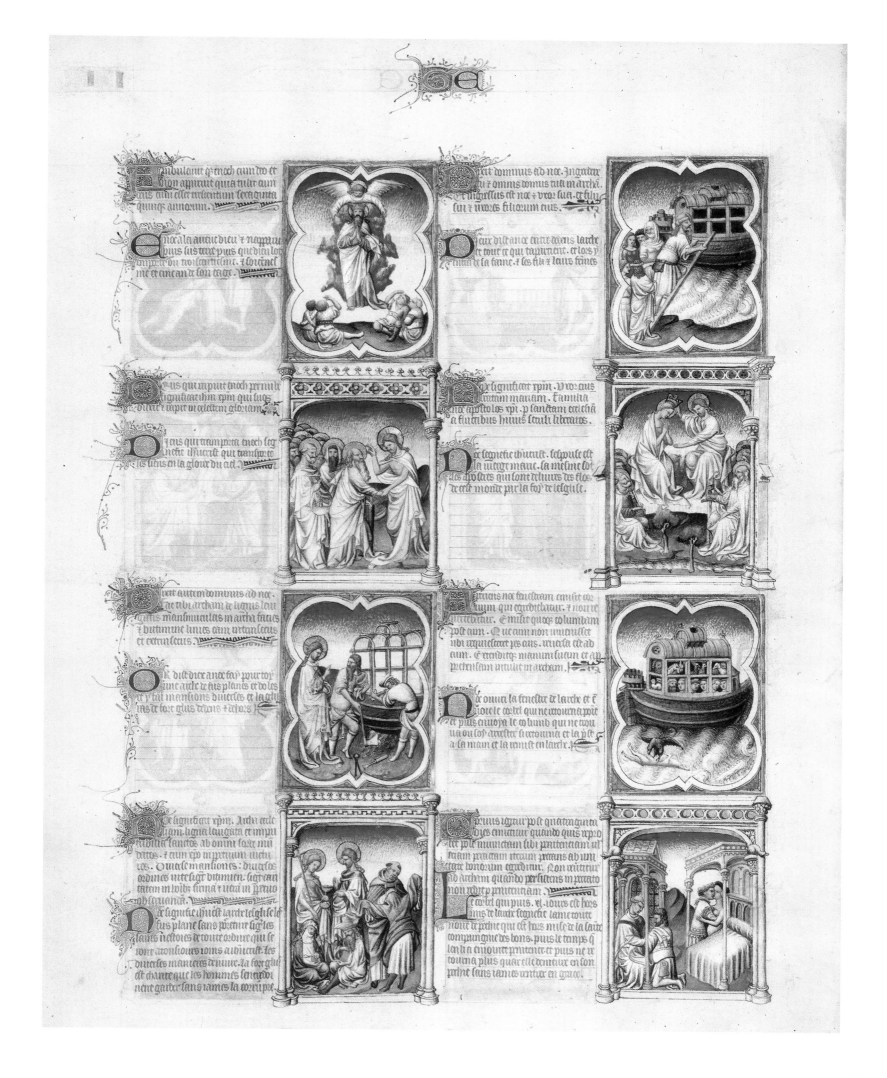

Dürer's First Self-Portrait

ALBRECHT DÜRER
(1471–1528)

It is difficult to resist the first of Dürer's many self-portraits, a drawing in silverpoint, and one of the earliest self-portraits that we have from northern Europe. The curious yet uneasy gaze, the finger raised as if in a questioning gesture, and the precise but refined draftsmanship make the portrait oddly compelling. Some time after he drew it, the painter wrote in the upper right corner: "I made this from life using a mirror in 1484, when I was still a child."

Albrecht Dürer, the third of eighteen children, was thirteen when he drew this likeness of himself, and was working for his father, a Hungarian immigrant in Nuremberg. Two years later, the boy entered the workshop of the painter Michael Wolgemut. In the interim he continued to draw portraits, one of which may be the likeness of his father, Albrecht Dürer the elder, shown on this page. Here the elder Dürer seems careworn, but also proud of the statuette that he holds in his right hand, presumably the product of his own workshop.

Portraiture, and preeminently self-portraiture, became a virtual obsession for Dürer, who admitted to being "deeply haunted by faces" and experimented constantly with the human likeness, painting the great self-portraits now on the walls of the Prado in Madrid and the Alte Pinakothek in Munich. Dürer also manifested an early taste for landscape. When he was eighteen, he painted a view of *Saint John's Cemetery*, a remarkable work in watercolor and gouache that reveals his early interest in color. The artist was buried in this same cemetery in 1528, after an astonishing career that brought him fame throughout Europe.

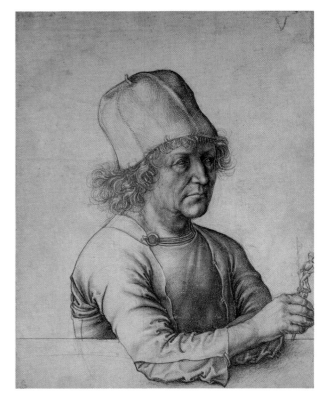

Portrait of the artist's father, Albrecht Dürer the elder, 1484. Vienna, Graphische Sammlung Albertina

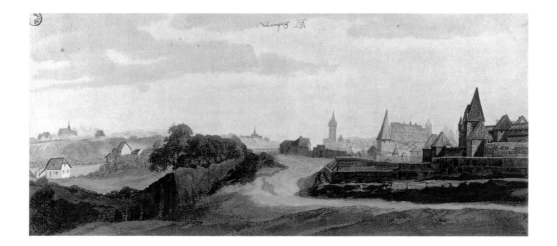

Left:
In this *View of Nuremberg from the West* of c. 1496 (Bremen, Kunsthalle), Dürer paid homage to his native city.

Opposite:
Albrecht Dürer, *Self-Portrait,* silverpoint, 1484. Vienna, Graphische Sammlung Albertina. Dürer produced this striking image, executed in a highly exacting technique, when he was thirteen.

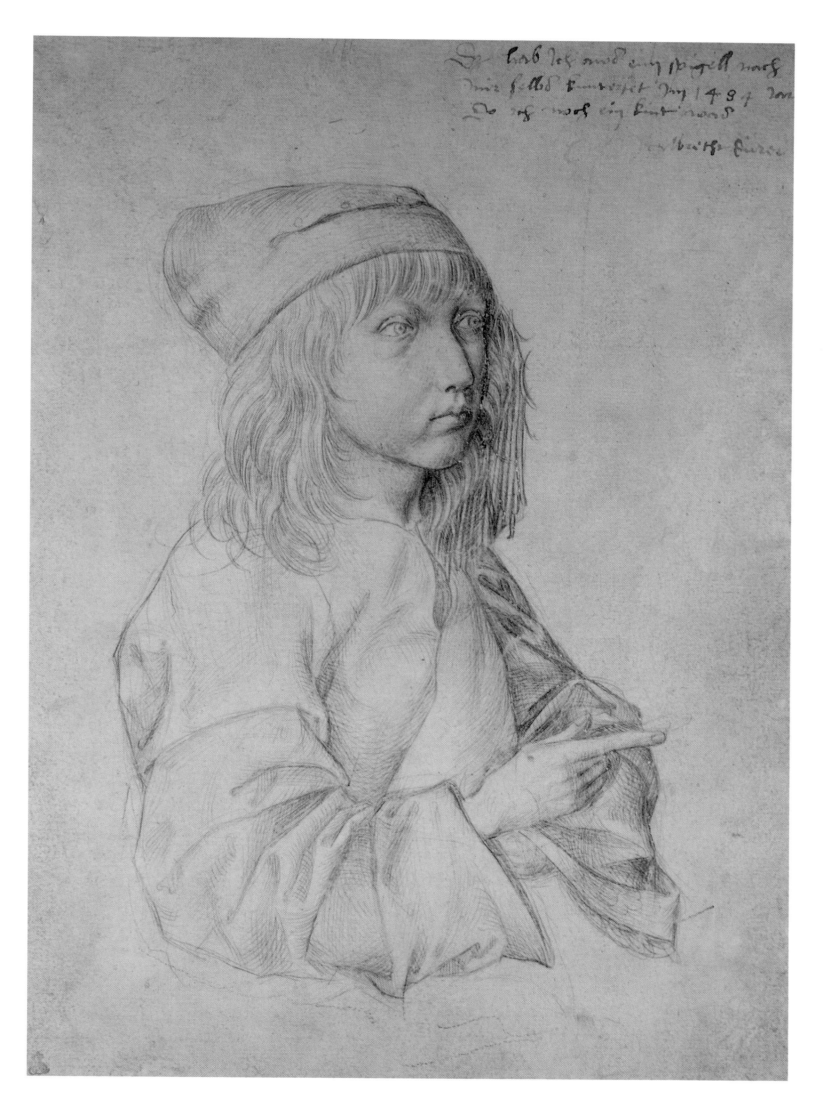

17

Early Sculpture

MICHELANGELO BUONARROTI, KNOWN AS MICHELANGELO
(1475–1564)

The second of five children, Michelangelo was born in Caprese, near Arezzo, on March 6, 1475, the son of Lodovico Buonarroti, then serving as mayor of Caprese, and Francesca di Neri.

The family returned to Florence, and the boy was entrusted to a wet nurse who was the wife of a stonemason in the nearby town of Settignano, which is set among rock quarries. Later the artist recalled, "If there is anything worthwhile in my mind, I owe it to my birth in the subtle air of the countryside near Arezzo, just as I took in the hammer and chisel I use for my figures with the milk of my nurse." The child was placed in the school of the humanist Francesco of Urbino; the artist later maintained that he had spent most of his time drawing in class instead of learning grammar, but perhaps this is an exaggeration, given the sophistication of his poetry and his correspondence.

The painter Francesco Granacci encouraged the boy to become an artist, although his father opposed the plan. Eventually, however, the father relented, reluctantly placing his thirteen-year-old son in the workshop of the Florentine painter Domenico Ghirlandaio, and signing a contract for a three-year apprenticeship. Instead of adopting the style of his master or the elegant manner of many successful Florentine artists of the day, Michelangelo was attracted to the monumental tradition of Tuscan art, especially the work of Giotto and Masaccio. He found in their work a grandeur and a dignity of expression, cast in simple, solid forms, which spoke very powerfully to him.

Michelangelo left Ghirlandaio's workshop in 1489, before his contract had run its course, to attend a school in the Medici gardens near the convent of San Marco. There, under the direction of the sculptor Bertoldo, a student of the great Florentine sculptor Donatello, he studied fragments of ancient sculpture in the collection of Lorenzo de' Medici. This encounter with the art of antiquity affected him deeply. Inspired by one ancient work, he carved a head of a faun. A short time later he produced a *Sleeping Cupid* (now lost), whose classicizing idiom was so convincing that it fooled the antiquarian Cardinal Raffaele Riario, to whom it was sold by an unscrupulous dealer as a genuinely ancient work.

Lorenzo de' Medici brought Michelangelo into his palace and raised him with his own children. While at the Medici court, the young artist carved a marble relief of a battle, and another of the Virgin and Child on a staircase, now called *The Madonna of the Steps*.

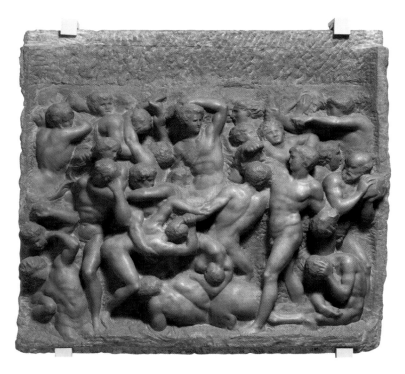

Above:
Michelangelo's early battle relief (Florence, Galleria Buonarroti), carved from a large block of cream marble, is a complex work. It is the earliest example of what would become one of his principal preoccupations: the male nude in action. Made in 1492, it remained in the artist's possession until the end of his life.

Opposite:
The small marble relief now called *The Madonna of the Steps* (Florence, Galleria Buonarroti) shows a few imperfections in the carving, attributable to Michelangelo's lack of experience. However, although the upper arm of the boy leaning over the balustrade and the left hand and right foot of the Virgin are awkwardly formed, the work is nevertheless a remarkable tour-de-force. Its shallow relief technique, pioneered early in the century by the sculptor Donatello, is extremely exacting. The work was probably in the collection of Lorenzo de' Medici.

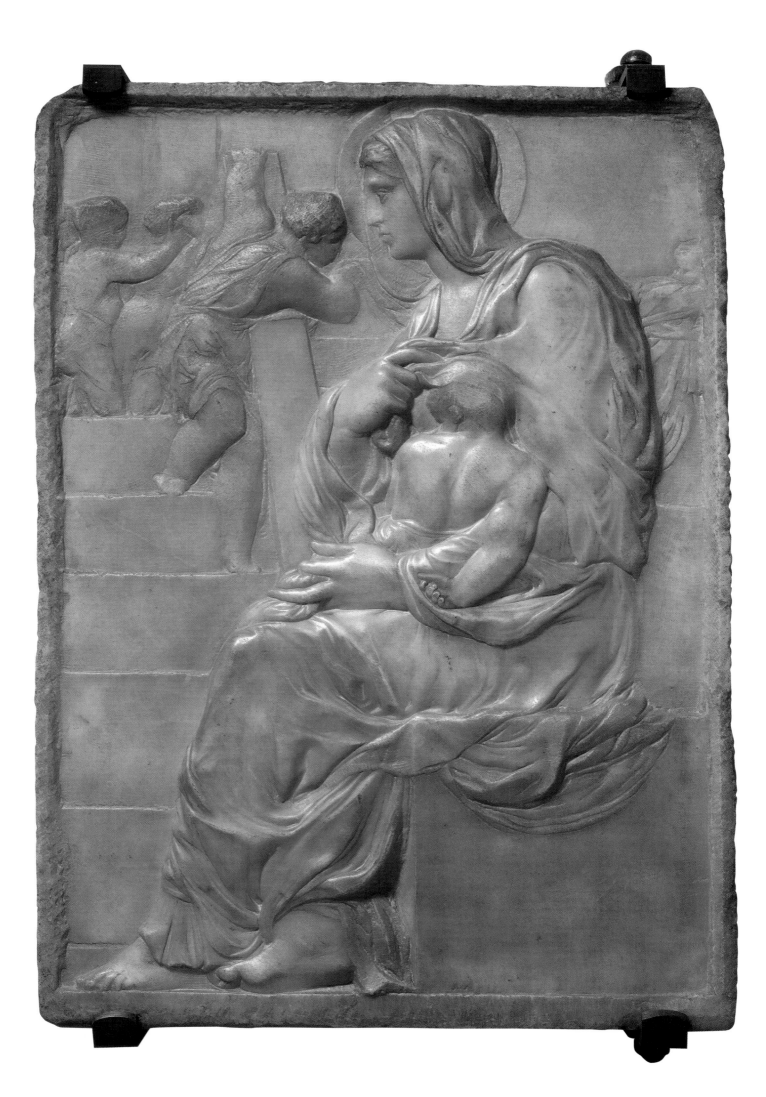

A Gift for Cardinal Gaetani

YOUNG MEMBERS OF THE CATHOLIC LEAGUE OF PARIS

(late sixteenth century)

This emblem book is the second of two volumes presented in 1590 by the Parisian members of the Catholic League to Cardinal Enrico Gaetani, who had come to Paris as the emissary of their ardent supporter, Pope Sixtus the Fifth. The book contains twenty-five allegorical Latin poems, accompanied by illuminations executed by young artists of the Parisian nobility.

Cardinal Gaetani had come to Paris to try to prevent Henry of Navarre, a Protestant, from succeeding to the French throne as Henry IV, and to negotiate for the succession of a Catholic instead. Once in Paris, however, he was swept up by the political crosscurrents of the city, and went so far as to encourage the Catholic nobility to disobey their Protestant sovereign, even leading the first procession of the Catholic League through the city.

A close examination of the calligraphy of the book reveals that several hands worked on it. It seems likely that the young nobles inscribed and illuminated the poems separately before they were bound together for presentation.

Four pages from the Emblem Book of Cardinal Gaetani (c. 1590; Paris, Bibliothèque Nationale de France), a collection of anti-Protestant poems illuminated by young members of the Catholic League. Each page is signed.

IVSTVS SICVT TORRENS FORTIS

N ascitur excelso montis de culmine torrens
 Camporum mediis funditur æquoribus.
Turba virum celerem fluxum tardare laborat:
 Fluminis hinc illinc æstus et inde furit.
Sic nemora exundant et tandem fertur ad oram
 Quam rigat et variis quam beat arboribus.
Mons esto Xistus; torrens Henricus: at ingens
 Turba Nauarei dæmonis instar erit

LVDOVICVS GLEYSE ARELATENSI

A Latin Poem by a Young King

LOUIS XIII

(1601–1643)

Reliable, detailed accounts of childhood in the seventeenth century are quite rare, even of the early years of future sovereigns. A remarkable exception is the diary of Jean Héroard, a doctor entrusted with the health of the young Louis XIII. His account of Louis's daily life is the only intimate account of the day-to-day routine of the childhood of any French king.

Present at the prince's birth on September 27, 1601, Héroard made certain that the child's wet nurse took a number of antidotes to prevent his being poisoned, and washed his body in wine mixed with rose-scented oil. He later described Louis as a fine boy, hardy, tall, muscular, with broad shoulders, a thick neck, and a finely shaped head.

The prince's father, Henry IV, decided to have his son raised at the château of Saint-Germain-en-Laye, where the boy lived from 1601 to 1609, far from his parents, who preferred to stay at Fontainebleau or at the Louvre in Paris. The prince's early education was entrusted to a governess, the authoritarian Madame de Monglat. Later, he was taken in hand by male tutors, notably the soldier Gilles de Souvré, who shaped the young man's character, imparted to him a sense of his rank and otherwise prepared him for his royal duties. He also tried to teach the boy the importance of generosity and good will toward other people.

When King Henry IV was assassinated in 1610, Louis, then still less than nine years old, became king. Héroard was well placed to describe the young king's education, in which he himself took part, as is documented by several anecdotes recounted in his journal. He also inserted into its pages a number of drawings and inscriptions from the king's hand, which are illustrated here. These images are the only extant children's drawings from the period.

Above:
This letter was sent by Louis to his sister after his coronation (Paris, Bibliothèque Nationale de France), along with two magpies shot while hunting. The young king writes that he will be hunting deer "after lunch."

Below:
One of several drawings by the boy king that Héroard placed in his diary. Paris, Bibliothèque Nationale de France

Above, left:
Attributed to Jean Limousin II, a pendant mirror case with portrait of the young Louis XIII. Paris, Musée du Louvre

Opposite:
A Latin poem written in the hand of the child Louis XIII (Paris, Bibliothèque Nationale de France):
The piety of Saint Louis
The clemency of Henry IV
The justice of Louis XII
Pharamond's love of truth
The temperance of Charles V
And with the grace of God
Louis XIII will surpass
all these kings.

Pietas Sancti Ludovici

Clementia Henrici quarti iiij

Justitia Ludovici duodecimi

Amor veritatis Pharamontius i

Fortitudo Caroli magni . i

Temperantia Caroli quinti v

& Ludovicus decimus tertius
superabit omnes hos Reges
gratia Dei .

Portraits by the Young Van Dyck

ANTHONY VAN DYCK
(1599–1641)

At age sixteen, Anthony Van Dyck opened his own workshop in Antwerp; at age nineteen, he became a master in the guild of Saint Luke and a principal collaborator of Peter Paul Rubens. These facts alone are a measure of the precocity of this Flemish painter, who was born into a prosperous family of Antwerp merchants and whose name is now irrevocably associated with the golden age of portraiture.

Van Dyck's earliest surviving works reveal the extent of his youthful virtuosity. He painted the portrait of an elderly man shown on this page just after turning fourteen, by which time he had been studying with Hendrik Van Balen for four years and, in all likelihood, had begun to frequent Rubens's workshop. At this age, too, the young artist had already begun to paint wonderful self-portraits, rendering himself as a young man with a provocative gaze, turning toward the viewer with an air of surprise.

Deeply curious and a tireless worker, Van Dyck decided early on to specialize in portraiture, with the enthusiastic support of Rubens. The influence of this celebrated master is apparent not only in Van Dyck's early work (for example, the large *Saint Jerome* illustrated here, painted when he was sixteen), but throughout his career, to such an extent that his own reputation as an artist sometimes suffered. Nonetheless, his services were eagerly sought after by prestigious patrons, from the Genoese elite to the British royal family, which early recognized his talent and showered him with commissions. In 1632 he moved to England, where he worked as a court painter and aristocratic portraitist until his untimely death nine years later.

Left:
Anthony Van Dyck, *Elderly Gentleman*, 1613. Brussels, Musées Royaux des Beaux-Arts. Van Dyck painted this small oval portrait when he was fourteen.

Opposite:
The young Van Dyck had not yet become an assistant to Rubens when he painted this striking *Self-Portrait* (Brussels, Musées Royaux des Beaux-Arts), which dates from 1613. Seated in front of his easel, he turns his head to gaze intently at his image in a mirror, and, as a result, at the viewer.

Below:
Anthony Van Dyck, *Saint Jerome*, 1615. Brussels, Musées Royaux des Beaux-Arts. Painted when the artist was sixteen years old.

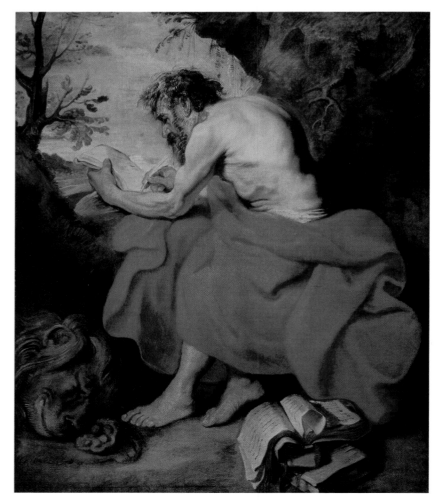

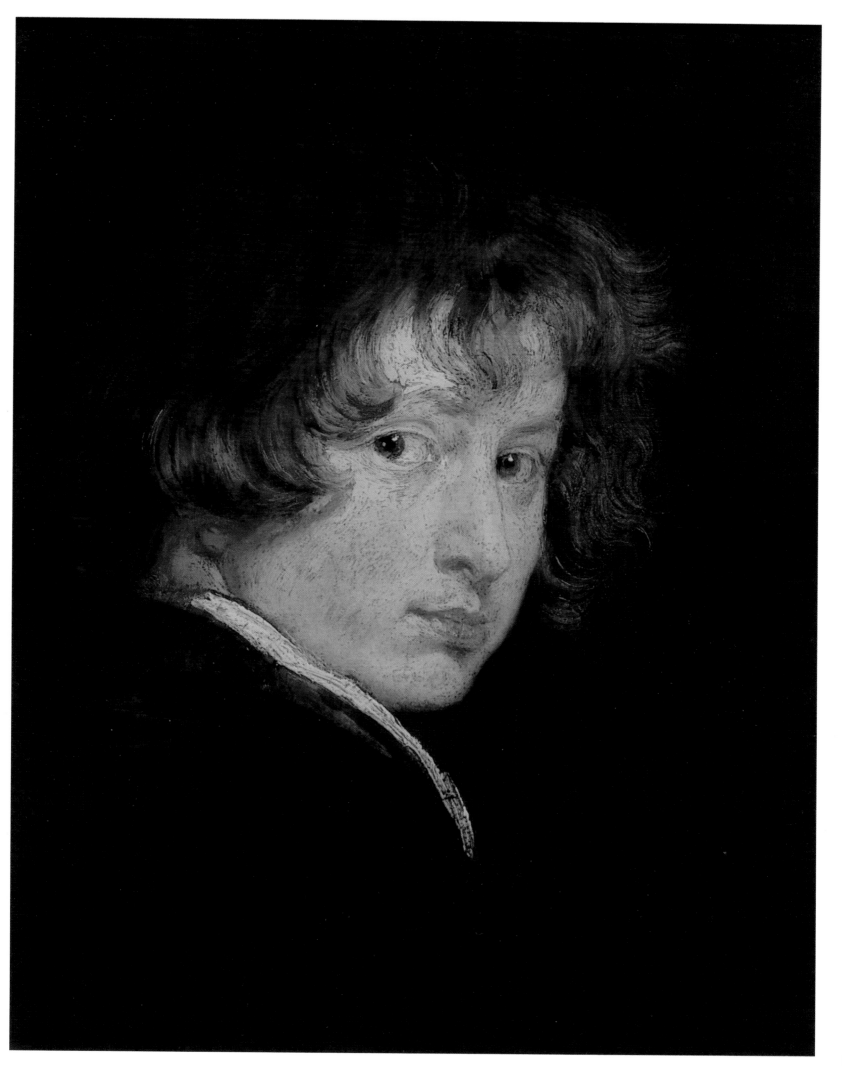

Writing History

LOUIS OF FRANCE, DUKE OF BURGUNDY, CALLED THE GRAND DAUPHIN

(1661–1711)

Louis, called the Grand Dauphin, son of Louis XIV and Marie-Thérèse of Spain, would have mounted the French throne if he had not died in 1711, four years before his father. In view of the great responsibilities that he was expected to inherit, he was given an exceptional education, overseen by Jacques Bossuet, a prominent Catholic bishop and orator. We can judge the character of the prince's education from a number of surviving documents, including a letter from Louis XIV to Pope Innocent XI, translated by Bossuet; fragments of assignments executed by the prince; works dedicated to him by his tutor; and short historical writings intended for a history of France that he and his tutor wrote. This was the *Abrégé de l'histoire de France* (Brief History of France), first published in 1747, more than three decades after the dauphin's death.

"This history," its publisher wrote in his preface, "is not by Bossuet alone; some of the credit for it can rightly be claimed by an author of uniquely privileged status: Monseigneur the Dauphin, the only son of Louis the Great and ancestor of the present king Louis XV." The double authorship resulted from Bossuet's teaching method, which he described in his letter to the pope: "We read out loud [to the dauphin] as much material as he can easily retain; we make him repeat it; he writes [first] in French and then translates it into Latin. Such are his composition assignments, and we correct his French as carefully as we do his Latin." Manuscript fragments of the *Abrégé* survive, some in Bossuet's hand and some in that of the prince with corrections by his teacher. Thus the published history was indeed a collaboration, although Bossuet was responsible for most of it.

To provide material for the book, Pierre de Clairambeault, the royal genealogist, assisted by several other scholars, was charged with "assembling materials that might contribute to the dauphin's historical studies." Furthermore, Bossuet produced (or instructed others to produce) summaries of works by the most important historians of each period, for the instruction of a young man who, it was expected, would himself write a few pages of the history of France in his own reign.

Left:

Anonymous, *Portrait of the Grand Dauphin as a Young Adult.* Château de Versailles

Below and opposite:

Several pages of an assignment in French history written by the Grand Dauphin and corrected by Bossuet around 1675. Below: in Latin. Opposite: in French. Paris, Bibliothèque Nationale de France, Département des Manuscrits, Rothschild collection, autograph manuscript by Bossuet no. 320

que la reine avoit par un certain resolue de suivre
resolu de suivre
le parti pour lequel elle se declarent. au milieu
de tant d'irresolutions les huguenots attentifs
a profiter des conjonctures estoient mis en estat
d'se rendre maistres a Orleans le ... le
gouverneur n'eut pas plutost veu la reine
declarée qu'il songea a se precautionner contre
eux, mais trop tard a l'arrivée de d'Andelot

un nouveau courage
il s'avoient pris de nouvelles forces et il n'y
avoit nulle doute quelque prince n'y fust maistre
s'il se hastoit de s'y rendre la reine l'amusa un peu
de temps par des propositions d'accommodement
precieuse, mais qui n'aboutirent a rien cependant
...
pressé par un colorans de thiodoit qu'il luy
mandoit s'il qu'il perdoit tout s'il retardoit
un seul moment son arrivée il marchoit

avec deux mille chevaux qui se suivoient à bride abatue
une si grande diligence que tout le monde eut
estonné sergents se renversoient eux
sur les autres sans s'arrester et les passants qui
les voyoient courir ... à une telle
precipitation les prenoient pour des insensez.
ils entrerent plus tranquillement dans la ville
avertis a la porte que d'Andelot ... n'estoit
assuré du gouverneur de se rien

1562
et ainsi ce parti encore foible qui n'avoit
acquis une place qui par
point de place d'armee ... eut une qui par
sa situation et son importance ...
de laquelle ... l'aida a l'ensuer tout les autres.
toutes les autres +/ le peuple de Paris n'eut pas
assemblée
plutost sceu la resolution de la reine qu'il attaqua
les huguenots dans un temple ou ils estoient attaqués
hors de la ville. il n'y eut point de sang repandu mais ils
connurent qu'il n'y avoit point de seureté pour eux

The Herbarium of Philibert Commerson

PHILIBERT COMMERSON

(1727–1773)

Although Philibert Commerson is known only to a few naturalists today, nearly everyone is familiar with the hydrangea bush and the flowering bougainvillea vine, both of which he discovered and introduced to Europe. The discoveries of these two plants are only two of his many contributions to botanical science in the course of his long career of travel and scientific work. After embarking in 1766 on a voyage around the world with the explorer Louis-Antoine de Bougainville, Commerson spent seven years gathering, describing, and drawing the flora and fauna of distant lands in the interest of scientific knowledge, as well as in the hope of finding ways to grow valuable spices in the French colonies. Although he was equally fascinated by zoology (for naturalists of the period claimed all nature as their domain of study), Commerson became seriously interested in botany when he was quite young. No one could have predicted that this son of a notary would devote his life to science, for his father wanted him to study law, but a period spent at a Jesuit college fostered other passions in him. One of his professors introduced him to the patient study of plants and encouraged him to gather specimens in the surrounding country-side. Thereafter, he never ceased adding to his botanical collection, and his knowledge of the field.

The herbarium that Commerson assembled while he was still at school, the first volumes of which date from 1742–43, when he was fifteen, already reveals his enthusiasm for botanical research. Not always sure how best to secure his specimens (they are variously sewn to the page, slipped into tiny notches in the paper, or fixed to it with pins), he recorded their therapeutic qualities. He was also attentive to the visual harmony of each sheet, placing the plants carefully and adding, on occasion, small paper cutouts. In short, he was developing his skills as a botanist. He began his first fully professional herbarium some years later, when, after having convinced his father to allow him to pursue a career as a naturalist, he was studying at the faculty of sciences in Montpellier. He had lost none of his passion for botany; determined to add to his specimen collection, he was forbidden access to the botanical gardens of his university because he had stolen a fruit from its rare and precious *Realmuria* plant.

Above, opposite, and following pages:
A few carefully organized
pages from the herbarium
assembled by the young
Philibert Commerson in 1742–43

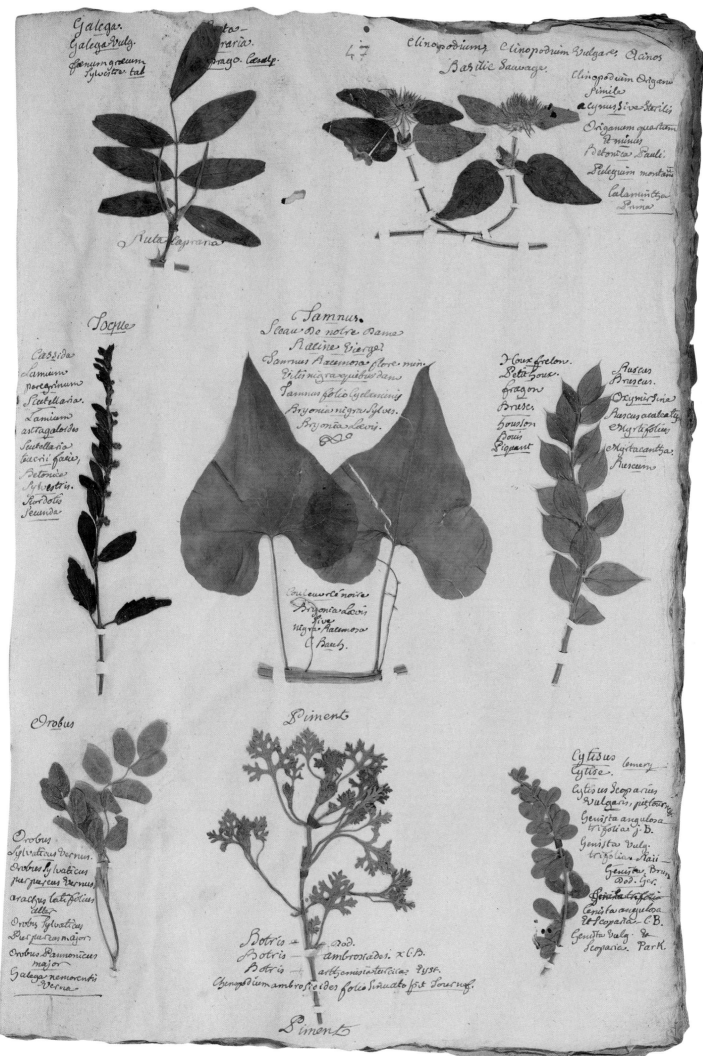

Philibert Commerson, voyager and naturalist.
Botanical Notebooks.
Album of Dried Plant Specimens, 1742–43. Four notebooks with mounted plant specimens. The specimens are all native to the Ain region, but the collection sites are not specified. Some pages are enlivened by paper cutouts. Paris, Bibliothèque Centrale du Muséum d'Histoire Naturelle, ms. 200

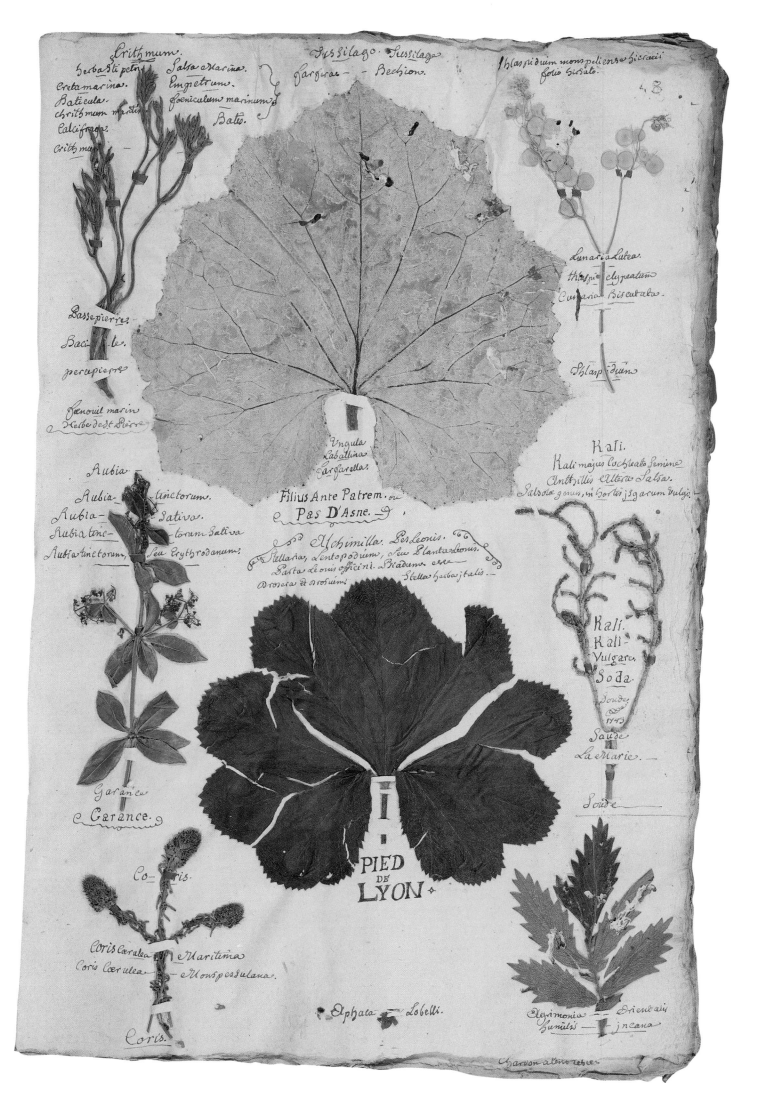

Crithmum.
Herba Sti petri. Salsa e Marina.
Creta marina. Empetrum.
Baticula. foeniculum marinum
chrithmum martis Bate.
Calcifraga.
Crithmum

Tussilago. Tussilago.
Cargeras — Bechion.

Thlaspidium monspeliense hieracii
folio hirsuto.

48

Bassepierre.
Bacible.
perupierre
fenouil marin
Herbe de St Pierre

Lunaria Lutea.
thlaspi clypeatum
Lunaria Biscutata.
Thlaspidium

Rubia —
Rubia — tinctorum.
Rubia — Sativa.
Rubia tinc — torum Sativa
Rubia tinctorum, Seu Erythrodanum.

Ungula
Caballina
Cargarella.

Kali.
Kali majus Cochleato Semine
Anthyllis Altera Salsa.
Salsola genus, in hortis, Sagarum vulgo.

Filius Ante Patrem, ou
Pas D'Asne.

Alchimilla. Pes Leonis.
Stellaria, Lentopodium, Seu Plantae leonis.
Pata Leonis officini. Sphiadum ere
Drosera te Drohuim Stella herbas talis —

Garance.
Garance.

PIED DE LYON

Kali.
Kali —
Vulgare.
Soda.
Soude
Saude
La Marie.
Soude

Co — ris.

Coris Coerulea — Maritima
Coris Coerulea — Monspessulana.

Coris.

Aphaca — Lobelli.

Agrimonia — Orientali
humilis — Incana

Chardon à te resier

+ Page Quinzième — Etimologie

Noms.
Bonus henricus.
Lapatium hortensis
Chenopodium folio
triangulo
tota bona.
atriplex lanira
Riger henricus
Spinaceum
olus Sylvestre
Rumex
Spinacia Silvestris
ou
Bon Henry.

Noms
Primula Veris
Primula pratensis
Verbascum pratense od...
Herba paralysis
alisma pratense
Attrica
Paralysis Vulg
Pratensis flore flavo
Dodecantheon
ou
Primevere.
Primerolle.
Coucou

Etimologie
On a apellé cette herbe primula veris
Et primevere parcequ'elle fleurit
une des premieres du printemps

Noms
Thymus Capitatus
Thymum Legitimum
Thymum Creticum
Thymum Cephaloten
Serpillum hortense
ou
Thim

Etimologie
Herba trinitatis ...
Viola tricolor parceque
cette plante est une espece
de Violette qui a trois
couleurs, le Blanc,
le Jaune, et le Violet.

Noms
Herba trinitatis
Viola tricolor
Viola trinitatis
Viola tricolor hortensis
Jacea major
Jacea flammea
Flos calidus
Jacea sen flos trinitatis
Hepaticum
Vacca tricolor
ou
Herbe de la trinité

31

"Madame my very dear Mother"

MARIA ANTONIA JOSEPHA OF LORRAINE, LATER QUEEN MARIE ANTOINETTE OF FRANCE
(1755–1793)

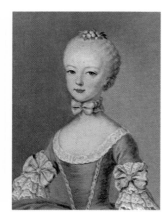

Krantzinger after Ducreux, *Portrait of the archduchess Antonia at age thirteen*, oil on canvas. Vienna, Kunsthistorisches Museum

The fifteenth child of the Empress Maria Theresa of Austria and the Holy Roman Emperor Emperor Francis I, the Archduchess Maria Antonia Josepha Johanna was born at the Hofburg Palace in Vienna on November 2, 1755. Her brothers and sisters, three of whom had died before her birth, were all much older than she.

The young archduchess showed an early interest in music. When she was four, she joined her brothers and sisters in entertaining their father at an evening celebration of his birthday. She sang some French verses set to music, while the older children played a variety of instruments, including the violin, cello, and drum. In 1763, she met the young musical prodigy Wolfgang Amadeus Mozart, who had been invited to the Viennese court. It is said that when Mozart, then only six years old, slipped on the floor of a salon, the little archduchess Antonia, herself only seven, ran to help him to his feet. Mozart is reported to have said to her, "You are good; I want to marry you."

The young archduchess was not a good student. She objected to every assignment and, being something of a chatterbox, kept her teachers quiet by talking constantly. Her sparkling conversation would later delight the court at Versailles. Her great confidante was her sister Maria Carolina, with whom she shared much uproarious laughter. Together, the two princesses indulged in their favorite pastime, which was mocking other people.

The archduchess Antonia loved not only laughter, but pleasures of all kinds: cream cakes, flowers, dogs, parties, and, above all, music, and she was destined to have her fill of all these things. After long and difficult diplomatic negotiations, she was betrothed to the heir to the French throne, the future Louis XVI, cementing an alliance of considerable importance to both France and Austria. When she was finally sent, at age fourteen, from her native country to France, a seemingly endless series of balls, theatrical performances, banquets, equestrian demonstrations, and fireworks displays were organized for her entertainment. The only companions that the young archduchess took on her long one-way journey were her tutor and her little dog. The Austrian archduchess had become Marie Antoinette, Dauphine of France.

Letter from the Dauphine Marie Antoinette to Empress Maria Theresa, July 12, 1770:

Madame my very dear Mother,

I cannot tell you how touched I was by Your Majesty's goodness toward me and I swear to you that every time I receive one of your dear letters my eyes fill with tears of regret at having been separated from so tender and good a mother. I am very well here. I ardently hope, however, to see my dear and very dear family again, at least for a short time.

I am in despair that Your Majesty has not received my letter. I thought it would go by courier, but Mercy thought it best to send it by Forcheron, and I imagine that is the cause of the delay. I find it very sad to have to wait for my uncle, my brother, and my sister-in-law without knowing when they will come. I entreat her to tell me whether it is true that she is to meet them in Graz, and that the emperor is much thinner since his trip, which would upset me as he doesn't have much fat. Regarding her query about my devotions and the general's wife I would say that I have taken communion only once. I said confession the day before yesterday to Monseigneur the abbé Modoux, but as it was the day I expected to leave for Choisy, I did not take communion, having decided that particular day was too distracting. As to the general's wife, it is the fourth time that she has failed to come for no good reason. Our trip to Choisy was postponed a day because my Mary had a cold with fever, but it only lasted a day. For having slept twelve and a half hours straight she felt very well, however, and fit to travel, so since yesterday we have been here, where, between one in the afternoon when we have lunch and one in the morning I cannot return to my apartment. I don't like this at all, since after lunch we play until six, when we go to the theater, which lasts until nine-thirty; then we dine and play some more until one and even sometimes one-thirty in the morning. . . .

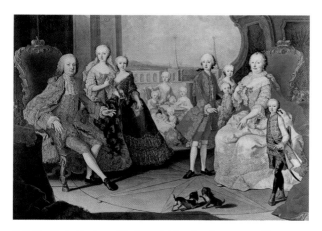

D. R. Martin de Meytens, *The Imperial Family,* oil on canvas. Vienna, Kunsthistorisches Museum. With each successive birth, this portrait of the Emperor Francis I, the Empress Maria Theresa, and their offspring was altered by the addition of the newborn.

Car ayant dormie 12 heure
et demie toute desuite
il ses trouve tres bien
portant et en état de
partire nous sommes
donc de peris hier ici
ou on est venu i heure
ou l'on dine jusqu'a
i heure. du soir sans
rentrere chez soi ce qui
me deplait fort car après
le dine l'on joüe jusqu'à
6 heure quelon vat au
ses spectacle qui dure
jusqu'à 9 heures et demie
et en suite le soupe de
la encore jeu jusqu'a
i heure et meme la demie
quelquefois mais le Roi

Madame tres chere Mere
je ne peu vous exprimer
combien j'etoit touchée des
bonté que Votre Majesté m'y
marque et je lui jure que
je n'ai pas encore recu une
de ses chers lettres sans avoir eu
les larmes aux yeux de regret
d'être d'une aussi tendre et
bonne Mere et quoique je
suis tres bien icy je souhaite
-rai pourtant ardenment
de revenir voir ona chere
et tres chere famille au
moins pour un instant.
je suis au desespoir que
v: M: n'a pas recu ma lettre
j'ai crut qu'elle yrai par
le courier mais
Mercy a jugé apropos

de l'envoyer par Forcheza
et s'est a se que je m'imagine
ce qui cause le retard.
je trouve que s'est bien
triste de devoir attendre
mon oncle mon frere
et ma belle soeur, sans
s'avoir quand ils viendront
je la supplie de me
marquer si s'est vrai
qu'elle est aller a leur
rencontre a gratz et que
l'Empereur est beaucoup
maigri de son voyage cela
pouroit m'inquieter n'ayant
pas trop de graise pour
cela. Pour se qu'elle me
demande pour mes devotion
et la General je lüi
dirai que je n'ai

comunié qu'une seule
fois je me suis confesse
avant hier a Mr. l'abbé
Modoux mais comme s'etou
le jour que j'ai cru partir
pour Choisy je n'ai point
comunié ayant crû
d'avoir trop de distraction
ce jour la. pour la
general s'est le quatrieme
mois qu'elle je vient
sans avoir de bonne
notre voyage de Choisy
a retardé d'un jour
mon Mary ayant eu
un rhume avec de
la fievre, mais cela
s'est passé dans un jour

"God Is Our Refuge"

WOLFGANG AMADEUS MOZART

(1756–1791)

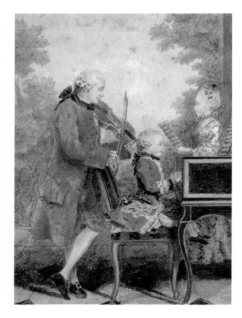

Wolfgang Amadeus Mozart was only three years old when he first sat down at his sister's harpsichord in the family house in Salzburg, "to find notes that like one another." He would make the search for beautiful combinations of notes his life's work. His father, a court composer and the author of a method for teaching the violin, soon realized his son's gift. It became clear that the boy, blessed with absolute pitch and an astonishing musical memory, could play any melody he heard, even if only once.

Very quickly, Wolfgang, who began to compose at age six, eclipsed his talented sister on the performance tours their father organized. As an amusing trick, he played the harpsichord blindfolded, and improvised at the organ. European courts from Vienna to Versailles clamored to see this phenomenon, who could move effortlessly from the harpsichord to the violin and had a knack for pleasing princesses. The Empress Maria Theresa, the Archduke Joseph, and the great German writer Johann Wolfgang von Goethe—who once saw "this little fellow with his wig and sword"—all marveled at his talent. When he arrived in Paris, he was feted by the royal family and the nobility.

While in France, Mozart also wrote a series of sonatas for harpsichord dedicated to Madame Victoire, one of the daughters of Louis XV, declaring himself her "very humble, very obedient and very young servant."

A few months later, the Mozart family traveled to London, where the boy met Johann Christian Bach, the youngest son of the great Johann Sebastian Bach. There he also discovered Italian music, and composed his first symphony. During this visit he wrote a choral setting for the English hymn "God Is Our Refuge," which he presented to the British Museum. The youngster's enthusiasm remained strong, but fatigue and illness exacerbated by constant travel exacted a toll on the entire family. By the end of 1766, the Mozarts had returned to their home in Salzburg. Now ten years old, the boy had been greatly enriched by his travels. His international experience would profoundly influence his art.

Opposite, top left:
Carmontelle, *Wolfgang Amadeus Mozart and His Father Leopold*. Chantilly, Musée Condé

Opposite, bottom right:
This dedication to Madame Victoire of France is glued into her personal copy—bearing the princess's coat of arms on the binding—of Mozart's early harpsichord sonatas. Paris, Bibliothèque Nationale de France

Autograph score of "God Is Our Refuge," which the child Mozart presented to the British Museum. London, British Museum

A Group of Early Portraits

ÉLISABETH VIGÉE, KNOWN AS ÉLISABETH VIGÉE-LEBRUN

(1755–1842)

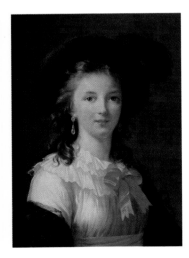

Louise-Élisabeth Vigée was born in Paris, on rue du Coq-Héron, on April 16, 1755. Her father, Louis Vigée, was a pastel painter who had no compunction about ignoring his wife to run after available younger women. Élisabeth was entrusted to a wet nurse until she was five. Then, as she later wrote, "at age six I was placed in a convent, where I remained until I was eleven. During this period I drew ceaselessly and everywhere; the margins of my writing workbooks, even the ones in those of my fellow students, were filled with little heads, facing front or in profile; on the walls of the dormitory, I traced figures and landscapes in charcoal . . . in moments of recreation, I drew in the sand whatever came into my head. I remember that when I was seven or eight I made a drawing by lamplight of a man with a beard that I still have. I sent it to my father, who exclaimed, transported by joy: 'You will be a painter, my child, or there's never been one.'"

In 1767 the girl returned to her family home, where she benefited at first from the instruction of her father, who unfortunately died only a year after her return. Encouraged by friends of the family, she worked in the atelier of Gabriel Briard— a painter of no great distinction, but a fine teacher—where she made drawings after casts of antique sculpture. She progressed so rapidly that Joseph Vernet suggested she come to see him. He offered her this advice: "My child, follow no stylistic system. Consult only works by the great Italian masters and by certain Flemish ones; but above all, work as much as you can after nature." The painter Jean-Baptiste Greuze, who remained a devoted friend until the end of his life, taught her what she later described as "the magic of color."

Painting soon became Vigée's means of support. She worked at her art with great intensity, and displayed a virtuosity that seemed almost casual. As she later wrote, "My father left no fortune; in truth, [by the time of his death] I was already earning a lot of money, having many portraits to paint." Her attractive appearance and social aplomb brought her success in exalted circles. Vigée's professional debut came in August 1774, when she exhibited her work publicly for the first time at the annual exhibition of the Academy of Saint Luke.

Left:
Élisabeth Vigée-Lebrun, *Self-Portrait*, c. 1782, oil on canvas. Fort Worth, Kimbell Art Museum

Opposite:
Élisabeth Vigée-Lebrun, *Étienne Vigée*, 1773, oil on canvas. The Saint Louis Art Museum. Élisabeth used some of the money she earned as an artist to finance the education of her younger brother, shown here in a portrait that she painted when she was seventeen.

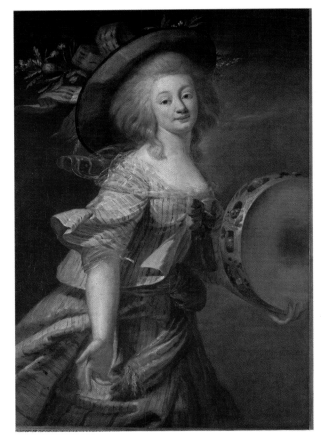

Another portrait by the young Élisabeth Vigée, of the celebrated dancer Camargo.

The Education of Minette

GERMAINE (MINETTE) NECKER, LATER MADAME DE STAËL
(1766–1817)

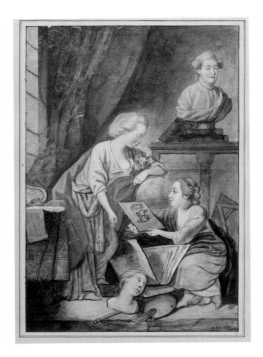

It would be impossible to describe the childhood of the writer Madame de Staël without discussing her remarkable parents. Her father, Jacques Necker, was a brilliant banker from Geneva who became Director of the Treasury for Louis XVI. Her mother maintained a salon in the Enlightenment Paris of Diderot and Voltaire. This influential couple embodied both worldly success and personal integrity, which in their case seem not to have been in conflict. Their daughter and only surviving child, Anne Louise Germaine, was born in 1766. In the family she was known as Louise, or more often, Minette.

Minette's mother oversaw her education, which began early. As soon as the child was old enough to understand, she was taught Latin, English, geography, physics, history, and literature. Bible study and training in rhetoric were also essential features of this curriculum, which strictly avoided all relaxation and play, occasionally to the point of overwork. Her father—the more indulgent of her parents—tried to temper the austerity of his daughter's education without compromising its high standards. Fortunately, Minette, by simply listening to the discussions in her mother's salon, was able to absorb some of the best conversation in one of the most glorious periods of intellectual life in European history. In such an environment, she could hardly have failed to develop her naturally keen intelligence.

Minette was deliberately separated from other children who might have slowed her progress; instead, an older female companion was chosen for her.

At age twelve, Minette—whose views with regard to many political and theological issues were already quite evolved—undertook to write a comedy entitled *The Inconveniences of Parisian Life*. Her mastery of language is already apparent even in this early play. But the amount of work that her studies entailed began to alarm her family's physician. He prescribed more freedom, distraction, and fresh air for the girl. Minette could now allow herself to be a child, after having mastered the basics that would secure her a place in adult society.

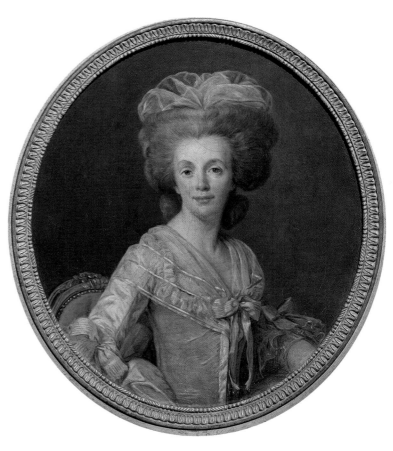

Upper left:
This drawing, executed by Germaine Necker when she was about twelve, shows her with her mother. In all likelihood, her mother helped her with its composition, in which a bust of Jacques Necker, the girl's father, figures prominently. Château de Coppet

Above:
Joseph-Siffred Duplessis, *Portrait of Madame Necker*. Châteaux de Versailles et de Trianon

Letter from Germaine Necker to her mother, early 1778. Château de Coppet

Saturday evening

My dear Mama,
 I need to write to you. My heart is shriveled; I am sad, and in this vast house that such a short time ago contained everything dear to me, that marked the limits of my universe and my future, I now can see only a desert. I realized for the first time that this space is too large for me, and I ran to my small bedroom so that my view might at least encompass the entirety of the void around me. This momentary lack made me tremble for my destiny. You find within yourself, my dear Mama, endless consolations, but within myself I find only you. You are my reason, my courage, and I feel that your lessons have taught me to regard yourself as the virtue that you taught me. A hundred times happy is he who need only follow the example of those he loves; but would one have loved virtue if you had been wicked? I curse this ball and all my frivolous tastes. I was greatly deceived in thinking that it would give me any pleasure. Did I think that, far from you, I would have the same eyes? I am respectfully, my dear Mama, the tenderest of daughters.

 Necker

v. 19. 20. on coupe tous les arbres qui ne portent pas de bons

fruits, et on les jettera au feu. C'est donc à leurs fruits

que vous les connoitrez.

explication

Jesus christ compare les faux prophêtes aux arbres qui ne

portent pas de fruits, et qui doivent être detruits puisqu'ils

sont inutiles dans le monde et par là même nuisible.

v. 21. Ceux qui me disent, Seigneur, Seigneur, n'entreront pas tous

dans le royaume du ciel, mais ceux là seulement qui font

la volonté de mon pere qui est au ciel.

explication

Ces paroles signifient qu'il n'i à aucune loüange, aucune

adoration, aucune priere, aucun jeune, qui puisse suppleer

à l'observance de la loi de Dieu.

Quel est le meilleur de tous les Gouvernement

Je crois que des quatre Gouvernements principaux établis en Europe, savoir, le Gouvernement Monarchique, l'Aristocratique, le Democratique et le Mixte, c'est le Gouvernement Mixte qui est le meilleur, mes raisons sont celles-ci, je trouve qu'un Gouvernement conduit par plusieurs personnes est beaucoup moins en danger d'être ruiné, d'être apauvrie, et détruit qu'un Gouvernement conduit par un seul homme; le Gouvernement Monarchique par exemple, est plus en danger d'être ruiné parce que toute l'autorité dépend d'un seul homme et que si cet homme étoit porté pour les dépenser ou pour quelques autres vices, il seroit capable de ruiner et de détruire entièrement son royaume, sans que personne y pourroit mettre obstacle, au lieu que dans le Gouvernement Mixte qui est administré par plusieurs membres si l'un d'eux se trouver avoir des vices ou n'est pas en état de conduire le Gouvernement, il est vraisemblable qu'entre tant

These two examples of composition assignments executed by Germaine Necker reveal the young girl's remarkable maturity. Opposite: interpretations of two parables from the Gospels. This page: beginning of an essay on "the best of all forms of government," in which Germaine argues that, of the four principal types established in Europe (monarchical, aristocratic, democratic, and mixed), the one most to be preferred is the mixed type. Archives, Château de Coppet

Cuvier's Plants

GEORGES CUVIER
(1769–1832)

At age six, it is said, Georges Cuvier could recite poems from memory and draw as well as a twenty-year-old. Always at the head of his class at school, this child of the Enlightenment had been born at Montbéliard in eastern France, "very weak, on August 23, 1769, a year that also produced men of another kind," as he wrote in his memoirs, a thinly veiled allusion to Napoleon Bonaparte. Blessed with an encyclopedic memory, he also had an insatiable curiosity—"the mainspring of my life," he later remarked—that sometimes left his mother speechless. He repeated his lessons in Latin to her (although she did not know the language) and soon became fascinated by history and literature. He also acquired a love of the natural world, which would later become his life's work. In this interest he benefited from reading such books as Solomon Gesner's *Catalogus Plantarum* (Catalogue of Plants) and, above all, the complete forty-four volume *Histoire Naturelle* (Natural History) by the naturalist Georges de Buffon and his colleagues, which the boy discovered in the library of a relative. Speaking of this last work, Cuvier later wrote, "As a child, it was my greatest pleasure to copy the illustrations and color them in accordance with the descriptions. I dare say that this exercise so famil-iarized me with quadrupeds and birds that few naturalists can have had clearer ideas about them than I did at the age of twelve or thirteen." It was at this age, too, that he founded his first scientific society.

As a child, Cuvier rose early and went to bed late, for he wanted to learn everything, copy everything, comprehend everything. He soon attracted the attention of an aristocratic lady, the sister-in-law of the Duke of Württemberg, who was the ruler of the province where he lived. The duke awarded him a full scholarship to an academy in Stuttgart, a remarkable stroke of luck for this fourteen-year-old, whose family would otherwise have been unable to provide him with a first-rate education.

Left:
Georges Cuvier, drawing of *Phoenix dactylifera* (with figures) from *Diarium Botanicum,* 1786. Paris, Institut de France, Bibliothèque de l'Institut

Below and opposite:
Every summer during his youth, Georges Cuvier explored the countryside, taking notes in Latin and making drawings of the local flora.

Die XIV. Septembris.

creslit in aula nostra academica,
fungus, hic in margine depictus.
descriptio. — Stipites plures ex eadem
basi; teretes, incurvi, albidi,
squamulis parvis, obsoletis, fulvis,
sparsis. Pileus orbicularis, convexus
supra, egregie luteus, squamis
brunneis, majoribus, per orbem positis,
margine pallidioribus, minus conspicuis.
lamellæ inæquales, ex albido rufescentes.
an Agaricus clavus.

Eodem Die. plantæ ex horto botanico.

Aloe viscosa. 2. Scapus
filiformis, flexuosus. Racemus
terminalis. flores pedicellati
erecti. Corolla albida, striis fuscis 6.
tubo cilindrico; folia punctulata.

colere cum caractere lin. optime
quadrant.

Veronica Spicata? tota planta
subincana: folia lanceolata, foliis V. spuriæ dupla breviora, oposita
petiolata, obtuse serrata, ambigua.
Caulis erectus, spica terminali, conferta.

Crithmum maritimum. 2

A Treatise on Conical Sections

ANDRÉ-MARIE AMPÈRE

(1775–1836)

The man who expounded the theory of electromagnetism, laid the foundations for an electronic theory of matter, devised the galvanometer, invented the electric telegraph, and, with a colleague, the electromagnet, was born near Lyon in 1775. The son of a silk merchant, he was raised first in Lyon and then, after his father's retirement in 1782, at the family estate, which was ten miles from the city. There the elder Ampère devoted himself to the education of his children, a subject on which his ideas resembled those of the philosopher Jean-Jacques Rousseau as propounded in his book on educational theory, *Émile*: "Let children develop on their own, striving only to instill in them a desire for knowledge and to encourage their curiosity, guiding them almost without their being aware of it."

Ampère wrote in his memoirs—in which he spoke of himself in the third person—that "Before he began to read, the young Ampère's greatest pleasure was to have read to him portions of Buffon's *Natural History*. He repeatedly asked to hear bits of the naturalist's descriptions of the animals and birds . . .while he amused himself by looking at their illustrations. The fact that he was free to study only when he wished resulted in his learning to spell long before he learned to read; he eventually taught himself to read with fluency by trying to decipher the parts of his books that were devoted to birds."

Ampère was remarkably precocious, blessed with a prodigious memory and a rare ability for assimilating information. With such gifts he never needed to attend school. Self-taught, he devoured book after book, storing away in his mind an encyclopedia that was both complete and superbly well organized.

In 1788 he was thirteen years old. His fitful education, literary above all, was completed by his father in the course of long walks, during which they discussed one subject after another. The boy had a special gift for mathematics, and when a copy of Rivard and Mazéare's *Elements of Mathematics* fell into his hands, he lost interest in all other subjects. With an audacity reminiscent of the young Pascal, he set about composing a *Treatise on Conical Sections,* using material from his reading and proofs that he thought were new.

The French Revolution worked havoc with the young man's life. Tragically, his father was arrested and guillotined during the Reign of Terror. The young Ampère responded characteristically to this blow by throwing himself passionately into the study of botany.

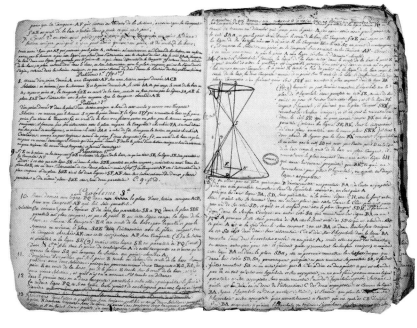

Above left:

David d'Angers, *Medallion Relief Portrait of André-Marie Ampère*

Left and opposite:
Autograph manuscripts by Ampère dating from 1788, when he was thirteen. Left: two pages from the *Treatise on Conical Sections*. Opposite: how to obtain the rectification of a circular arc. Paris, Archives de l'Académie des Sciences

une Courbe telle que la Corde de 60° de son cercle generateur
= l'ordonée de la Courbe tirée de l'extremité de la corde et successivement chaque ordonée = les
cordes qui repartent des arcs de plus de 60:

$$BO : OT :: OT : OM = \frac{OT^2}{BO}$$

$$a : 3a :: 4a : \frac{12aa}{a} = 12a$$

$$aa \quad a^2 : 3a^2 :: 4a^2 : 12a$$

Comme 16 : 12

Probleme

Trouver la rectification d'un arc quelconque plus petit que la demi circonference, dans le Cercle.

Solution: Soit un angle droit BCA; sur le moindre côté BC soit décrite une demie circonference BPC divisée
en un nombre quelconque de parties egales, en six par exemple: par les points de divisions soient menées des paralleles
a AC, et divisés AC en six parties aussi egales: donnés a LR, cinq parties de AC, quatre a VS, trois a QP,
deux a MO, enfin une a N1 et joignés les points B,N,M, Q,V,L,A, par une courbe continue; Soit maintenant
BO = x, OM = y, BPC = c, AC = a. puisque l'arc **BO** est les $\frac{2}{6}$ de la demi circonference BPC et que pareillement
la ligne MO est les $\frac{2}{6}$ de AC, on aura BPC : BO :: AC : MO, ou algebriquement c : x :: a : y = $\frac{ax}{c}$
et differenciant dy = $\frac{adx}{c}$, mais si on mène la Tangente OT, et l'ordoné mo infiniment proche
de MO, de plus la ligne Mr parallele a OT et enfin mT par les deux points m,M, on aura mr = dy
= $\frac{adx}{c}$, et Mr = Oo = dx a l'analogie des Triangles Semblables mrM, MOT, nous donnera
mr $\left(\frac{adx}{c}\right)$: Mr (dx) :: MO $\left(\frac{ax}{c}\right)$: OT = $\frac{acxdx}{acdx}$ = x = l'arc **BO** qui se trouve rectifié par ce moyen

Autre Solution

En Suposant la même construction on a les Triangles Semblables Tom, TOM, qui donnent
To : TO :: om : OM; Soit maintenant Bo = X, BO = x, om = Y, OM = y, on aura Y = $\frac{aX}{c}$
et y = $\frac{ax}{c}$ donc Y : y :: $\frac{aX}{c}$: $\frac{ax}{c}$, ou Y : y :: X : x, c'est a dire om : OM :: BO : Bo ou bien
et parconsequent To : TO :: Bo : BO; donc Substrahendo To − TO : TO :: Bo − BO : BO ou ce qui
revient au même oO : TO :: oO : BO; d'ou l'on conclud comme cy devant TO = l'arc BO.

Si vous menez une Tangente de l'une des extremités de l'arc OB de 60° du cercle figurateur
la Cycloïde Je dis que les deux tiers de cette Tangente = OB, de plus que cette tangente
coupe la base de la Cycloïde en deux parties egales, en outre que la corde BO de l'arc de 60°
etant prolongée sur cette base de la cycloïde termine cette base en sorte qu'elle egale la demi circonference
Je dis encore que cette corde ainsi prolongée est parallele a la Tangente de la cycloïde menée
du point ou une de ses ordonées rencontre l'extremité l'arc OB de 60° menée parallelement a la base

"The History of England"

JANE AUSTEN

(1775–1817)

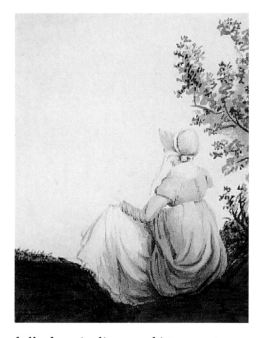

The accomplished novelist who became famous for writing *Pride and Prejudice* and *Sense and Sensibility*, was also, at least in youth, something of an amateur historian. In the autumn of 1791, at the age of sixteen, she wrote a *History of England from the Reign of Henry IV to the Death of Charles I* on thirty-four sheets in a clear hand. True, the author admitted on the title page that, as a historian, she was partial, full of prejudice, and ignorant, a confession that set the tone for the whole. Even at this young age, it would seem, Austen was in possession of the satiric gift that would color the novels to come. Indeed, fiction was her genuine vocation; from the age of twelve, she filled dozens of pages with stories that she then read to her family.

Her youthful work of history, a parody of Oliver Goldsmith's four-volume *History of England from Its Origins to the Death of George II*, goes so far as to imitate that work's chapter headings, which featured portraits of the various sovereigns. In Austen's manuscript, these drawings are the work of her sister Cassandra, who transformed kings and queens into ordinary people with surly or triumphant features according to the political preferences of the two young girls, who favored the Stuart line. The result, charming in its freshness and humor, is now in the British Library.

Left:
Cassandra Austen, *Jane Austen*, watercolor, 1804. Private collection

Opposite:
Manuscript page from *The History of England*, written by Jane Austen at age sixteen. The medallion portrait is by her sister Cassandra. Below: Cassandra's medallion portraits of Queen Elizabeth and Mary Queen of Scots. London, British Library

Mary.

Mary
C E Austin pinx

This woman had the good luck of being advanced to the throne of England, inspite of the superior pretensions, Merit, & Beauty of her Cousins Mary Queen of Scotland & Jane Grey. Nor can I pity the Kingdom for the misfortunes they experienced during her Reign, since they fully deserved them, for having allowed her to succeed her Brother— which was a double piece of folly, since they might have foreseen that as she died without Children, she would be succeeded by that

Early Watercolors

JOSEPH MALLORD WILLIAM TURNER

(1775–1851)

It is a rare artist whose family approves of his (or her) choice of profession. Generally, the family hopes that the young person will enter a more stable and secure line of work. Turner, however, was an exception to this rule. His mother, the granddaughter of a butcher, and his father, a barber and wigmaker, took enormous pride in his talent; his father even exhibited the boy's first works in his shop. Indeed, Turner, whose first surviving drawings date from his twelfth year, manifested remarkable gifts early, as evidenced by his first self-portrait, a watercolor miniature executed when he was sixteen.

By that time, the boy had no doubts about the life ahead of him. He was already working for several architects, who valued the precision of his drawing and the elegance of his perspective renderings of buildings, skills that he had honed under the guidance of one of the most highly respected topographical draftsmen of the day, Thomas Malton, as well as at the Royal Academy school. At age fifteen, he showed a watercolor at the annual exhibition organized by the Academy, one of the great cultural events of the London calendar.

It is surprising that this master of watercolor, this magician of haze whose images of clouds are familiar to every art lover, should have first become known as a conventional draftsman. Often working on commission, the young Turner traversed the countryside making topographical sketches, which brought him fame while he was still a young man. Lord Elgin considered bringing him along on his famous expedition to Greece—the voyage that resulted in the Parthenon sculptures being brought to England—but ultimately abandoned the idea. Even at twenty-five, Turner was too expensive.

Left:
In the early 1790s, Turner produced his first sketchbook, which includes this watercolor, *View of Traeth Bach on the Snowdon with Moel Ebog and Aberglaslyn*. London, Tate Gallery

Opposite:
This remarkable portrait dates from 1790, when Turner was sixteen. London, National Portrait Gallery

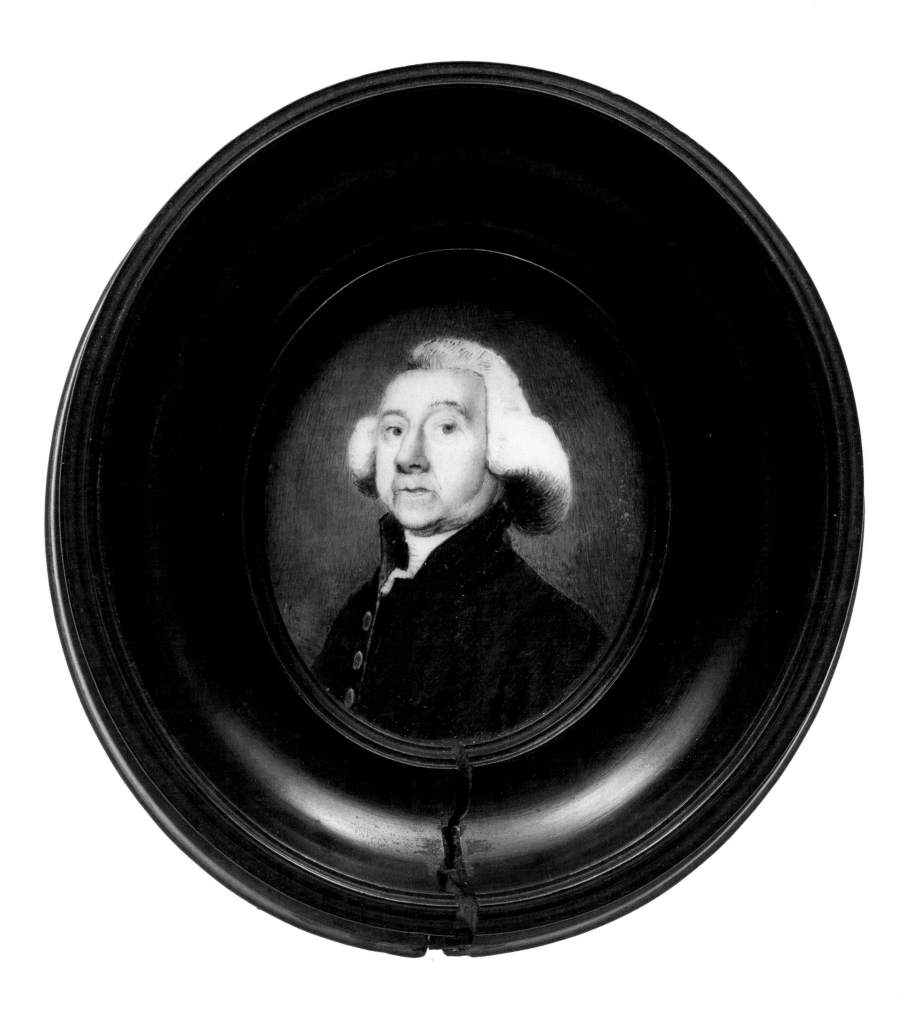

A Preview of a Great Talent

JEAN-AUGUSTE-DOMINIQUE INGRES

(1780–1867)

Ingres was eighty-two when he painted his great masterpiece in oil, *The Turkish Bath*. Just as astonishing as the youthful spirit that can be seen in this work of the artist's old age is the remarkable maturity of the artist's early drawings. For example, at the age of eleven he drew this stunning red chalk profile portrait of his grandfather; at age thirteen he produced a black chalk portrait, with highlights in lead pencil, of another gentleman. Unquestionably, Ingres was an extravagantly gifted child.

The son of Joseph Ingres, an ornamental sculptor, the young painter early mastered the art of portraiture as well as that of landscape, a genre that he did not pursue as an adult. *Landscape with Fishermen*, apparently a straightforward copy of a Dutch print, demonstrates how very assured his hand was at the age of twelve. Already at this age, Ingres was a student at the Academy of Fine Art in Toulouse, where he won third prize in a class dedicated to drawing after the human figure and casts of antique sculpture, and he worked constantly at his father's side. The boy was also an accomplished musician. Both he and his father played the violin, sometimes performing together, much like Mozart and his father, in the reception rooms of Monseigneur de Breteuil, Bishop of Montauban.

During his youth in Toulouse, Ingres often took first place in local art competitions. In 1797, he headed to Paris to complete his education, armed with a certificate that read as follows: "The jury of instruction affiliated with the Central School of the department of the Haute-Garonne, which has followed the progress of Citizen Ingres . . . is pleased to predict that one day this young artistic aspirant will honor his country through his superior gifts, which he has very nearly mastered." He no doubt presented this document to the painter Jacques-Louis David, who immediately accepted him into his atelier.

Left:
Jean-Auguste-Dominique Ingres, *Joseph Ingres, His Wife Anne Moulet, and Their Two Daughters*, graphite, pen and ink, and wash, c. 1793–97. Montauban, Musée Ingres

Opposite:
Jean-Auguste-Dominique Ingres, *Jean Moulet* (the artist's grandfather), copy in red chalk of an earlier red chalk drawing made by his father, Joseph Ingres, 1791. Montauban, Musée Ingres

Jean-Auguste-Dominique Ingres, *Landscape with Fishermen*, pen and ink, before 1793. Montauban, Musée Ingres. This is probably a copy after a Dutch print.

50

Fait par ingres fils agé de onze ans, le 15. 8.bre — 1791 —

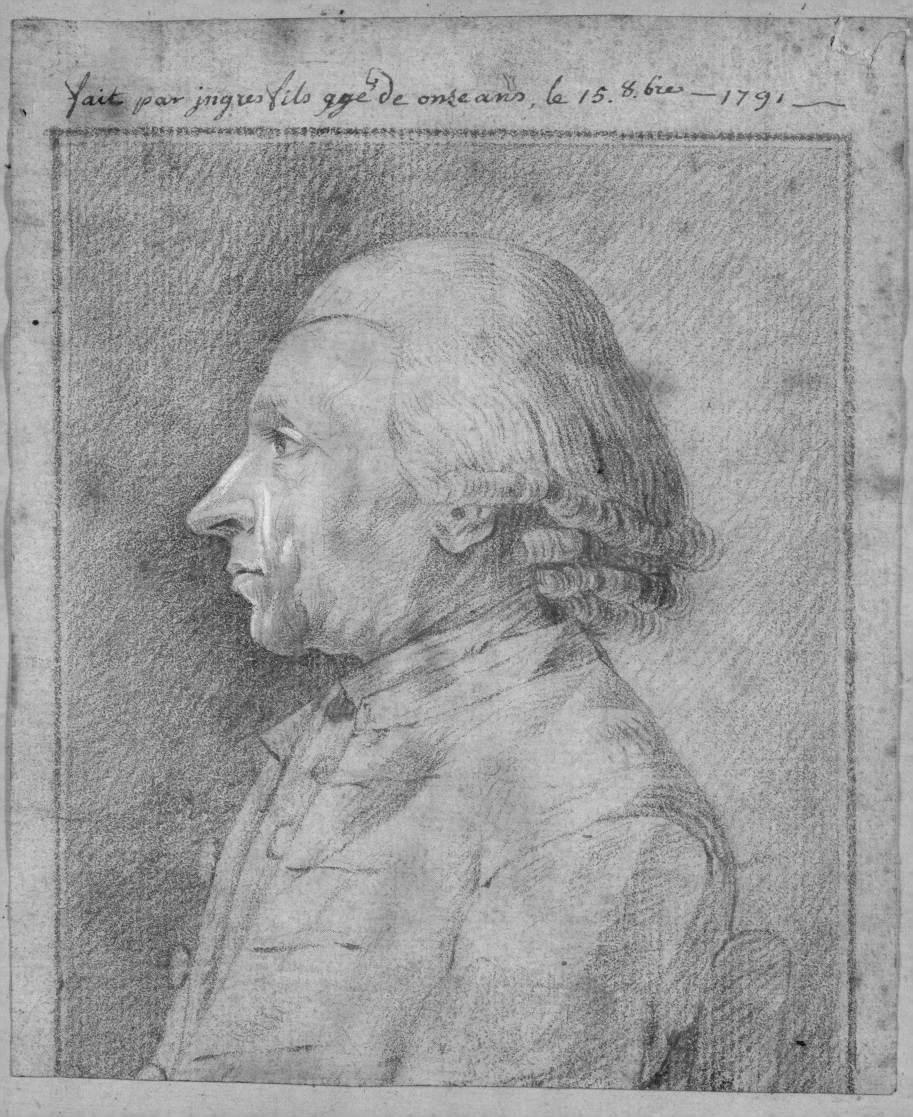

Henri's Advice

HENRI BEYLE, KNOWN AS STENDHAL

(1783–1842)

Henri Beyle was ten years old when Louis XVI was beheaded. In Grenoble, a bourgeois city that he was beginning to hate, the child rejoiced at this "great act of national justice," as he wrote some years later under the name of Stendhal in *The Life of Henry Brulard*. In one of his school notebooks, however, this young political maverick also scribbled in the margin: "Long live the *chouans*!"—a reference to a group of insurgent Breton royalists. The inconsistency of these statements, at first puzzling, make sense in one respect, namely that the boy was attracted to romantic drama of all kinds.

The loss of his mother, who died when Henri was seven, sounded the death-knell of his carefree life. Henceforth, his childhood unfolded in hatred: of his tyrannical father; of the narrow-minded religion represented by his tutor, a Catholic priest; of the bourgeois milieu in which he was raised. But there were compensations: his maternal grandfather, a doctor and scholar who introduced him to the delights of astronomy and botany; his much-loved sister; music; and, above all, books, which he devoured avidly. A first prize in mathematics in 1799, when he was sixteen, qualifying him to compete for admission to the State Polytechnical School in Paris, provided a means of escape.

After arriving in Paris, however, he was overcome by loneliness, and withdrew from the school to begin a career at the War Ministry. His somber new life was enlivened by reading, which he recommended to his sister Pauline, three years his junior. His letter to her is both moving and informative, affording a glimpse of the tastes of the young writer, who, although he had not yet fully mastered the language that was to become his medium, would soon make up for lost time.

Paris, 18 Ventôse, Year 8 [March 9, 1800]

I no longer recognize myself, my dear Pauline, when I realize that I've let five months pass without writing to you. I've been thinking about doing so for some time, but the variety of my occupations has always prevented me from satisfying my desire. First, I want you to write to me every eight days without fail; if you don't, I'll scold you; then I want you to refrain from showing either your letters or mine to anyone. I don't like to feel constrained when I write from the heart. You'll tell me how your piano lessons are going; if you're learning to dance. Did you dance this winter? I think so. Are you learning to draw? The devil's meddling in my affairs has prevented me from learning since I arrived here. I'm learning to dance from a dancer at the Opéra; her style is completely different from Beler's; since the one I'm learning is the right one and will make its way to the provinces sooner or later, I suggest you prepare yourself by bending your knees deeply with every step and by practicing your footwork with particular diligence. I dance with Adèle Rebuffel who, although only eleven years old, is full of talent and spirit. One of the things that has most contributed to her acquisition of them is her wide reading; I would like you to take the same route, for I'm convinced that it is the only good one. . . .

Above:
Drawing of Henri Beyle from a school notebook

Below and opposite:
Letter from Henri Beyle to his sister Pauline, March 9, 1800

Paris 18 Ventose an 8. (9 Mars 1800)

je ne me reconnais plus, ma chère pauline, lorsque je pense que
j'ai pu rester 5 mois sans t'écrire. il y a déjà quelque temps que j'y
pense mais la variété de mes occupations m'a toujours empêché
de satisfaire mon désir. d'abord je veux que tu m'écrive tous
les 8 jours sans faute sans cela(1) je te gronde, ensuite je veux
que tu ne montre tes lettres ni les miennes à personne. je
n'aime pas quand j'écris de cœur être gêné. tu me diras comment
va le piano, ~~si tu apprends~~ si tu apprends à danser.
as tu dansé cet hiver j'espère que oui. apprendra tu à
dessiner. le diable qui se mêle de mes affaires m'empêche
d'apprendre depuis que je suis ici. j'apprend à danser d'un
danseur de l'opéra, son genre ne ressemble en rien à celui
de Beter, comme celui que l'on m'enseigne est le bon et que
comme tel il parviendra tôt ou tard en province je te
conseille de t'y préparer en pliant beaucoup dans tous tes pas
et en exerçant particulièrement le cou de pied. je danse

(1) Voir Vie de Henri Brulard - anecdote Daru.

53

"My Dear Mama"

HONORÉ DE BALZAC
(1799–1850)

Opposite:
Letter from the young Balzac to his mother.

In the register of arrivals and departures at the boarding school in Vendôme, entry no. 460 reads as follows: "Honoré Balzac, age eight years and five months, has had smallpox, no infirmities; full-blooded character, easily excitable, subject to occasional bouts of enthusiasm. Entered the school on June 22, 1807. Contact Monsieur Balzac, his father, in Tours." From that day until April of 1813, Balzac did not leave the walls of the school, which he later recalled as a "prison." Discipline was strict; the students could not visit the town, remained at the school over vacations, and were obliged to write their parents every month, a regulation with which Balzac no doubt complied, although this is the only one of his letters from school to survive. He wrote it at age ten and addressed it to his "dear mama," who over the six-year span came to visit her son only twice. "I never had a mother," the author later said, and we know how this absence of maternal love tormented him. His sister Laure, two years his senior and a great comfort to him, confirms their mother's severity in her memoirs, but without the novelist's characteristic exaggeration, so we can trust her when she says she saw her brother twice a year, at Easter and at prize distribution ceremonies. But the details don't much matter: Honoré was thrown into a horrible dormitory where he felt "deprived of all communication with the outside world and denied the caresses of his family," as he wrote in his autobiographical novel *Louis Lambert*, a title that combines the first and second given names of one of his fellow students in Vendôme.

However reluctantly, Balzac managed to live with the school's rigors. As a student he was rather good, although not brilliant. Like everyone else, he was occasionally sent not to the corner but to the "alcove," a small punishment nook under the stairs—a situation he turned to good account by reading, in secret, all the books he could lay his hands on. He also won a few commendations as well, for example, the one in Latin reported here, for which, as was customary, he received a book, Voltaire's *History of Charles XII*.

Vendôme the 1st of May [1809]

My dear Mama,
I think that my father must have been upset when he learned that I had been in the alcove. Please console him by telling him that I won a commendation. I am not forgetting to brush my teeth with my handkerchief. I have begun a notebook into which I enter fine copies from my other notebook for which I was commended and it's in this way that I try to please you. I embrace you with all my heart and the whole family and the gentlemen of my acquaintance.
Balzac Honoré

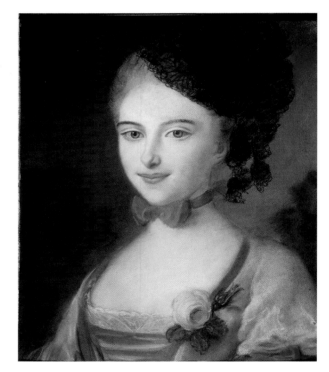

Balzac's lovely mother rarely came to visit him at boarding school.

Top left:
This beguiling portrait of the young Honoré de Balzac is now at the library of the Institut de France in Paris.

Vendôme le 1er Mai

Ma chère maman

Je pense que mon papa a été désolé quand il a su que j'étais à la lisière je te prie de le consoler en lui disant que j'ai eu un accessit, je n'oublie pas de me frotter les dents et d'avoir bien meilleur, j'ai fait un cahier où je recopie mes choses nettement et j'ai du bois pointé et c'est à cette manière que je compte te faire plaisir je t'embrasse de tout mon cœur et toute la famille et les messieurs de ma connaissance. dis lui les noms que je de ceux qui ont eu du prix et qui sont de vendôme

D'Oissecompte
je ne me rappelle
que le tu

 Sin fils
 Oosmel et
 affectionné

The Young Composer

FRANZ SCHUBERT

(1797–1828)

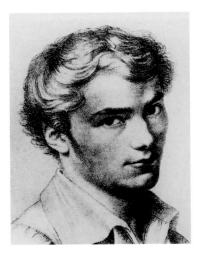

Franz Schubert was both the last representative of the illustrious line of Viennese classical composers and, at the same time, a quintessential Romantic figure. His character seems to have been double-sided, too. Outwardly, he was a sociable and apparently happy man; yet, in his imagination at least, he was also a tormented creative spirit, the perpet-ual wanderer of his celebrated song cycle *Die Winterreise* (The Winter Journey), whose excesses of solitude and despair seem to have characterized the young composer's inner life.

His father, a cellist, taught him musical fundamentals; his mother encouraged him, and friends and family members played his trios and quartets at informal gatherings. At age eleven, the boy qualified for entry into the Imperial Conservatory. He sang, played piano and violin, and was already composing. The results were his first surviving works, produced when he was twelve or thirteen. His *Fantasy for Piano for Four Hands* is somewhat awkward, as one would expect of a piece written by a child of that age. At about the same time, he also wrote a comic opera in German, and his first songs.

The manuscripts of these songs show Schubert developing what would become one of his principal means of expression: dramatic and lyrical settings of German texts by the greatest poets of his day for voice and piano. In this musical form, the shy, introverted, and secretive young man could express his deepest feelings, and confess his sufferings and hopes with startling immediacy. It would not be long before his first masterpiece in this genre would see the light of day: *Gretchen am Spinrade* (Gretchen at the Spinning-Wheel, derived from a scene in Goethe's *Faust*), composed when Schubert was seventeen.

Left:
Franz Schubert in early youth

Opposite:
The opening bars of an overture, composed when Schubert was twelve years old

Another manuscript by the young Schubert

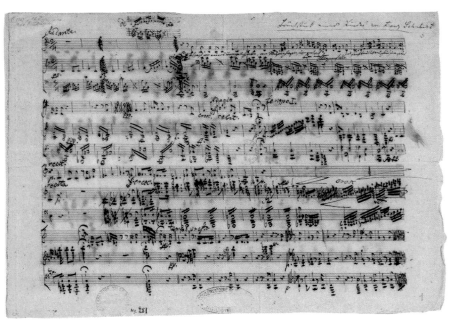

Ouverture.

"George Sand's" First Letter

AURORE DUPIN, KNOWN AS GEORGE SAND

(1804–1876)

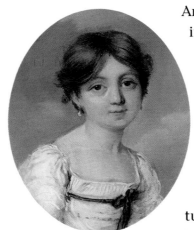

Amandine-Aurore-Lucile Dupin was born in Paris on July 1, 1804. Her mother, Sophie Delaborde, was the daughter of a bird merchant who operated a stall in the market on the Quai de la Mégisserie, near the cathedral of Notre-Dame in Paris. The girl's father, Maurice Dupin, an actor by profession, was a grandson of a great military hero of the eighteenth century, Maurice of Saxony.

Aurore's childhood was darkened by the death of her father in 1808, three years after that of her younger brother. In 1809, at the age of five, she was all but abandoned by her mother, who often reproached her for her lack of beauty. The girl was sent to her paternal grandmother, Madame Dupin de Francueil, who lived on the family estate of Nohant. Aurore's childhood was troubled by quarrels between her mother and her grandmother, who, although she had never been reconciled to her son's marriage, nevertheless cherished her granddaughter, whom she often called "Maurice" and even "my son," as if to compensate for the early death of the girl's father. Very early on—far too early in the life of a child—this loving yet abusive grandmother reported to Aurore some disgraceful actions that she claimed had been committed by the girl's mother, thereby compounding the earlier trauma of her childhood.

Aurore's education combined her grandmother's aristocratic precepts and the liberated thinking of her mother. At the age of fourteen, she was sent to boarding school at a convent of English Augustinian nuns, located in a building where her grandmother had been imprisoned during the Revolution. Fortunately, this convent became a calm refuge for the girl from the tensions of her family life. She lost her grandmother when she was seventeen. The funeral brought her another trauma: her tutor seized the occasion to force the girl to kiss the forehead of her father's corpse in the family crypt. Thereafter, Aurore's mother took her in hand, now able to visit unlimited misery on the girl.

With this history of traumatic and heartbreaking events in her childhood, it is not surprising that the future George Sand became a woman of independent temperament, willful and provocative, but also maternal and fiercely independent, whose need for love from the men in her life was as intense as her determination to brook no deception from them. She married the first suitable young man who came along so that she could escape the authoritarian rule of her mother, an alliance that was to be an apprenticeship for her freedom as a woman and a writer.

Opposite and above:
Letter written by Aurore to her mother when she was seven years old, evidently during a period when her mother and grandmother were quarreling

Top left :
Aurore Dupin,
by Aurore de Saxe

How I regret not being able to say goodbye to you! You see how sad I am to be separated from you. Farewell, think of me and rest assured that I won't forget you.

Your daughter

P.S. You can hide your answer to this behind the portrait of Grandfather Dupin.

que j'ai de regret
de ne pouvoir te
dire adieu. tu vois
combien de chagrin
de te quitter adieu
pense à moi et sois
sure que je ne t'oublie
—rai point

ta fille.

214

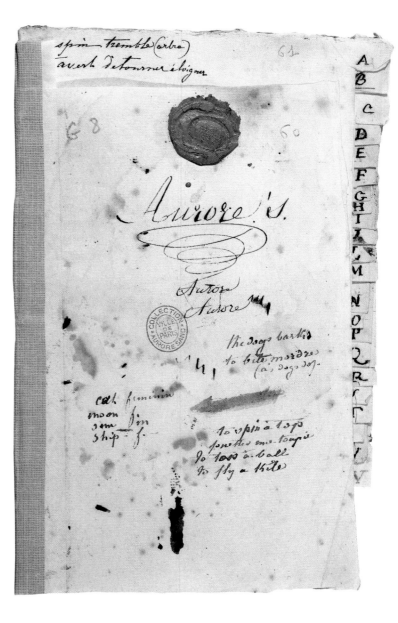

These pages from the notebooks kept by Aurore Dupin at the convent of English Augustinian nuns give some indications as to the nature of the education she received, documenting her religious instruction, preparations for her first communion, and her study of English and Spanish vocabulary.

G

Ils descendront.

C'est un sujet effrayant sans doute que celui que
je vais traiter. et je ne l'entreprendrais point
si en ménageant votre délicatesse naturelle
je ne me rendais répréhensible. ~~par~~ ~~le silence~~ si
en vous taisant une des plus ~~effr~~ terribles vérités
de la religion ~~je ne vous exposais à tomber~~ sur ~~ce point~~
~~assez le péché~~ ~~qu'elle~~ ~~nourrissant~~ ~~précipice~~, Si enfin pour n'avoir
point entendu parler de ses tourments et ~~s'y~~
~~avoir~~ point réfléchi pendant sa vie ~~je ne puis~~ conséquir
~~qui~~ m'entendant ne vint à ~~s'y laissant tomber après~~
~~le~~ mort faisons nous donc une ~~forte~~ violence ~~moi~~
pour vous parler et vous pr m'écouter et ~~transpo~~
à faveur du flambeau de la foi descendons
~~en~~ esprit dans ces sombres et affreuses demeures que
la plupart de nos ~~traducteurs~~ placent dans le
centre de la terre. Quelque ~~en soit~~ le lieu ~~remisson~~
~~en la durée l'ét...~~ les sujets de nos réflexions
Quand nous aurons invoqué ~~l'ét...~~ ~~lumières~~
de l'esprit Saint. par l'intercession de Marie

~~ave maria~~

L'apôtre St Paul nous représente l'enfer comme
un ~~vaste~~ étang de soufre et de feu dont les
flots embrasés s'accumulent s'amoncellent et
viennent ~~à ch...~~ l'inonder ~~à ch...~~
instant et ~~sans cesse~~ ajouter de nouvelles
douleurs à son ~~t...~~ supplice! Ah si
~~en sur la terre~~ c'est le plus cruel des to...
mens, si nous ne pouvons supporter sans

Youthful Drawings

ALFRED DE VIGNY

(1797–1863)

Alfred de Vigny was a child of the early years of the nineteenth century. Born on March 27, 1797, at Loches in the Loire Valley, he was the fourth son of Marie-Jeanne-Amélie de Baraudin, who, forty at his birth, had lost her first three sons in succession when they were quite young. His father, Léon-Pierre de Vigny, was sixty at the time, a member of a noble family from an agricultural area southwest of Paris. His wife's ancestors were Italian by descent. Deeply shaken by the events of the Revolution, Alfred's parents instilled in him a profound nostalgia for the old world that had been lost.

Vigny spent part of his early youth in the gardens of the Élysée-Bourbon palace in Paris (now the Élysée Palace, the residence of the presidents of France), which had been seized by the Revolutionary government and divided into apartments. His mother raised him by herself, with great hardship, until 1807, when, at age eight, he entered school, from which he advanced to a distinguished upper school, the Lycée Bonaparte.

Thanks to his early family education, Vigny was introduced to poetry and the arts at a young age. "Everything around me was harmonious, but too exquisite for the beginning of life and too focused on the perfection of sovereign beauty," he later recounted in his autobiographical writings. "In early childhood, I was given Painting and Music as my two beautiful nurses, and also as cradle songs and comrades, for I was segregated from children my own age; never, in these early years, did the severe and jealous tenderness of my parents allow me to spend time either with companions my own age or with the servants."

The only available companions of his own age were the boys at school, who went out of their way to torment him, mocking his effeminate appearance, making fun of his noble title, and expressing irritation at his unusual intelligence. "I felt like a member of a cursed race. . . . I saw that nobles in France, like men of color in America, were prosecuted over twenty generations and beyond," he later wrote.

In the end, his mother kept him at home and entrusted his education to tutors. Having studied drawing and painting in the atelier of a student of Jacques-Louis David, Vigny delighted in saying that if he had been a painter, he would have wanted "to be a black Raphael: angelic in form, dark in color." This remark conveys his heightened awareness of the malaise experienced by all members of his generation, a frame of mind that pushed them to violate traditional rules of thought in theater, music, painting, and poetry.

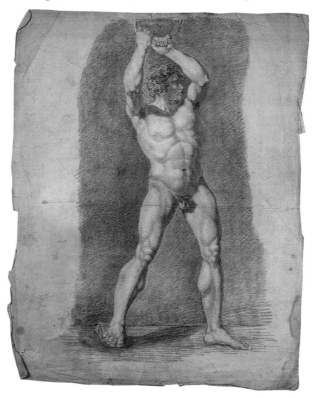

Top left:
François Kinson or Kinsoen, *Alfred de Vigny at Age Seventeen*. Paris, Musée Carnavalet

Left, opposite, and following pages: Drawings of the male nude executed from life by Alfred de Vigny at age fifteen. Collection Édouard and Christian Bernadac

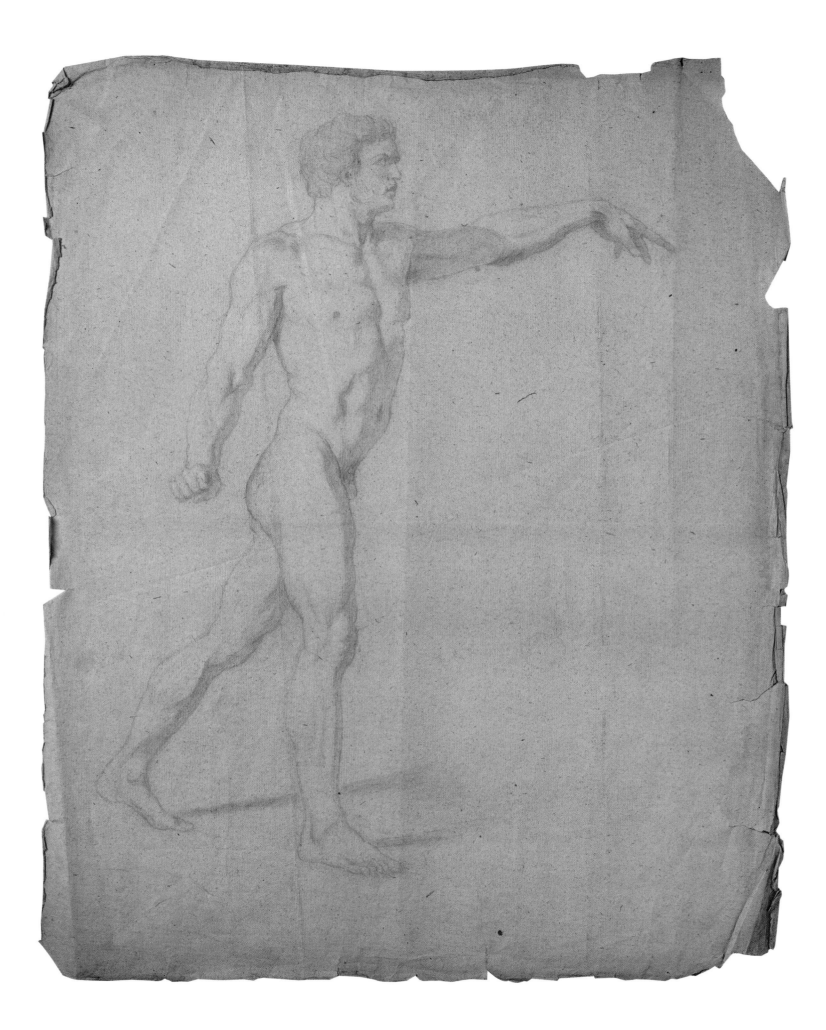

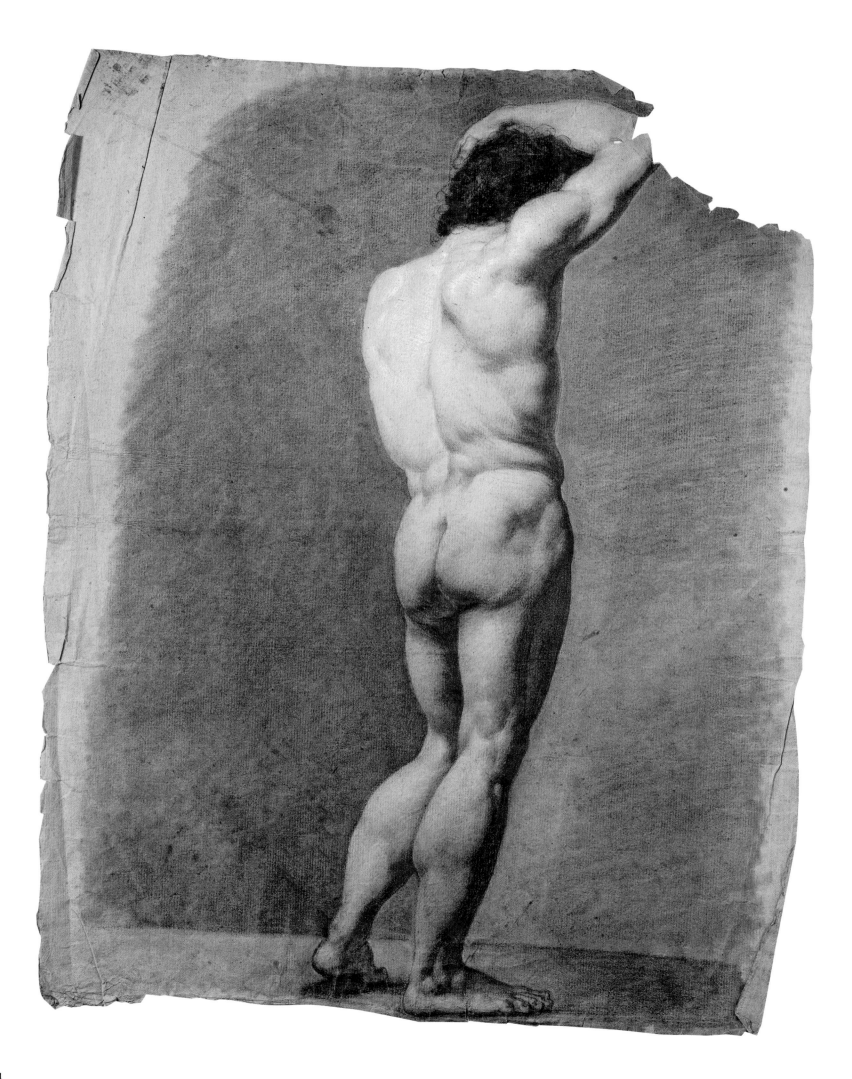

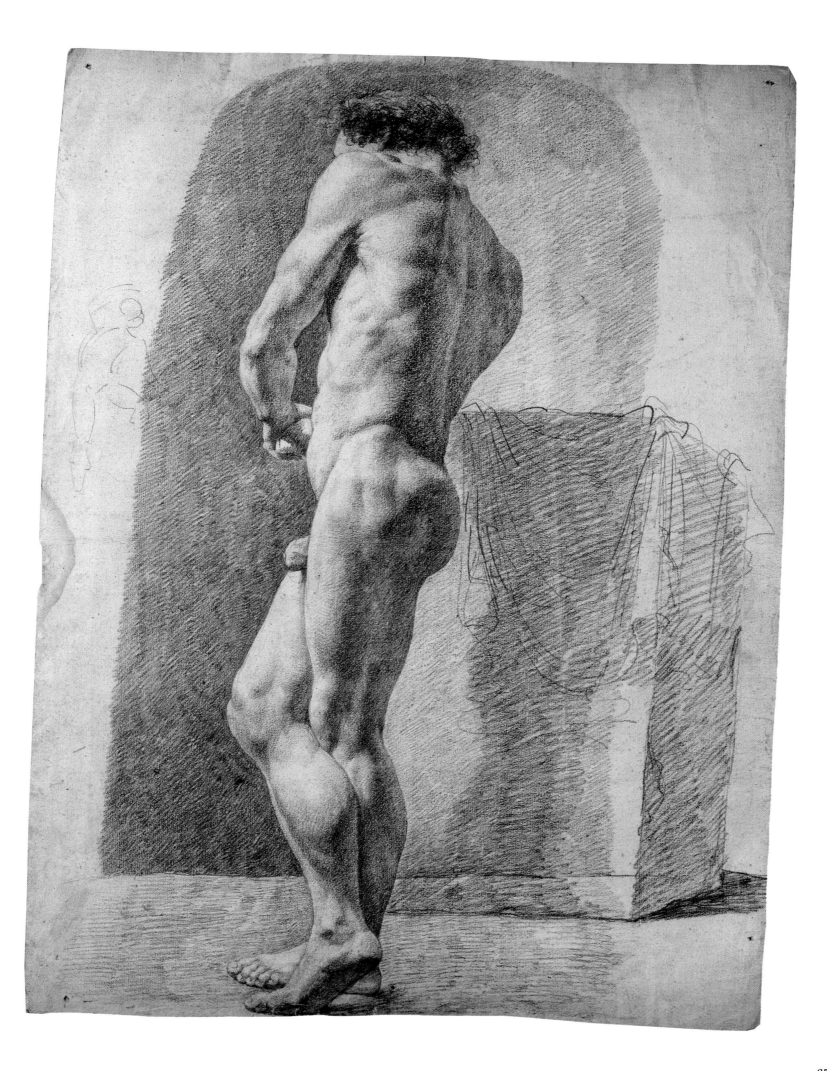

Eugène's Notebooks

EUGÈNE DELACROIX
(1798–1863)

Presumed portrait of the young Delacroix

"I remember that, when I was a child, I was a monster," Delacroix remarked. Indeed, the boy was willful and even a bit wild; while still a child he had two brushes with death, one by fire and one by drowning. But he also had a vision of himself and his destiny, seeing, not fairies, but muses bending over his cradle. It was clear early on that he had been blessed with exceptional gifts in drawing, music, and writing.

Art was something of a family tradition. His mother's antecedents were cabinetmakers who had worked for the royal family before the Revolution, and his maternal uncle had studied with the great painter Jacques-Louis David. When the boy was nine he was taken for the first time to the Louvre, where he admired works by the great Italian and Flemish masters, an experience that seems to have decisively influenced his career choice. His exercise books, notebooks, and drafts of early attempts at writing—at age sixteen he began a romantic play entitled *Victoria*—are full of figures and landscapes, profiles and caricatures, rendered in nervous pen lines. From 1814 he began to draw political cartoons on his own, and in 1821 placed his gifts as a cartoonist at the service of a liberal anti-government journal called *Le Miroir des spectacles, des lettres, des moeurs et des arts*.

His uncle, taking note of his talents, introduced him to Baron Gérard, at whose home Delacroix met the painter Pierre-Narcisse Guérin, who was destined to become his teacher. Soon after entering Guérin's atelier at age seventeen, the young man became the friend of one of his master's former students, Théodore Géricault, whose personality enchanted him. Before long, he was posing for *The Raft of the*

Medusa, Géricault's great canvas first shown at the Salon of 1819. That same year, while still a student at the École des Beaux-Arts, Delacroix was commissioned to paint a *Virgin of the Harvest* for a church in a town southwest of Paris. This was just the beginning of what was to be a stunning career.

Above:
Some of Delacroix's early experiments with his signature

Opposite and following pages:
Pages from Delacroix's notebooks, executed when he was sixteen years old

66

A Mother's Death

JULES MICHELET
(1798–1874)

On Tuesday, February 8, 1815, having been weakened by a chest ailment that had progressed to severe edema, Angélique Constance was dying. Her son remained by her side until midnight, when he withdrew to work on a translation of Seneca, but he remained preoccupied by thoughts of death. We know this from the earliest handwritten document that he decided to preserve, on which he later inscribed the sentence: "The night my mother died."

Jules Michelet was sixteen years old at the time. Born in Paris on the fifth day of Fructidor, Year VI (August 21, 1798), he was the second son of Jean-François Furcy Michelet, a printer, and Angélique Constance Millet. His first name reflected his parents' uncertainty about the future: Jules could evoke either Julius Caesar, desirable if the Republic should survive, or Pope Julius, a namesake that might prove advantageous should Catholicism prevail.

But his father's fiscal difficulties—he was imprisoned for debt—reduced the family first to financial difficulty, then to real poverty, and the future historian was often cold and hungry. Michelet grew "like a weed without sunlight between two paving stones in Paris." He learned to read very quickly, using a dictionary of fables as his primer, and was not yet ten when he began work on several literary projects, notably a tragedy entitled *The Death of Brutus*. As a young man he spent most of his time alone, once remarking, "I have never regretted being alone and remaining silent; I have often regretted being with others."

Early study in a private school made it possible for him to register, in the fall of 1812, at the prestigious and demanding Lycée Charlemagne. There, unfortunately, both teachers and students found it difficult to accept this newcomer from an impoverished background. Mocked mercilessly, he was, as he later remarked, "as startled as an owl in daylight." But hard work and his passion for study eventually prevailed over all difficulties. It was a proud Jules Michelet, flush with the success of having won first place in composition, who returned home in January 1815, only a few weeks prior to his mother's death.

The night my mother died.

How mad it is, how oblivious of the frailty of human life, to fear death because you hear thunder! Is, then, your existence so dependent upon thunder? Will you be comforted if lightning doesn't strike you? Perhaps you will perish by the sword, by fever, by a falling rock. Lightning is not the greatest danger, it is the most apparent. Doubtless you will have cause for complaint if the rapidity of a sudden death should prevent you from feeling it, if you should die of natural causes, if your very end should prove useless.

If you were to be buried on a spot marked by lightning you would be most unhappy! But you tremble at the sound of thunder, at the smallest cloud you throb with fear that the sky will flash and you will die of fright. Well! Do you find it more beautiful to die from fright than from the effect of thunder? Then arm yourself with courage against the threat of storms, and should you see the world engulfed in a universal conflagration, reflect that in this immense ruin you have nothing to lose. If, however, you think that the unique end of this elemental combat is your destruction, that it is in opposition to you that these gathering clouds collide with one another and create such a fracas, that it is for your ruin that the sky arms itself with so much fire, then consider with pride how much power is required to destroy you.

la nuit où
mourut ma mère

A. 3795 (34)

Michelet.

une version
t... d...
s'en gar...

B.1.1

Quelle folie, quel oubli de la fragilité humaine,
que de craindre la mort, parcequ'il tonne? Votre
existence dépend-elle donc tellement ~~de la foudre~~ du tonnerre?
Vous serat'elle assurée, si ~~la~~ la foudre ne vous
atteint pas? ~~une~~ peut-être périrez-vous par l'épée, par
la fièvre, par la chûte d'une pierre. La foudre n'est
pas le plus grand danger, c'est le plus apparent.
Vous serez sans doute ~~bien~~ à plaindre, si la rapidité
d'une mort soudaine, vous dispense de la sentir, si
la nature se charge de votre mort, si votre fin, au même
lieu d'être inutile,

! Vous serez bien malheureux, si l'on vous
ensevelira au lieu marqué par la foudre! Mais vous
tremblez au ~~bien~~ bruit du tonnerre, à la moindre
nuée vous palpitez de crainte, que l'éclair brille
et vous mourez d'effroi. Quoi donc! trouvez-vous
qu'il est plus beau de mourir de frayeur, que de
effets du tonnerre. Armez-vous donc de

Hugo's Notebooks

VICTOR HUGO

(1802–1885)

It is easy to imagine the childhood of Victor Hugo as that of a radiant prodigy. Nothing, however, in his two earliest lines of verse ("The great Napoleon / Fights like a lion") heralds his later literary achievements.

The third son of an adventurous Bonapartist general and a royalist mother, Victor had a childhood marked by the constant wrangling of his politically opposed parents. Discord and frequent separations pulled him back and forth, from the green paradise of the family's home in Paris to various trips abroad, most often to Spain. In 1815, his father took him away from his mother and placed him and his brother Eugène at a school in Paris. Thirteen at the time, he began his *Cahier de vers français* (Notebook of French verse), which would eventually fill sixteen volumes, ten of which in later years the poet, wary of the judgment of posterity, burned. In 1816 he tried his hand at playwriting, with a five-act tragedy. Admittedly, his was a literary family; his older brother Abel left the army after the fall of Napoleon to devote himself to poetry, and his father left behind, in addition to his memoirs (published in 1823), a verse drama entitled *Vercingétorix* and several unpublished novels.

When not writing, Hugo drew in pen and ink—on his literary drafts, in his assignment books, on his letters—and indulged his passion for physics. At age sixteen, he won fifth place in the national physics competition. Beginning in 1818, he began to study the law, but he could not muster much enthusiasm, preferring instead his work as a writer for a literary journal that he and his two brothers had founded. At age eighteen he met his idol, the essayist and novelist François de Chateaubriand, and published his first novel. This was in 1820, by which time he was no longer a precocious child, but a young writer, ideally suited to the Romantic movement, which he would shortly help to create.

Above:
Inscription scribbled by Hugo on the manuscript of his *Essays* (1817–18)

Left:
Hubert Clerget, *The Birthplace of Victor Hugo* (in Besançon). Paris, Maison Victor Hugo

Opposite:
In a history notebook dating from 1817, Victor Hugo illustrates an episode from the Punic Wars. Paris, Bibliothèque Nationale de France

Victoire

Communicius Dassan voulant se sauver de [...] angleterre, apiès avoir été défait par [...]tar et trouvant les vaisseaux avec Maia le vent bon [...] la [...]ar de s'embarquer et de faire [...] de toutes les voiles [...] il se croie à l'abri que le [...] [...] était déjà en mer et que par [...] heureus il lui a été échappé de [...] [...] Les [...] de toute [...] une bataille perdue, et le vaisseau proa[...] et [...] les Romains [...] [...] de [...] [...] et s'y [...] tout a coup [...] de grands cris les [...] les Romains [...] de s'emparer [...] et Dona Anglecarthug[...] le moyen de l'évader.

[...] Gallia Britanniam [...] Dans **Victoire** Communicia à l'ostia [...] Debellatia [...] Navigia viduat [...] tamen a prospera [...] la via [...] [...] omne [...] [...] Hoy [...] Caesar cum [...] prodem in [...] sic que frequen magisque propuam [...] [...] [...] A[...] a romaine devici [...] peste [...] se Sabina Gerg[...] [...] [...] que magnan ad coelum slaves [...] [...] inter [...] um Romain [...] obstructi [...] [...] e [...] et [...] Sima [...] [...].

Victoire

Communicius Etheban, cum a [...] Victor ex Gallia in Britanniam fugerent, et [...] ad [...] [...] vento [...], [...] Navi in Sicci a littore tut et fecerent, Bandi [...] minut [...] Vale Gotht. Que cum [...] prent [...] cum er longinquo [...] effla [...] [...] videttet, [...] prospero tibi [...] Caesar, [...] [...] classe superati, Qua Romanos [...] et [...] Avertere [...] Nave [...] Suciditt [...] [...] que [...] [...] ad victor [...] [...] [...] [...] evadend amdaret.

Les Carthaginois

pour échapper aux Romains fugirent de tomber en un [...].

Géométrie Analytique. Discussion des équations

$$y = -\frac{Bx+D}{2A} \pm \frac{1}{2A}\sqrt{(B^2-4AC)x^2 + 2(BD-2AE)x + D^2-4AF}$$

$$y = -\frac{Bx+D}{2A} \pm \frac{1}{2A}\sqrt{(B^2-4AC)\left(x^2 + \frac{2(BD-2AE)}{B^2-4AC}x\right) + \left(\frac{D^2-4AF}{B^2-4AC}\right)}$$

$$x = -(BD-2AB) \pm \sqrt{(BD-2AB)^2 - (B^2-4AC)(D^2-4AF)}$$

$$B^2-4AC$$

$$y = -\frac{Bx+D}{2A} \pm \frac{1}{2A}\sqrt{(B^2-4AC)(x-x')(x-x'')} \qquad \text{hyperbole}$$

$y^2 - 2xy - x^2 + 2 = 0$	$x^2 + 2xy - y^2 = 0$
$y^2 - 2xy = x^2 - 2$	$x^2 + 2xy = y^2 + 2$
$y = x \pm \sqrt{2x^2 - 2}$	$x = -y \pm \sqrt{2y^2 + 2}$
$y = x \pm \sqrt{2(x^2-1)}$	$x = -y \pm \sqrt{2(y^2+1)}$
$y = x \pm \sqrt{2(x+1)(x-1)}$	

$y = 0$

$x^2 = 2$

$x = \pm\sqrt{2}$

le diamètre ne serait pas rencontré par le cercle

Attraction et Répulsion électrique.

(dans la théorie de Franklin) soient deux corps dans leur état naturel, opposons-les l'un à l'autre par l'action, les corps A et B ont des masses m et m'. Ils contiennent E et E' f. é. E : E' :: m : m'

force attraction $= mE'$, force répulsion $= EE'$, $mE' = EE'$

Théorie de Franklin
$$\begin{cases} att. = mE' \\ Rep. = EE' \\ dd. = mE \\ Rep = mm' \end{cases}$$

Th. de Coulomb
$$\begin{cases} act = VR' \\ Rep = VV' \\ act = VR \\ Rep = VR' \end{cases}$$

(Théorie de Coulomb)

A — état naturel N et B — état naturel N'

$$\begin{array}{cc} A & B \\ N & N' \\ V & V' \\ R & R' \end{array}$$

A opposé à B — NN', Réaction B — $VR' = NV'$

$NN' = 0$

$NV \} = +$

$NR \} = +$

$VR' \} = +$

$VV' \} = -$

$VR' \} =$

+ indique l'attraction
− indique la répulsion

Physique. Électricité.

The diligence of the young Hugo is apparent in these impeccable pages from his geometry notebook, dating from his studies at the Collège Louis-le-Grand in 1816–17. Despite appearances, he had already become more interested in literature. Paris, Maison Victor Hugo.

Mendelssohn's Good Fortune

FÉLIX MENDELSSOHN-BARTHOLDY
(1809–1847)

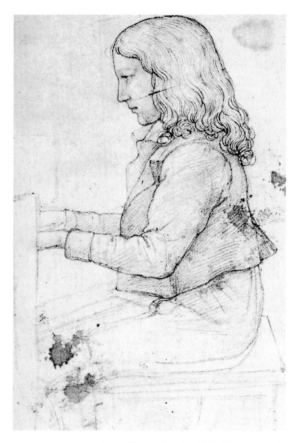

Like Eugène Delacroix and Alfred de Vigny, Felix Mendelssohn was a child of the newly born nineteenth century, one of a generation that carried Romanticism to unparalleled heights. Everything boded well for him: a grandfather (a translator of Plato) who was a leading light of the German Enlightenment, a happy childhood in a close-knit and culturally sophisticated family, early lessons in several languages, and the acquaintance of no less a personality than the great German writer, Johann Wolfgang von Goethe.

Music was second nature to the boy. At twelve, he began to compose, producing musical works of astonishing maturity and stylistic assurance. These included a stunning *Sonata in G Minor*, a *Capriccio* that combined virtuosity with ethereal melody, fire, and sensitivity; and a comic opera entitled *Die Beiden Pädagogen* (The Two Teachers), in which he tried to develop the tradition of German musical comedy with spoken dialogue, in the manner of Mozart's *Magic Flute*. His career continued to unfold at a rapid pace; when Mendelssohn was fifteen, Karl Friedrich Zelter, his teacher, who had introduced him to the works of Johann Sebastian Bach and George Frideric Handel, announced that he could teach him nothing more. Five years later, Mendelssohn conducted, in Leipzig, the first performance of Bach's *Saint Matthew Passion* since its composer's death.

Every single work by Mendelssohn remains vital, from the incidental music for *A Midsummer Night's Dream* to the *Italian Symphony* and the *Second Concerto for Violin*—one of the most beautiful works for that instrument ever written. Each page of his music breathes with the freshness, poetry, and nostalgia of this intensely imaginative man. Mendelssohn's accomplishments were such that we scarcely know which of his achievements to admire most—his work as a composer, a pianist, a conductor, or as the founder of a conservatory in Leipzig.

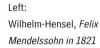

Left:
Wilhelm-Hensel, *Felix Mendelssohn in 1821*

Opposite:
Page from the manuscript piano score of *Die Beiden Pädagogen*, a comic opera composed by Mendelssohn in 1820–21

Above:
Karl Friedrich Zelter, who taught Felix Mendelssohn and his sister Fanny music theory and piano technique, in 1819

Terzetto.

Andante.

77

Early Works

THÉOPHILE GAUTIER
(1811–1872)

Théophile Gautier was a child of both the Mediterranean and the north of France. His father was from Provence, but when the boy was three years old, the father became head of the tariff office in Paris, which now became the family's home. "As a child I was sweet, sad, and sickly, with a bizarre olive cast that startled my young pink and white comrades. I resembled a small, chilled Cuban boy, nostalgic for home." When he was five, someone gave him a book, saying to him: "Keep it for next year since you don't yet know how to read." "I know how to read," the boy protested, pale with anger and puffed up with pride, and immediately set about teaching himself to do so. Thus, as he wrote later, "The mysterious seal that closed libraries to me was broken." His favorite book was *Robinson Crusoe*: "It made me crazy, I no longer dreamed of anything save desert islands and the free

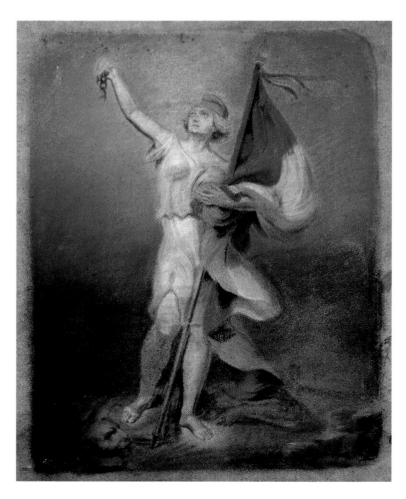

life at nature's bosom." And he devised his own island under the table in the family living room.

At the age of eight, Théophile became a pupil at the Collège Louis-le-Grand, but he became so depressed there that his parents took him out of the school. His departure occasioned this appraisal from his teachers: "During his too short stay at the college, he showed himself to be gentle, well-behaved, and full of promise, and we can only reproach him for a lack of application during his last days here." Gautier's character as a adult is already present in this description. He continued his studies as a day student at a different school, the Lycée Charlemagne, where he became friends with Gérard Labrunie, who would become known as a poet and essayist under the name Gérard de Nerval.

Gautier penned his first poems at about the same time that he made his first drawings. "The first piece that I remember was called *The River Scamander*, doubtless inspired by Lancrenon's painting and translations of the Greek Anthology, followed by *The Rape of Helen*, a poem in decameter. All of these pieces are lost, but there is no reason to mourn them. A cook used them to roast poultry, not wanting to burn blank paper."

Toward the end of his secondary-school education, Gautier frequented the atelier of a painter in the hopes of pursuing an artistic career. Hesitating between poetry and painting, however, he found a mentor in Victor Hugo, to whom he also introduced his school friend Gérard Labrunie. He was not yet nineteen when he flung himself into the controversy over the freedom of meter in Hugo's Romantic play *Hernani*. At this time he began to wear a red vest—almost scandalous attire in this age of black suits—for which he later became famous.

Théophile Gautier, *Marianne*. Collection Édouard and Christian Bernadac. Dating from Gautier's early youth, this pastel may have been inspired by Delacroix's *Liberty Leading the People* (1830).

Opposite:
Letter written by Théophile Gautier to his father on July 4, 1825, when he was thirteen. Paris, Institut de France, Bibliothèque de l'Institut, Fonds Lovenjoul (text given in the appendix)

Maupertuis le 4 Juillet 1829.

Mon cher papa

Je vais te faire comme tu m'en as prié une relation
de tout ce qui nous est arrivé depuis notre départ de
la maison ; lorsque nous fumes arrivés a la place
Royale, maman dit à honoré de s'arrêter parce
qu'elle s'imaginoit que la robe pourroit être finie.
en conséquence Samuel descendit de notre char
triomphal et alla chez M᷎ᵉ Poteau, au bout
d'un assez long espace de temps nous le vimes revenir
non avec la robe mais avec hélène qui nous fit
ses adieux. maman lui donna au travers des ridelles
de la charrette ses dernieres instructions. nous montames
assez lentement la rue du pas de la mule, la
honoré s'avisa d'aller parler à huard ; nous fumes donc
obligé de rester en panne. tout sembloit s'opposer
à notre sortie. Paris ne nous laissoit abandonner
qu'à regret ses dédales tortueux. honoré resta au moins ½ heure

"A New Mozart"

FRANZ LISZT

(1811–1886)

"My son, you have been chosen by destiny! You will realize the artistic ideal that was the enchantment of my youth." So reads an entry in the diary of Adam Liszt, manager of the properties of Prince Esterhazy in Austria-Hungary and an amateur composer. It is clear that he had no doubts about the brilliant future of his son Franz, who at an early age was already showing great musical ability. At age six, he began to study piano with his father, who noted three years later that the boy had taken "giant strides." By that time, the music of Bach, Mozart, and Beethoven held no difficulties for the young virtuoso, who was then sent to Vienna to study with the celebrated teacher Karl Czerny and the composer Antonio Salieri. Both men quickly recognized the child's genius, to the point of refusing payment for their services.

In 1822, when Liszt was eleven, he gave his first public performance in Vienna, which was a triumph. His first composition, *Variations on a Waltz by Diabelli*, appeared the same year. After his second concert, Beethoven himself sought him out and embraced him. The youngster seemed destined for glory. Thereafter, "Franzi" led the peripatetic life of a musical prodigy on concert tours. Performances in Munich (where he was proclaimed "a new Mozart"), Augsburg, Stuttgart, and Strasbourg were simply preliminaries to what was, after Vienna, the second musical capital of Europe: Paris. There, however, he met with a cruel disappointment. Despite enthusiastic recommendations, Luigi Cherubini, then director of the Paris Conservatory, refused to admit Franz on the grounds that he was a foreigner. Fortunately, other teachers undertook to continue his training, and within a matter of months he had created a sensation both in Paris and London. By the time he was thirteen, Liszt was in a position to devote more time to composition, producing études for piano as well as an opera, *Don Sancho, or the Castle of Love*, his first and last essay in the genre. In 1827, exhausted by his European tours, Franz took a vacation with his father on the Norman seacoast to get some needed rest. Several weeks later his father died, leaving his son—who, while not yet sixteen, was henceforth no longer a child—to fulfill alone the destiny that his father had foreseen for him.

Monsieur!

I would be infinitely obliged if you would be so kind as to come and see me today at three fifteen. Having completed a few pieces, as I would like to have them engraved, I address myself to you asking that you listen to them so that you will know what you are getting.

F. Liszt

London July 20 / 1824 / leap year

"Étude for Piano-forte" by "The Young Liszt," cover.
Paris, Bibliothèque Nationale de France

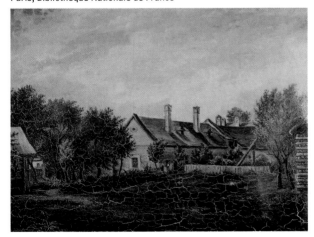

Anonymous, *Liszt's Birthplace in Hungary*, c. 1856.
Private collection. This painting belonged to the composer.

Monsieur!

Je vous serais infiniment obligée
si vous voudriez bien vous donner
la peine de venir me voir aujourd'hui
à 3 heures un quart ayant quelques
morceaux de fini et comme je désire
de les faire graver je m'adresse
à vous en vous priant de vouloir bien
les entendre pour que vous n'achetez
pas le chat dans le sac.

18 great Marlborough[t]

Londre 20 Juillet Franz Liszt
 1824
Marlboroughstreet

"National Elegies"

GÉRARD LABRUNIE, KNOWN AS GÉRARD DE NERVAL

(1808–1855)

A prolific poet from early adolescence and a published author before his graduation from college, Gérard de Nerval had already written hundreds of poems by the time he was twenty. While these youthful attempts require a certain amount of indulgence on the part of the reader, they are nevertheless worthy of serious attention.

When he embarked on his literary adventure, this middling student at the Lycée Charlemagne, who transcribed his *Essais poétiques* (Poetic Essays) into a manuscript volume decorated with graceful tailpieces, made no secret of his political convictions. *L'Enterrement de la Quotidienne* (The Burial of the *Quotidienne*), an "epic-heroic poem" in six books, written when he was sixteen, is an attack on the French government of the day. The Romantic generation, to which Nerval belonged, longed for a hero, for an epic comparable to that of Napoleon. The memories of Gérard's father, a doctor in Napoleon's armies, must have fueled the dreams of his son, whose first volume of poems, issued in 1826, was entitled *Élégies nationales: Napoléon et la France guerrière* (National Elegies: Napoleon and Martial France). Its author, seventeen at the time, identified himself only as "Gérard L. . . ." The same year, he published a comic satire in verse on the French Academy. Even its title, *L'Académie ou les membres introuvables* (The Academy, or the Undiscoverable Members), proclaims the author's low regard for that institution.

Encouraged by these modest successes, Gérard left school. In 1828 his translation of Johann Wolfgang von Goethe's *Faust* appeared. Although extremely free and based on two previous translations, it pleased the German master, as he confided to the German writer Johann Peter Eckermann in 1830—something that Nerval would learn only twenty years later.

Top left:
Pierre Jean David d'Angers, *Relief Medallion Portrait of Gérard Labrunie*

Above:
Title pages of *Essais poétiques. Poésies et poèmes* (Poetic Essays. Poems), an autograph manuscript by the young Gérard Labrunie. Private collection

Opposite:
Page from a handwritten manuscript of *Élégies nationales* (National Elegies) by Gérard Labrunie

Les Succès

Quèlque fois à l'aspect des illustres débris
Des témoins immortels d'une gloire passée,
Les grands ressouvenirs de nos beaux jours flétris,
Comme un brillant reflet luisent à ma pensée,

Alors je veux chanter, mais des sons incertains
Partent seuls de ma voix plaintive et chancelante,
Un grand nom vient mourir sur ma lèvre tremblante,
Et la harpe sonore échappe de mes mains.

Et ce jour cependant je prends encor la lyre,
Je vais jetter aux vents quelques accords nouveaux,
Ils sont plaintifs la douleur qui m'inspire,
Ne se plaît qu'autour des tombeaux.

Love and Poetry

ALFRED DE MUSSET

(1810–1857)

Alfred de Musset, print. Collection Christiane Sand

Alfred de Musset was born on December 11, 1810, in Paris. His parent's marriage was a happy one, and his father's career at the Ministry of the Interior provided a comfortable childhood, characterized by aristocratic values and a fine education.

Alfred, a very precocious child, was so smitten with his cousin Clélie that he asked her to marry him when he was only four years old! His feelings for her were so strong that, when she married another man some time later, his parents were afraid to tell him.

While he was at school, Alfred befriended a classmate, Paul Foucher, whose sister Adèle would later marry Victor Hugo. After entering the Lycée Henri IV at age nine, Alfred was persecuted by his classmates—with the exception of Paul, who defended him. This mockery, prompted as much by the feminine appearance of his long hair as by his high grades, filled him with a distaste for society and a genuine horror of politics and community. Throughout his adolescence, the future poet immersed himself in an aristocratic literary milieu that, with his studies and readings, shaped his sensibility. His earliest poems, written when he was fourteen, reveal a hypersensitive personality already irreparably disappointed with the world.

Musset's youthful letters to his friend Paul Foucher are fascinating, for they reveal the true nature of their author's character. He wrote, "Poetry is for me the sister of love. The one issues from the other and they always go together. When I am relieved of the propensity to fall in love as easily as one catches cold, I will no longer be gripped by such desires. Then I will be myself, those who don't know me will say: What an odd creature! And those able to divine something of my innermost thoughts will say: What a beastly man!" he wrote to Foucher when he was sixteen.

When he wrote this in September 1827, Musset, then preparing to enter law school, was visiting his godfather, the Marquis of Musset, at his home, the Château of Cogners. Somewhat bored, and finding himself in the transitional no-man's-land of late adolescence, he would soon try to obliterate the disappointments and pain of his life by drowning himself in love and writing; this course quickly descended into a morass of alcohol, drugs, and debauchery. After returning home from Cogners, Alfred wrote his friend Paul: "I will never be good for anything; I will never practice any profession. . . . I will never resign myself to being any particular kind of man."

Above and opposite: Letter from Alfred de Musset to Paul Foucher, September 23, 1827. Paris, Bibliothèque Historique de la Ville de Paris (For complete text, see appendix)

Non, mon vieil ami, je ne t'ai pas oublié; tes malheurs ne m'ont pas éloigné de toi, et
tu me trouveras toujours prêt à te répondre, que tu demandes des pleurs ou des ris,
que tu aies à me faire partager ta joie ou ta douleur. As-tu pu croire un instant
que ton amitié me fut importune? — Tu as eu tort, car je n'aurais pas eu, à ta place,
une semblable idée — Et d'ailleurs, me crois-tu plus favorisé que toi de la fortune?
Écoute, mon cher ami, écoute ce qui m'arrive —

J'avais à peine expédié mon examen, que je pensais aux plaisirs qui m'attendaient ici;
mon diplôme de Bachelier rencontra dans ma poche mon billet de diligence, et
l'un ne rendait que l'autre — Me voici au Mans, je cours chez mes belles voisines,
tout s'a...... à merveille — On m'emmène dans un vieux château — On me dit
Catharre oublié depuis six mois reprend ma grand-mère — Je reçois une lettre
qui m'annonce qu'elle est en danger, et huit jours après — une seconde lettre
vint m'avertir de prendre le deuil — Voilà donc à quoi tient le plaisir, et le
bonheur de cette vie; je ne puis te dire quelles affreuses réflexions m'a fait faire
cette mort arrivée si vite; je l'avais laissée, quinze jours auparavant dans une
grande bergère, causant avec esprit, et pleine de santé; et maintenant la terre
recouvre son corps; les larmes que sa mort fait répandre à ceux qui l'entouraient
seront bientôt sèches, et voilà, voilà pourtant le sort qui m'attend, qui nous
attend tous! Je ne veux point de ces regrets de commande, de cette douleur que
l'on quitte avec les habits de deuil; j'aime mieux que mes os soient jetés au
vent; toutes les larmes feintes ou trop promptement taries ne sont qu'une affreuse
dérision —

Mon père est reparti pour Paris; je suis resté seul dans cet infernal château dont
je ne puis me dépêtrer, et où je ne puis parler à personne qu'à mon oncle,
qui, il est vrai, à mille bontés pour moi; mais les idées d'une tête à cheveux
blancs, ne sont pas celles d'une tête blonde; c'est un homme excessivement
instruit; et quand je lui parle des drames qui me plaisent, ou des vers qui
m'ont frappé, il me répond: Est-ce que tu n'aimes pas mieux lire tout cela dans
quelque bon historien? Cela est toujours plus vrai et plus exact — Toi qui as lu
l'Hamlet de Shakspeare, tu sais quel effet produit sur lui le savant et
crédule Polonius! Et pourtant cet homme là est bon, il est vertueux; il est
aimé de tout le monde! N'est-ce pas de ces gens pour qui les ruisseaux n'est que
de l'eau qui coule, les forêts que du bois de telle ou telle espèce, et des
cents de fagots! — Que le ciel les bénisse; ils sont peut-être plus heureux que toi et
moi.

"The Search for Happiness"

CHARLOTTE BRONTË
(1816–1855)

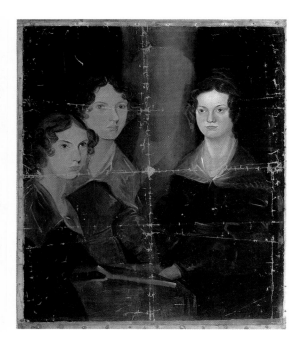

Charlotte Brontë grew up in the austerity of the parsonage of Haworth, a rather bleak town in a desolate region of Yorkshire, where her father was the local curate. There were eight members of the family: Charlotte's father and mother, and their six children, Maria, Elizabeth, Charlotte, Branwell, Emily, and Anne. When the children's mother died in 1821, their mother's sister came to live with them, to assist in their education.

In 1825, another tragedy struck, which marked Charlotte for life. Within a few months she lost both of her older sisters to tuberculosis. After a miserable year at boarding school, the little girl received the rest of her education at home. Charlotte read voraciously, wrote stories, drew passionately, and staged plays with her brother and sisters. Her brother Branwell devised an interesting project, which he and Charlotte carried out with considerable enthusiasm: the production of a series of miniature manuscript books. Only four inches high, these tiny volumes, sewn together and written for the most part by Charlotte, have all the features of commercial publications, including a preface, title page, table of contents, and even a mock list of the author's previous "publications." In 1829, the children produced no less than eighteen of these miniature books, including *The Search after Happiness*, "a tale by Charlotte Brontë. Printed by herself, and sold by no one." Clearly, the sixteen-year-old girl already knew what she wanted.

Opposite:
One of the earliest surviving miniature manuscript books of Charlotte Brontë
Top left:
Branwell Brontë, *Anne, Emily, and Charlotte Brontë*, 1834. London, National Portrait Gallery

Below:
Charlotte Brontë also drew. This watercolor of a primrose dates from 1830. Haworth, Brontë Parsonage Museum

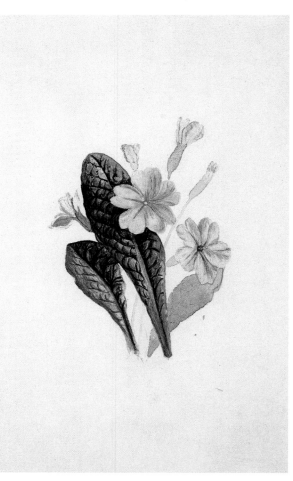

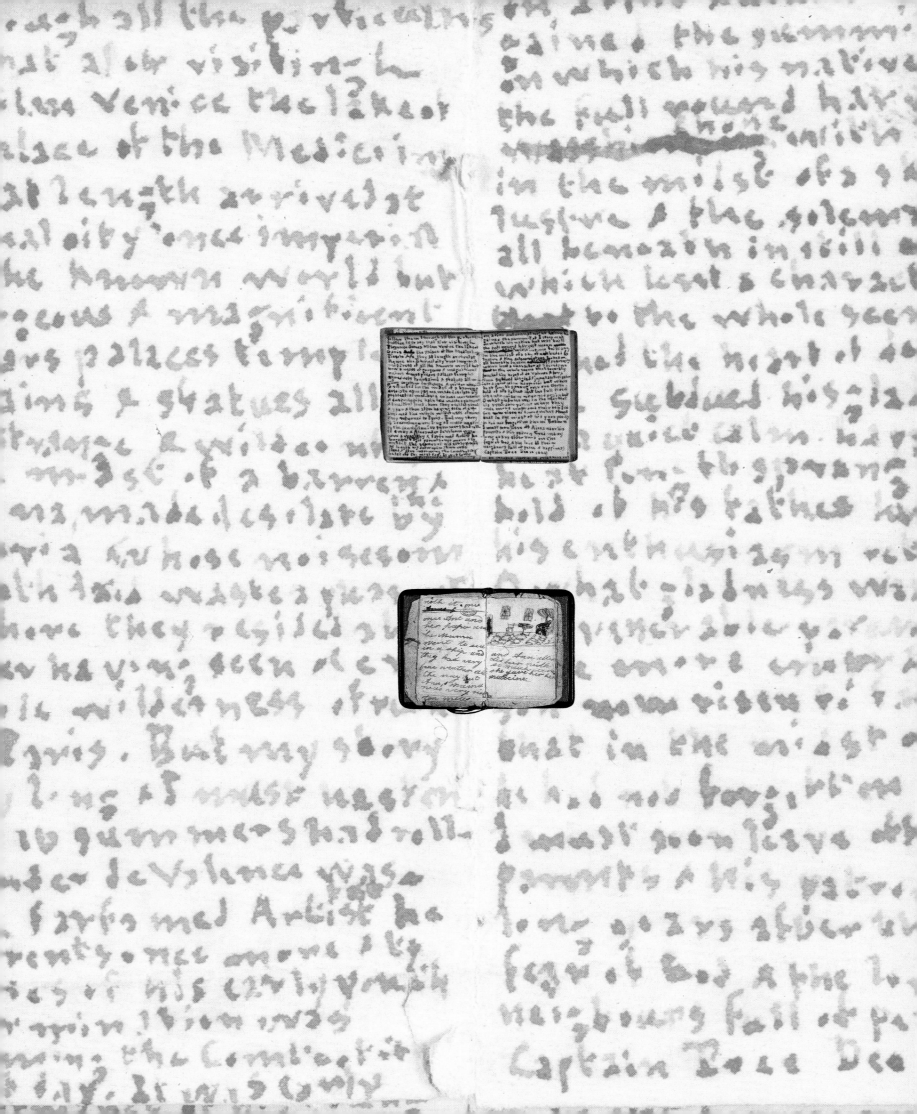

Duty and Tradition

HENRI OF ORLÉANS, DUKE OF AUMALE

(1822–1897)

The fifth son of the Duke and Duchess of Orléans was born on January 16, 1822. Christened Henri-Eugène Philippe-Louis, he was given the title Duke of Aumale. He had four brothers and three sisters. The titles given to these four princes (Chartres, Nemours, Joinville, Penthièvre) are in keeping with the inheritance that made their father, who ascended to the French throne as King Louis-Philippe in 1830, one of the richest princes in the country. The godfather of the young Duke of Aumale was the Prince of Condé, also immensely wealthy, and the owner of a number of properties that included the château of Chantilly. The Prince named his godson the sole heir to his fortune.

When Henri reached the age of three, he began an intensive educational regime. He rose every morning between seven and seven-thirty. At eight o'clock, he ate breakfast with his brothers, then paid a visit to his mother or his aunt; at ten, he went to the schoolroom, where he was kept busy or amused himself. During the prince's early years his education was conducted by a Monsieur Dupuis. Dupuis was replaced when the boy was five by a tutor, Alfred Auguste Cuvillier-Fleury, who began to teach the prince to write, and the following year, English. At age nine, the duke was obliged to study for fifty-three hours every week, as opposed to the sixty-four hours allotted for sleeping, eleven for eating, ten for washing and grooming, and twenty-nine for exercise and play. His curriculum included Latin, Greek,

and history. By the time he was nine years old in 1831, he was writing essays in Greek, although his Latin was better. On May 22 of that year, Cuvillier-Fleury noted: "Conduct: good, except in the salon, where everyone complains about your babbling. Children's chatter is insufferable. In adult men it is the sign of a mediocre mind." And a year later: "Conduct: still heedless in the salon, a chatterbox at the table, oblivious of warnings directed toward you."

As for the teacher in charge of his studies at the Lycée Henri IV: "The Duke of Aumale recited his lesson very badly. I decided not to punish him this first time." And later: "If the Duke of Aumale continues to waste his time in class, the teacher will have to inform the household."

Nonetheless, the duke sometimes got good grades, even taking first place in composition on several occasions. Until the age of ten, he took occasional classes at the Lycée Henri IV, where he enrolled as a full-time student only in January 1837. Eventually, his teachers recognized that he was markedly superior to his schoolmates. In 1837, he was, with one of his brothers, winner of the Concours Général, an annual competition among the students of the lycées of France.

Top left:

Louis Hersent, *Queen Marie-Amélie with her two sons, the Duke of Aumale, in the uniform of a light infantryman, and the Duke of Montpensier, in the uniform of artilleryman, with a view of the park of the château de Neuilly* (detail). Châteaux de Versailles et de Trianon

Left:

One of the few surviving homework assignments of the Duke of Aumale, dating from 1833. Collection Alain Nicolas

Mon cher Papa,

Je vous adresse ce petit mot de souvenir persuadé qu'il vous fera plaisir. Je voudrais bien vous voir de retour. J'espère que nous vous trouverons en bonne santé.

Adieu, mon cher Papa, jusqu'à mercredi.

Votre respectueux fils,
D'Aumale.

Neuilly – 17 Novembre.

Letter from the Duke of Aumale to his father.
Collection Alain Nicolas

My dear Papa,
 I send you this short note as a reminder, persuaded that it will give you pleasure. I am looking forward to seeing you when you return. I hope that we will find you in good health.
 Farewell, my dear papa, until Wednesday.
 Your respectful son,
 D'Aumale

Neuilly, November 17 [1829]

Flaubert's Passion

GUSTAVE FLAUBERT

(1821–1880)

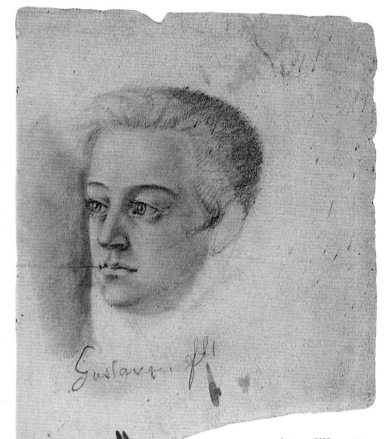

When he was a small boy, the Flauberts thought of their son Gustave as "the family idiot." His mother tried to teach him to read, and was perplexed to find him unable to master this skill, although he was clearly determined to learn, and wept in frustration. Once he began to attend grammar school, however, he caught up with children his own age in a matter of months.

Having cleared this hurdle, he discovered a passion for reading and writing. This becomes clear in a letter he wrote to his friend Ernest Chevalier on January 1, 1831, which contains this startling proposal: "If you want to form a writing partnership, I'll write comedies and you can write your dreams." The child also developed a love of history, as indicated by his decision to recount the reign of Louis XIII in a text he presented to his mother on July 28, Saint Caroline's day (see appendix). It is clear from this essay that at the age of nine—the same age as his subject was when he acceded to the throne—he had nearly mastered spelling. The essay also reveals an oddly powerful visual imagination, notably in a passage describing the political assassination of Concini, a personal friend of the queen mother, Marie de' Medici.

As Flaubert's primary education proceeded, he became more and more productive. Between an ode to the seventeenth-century playwright Corneille and an essay on constipation—subjects that nicely sum up his preoccupations as an adult—he multiplied his literary activities, publishing a manuscript periodical in secondary school called *Art et Progrès* (Art and Progress), beginning a history of Margaret of Burgundy (a fourteenth-century Queen of Navarre smothered to death for adultery), and undertaking historical and literary studies of every conceivable kind. In 1836, when the "family idiot" turned fifteen, he began *Mémoires d'un fou* (Memoirs of a Crazy Man) an autobiographical work that he later reconfigured as one of the greatest novels of the nineteenth century, *L'Éducation sentimentale* (The Sentimental Education).

Opposite:
Letter from Gustave Flaubert to Ernest Chevalier, 1829 or early 1830. Paris, Bibliothèque Nationale de France

1829 or early 1830
Dear friend,
 I think you are out of danger; we will all see one another soon, thank God.
 I received your letter; it gave me great pleasure. I received news from your good family; your illness was beginning to make me fearful. If your good father had not come to give me news of you, I would be concerned about my best friend. I am impatient to see the best of my friends, with whom I will always be friends and love, a friend who will always be in my heart. Yes, [a] friend from birth until death.

Your friend
Gustave Flaubert

Top left:
Gustave Flaubert at fifteen

ami qui sera toujours dans mon

cœur. Oui ami depuis la naissan

ce jusqua la mort.

ton ami

Gustave Flaubert

1 1829 ou 1er mars
 de 1830 1

Cher ami

Je pense que tu est hors de danger, nous

nous verront tous à Radepont Dieu merci.

J'ai reçu ta rettre elle ma fait beaucoup

de plaisir. J'ai reçu des nouvelles de ta

bonne famille, je commençait à avoir

peur de ta maladie, si ton bon père

n'était pas venu me donner des nouvelles

de toi, je serait dans L'inquietude du

meilleur de mes amis. Je suis dévoré

d'impatience de voir Le meilleur de mes

amis celui avec Le quel je serait

toujours amis nous nous aimerans,

To mama on her name day
Louis XIII

Since Louis XIII was only nine years old [when he became king] the *parlement* gave the regency to his mother Marie de'Medici. Intrigue and meanness prevailed at the court; Sully, the friend of the good Henri IV, was dismissed. Marie de'Medici placed her trust in an Italian named Concini and in his wife. Luines, the young king's favorite and a particular enemy of the queen, undertook to get rid of the Marshal of Ancre (Concini), and did everything to inspire in the Dauphin the desire to rule. . . .

maréchal de france et obtint du roi des
lettres patentes que le meurtre du maréchal
d'Ancre avait été fait par commandement
exprès du roi,

Le corps de concini fut enveloppé d'un crap
noir et enterré à St germain l'auxerrois
vers minuit, mais le lendemain le peuple
se porta en foule et malgré la résistance
du clergé le corps fut exhumé traîné jusqu'au
pont neuf et pendu à une potence que le maréchal
y avait fait, il déchira eux ceux qui parlai
ent mal de lui. On le dépendra ensuite
on le coupa en milles pièces et l'on vendit les
restes, et même une femme en mangea. On
mit les enfans du maréchal dès le jour même
à la porte du palais et l'on vit courir dans
les rues un enfant du maréchal d'ancre couvert
de broderie on lui demanda ce qu'il
avait il répondit je porte la dépouille
de mon père, Galigai sa femme périt
sur un échafaud accusée d'être sorcière

Des protestans ayant à se plaindre de la cour
prirent les armes et marchèrent contre Louis le roi
les assiégea à montauban mais il fit lever le siège.
Richelieu vint ensuite au ministère, fonda
l'académie française et rétablit les affaires de la france,
Son monument le plus glorieux est le siège de la rochelle
le boulevard des huguenots, par une digue merveilleuse
Richelieu ferma le port aux Anglais, il commandait
lui même les troupes et les Rochellois se soumirent
Le siège de la rochelle fut le dernier coup
donné aux protestans ils conservèrent leur religion
mais ils perdirent leurs places fortes.

Louis signala sa bravoure dans la bataille
de montant contre le roi d'espagne Richelieu
y exerçait ses talens militaires

Après avoir triomphé des ennemis de son
maître à grande politique sut se défaire des
siens.

Le ministère de Richelieu fut despote il assujétit
les grands aux devoirs et en un mot prépara les
merveilles du règne de Louis 14

Louis 13 mourut 5 mois après Richelieu
l'an 1642 agé de ** après en avoir regné
33

Inventions découvertes

1614 Marie de Médicis fait commencer le
Luxembourg et planter les champs élisées
1635 inv. du télescope par Corneille Drebbel.
1619 Découverte de la circulation du sang par
Harvey anatomiste Anglais.
1620 invention du microscope
1635 fondation de l'académie française,
Auteurs de leur mort. Personnages célèbres
1611 Du duc de mayenne
1615 Crillon
1626 Le connétable de Ludiguères

1628 Malherbe poête
1641 Sully
1642 Richelieu

Événemens mémorables

1621 Guerre de religion
1624 Commencement de la fortune de Richelieu
1625 Deuxième guerre de religion
1627 La Rochelle est prise par les français
1632 Comtat de Castelnaudary.

A Letter to His Brother

CHARLES BAUDELAIRE
(1821–1867)

Charles Baudelaire's father, François Baudelaire—a former priest, tutor, administrator for the French Senate, art enthusiast, and amateur painter—married a woman thirty-four years his junior in 1819. From a previous marriage, he had a son named Alphonse, who was sixteen when Charles was born. Sadly, the future poet had little time to know his father, who died when the boy was six. His mother was almost immediately remarried, to a Major Jacques Aupick. It was in this context that Charles grew up, first in Paris and then in Lyon, where his step-father was named chief of the general staff. There the boy was enrolled as a boarding student at the Collège Royal.

In 1835, at age fourteen, Charles was a good student, although he was often punished for talking. One of his schoolmates that year, Henri Hignard, later wrote this portrait of him: "Much more refined and distinguished than any of our schoolmates, one could hardly imagine a more charming youth. We were linked by a deep mutual affection based on common tastes and a precocious love of fine literature, a shared cult of Victor Hugo and Lamartine, whose works we read to one another over and over during monotonous playground breaks and insipid walks through the quarter. We even wrote verse ourselves— which, thank God, does not survive." Although these poems are lost, some of Baudelaire's correspondence from this period has survived. Many letters to his half-brother Alphonse tell us about his aspirations and the vicissitudes of his life at school, as well as providing glimpses of his growing command of the French language. Such is the case in this letter from late August 1835, in which Baudelaire mentions a cholera epidemic that had caused panic in Lyon, his second prize for drawing (a talent that he would cultivate into adulthood), and his pending arrival in Paris, where some months later he would enroll at the Lycée Louis-le-Grand.

[Lyon, late August or early September 1835]

My dear brother,

Many thanks for your concern about my mother and me, when you offered to take us in if cholera should strike the city of Lyon; it was very kind of you; we all thank you. But, thank God, things haven't come to that yet; it hasn't gotten past Vienna . . .

Perhaps . . . you are expecting a bunch of prizes. I only won one, as well as five commendations, which delighted my father. Don't be of a mind to be more difficult than he is, as difficult as my mother for example, who thinks I should have won first place in everything. I can't hold her exigency against her; her excessive fondness makes her dream endlessly of success for me. You should also know, my brother, that this year they used a different distribution system. The prizes are no longer for a single composition but for the whole year's work. And I thought it would make sense to save my efforts for the end.

So you're learning to swim? A friend of my father's has offered to give me lessons, too, but [the water's] too cold. I guess the rains haven't cooled down the Seine as they have the Rhône.

The moment approaches, my brother, when I'll be able to embrace you, for mama has decided that I must study rhetoric in Paris. Doubtless you will find I've grown a lot, in wisdom as in size.

Your brother
Ch. Baudelaire

Many regards to my sister [and] Théodore, both of whom I hope remember me kindly. Until I come to Paris to embrace you in reality, I send you as partial payment a thousand thousand endearments.

Vale

Left:

Gustave Moreau, *Landscape (Honfleur). The Garden of Madame Aupick, Baudelaire's Mother*. Paris, Musée Gustave Moreau

Mon cher frère,

Je te remercie beaucoup de l'attention que
tu as eue pour maman et pour moi, lorsque
tu as proposé de nous sauver chez toi. Si le
choléra venait purger la ville de Lyon.
C'est bien aimable à toi, nous t'en remercions
tous, mais dieu merci nous n'en sommes pas
encore là, il n'a pas passé. Vienne, il
y a eu là un seul cas, donc, nous
sommes jusques à présent sans inquié-
tude. D'ailleurs, notre dame de Fourvières
n'est-elle pas là!

Tu t'attends peut-être, colin mon
grand frère à une foule de prix
Je n'en ai eu qu'un, accompagné de
cinq accessits, qui enchantent mon
père. Ne vas pas t'aviser d'être
plus difficile que lui, difficile comme
maman par exemple, qui s'ima-
gine que je devrais être le premier
en tout. Je ne puis lui en vouloir de
son exigence, s'attendre est nécessaire
lui fait sans cesse rêver des succès pour
moi. Il faut aussi que tu saches, mon
frère, que on a suivi cette année un système
différent dans le mode de distribution

Les prix qui ne dépendent plus que
du résultat d'une seule composition
dépendent du travail de toute l'année
Et moi j'ai cru qu'il était temps
de travailler à la fin —
Voilà donc que tu apprends aussi à
nager? un ami de mon père s'offre
aussi pour me donner des leçons, mais
la température ne le permet pas:
Il faut croire que dans ce moment
les pluies n'ont pas refroidi la Seine,
comme elles ont refroidi le Rhône
Le moment approche, mon frère,
où j'irai t'embrasser, parceque Ma-
man est bien décidée à me faire faire
ma Rhétorique à Paris, tu
me trouveras sans doute bien
grandi et en sagesse et en
taille.
Ton frère
Ch. Baudelaire

Bien des choses pour ma sœur, Théodore,
qui me conservent tous deux je pense
une place dans leur souvenir.

En attendant que j'aille t'embrasser
à Paris, invariable, je t'envoie
en acompte mille et mille t'em-
ter—

Vale.

"The Napoleon of Painting"

THÉODORE CHASSÉRIAU

(1819–1856)

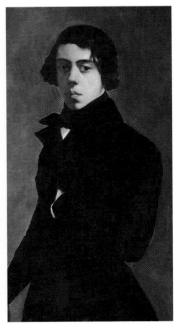

Benoît Chassériau, a gentleman from La Rochelle, France, met and married a young woman whose family had owned a plantation in Haiti for a number of years. The couple's first son, Théodore, was born in the colony on September 20, 1819. In the following years, two more boys and two girls were born, all of whom were later to serve as their oldest brother's models. When Haiti was torn by civil war in 1822, the family returned to France.

Attracted to drawing from a very young age, Théodore was allowed to leave school and devote his energies to artistic training. Sponsored by a relative, the painter Eugène Amaury-Duval, at age eleven Théodore entered the atelier of Ingres, who quickly became attached to this gifted child. One day when the boy was drawing from the live model, the master, passing behind him, paused in wonder and then summoned the other students: "Come see, gentlemen, come see. This child will be the Napoleon of painting!"

Chassériau produced his first paintings in 1833. These were commissioned by Théophile Gautier and Gérard de Nerval as part of the decoration of their rooms on the impasse Doyenné—a cul-de-sac in a quarter that was slated for demolition to create the courtyard of the Louvre—for a ball. This event became famous as the "bal du Doyenné," a landmark in early Romantic social life. As Gautier wrote later, Chassériau

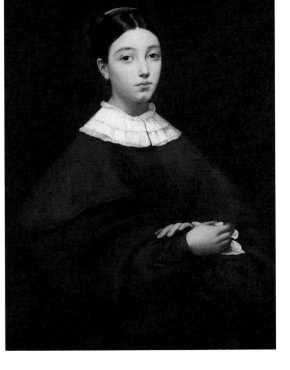

"offered . . . a *Diana at the Bath* already marked by the savagery mixed with the purest Greek taste that gives the works he made later their strange beauty."

In 1834, when Ingres was about to leave Paris to become director of the French Academy in Rome, he suggested that his student accompany him. "You can learn nothing more here," he told Chassériau. "The school will be deadly for you. Come to Rome with me." The young man was not able to follow this advice until six years later, since his family had only limited means. In the meantime, the young artist rented a small studio and worked toward an exhibition, allying himself with a constellation of young artists, including Corot, Rousseau, Gavarni, Devéria, and Delacroix.

Chassériau exhibited for the first time at the Salon of 1836, where he showed two subject pictures and four portraits: of his mother, his father, his sister Adèle, and the painter Prosper Marilhat. He won a third-class medal and instantly joined the select circle of young artists from whom great things were anticipated. His many surviving sketchbooks from the period reveal a prodigious talent determined to explore any number of paths. But his premature death at the age of thirty-seven cut short what had promised to be a great career.

Top left:
Théodore Chassériau, *Self-Portrait*, 1835. Paris, Musée du Louvre

Left:
Théodore Chassériau, *Adèle Chassériau, The Artist's Sister*, 1835. Paris, Musée du Louvre

Opposite:
Théodore Chassériau, *Venus Anadyomene*, 1839. Paris, Musée du Louvre. This painting, which long adorned the walls of the artist's atelier on rue Frochot, was exhibited at the Salon of 1839; its success occasioned Chassériau's first official commission.

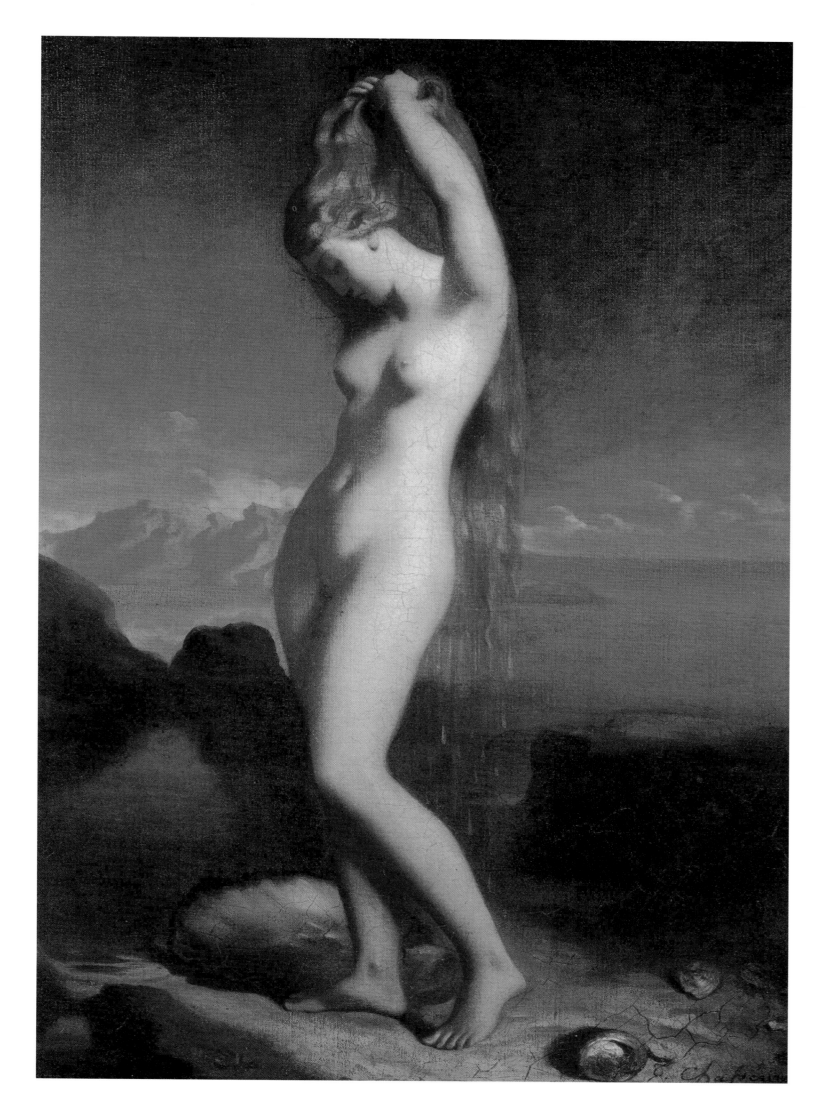

A Letter from the Young Jules Verne

JULES VERNE

(1828–1905)

The earliest known letter in the hand of Jules Verne, addressed to his aunt, concerns a scientific discovery, that of the telegraph. Apparently the man who later remarked, with an air of apology, "I belong to the generation between those two geniuses, Stephenson [the English inventor of the steam loco-motive] and Edison," was interested in science as a child. Doubtless he listened attentively to his father, who nurtured a passion for modern inventions when he wasn't writing poetry. In any case, one thing is clear: the boy was not a good speller, although his writing is easily understood.

When he wrote this letter, he was probably eight years old. He was living in Nantes, capital of the "ebony trade"—a contemporary euphemism for the slave trade—and could see ships plying the river from his window. He imagined himself captain of them all, of every ship in the world: "In imagination, I climbed their sails, I lifted myself up to their tops, I held fast to the knobs of their masts . . . It seemed to me that, once a ship had drifted free of the quay, its ropes would be loosened, its masts would be obscured by sails, I, an eight-year-old helmsman, would guide it out to sea!" This passion would continue, on top of and under-neath the ocean, although the travels could end oddly, as he learned from his favorite book, *Swiss Family Robinson* by J. D. Wyss (1812), the story of a family shipwrecked on a remote and uninhabited island.

Letter from Jules Verne to Madame de Châteaubourg, March 30, 1836

My dear aunt,
I would very much like you to come and see us because I love you with all my heart. I beg you come to see us and then would you bring me the little telegraphs you promised us because Paul will have one too. Paul loves you with all his heart. I write this letter because Paul does not know how. He has just started and I've been at boarding school more than a year . . .

Right:
Diver Searching Wrecks at Le Havre, illustration to a tale by Jules Verne published in the illustrated supplement to the *Petit Journal* in 1892

Far right:
New Year's Day poster for J. Hetzel, Jules Verne's publisher

ETRENNES 1888
ENFANCE JEUNESSE

J. HETZEL & CIE

Jules Verne fils St Lo Chorent le 30 Mars
1836

Ma chere tante je voudrais bien que tu vien
nous voir parceque je t'aime de tou—ma cœur
je t'empris vient nous voir et puis voudra tu
maportez les pettes télégraphe que tu nousavait
promis parceque paul en aura un aussi paul t'aime
de tous son cœur j'écris la l'êttre parceque paul ne
se'y pas ecriuent il ne fait que commencé et moi
y a plus d'une an que je suis en pension et Mon
Oncle comment se porteté
Notre tante Verne et arivez chez nous de la
Rochele il ni a pas lon temps quels est arevé avan
d'arivé son frere nous a ecris dans sa lettre une
afreuse nouvelle que son mari etait mort ma
bonnemamant maman et Ma tante trosou et
mescousine le save nos deuc cousin henri et edmon
son a colege dandion. il ne le save pas ncais
on leur ecrira
Adieu Ma chere tante et mon chere oncle
je vous enbrass tous les deuc de tous mon cœur

99

A Young Seminarian Loses His Vocation

ERNEST RENAN

(1823–1892)

In his *Youthful Recollections*, Ernest Renan offers a moving portrait of his mother: "Everything about her was of the people, and her innate wit gave the long stories she told, which few others knew, surprising life. Her suffering by no means diminished her astonishing gaiety; she was still telling jokes the afternoon she died." This woman, who "spoke Breton admirably and knew all the sailors' proverbs," had led a modest life marked by the death of her husband, who had been lost at sea under mysterious circumstances. Ernest, the youngest of the family, was five at the time. As the years passed, he proved himself a brilliant student. At age fifteen, he left his native and much-loved Brittany to enter the seminary of Saint-Nicolas-du-Chardonnet in Paris, for at the time, the priesthood was virtually the only career open to successful students from families without means.

Thus it was that Ernest, a shy and studious boy, arrived in the teeming Paris of the late 1830s. The shock was brutal, for, as Renan himself admitted, "young Bretons are difficult to transplant." The directorship of the seminary had recently been assumed by Father Dupanloup, who had resolved to make the school there "as fine as . . . any college in Paris and even . . . in Europe." The bar was placed high; Ernest, like most of his schoolmates, was obliged to repeat the second year. Although Dupanloup's methods could be inspirational, his inflexible discipline caused considerable despair. Renan resisted. After a period of study at two more seminaries, the discovery of German philosophy changed his life. He left the priesthood and turned away from religion. Many years later, now famous as the author of a polemical *Life of Jesus*, Renan found himself forcefully opposed by the Bishop of Orléans—his former schoolmaster, Father Dupanloup.

Top left:
Émile Cohl, *Caricature of Ernest Renan*

Above and right:
Letter from Ernest Renan to his mother, written shortly after his arrival in Paris. Paris, Bibliothèque Nationale de France

Paris, le 8 septembre, 1838.

Ma chère maman,

Me voila donc loin de vous, dans Paris, dans ce gouffre
immense, au milieu de ce fracas qui contraste si singuli-
èrement avec la tranquillité de notre petite ville; il est
vrai que je n'entends rien de tout ce bruit et que je
vous écris bien tranquillement du séminaire Saint-
Nicolas où je suis entré hier. Vous m'accuserez, peut-être,
ma bonne mère, de négligence, en voyant combien j'ai tardé
à vous écrire, mais je n'ai pu le faire plus tôt, car en
arrivant je me suis couché, et aussitôt mon réveil nous
sommes allés chez le monsieur qui m'a procuré une
bourse, et qui est le médecin d'Henriette.

bon monsieur à qui sa grande vertu à procuré
beaucoup de connaissances parmi les
ecclésiastiques de la capitale nous a témoigné la plus
grande bonté.

J'ai eu une bien grande joie, ma bonne mère, d'apprendre
qu'Allain venait à Paris; nous serons donc tous
les trois réunis ici, quand vous serez seule en
Bretagne, mais consolez-vous, excellente mère, bientôt vous
les verrez auprès de vous, et moi, j'espère aussi vous
revoir bientôt, car vous n'allez, sans doute, pas rester
si loin de nous, ô ma bonne mère. Il faut que

A Plea for Advice

LOUIS PASTEUR

(1822–1895)

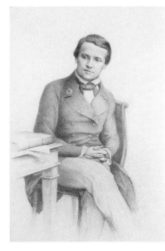

"Once one has settled into work, one can't live without it. What's more, the entire world depends upon it; with science, one is happy; with science, one rises above all the others." So wrote Louis Pasteur, not at the end of his long and productive life but at the dawn of his maturity, when he was only seventeen. It is perhaps surprising to hear such serious reflections coming from so middling a student, the only son of a tanner, a nostalgic grumbler who managed to instill in his children a sense of the grandeur of France. According to one witness, "The father exerted an absolute authority over his family, but he was even-handed and reasonable. Everyone obeyed him, his wife as well as their children." It was to this man, the scientist later said, that he owed the day-to-day tenacity that was the foundation of his accomplishments in life.

In childhood and youth, however, despite the fact that his schoolwork improved steadily, the young Pasteur was not a stellar student. Nevertheless, he was encouraged by his teacher and by the principal of his secondary school, who first suggested that he apply for admission to the state teachers' college, the École Normale—two words that the young Louis could not get out of his head. His sensitivity almost compromised his ambitions. At age sixteen he went to Paris to pursue his studies, but was twice sent home because he could not bear to be separated from his family. There he gave free rein to another passion: drawing in charcoal, graphite, and, above all, pastel, which he used to make portraits conscientiously signed "Pasteur Louis."

In 1839, Louis decided to attend college in Besançon, in eastern France. After successfully completing a year's study in literature, in 1840 he enrolled in the science department. At the end of the year, however, he failed his examinations. A second year brought a second failure. His third attempt, however, proved successful. Now he could finally realize his great ambition—to attend the École Normale.

Above:
The residence of the Pasteur family in Arbois. Paris, Institut Pasteur

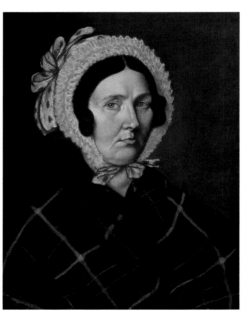

Top left:
Charles Lebaye, *Louis Pasteur as a Student at the École normale supérieure*. Paris, Institut Pasteur

Left:
Louis Pasteur, *Portrait of the Artist's Mother*, pastel. Paris, Institut Pasteur

Draft of a letter, surrounded by mathematical calculations, from Louis Pasteur to a friend of his father

Monsieur,

I have just received a letter from my father in which he tells me to ask you for whatever advice you might have to offer regarding the decision I should make about the school at Saint-Cyr, or the Polytechnique. When he came to Besançon, as you doubtless know, he wanted me to apply to the Saint-Cyr school in February, and judging from the letter I have just received, it seems to me he is uncertain about what I should do. Please be so kind as to indicate a day and time when I might come to see you to hear your advice regarding this subject so that I might make my decision accordingly.

"Fresh as an Apple"

MAURICE DUDEVANT, KNOWN AS MAURICE SAND

(1823–1889)

"Maurice is tall, fat, and as fresh as an apple. He is very good, very petulant, rather obstinate, and a bit spoiled, but holds no grudges, doesn't remember vexations and resentments. I think his character will be sensitive and loving, his tastes fickle; his good-humored and easy-going nature will, I think, come to terms with things rather quickly. Such, as best I can tell, are his qualities and his faults; I will try to strengthen the former and mitigate the latter." So wrote George Sand to her mother, Madame Maurice Dupin, on October 9, 1826. This assessment of her son Maurice, then three years old, turned out to be remarkably perceptive. She had sensed very early the many interests of this precocious little boy, who grew up to be a somewhat lazy and dilettantish young man, in some ways almost suffocated by his mother's overwhelming presence.

A jack-of-all-trades with an undeniable knack for drawing and literature, Maurice Sand would, at various times, try being a writer, a caricaturist, a painter, a novelist, a playwright, a theater historian, a folklorist, an archaeologist, a geologist, and a botanist. His most remarkable gifts, however, were for marionette puppetry and, especially, for entomology. His childhood was relatively untroubled, for his mother was devoted to him, so much so that he was, in effect, the love of her life. He was made miserable, however, by the cruel stories that he was forced to hear about her from his classmates at the Lycée Henri IV.

Maurice—of whom Victor Hugo remarked that he had "a parcel of his mother's genius"—left behind him some ten books, many of them reworked by his mother, several albums of sketches and caricatures, and above all, his magnum opus, a formidable *Catalogue des lépidoptères du Berry et de l'Auvergne* (Catalogue of Butterflies and Moths in Berry and Auvergne).

Above: Portrait of the young Maurice Sand. Paris, Musée de la Vie Romantique

Below, opposite, and following pages: Pages from one of the young Maurice Sand's sketchbooks, with drawings of military life. The gold paperweight in the form of a hand, visible on the following pages, was a favorite object of George Sand's. Collection Christiane Sand

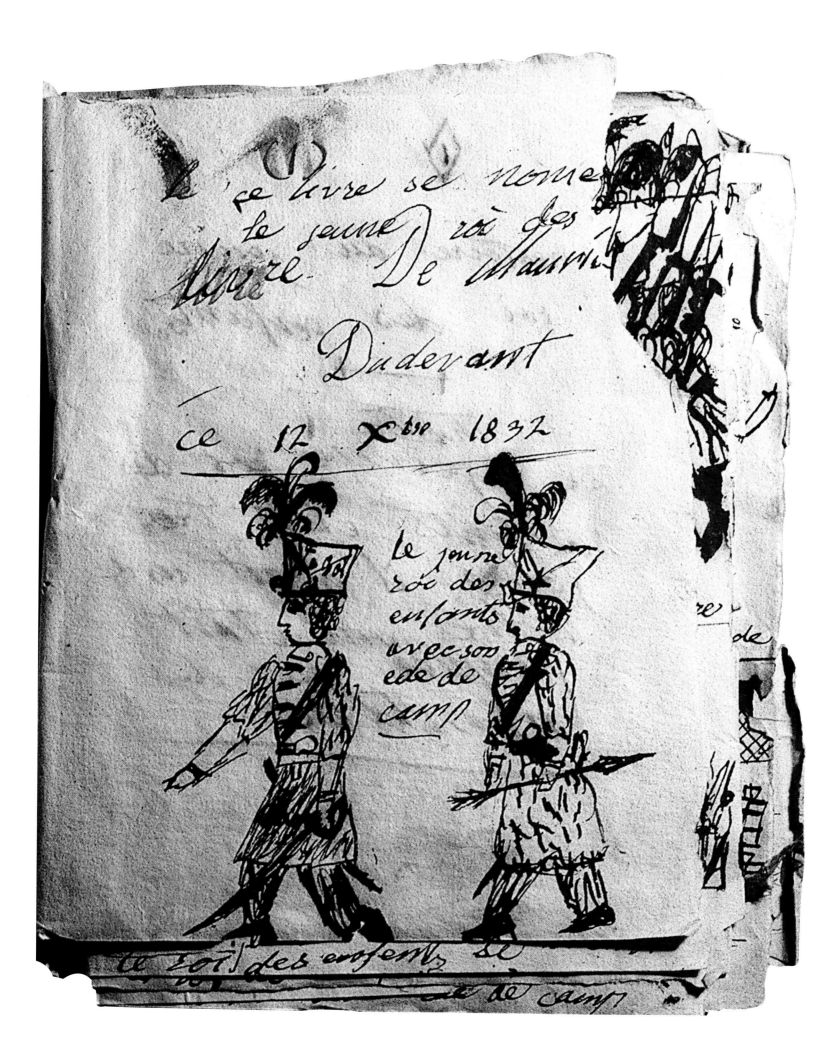

Ce livre se nomme
le jeune roi des
enfants. De Maurice

Dudevant

ce 12 Xbre 1832

Le jeune
roi des
enfants
avec son
aide de
camp

le roi des enfants se
aide de camp

chapitre V
le petit roi ayant
été à la campagne
dit à son ede de camp
de gouverner pendant
quelque que temps et
l'ede de camp le fit
après quinze jours
le petit roi revint
et ... reprit
gouvernement

on apporte de l'argent au jeune roi

le jeune roi fait ... de ses ...

histoire du jeune
roi des enfants

chapitre I
le jeune roi des
enfants était très
joli il avait une
ville qui était
peuplée par des
enfants etc

le roi des enfants s'en allant à la guerre

le roi des enfants se batant

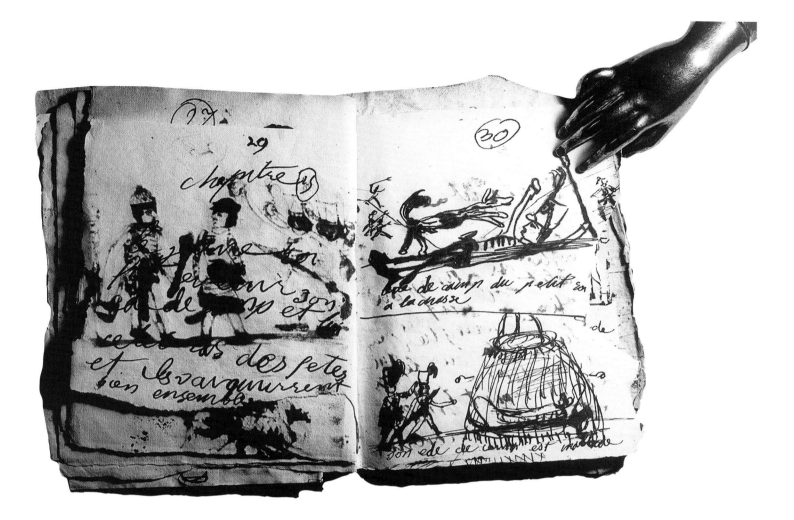

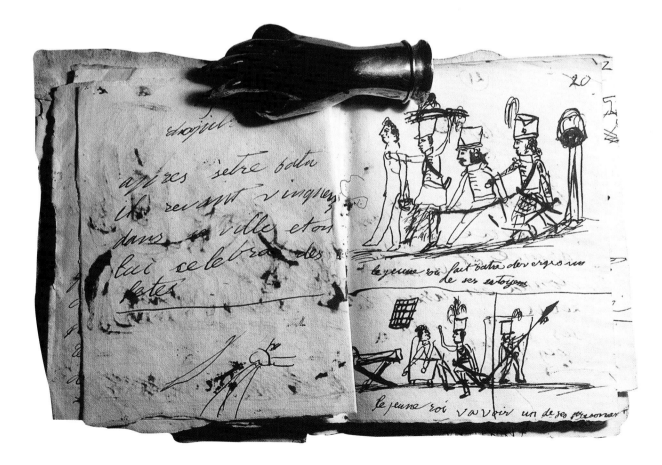

Moreau's Landscapes

GUSTAVE MOREAU

(1826–1898)

"My discovery of the Musée Gustave Moreau when I was sixteen shaped my way of loving forever. Beauty, love, it is here that they were revealed to me through the faces and poses of certain women." Thus wrote the—often harsh—critic and Surrealist painter André Breton in 1961, expressing himself with uncharacteristic warmth. Perhaps in the course of his visit to the house he saw, among the many ravishing female silhouettes in the artist's paintings, the portrait drawing of Moreau's sister Camille. Far from the feminine ideal of the Symbolists, this guileless and melancholy face bears the stamp of the romantic sensibility characteristic of Moreau's early drawings of his family.

From the age of eight, this gifted but sickly child, the son of an architect and a mother who loved music, made many drawings in graphite pencil. Between 1837 and 1839, he was a boarding student at the Collège Rollin in Paris, where he took first prize in drawing. In 1840, however, a tragic event prompted his withdrawal: the death of Camille, his only sister, at the age of thirteen. Moreau, only one year older than she, had just drawn her likeness. Along with the artist's mother and father, Camille was one of the "adored beings" whose loss the painter never ceased to mourn. In 1897, a year before his own death, he moved her pencil portrait, along with other family mementos, into his bedroom, where they can still be found today, in the house that is now a museum dedicated to his life and work.

An Andante at Five and a Half

CAMILLE SAINT-SAËNS
(1835–1921)

When we speak of musical child prodigies, the name of Mozart seems to spring to mind first. However, we should not forget another remarkable young genius, who was to become one of the great figures of nineteenth-century French music: Camille Saint-Saëns. We tend to focus on the end of his long career, which is under-standable. The composer of *Carnival of the Animals* was indeed a man of his century: a friend of Liszt, and a defender of Berlioz, Bizet, and Franck. But he was also a true child prodigy. A pianist of genius, he was encouraged by his mother to pursue music from early childhood. He gave his first concert in Paris at age eleven, entered the Paris Conservatory at thirteen, and at eighteen became the organist at the church of Saint-Merri. His earliest compositions reflect his first enthusiasms as a pianist: a charming short Andante for piano, Mozartian in style and meticulously

written out, composed when he was five and a half; another piano piece, "First Gallop," and studies for a symphony, both composed when he was eight. From the beginning, the boy composed with a disarming facility that stayed with him for the rest of his life, permitting him to take up every conceivable musical genre with happy results, including symphonies, sacred music, concertos, and operas.

The precision, transparency, balance, and melodic limpidity of Saint-Saëns's music can evoke a deep esthetic response of a kind that sets it very much apart from the sentimental effusions of some of his contemporaries. To become convinced of this, one need only listen again to the famous *Danse Macabre*, the *Second Piano Concerto*, or the unforgettable finale of the *Organ Symphony*.

Left:
Andante for Piano, a handwritten score dated August 25, 1841. Paris, Bibliothèque Nationale de France

Opposite:
"First Gallop," a handwritten score dated June 6, 1841. Paris, Bibliothèque Nationale de France

1.ᵉ Galop. le 6 juin 1841.

Minore
Fine

Ms.854

Illustrated Stories

GUSTAVE DORÉ

(1832–1883)

Could Gustave Doré remember a time when he didn't draw? At age five, he was already scattering little sketches throughout his letters and notebooks; the following year he promised his mother to work "without rest so that one day I can become a good artist. . . . I will strive to do my best at whatever I undertake; my handwriting will improve, and soon, as you will see, I will no longer be what I was."

He kept his promise. In 1840, when still only eight years old, he produced his first comic albums: manuscript narratives in which each paragraph is preceded by an illustration from his hand. Entitled *The Brilliant Adventures of Monsieur Fouilloux, The Story of Calypso, The Adventures of Mystenflūte and Mirliflor*, and *The Adventures of Jupiter*, these efforts laid the groundwork for the style that would make Doré one of the subtlest illustrators of his day. His wild imagination, comic sense, and precision are all here in embryo.

His favorite medium was pen and ink, with which he produced lively, incisive drawings that are already elegantly placed on the page; the composition from *The Festival in Brou* reproduced below, for example, features a frieze of fantastic human figures with animal heads. Its creator, only twelve years old, was already a rather accomplished lithographer, a medium that later brought him considerable success. Three years later, this good student—gay and lighthearted by temperament—who had grown up in Strasbourg and provincial eastern France, discovered Paris, where he immediately decided to stay. To this end, he showed some of his drawings to the editor of the *Journal pour rire* (Laughter Journal), who convinced the young prodigy's parents to let their son remain in the capital. The boy was still only fifteen, an immensely gifted elf, when the writer and photographer Nadar remarked playfully about him: "He is a child who somersaults like a monkey and draws like an angel." His career was launched.

Above:
The Adventures of Mystenflūte and Mirliflor. Musée de Brou

Opposite:
Page from *The Adventures of Jupiter*. Musée de Brou

Left:
The Festival in Brou. Musée de Brou

outre celui des poètes qui a donné la plus noble idée de Jupiter, le représentent les sourcils noirs, le front couvert de nuages, la foudre à la main et l'aigle près de lui. A ses pieds siégeaient le respect et l'équité; devant lui étaient les deux coupes du bien et du mal qu'il répandait à son gré sur le monde.

Quelquefois il est placé sur un char, et assez souvent porté sur l'aigle que pour cette raison on appelle l'oiseau de Jupiter (voyez page 9).

L'arme défensive de ce Dieu est l'égide ou l'ægide; c'est un bouclier ou une cuirasse formée de la peau de la chèvre Amalthée, ou tout simplement cette peau dont Jupiter entourait son bras gauche. Amalthée était la chèvre qui avait nourri Jupiter dans son enfance. Après sa mort, le Dieu, reconnaissant, la plaça parmi les constellations et se fit de sa peau l'égide, mot grec qui veut dire chèvre. Il donna dans la suite cette arme défensive à Minerve, qui y attacha la tête de Méduse, comme nous le verrons en son lieu.

L'aigle qui servait de monture à Jupiter rappelle un trait de l'injustice de ce Dieu. Un roi d'Athènes nommé Periphas avait tant de vertus que ses sujets ne le comparaient qu'au souverain des Dieux. Jupiter irrité de voir un mortel partager en quelque sorte sa gloire, levait déjà la foudre sur lui pour l'anéantir; mais à la prière d'Apollon, il retint son bras, et se contenta de changer le bon roi en aigle, pour planer et plus communément dans les airs sur son dos.

983-77

113

Early Compositions

GEORGES BIZET

(1838–1875)

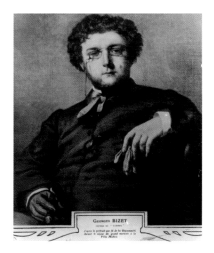

On October 26, 1838, Alexandre-César-Léopold-Georges Bizet came into the world. Whether or not his three triumphant forenames indicate ambition on the part of his parents, the child himself chose to be called, simply, "Georges," which was his baptismal name. His was a musical family: his mother was a fine pianist; his father, a hairdresser and wigmaker by profession, later became a singing teacher and composer in his spare time; his uncle, François Delsarte, was a famous music teacher; and his aunt had studied with Cherubini and Halévy. Georges, who learned the notes of the scale along with the letters of the alphabet in his mother's lap, benefited from them all. Able to play pieces from memory after a single hearing when still only a child, he entered the Paris Conservatory in early youth.

His mother oversaw his progress in piano, and he began to compose while quite young. He wrote several songs, including a barcarole for two sopranos, when he was only eleven. Later, he proudly wrote this inscription on the handwritten manuscript of the barcarole: "I was eleven years old and four months." When he was seventeen, he wrote a symphony in C major, which he considered a failure; rediscovered in 1933, it is now one of his most popular works. At age eighteen he won the Rome Prize, a fellowship that allowed him to travel to the Italian capital for further study at the French Academy there.

This exceptionally gifted child did not, as an adult, meet with the success that was anticipated for him. His operas were not well received during his lifetime, and fame came to him only posthumously. He died at age thirty-seven during the thirty-third performance of *Carmen,* which had not yet become a repertory staple.

Top left:

Portrait of Georges Bizet, a print after a portrait painted by Félix Giacometti when the two men were scholarship students at the French Academy in Rome

Giuseppe Canella, *The Théâtre de l'Ambigu Comique and the Boulevard Saint-Martin,* 1830, a part of Paris well known to Bizet. Paris, Musée Carnavalet

Barcarolle: Duo for Two Sopranos, a handwritten score by Georges Bizet. Paris, Bibliothèque Nationale de France. According to the inscription along the left margin, which the composer added later, the duet was written when he was eleven years old and four months.

Early Figures

A U G U S T E R O D I N
(1840–1917)

Afflicted with a bad case of myopia, the young Auguste Rodin was at best a middling student. He never really mastered spelling, punctuation, or grammar. His father, a police adminis-trator—something that Rodin always tried to hide—who wanted his son to be "a man above the ordinary worker," was upset when the boy asked to take drawing lessons. His interest may well have been encouraged by prints after Michelangelo that he had seen in the Bibliothèque Sainte-Geneviève, but, according to the sculptor himself, his passion for art dated from early childhood. As he recalled, "When I was very small, as far back as I can remember, I drew. A grocer patronized by my mother wrapped his plums in paper bags made from the pages of illustrated books and even of engravings. I copied them. They were my first models."

Having decided to be an artist, the boy had to convince his father, who doubted the wisdom of his choice. His mother and sister supported his ambition, however, and at the age of fourteen Auguste entered the Imperial Drawing School (called the *Petite École*, or little school, to distinguish it from the École des Beaux-Arts). There he worked furiously, and also pursued further studies elsewhere in his free time. He worked with both the painter Pierre Lauset, a friend of the family, and Hippolyte Lucas at the Gobelins tapestry manufactory. He also copied works in the Louvre, studied prints in various libraries, and tried to fill gaps in his literary education by reading ancient and modern literature, from Virgil to Hugo. His drawings from life of the male nude bear the stamp of his determination to succeed. At age seventeen, he won two first prizes for drawing after the antique, an indication of his emerging involvement with sculpture. When he finally sought admission to the Beaux-Arts itself, however, he presented himself three times, and three times was rejected.

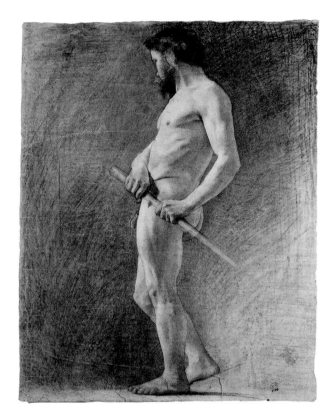

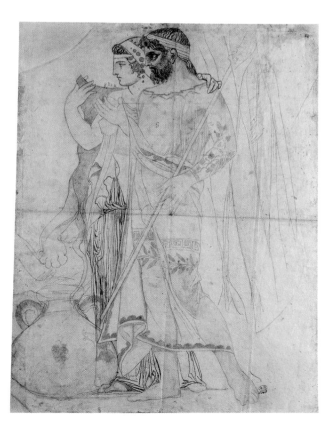

Top right:
Auguste Rodin, *Male Nude with Baton*, 1854–57, charcoal on cream watermarked paper. Paris, Musée Rodin

Right:
Auguste Rodin, *Couple after the Antique*, 1854–57, graphite, pen and brown ink on cream watermarked paper. Paris, Musée Rodin

Auguste Rodin, *Male Nude*, c. 1857,
oil on canvas. Paris, Musée Rodin

117

"What the Three Storks Said"

STÉPHANE MALLARMÉ
(1842–1898)

Stéphane Mallarmé's childhood and early youth were marked by mourning. When he was five, he lost his mother. Ten years later, his sister Martha, two years his junior, died after a brief illness. Between these two tragic events, the boy's father remarried, and in the ensuing years four more children were born into the family.

Stéphane was a poor student at boarding school, where his teachers complained of his "insubordination and conceit." However, while he was doing poorly in his academic work, he was seeking refuge in writing, an outlet that offered him an escape from the many hurts he had suffered.

Mallarmé's early works, stories he wrote beginning in 1854, when he was only twelve, are preoccupied with death. The most moving of these is *Ce que disaient les trois cigognes* (What the Three Storks Said), written in 1857. This very long narrative about a father tormented by an apparition of his dead daughter, which includes a song in verse, is our earliest evidence of Mallarmé's exceptional literary gifts in both prose and poetry. Its linguistic mastery and its strange and morbid beauty are so reminiscent of the work of Baudelaire, whose collection of poems, *Les Fleurs du mal* (The Flowers of Evil), had appeared only two months earlier, that some scholars have suggested that he rewrote the story two or three years later. If so, this revision may have been made in response to the death of yet another sister, Maria, a "poor young phantom, who was thirteen years my sister, and who was the only person I adored," as he wrote to a friend on July 1, 1862. Even if Mallarmé did revise the story, it is still remarkable for its length and complexity. Significantly, he wrote to his friend Eugène Lefébure in 1865: "As a child in secondary school I wrote stories twenty pages long, and I was notorious for not being able to stop myself." Until the age of eighteen, this creative energy characterized his first poems, which he gathered in an album entitled *Entre quatre murs* (Between Four Walls), a prelude to one of the greatest bodies of work in French literature.

Above and opposite:
Stéphane Mallarmé, *Ce que disaient les cigognes* (What the Storks Said), a handwritten manuscript. Paris, private collection

I

Ce que disaient les trois Cigognes

—

Il a neigé tout le jour. La terre est en blanc Comme une mariée, et les Constellations limpides diamantent un Ciel lacté.

Deux gémissements sinistres traversent Cette froide rêverie de la neige et du Clair de lune.

Le premier est Celui d'une porte tournant sur ses antiques ferrures, la porte de Dick Sarrit qui sort de sa Cabane, — un nid dans les broussailles. Dick Sarrit ramasse le long du mur deux fagots d'aubépine, secoue les grappes de neige dont l'hiver les refleurit par Compassion. avant qu'ils — brûlent pour l'éternité, et rentre.

Le second gémissement, assez semblable au premier du reste, part des airs.

Est-ce le vent qui se plaint désespérément à travers les branches grises et mouillées?

Ou quelqu'oiseau passager qui pleure la mort des feuilles?)

Puis, il n'entendit plus rien.....

— Sauf les pas légers de l'aurore grelottante sur la neige, et le Craquement de quelques branches mortes sous leur blanc fardeau.

—

Stéphane Mallarmé

Oscar's Caricatures

CLAUDE MONET

(1840–1926)

I was undisciplined from birth, no one, even when I was very young, could make me follow rules. . . . School always seemed like prison to me and I could never resolve to spend even four hours a day there," reported Claude Monet. He passed most of his childhood in the port of Le Havre, on the English Channel, where his family moved when he was five years old. At school, where he was commended for his "excellent nature, very agreeable to his schoolmates," he was bored. As he wrote later, "I garlanded the margins of my books, I decorated the blue paper of my notebooks with incredibly fantastic ornaments, and I represented, in the most irreverent way, distorting them as much as possible, the faces and profiles of my teachers."

Monet's gift for caricature, little known today, was considerable. After his mother died in 1857, when he was sixteen, he turned his irrepressible joy in this genre into a business. He left school, entered his aunt's painting studio, and sold caricatures, all vivid and in some cases absolutely merciless. They are signed "O. Monet," the "O" standing for Oscar, the name given him by his parents. His first dealer, a stationer and framer, exhibited these early sheets next to landscape paintings by Eugène Boudin. Soon the two artists became friends and began painting together in the open air. For Monet, this was a revelatory experience: "If I became a painter, I owe it to Eugène Boudin," he remarked late in life.

Above: Claude Monet, *Groom in a Top Hat,* 1857. Paris, Musée Marmottan–Claude Monet

Claude Monet, *Young Man with a Monocle*, 1857. Paris, Musée Marmottan–Claude Monet

Rimbaud's Ambition

ARTHUR RIMBAUD

(1854–1891)

As a student at the Institution Rossat, a prestigious school in Charleville, in northeastern France, Arthur Rimbaud was restless and impatient with having to study Greek and Latin. Nevertheless, he was first in his class, won many prizes, and was commended for both his deportment and his scholastic performance. Arthur and his elder brother Frédéric lived with their two sisters and their mother. "Mother Rimbe," as Arthur dubbed his mother, was an ill-tempered woman whose impossible character had so disheartened her husband, a professional army officer, that some years earlier he had simply left home, never to be heard from again. His absence was regrettable in more than one respect, for Arthur probably could have shared his literary enthusiasms with him. For, judging from the elegance of his military reports, Rimbaud senior was also a gifted writer.

At school, although the young Rimbaud complained about having to learn classical languages, Latin verse flowed effortlessly from his pen. In 1868, in secret, he sent a long poem to the Prince Imperial on the occasion of his first communion. The prince's tutor responded by thanking the young author, whom he excused for his poor verse. This did not discourage the poet, however, who had the pleasure of seeing one of his Latin compositions published in the *Gazette of Secondary Education,* where we read the following line, placed in the mouth of Phoebus addressing the narrator: "*Tu vates eris!*" ("You will be a poet!").

Above:
Anonymous watercolor of the Place Ducale in Charleville, a replica of the Place des Vosges in Paris. Charleville, Archives Départementales

Top left:
Photograph of Rimbaud as a boy. Paris, Bibliothèque Nationale de France

Right:
Anonymous watercolor of Rimbaud's birthplace in Charleville. Charleville, Archives Départementales

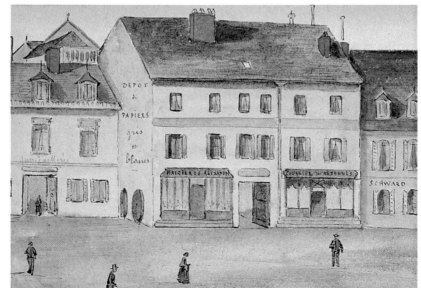

Opposite and following pages:
Pages from one of Rimbaud's school notebooks. Bibliothèque de Charleville–Mézières

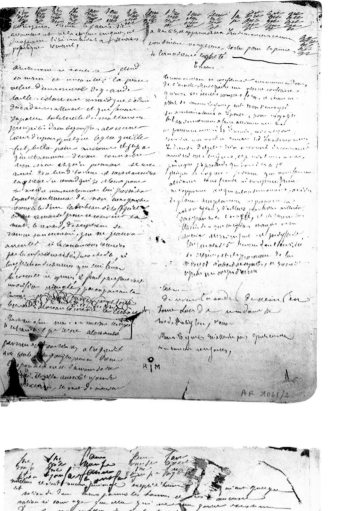

The Mysteries of the Orient

JULIEN VIAUD, KNOWN AS PIERRE LOTI
(1850–1923)

Louis-Marie-Julien Viaud was born on January 14, 1850, in the "small sad town" of Rochefort, a seaport on the west coast of France. He was the third child of Jean-Théodore Viaud, secretary-in-chief to the mayor, and his wife, Nadine Texier.

As a youngster, Julien lived in a secret world consisting of various childhood collections (dried flowers, butterflies, beetles, bird nests, fossils, shells), a favorite place (a small pool in the garden of the family house), and carefully preserved memories. "With a puerile and disconsolate obstinacy, I was married since early youth to the notion of fixing everything that passed, and this vain quotidian struggle must have worn down much of vitality."

Initially, his education consisted of private music lessons and family tutoring, but in October 1862 he began to attend the town's secondary school as a day student. He was unhappy with this development, for it brought to an end an existence in which he had been mothered, protected, and spoiled by a family circle consisting almost exclusively of elderly women. "Too closely managed, too pampered, somewhat overheated intellectually, I was as delicate and enervated as a hothouse plant. I should have spent time with boys my own age: madcap, boisterous little brutes. Instead, I sometimes played with little girls: always decorous and prettily got up, with curled hair and faces like little eighteenth-century marquises."

Julien hated having to attend school. "My first impression was one of astonishment and distaste at the ugliness of the walls scribbled with ink, at the old wooden benches that had been smoothed, worn, slashed by penknives, that spoke of the suffering of so many students. Without knowing me, my new companions addressed me in the familiar *tu* form, with a patronizing, even cunning air. For my part, I timidly stared them down, finding them impudent and, for the most part, slovenly." Before long, the boy who would one day become the novelist Pierre Loti was filling his school notebooks, as he later would his private diaries, with drawings of Egyptian inspiration: sphinxes, "hieroglyphics," cabalistic symbols, and mysterious signs, elements in a code that only he could decipher.

Pages from one of Julien Viaud's school notebooks with pseudo-Egyptian drawings and "hieroglyphics." Collection Édouard and Christian Bernadac

A Letter to Lavisse

EUGÈNE-LOUIS-NAPOLÉON BONAPARTE, KNOWN AS THE PRINCE IMPERIAL

(1856–1879)

The Prince Imperial, son of Napoleon III and Empress Eugénie, was christened Eugène-Louis-Napoléon-Jean-Joseph, names all chosen in honor of illustrious ancestors. His birth on March 16, 1856, eagerly awaited as a guarantee of dynastic continuity, occasioned wild expressions of joy. It was followed by a happy childhood near his family at the Tuileries Palace in Paris and at the châteaux of Compiègne and Fontainebleau. The young Napoleon was adored by his father, who indulged his every whim, even allowing him to enter the imperial office during official meetings. For her part, the empress was determined to see that the prince received a good education.

Although he was pampered and spoiled by everyone, the young prince was nevertheless generous, affectionate, animated, and open to others, qualities that he retained as he grew and that were appreciated not only by his family but by the people of Paris, who cheered him at every public appearance.

His early education was entrusted to an English governess, Miss Shaw. She was succeeded by a rather incompetent tutor named Monnier, whose ill-conceived lessons and lax discipline momentarily compromised the young prince's progress. On the advice of his mother, he was never allowed to cultivate his gifts for drawing and music.

His passion for arms and things military revealed itself early, and the martial demeanor of General Frossard, his tutor from 1866, only reinforced this predilection. In 1870, wearing his second lieutenant's uniform, he eagerly accompanied the emperor into the theater of operations of the newly begun Franco-Prussian War. After defeat obliged the imperial family to seek exile in England, he was admitted to the Royal Academy at Woolwich. It was at this time that the Prince Imperial began to study history with the historian Ernest Lavisse, who had come to visit the exiles.

In 1879, at age twenty-three, he decided, against his mother's wishes, to take part in a South African expedition against the Zulus, who had just massacred the inhabitants of a British colony. There he perished on June 1, 1879, pierced by Zulu spears.

Top left:
Jules-Josèphe Lefebvre,
The Prince Imperial. Château de Compiègne

Right:
Letter to Ernest Lavisse dated August 12, 1871. Paris, Bibliothèque Nationale de France. The young man writes of his "baptism by fire" the preceding year, as well as a letter that Lavisse had sent him at the time. (For complete text, see appendix)

Camden place
Chislehurst

le 22 Mars 1872.

Mon cher Monsieur Lavisse,

J'ai lu avec un

grand plaisir votre lettre, parceque

les sentiments qui y sont exprimés

sont gravés dans mon cœur en lettres

que ni le temps ni les circonstances

ne pourront effacer. Je suis heureux

de voir, et chaque jour qui passe

me le fait constater d'avantage, que

bien des gens en France pensent com-

-me vous, cher Monsieur Lavisse, et

que quoiqu'on en dise le sentiment

du devoir, l'amour de la patrie ne

sont point si rares parmi nous;

Je finis en demandant au ciel

Mr Lavisse 5 rue de Médicis

Letter to Ernest Lavisse dated March 22, 1872 (see appendix). Paris, Bibliothèque Nationale de France (For complete text, see appendix)

A Young Aristocrat

MARIE BASHKIRTSEFF
(1860–1884)

At a time when aristocracy was synonymous with cosmopolitanism, Marie Bashkirtseff, from earliest youth, traveled throughout Europe with her mother. Due to her mastery of five languages, her gift for music and art, her lively, brilliant mind, and her attractive features, she was much remarked and sought after by the intelligentsia of the day. "Never was a life lived with more fire, with a greater thirst for living. She had the great gift of experience, this vigorous and delicate sensibility enclosed in a seductive exterior in which child and artist were confounded," wrote the Austrian poet and playwright Hugo von Hofmannsthal, a great admirer of Marie's diary, begun in 1873 and published in French one year after her death.

"My diary begins when I was twelve and doesn't amount to much until I was fifteen or sixteen," acknowledged the precocious girl, who confided to its pages her first and secret loves for the Duke of Hamilton and the Count of Larderel, her observations about painting, and her impressions of the people she had met. Among these were many celebrated political and artistic figures of the day, including Émile Zola, the Goncourt brothers, Guy de Maupassant—with whom she corresponded—and the painter Étienne Bastien-Lepage, with whom she studied. What did Marie want? A great love, of course, something that was undone more than once by her dizzying narcissism. What Marie desired above all else was glory—and at any price, coveting it with the ardor of a doomed woman.

Beginning in 1874, she felt the early symptoms of consumption: pain, migraine headaches, and the gradual loss of her voice and her hearing. She was only twenty-four when the illness finally claimed her.

Simultaneously guileless and lucid, her diary not only provides rare access to the interior life of a cultivated young Russian woman; it also offers a refined account of a fascinating period that Marie traversed like a brilliant comet.

Entry from the diary of Marie Bashkirtseff. Paris, Bibliothèque Nationale de France

Sunday February 16, 1873. To church (blue dress). To lunch. Madame Savelieff also brought us her nephew Monsieur Savelieff, who is here with his wife for a week. Then music, a large crowd. Borrech passed by . . . while we were listening to the music but not in front of us he went by too quickly and greeted mama. I turned very red and asked: "Why does he greet you, mama?" . . .

He greeted her, and that means he doesn't want to avoid me; he needn't have done this since he has not even been introduced. Or perhaps he gave the greeting to see what kind of face I would make. He passed by us slowly several times, he was truly very handsome today! He pleased me very much but I mustn't show it.

How I would like him to be introduced to us. If one day he [were to say] that I love him [sic], I would tell him that I don't love him but that I see a resemblance between him and my dog. I said that several times at home and was teased, which is why I blushed on seeing him. I imagine he was startled and then perhaps he'd like to make me love him, and he'd love me. I think the duke is at G[illegible]'s house because she didn't come out.

Early Works

HENRI DE TOULOUSE-LAUTREC
(1864–1901)

Henri de Toulouse-Lautrec, *Self-Portrait,* 1880. Albi, Musée Toulouse-Lautrec

"When my sons kill a woodcock, they finish it off three times: with a bullet, a crayon, and a fork," the paternal grandfather of Henri de Toulouse-Lautrec liked to say. In this family of bon vivants, the little boy pulled his weight. His passion for riding would be frustrated by illness (he suffered from a congenital condition that stunted his arms and legs), but he did not neglect the pleasures of the flesh, and it became clear early on that he was a peerless draftsman.

Initially raised in Albi, in southern France, the child arrived in Paris with his mother in 1872, when he was eight. As he wrote his grandmother at the time, "I long to return to Bosc [the family château] over vacation, although I'm not bored in Paris. We're on vacation right now, and I'm trying to take advantage of it; unfortunately I have pimples that I spend lots of time scratching." At the Lycée Fontanes (the future Lycée Condorcet), where he was enrolled, Henri was an excellent student, easily winning first prizes in English, a language he spoke frequently with his mother. He also filled the margins of his notebooks with drawings of great vivacity and narrative immediacy that anticipate the verve of his later caricatures and illustrations. At age ten he was obliged to leave school for reasons of health and return to the château of Bosc, where he continued his studies with a tutor. Thereafter he filled his sketchbooks with thousands of drawings in pastel, watercolor, red chalk, and ink. An entire bestiary invaded the pages of this solitary student, who dashed off extravagant illuminated letters, friezes, and burlesque figures. In 1878, a fracture of his left leg obliged him to undergo a painful regime of physical therapy; scarcely had he recovered from this when, the next year, he broke his right femur. When he was sixteen, he painted his only known self-portrait in oils: a picture of an elusive, almost furtive figure, whose gaze is obscured by shadow.

Below and opposite: Pages from one of Toulouse-Lautrec's notebooks from his stint at the Lycée Fontanes, 1873–74. Albi, Musée Toulouse-Lautrec

Te loquor absentem; te vox mea nominat unam:
Nullaque sine te nox mihi, nulla dies.
Quin etiam sic me dicunt aliena locutum,
Ut foret amenti nomen in ore tuum.

c'est tout

Vide &c.

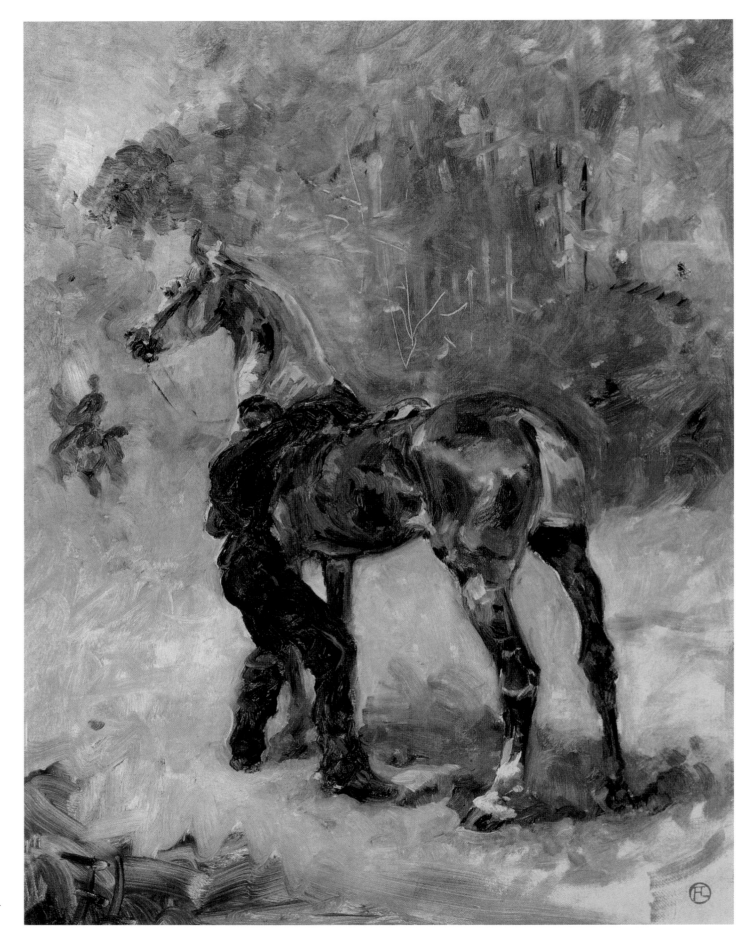

Henri de Toulouse-Lautrec, *Artilleryman Saddling His Mount*. Albi, Musée Toulouse-Lautrec

Henri de Toulouse-Lautrec,
*Two Horses with an Aide-
de-Camp.* Albi, Musée
Toulouse-Lautrec

Stylistic Exercises

GEORGES SEURAT
(1859–1891)

Georges Seurat had a rather easy childhood in a prosperous household on boulevard Magenta, one of the great thoroughfares that Baron Haussmann cut through old Paris. Seurat's father, a former bailiff, lived on the income from his real estate. His mother, attentive to the youngster's desires, did not stand in the way of his plan to become an artist; her brother-in-law, the celebrated master glazier Léon Appert, even encouraged him. Thus it seemed only natural when, in 1875, he began to take classes at the municipal sculpture and drawing school.

The boy's earliest surviving drawings after antique sculpture date from this period of apprenticeship. An example is the illustrated figure of the Illissos River from the Parthenon, made when he was sixteen. Little by little, he mastered modeling, light, and shadow; two years later he produced this admirable male nude seen from the back, before competing for entry into the École des Beaux-Arts. His master there was Henri Lehmann, who had studied with Ingres and who dismissed the Impressionists as "neurotics." Seurat paid no heed, merely trying to learn whatever he could of value. His work was judged mediocre, and he was ranked seventy-seventh out of eighty students.

After a year, Seurat left school to work independently with his colleagues Aman-Jean and Ernest Laurent, with whom he rented an atelier. The three artists painted together in the open air and discussed Delacroix, a master whose painting Seurat greatly admired. Indeed, it was color—considered from a scientific point of view—that most fascinated him. He was a passionate reader of Charles Blanc and Michel-Eugène Chevreul, authors, respectively, of treatises on esthetics and optics that would greatly influence his mature divisionist style.

Above:
Seurat's palette. Paris, Musée d'Orsay. One wonders if Seurat followed the advice of Delacroix, who wrote: "Green and violet: it is essential that they be applied one after the other, and not be mixed on the palette."

Opposite:
Georges Seurat, *Male Nude Viewed from the Back*, October 1877. Paris, Musée du Louvre

Right:
Georges Seurat, *The Illissos River, from the Parthenon*, 1875. Paris, Musée du Louvre. Drawing after antique sculpture was considered an essential part of artistic training in the nineteenth century.

27 Octobre 1877

137

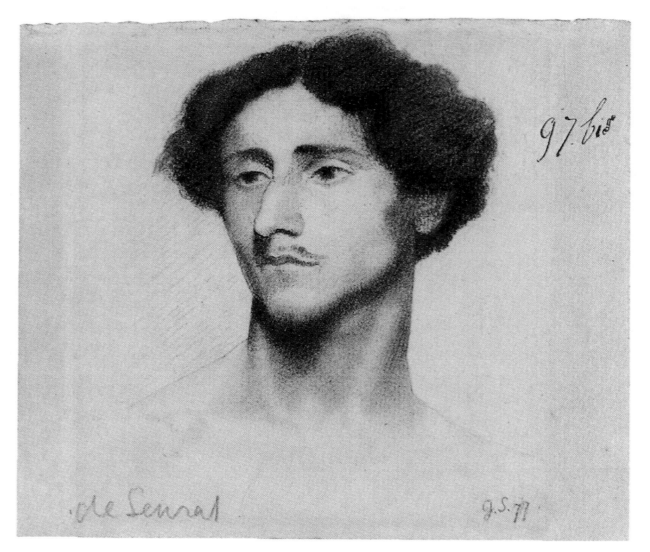

Above:
Georges Seurat,
Head of a Man, 1877

Left:
Georges Seurat, *The Hand of
Poussin, after Ingres*, 1875–77. A
portion of the partially illegible
inscription in Seurat's hand
reads: *"voilà le génie"* ("now
that is genius").

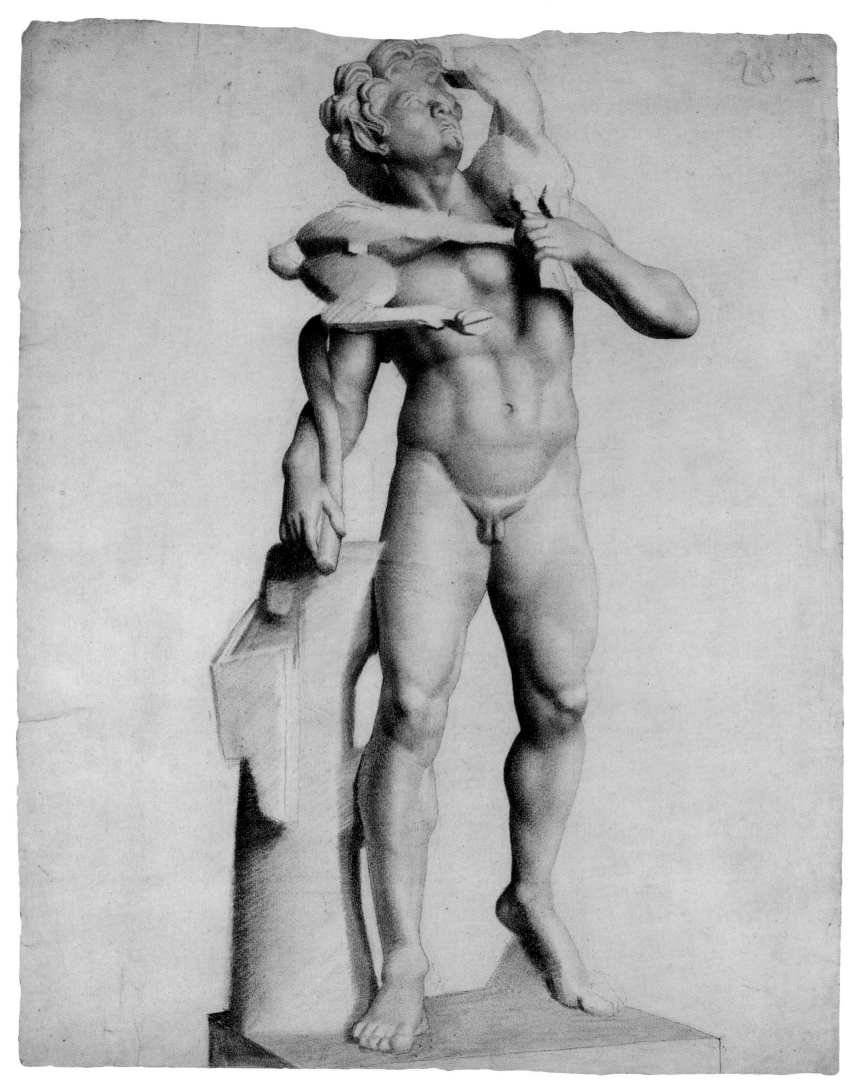

A Prodigy in Sculpture

CAMILLE CLAUDEL

(1864–1943)

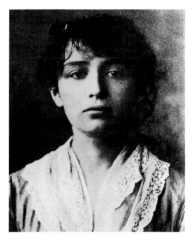

Camille Claudel was born on December 8, 1864, in a town not far from Reims, located in a "rough and austere" region where, "when it rains, it does so fiercely, violently," where "the terrible wind . . . makes the weathercock on the bell tower ceaselessly creak and turn," a country that her brother Paul, four years her junior, compared to that of *Wuthering Heights.*

The daughter of Louis Prosper Claudel, a civil servant, and Louise Athénaïse Cerveaux, a doctor's daughter from Champagne, Camille led a cloistered life as a child. The atmosphere in her household was somewhat tense, as the family lived an isolated, inward-turning life, and quarreled constantly over religious questions. At the age of twelve, without having had any formal training in modeling, drawing, or anatomy, Camille began to sculpt in clay, plaster, and stone. She had a mercurial ten simultaneously proud and self-effacing, t violent, and above all, fiercely independ age thirteen, she modeled a remarkable *l and Goliath* (lost), which so impressed family that they sought artistic training her. Her mastery of her medium at this age so astonishing that Paul Dubois, directo the École des Beaux-Arts, asked her if s had not "taken lessons from Monsie Rodin."

She was not to meet Rodin until si years later. Shortly after that, she became at age nineteen, both the student and the lover of the great sculptor, who was twenty-five years her senior. Born at a time when women were not admitted to the École des Beaux-Arts and female artists were rarely taken seriously, Claudel was a phenomenon. Even today it is seldom acknowledged that she was one of the greatest women sculptors of the nineteenth century.

The latter years of Claudel's life and career were tragic. She broke with Rodin in 1898, ending what had been a long and stormy relationship. Beginning in 1900 she gradually sank into poverty and suffered increasingly from emotional breakdowns. Committed to a psychiatric hospital on March 10, 1913, she spent the next thirty years—until her death—in such institutions, where it is far from clear she belonged. Although it is not known where she is buried, she left behind, as a fitting memorial to her life, a body of work of great beauty and formal power.

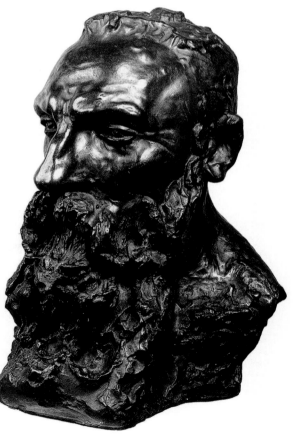

Top left:
Anonymous photograph of Camille Claudel, 1878

Top right:
César, photograph of Camille Claudel taken in 1913, after she had been committed to a psychiatric hospital

Left:
Camille Claudel, *Auguste Rodin,* 1892. Paris, Musée Rodin

Opposite:
Camille Claudel, *Paul Claudel as a Young Roman,* 1881–82, bronze. Camille's brother was thirteen when she made this bust. Musée de Chateauroux

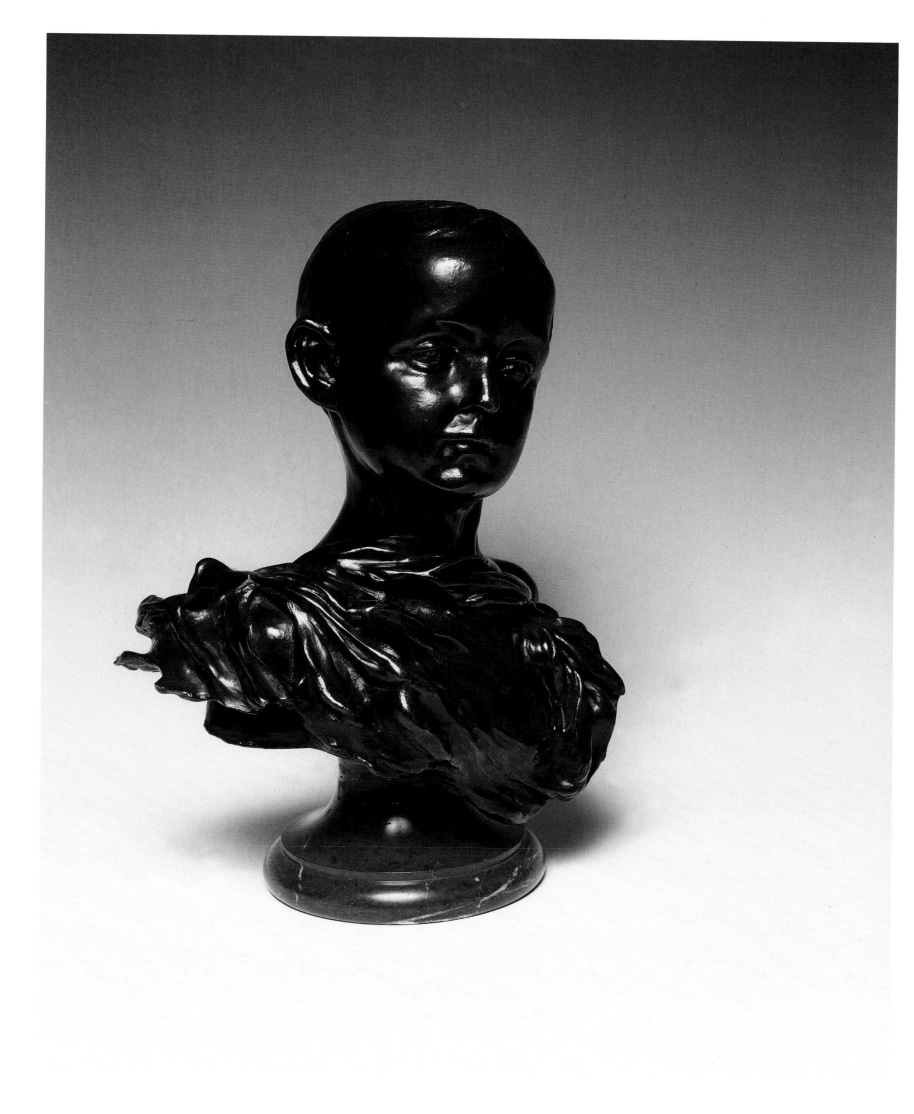

Marie's Rebellion

SUZANNE VALADON
(1867–1938)

The daughter of a laundress and an unknown father, Marie Valadon spent her childhood in Montmartre, where her mother worked as a housekeeper. After rudimentary schooling in a religious school, the rebellious girl experimented with several ways of earning a living, including working in a dressmaker's shop, in a florist's shop, in an open-air market, and in a circus.

As a dazzlingly beautiful fifteen-year-old, she obtained work as a painter's model under the exotic name of Maria. Apparently, few artists could resist her charms. Puvis de Chavannes was her senior by forty years when he made her his mistress, Renoir by twenty-four years. Henri de Toulouse-Lautrec, her contemporary and quite smitten with her, suggested the name she would use as an artist: Suzanne, a playful evocation of the Old Testament story of Susanna and the elders.

Since infancy, Valadon had drawn with the same intensity that characterized the rest of her life. Thanks to the many hours she spent in the studios of some of the period's best artists, she was able to develop an acute eye and to learn the techniques of painting. By 1883, when she was fifteen, she was sufficiently accomplished to produce this compelling self-portrait in pastel, her earliest known work. The same year she gave birth to a boy, of unknown paternity, whom she named Maurice. He is better known to us by the name with which he signed his canvases: Utrillo.

In response to a questionnaire sent to her many years later by the art historian Germain Bazin, Suzanne Valadon dated the beginning of her career to 1883 and wrote under the heading "Education": "Free—innate talent, exceptionally gifted." And under the heading "Benchmarks of artistic life": "Drew from 1883, the beginning, like a woman possessed, not to make beautiful drawings for framing, but good drawings that capture an instant of life, in movement, in all its intensity. I drew madly so that, when I could no longer see, it would still be at the tips of my fingers."

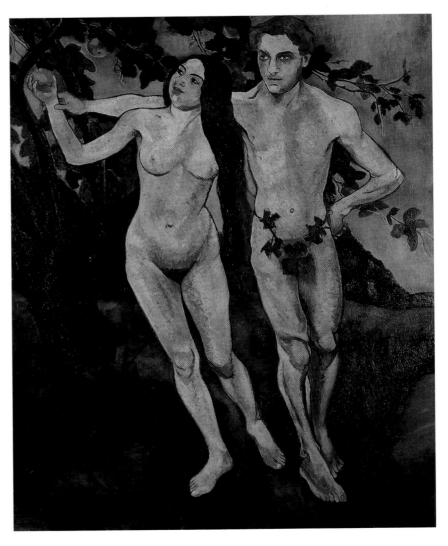

Above:
Suzanne Valadon, *Adam and Eve*, 1908. Paris, Musée National d'Art Moderne Centre Georges Pompidou

Opposite:
Suzanne Valadon, *Self-Portrait*, 1883, pastel. Paris, Musée National d'Art Moderne. The artist was fifteen years old at the time.

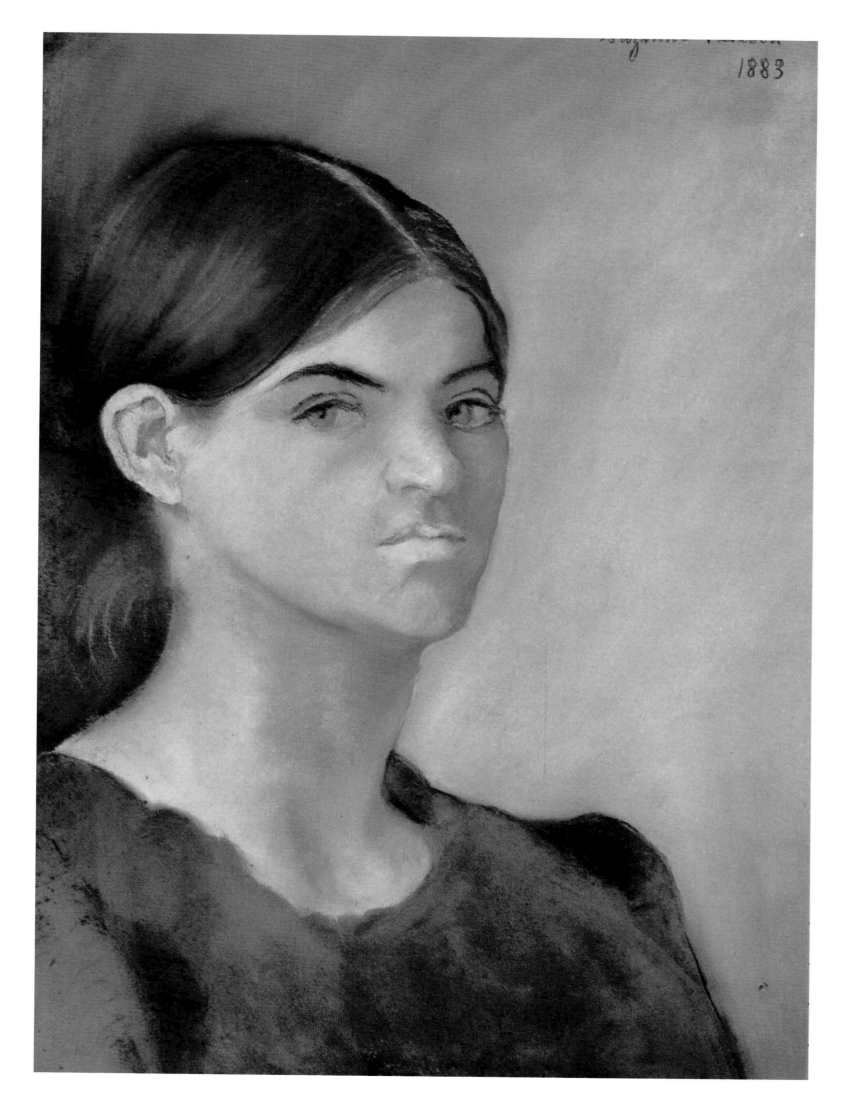

143

Proust's School Compositions

MARCEL PROUST

(1871–1922)

Reading the school compositions of the twelve- and thirteen-year-old Marcel Proust, one would think that their young author must have romped to the head of his class at the Lycée Condorcet in Paris. Some of his teachers did indeed sense that the boy had special gifts, but he was not an academic star. This was in large part because he was often absent due to asthma, from which he suffered from the age of nine, and which forced him to repeat a year of school. There was no known cure for asthma at the time, as the boy's father, a doctor, knew only too well; ultimately, the disease was the cause of Proust's premature death.

Since early youth Proust was enthralled with reading. This is evident from his school compositions, which are rich in allusions to literature from the ancients to Alfred de Vigny and the seventeenth-century playwright Corneille. Whether treating a subject inspired by antiquity ("The Dying Gladiator") or trying his hand at naturalist fiction (in a piece in which a hawthorn blossom, a flower conspicuous in *Remembrance of Things Past,* is an important feature), he explored several themes that figure prominently in his mature work: emergent consciousness, the complexity of psychological situations, and the role of the narrator. Even his working method—which involved a number of rough drafts before he completed his final text—was already in place. This approach was so successful even at this early stage that these documents shed considerable light on a body of work whose elaborate patterns even today have yet to be fully analyzed.

Left:
Jean Béraud, *Leaving the Lycée Condorcet.* Paris, Musée Carnavalet. Proust attended this school in Paris.

Right, opposite, and following pages:
Little-known composition assignments written by the young Marcel Proust during his secondary schooling
(For complete text, see appendix)

Marcel Proust Devoir de français

L'air est embaumé des senteurs qu'exhale un frais
lilas. Le soleil se lève gaiement. Il dore la cam-
pagne de ses rayons: enfin c'est un radieux matin
de Mai qui nous occupe. Là bas
lée sous l'aubépine est une vieille chaumière
se enfumée que Denis Revolle a acheté lors
de son mariage. C'est le témoin de douces
soirées passées au foyer. Ce grand brun à veste
blanche et à casquette bleue qui sort du
tournant du petit édifice c'est ce même
Denis Revolle qui il y a se trouvait
à St André, pourquoi c'est ce qu'il est inutile
de dire. On dirait qu'il hésite de sortir
il hésite, se tourne penche vers la maison, mais
vers la ville, enfin il rentre dans sa modes-
te demeure. Au bout de 5 minutes, peut'être
10, car l'impatience que j'avais de connaître
sa dernière résolution m'avait fait trou-
ver le temps long, il ressort suivi d'une jeu-
ne femme assez jolie blonde avec des yeux
bleus. ce qui va sans dire, enveloppée
dans un cachemire cachemire duquel l'on
l'on aurait pu dire: Et les trous sur le drap
marquaient tous ces exploits, n'en dépl[ai]

Les Nuages

Dans tous les temps, dans tous les pays où le ciel n'est pas toujours limpide et bleu, les nuages ont dû séduire l'imagination de l'homme par leurs formes changeantes et souvent fantastiques. Toujours l'homme a dû y deviner les êtres imaginaires ou réels qui occupaient son esprit. Chacun peut y trouver ce qui lui plaît; le contour de ces vapeurs est si léger, si indécis..... une brise les transforme, un souffle les détruit. Le soir quand le soleil vient de disparaître à l'horizon, que ses reflets pourprés colorent encore le ciel, les nuages découpés en formes bizarres sont amoncelés au couchant; l'homme religieusement ému par le calme majestueux et solennel de cette heure poétique, aime à contempler le ciel; il peut découvrir alors dans les nuées, des géants et des tours et toutes les fantaisies brillantes de son imagination exaltée. Les belles couleurs de pourpre et d'or donneront à son rêve un éclat magnifique et grandiose plutôt que charmant et gracieux; et pourtant dans les vapeurs légères et roses qui voltigent çà et là dans le ciel, on peut saisir les contours poétiques d'un chœur dansant de jeunes filles. Puis, se laissant aller presque involontairement à une rêverie qui l'absorbe, l'homme oublie peu à peu les objets qui l'entourent, ne voyant plus rien, n'entendant plus rien près de

Composition française

Depuis trois jours Corinthe est la proie des flammes les murs de
cette belle cité sont tombés sous les coups redoublés des béliers romains
et les œuvres d'art qu'elle contenait sont le butin de soldats igno-
rants et barbares, du consul Mummius et de ses légionnaires. Les habi-
-tants ont été massacrés presque tous, les femmes emmenées en escla-
vage et de cette population si civilisée il ne reste plus que des en-
fants. Le farouche Mummius a décidé leur sort. Les enfants nobles
périront; c'est un exemple à donner aux cités révoltées,. mais à quoi
bon faire mourir les fils des esclaves. Rome peut tirer des avanta-
ges de sa clémence à leur égard. mais comment les distin-
guer? Mummius s'est souvenu que tout grec libre savait écrire
et il a ordonné qu'on lui amenât les petits Corinthiens pour
leur faire tracer quelques mots lignes,. il les attend sur la place
publique, entouré de quelques lieutenants:
Bientôt tous ces ~~petits~~ enfants arrivèrent, les uns déjà grands, petits encore
les autres déjà grands et qui pouvaient atteindre leur quatorzième année. De-
vant, derrière eux, les maisons enflammées s'écroulaient avec
d'horribles craquements. La sinistre lueur de l'incendie donnait
aux ombres des soldats et des maisons en ruine un aspect de fan-
tômes effrayant. Les rues étaient teintes de sang, jonchées de ca-
davres, le ciel était embrasé. Beaucoup de ces enfants pouvaient
voir le cadavre de leur père gisant mutilé non loin d'eux,
beaucoup pouvaient entendre les gémissements de leur

A Young Diarist

HENRI BARBUSSE

(1873–1935)

Henri Barbusse was a descendant of Protestants from the highlands of central France, who had fought fiercely for the freedom to practice their religion. Perhaps partly stemming from this heritage, he had a combative temperament and was determined to honor his deepest convictions.

Barbusse was born in Asnières, just outside of Paris, on May 17, 1873, the son of Adrien Barbusse, an author and playwright. He performed brilliantly at the Collège Rollin, where his teachers included Stéphane Mallarmé and the philosopher Henri Bergson. His literary proclivities were apparent from early on, and he won first place in French composition in the general lycée competition in 1891. After winning a poetry competition organized by the journal *L'Écho de Paris*, he met the poet Catulle Mendès (whose third daughter Hélyonne he would marry in 1898), who introduced him into Symbolist circles.

Upon completion of his bachelor's degree in 1895, he launched his literary career with *Pleureuses* (Mourners), a collection of poems already marked by

his characteristic empathy for fortune's outcasts, which won an honorable place for him in the literary world. Besides poetry, he also wrote novellas, and published columns almost every day in the journals *Le Matin* and *Fémina*.

The First World War revealed Barbusse's true temperament. Enrolling as a volunteer in 1914, serving first in the infantry and then in the ambulance corps, he won two combat citations before being evacuated for illness and invalided out of service. The sufferings of the combatants deeply affected him, with the result that he decided to stop writing for a "decadent elite," and chose instead to bear witness to what he had seen. In a fictionalized account of the front, *Le Feu: Journal d'une escouade* (Under Fire: Journal of a Squadron), dedicated to the memory of his dead comrades, he described the war in all its horror and monotony, striving to convey something of what soldiers in the trenches had experienced. Although the novel's demythologizing brutality evoked outrage in some quarters, it won the Goncourt Prize in 1917.

Above and opposite:
Pages from a diary kept by the young Henri Barbusse and his sister, 1884.
An excerpt from this diary is transcribed in the appendix.

BAINS DE MER

1884

Samedi 1er

.Nous partons après avoir
eu bien peur de manquer
le train 8 h. 10

Nous avons pour com-
pagnons de voyage un
jeune homme de vingt
ans environ, et d'un mon-
sieur et sa dame (l'un
normand, l'autre au-
vergnate) qui changè-
rent de train à Mantes.
Le jeune homme s'arrê-
ta à Boisset-Pacy, une
station avant Evreux.
Reste 2 heures d'arrêt à
Caen visité un peu la
ville. Lilly, Annie et moi
malades. Arrivé à
destination le soir à
9 heures (Sottevast) L'hô-
tel de M. Renaud, le seul
de l'endroit était fermé
nous couchons comme

Like the Leaves of a Clover

ANNA DE BRANCOVAN
(1876–1933)

Children's letters, however moving, funny, or precocious, tend to be short. Young writers are easily distracted by impatience, obligations imposed by their parents, the prospect of play, and countless discoveries waiting to be made. The first letters of Anna de Brancovan, who would later become famous as the poet Anna de Noailles, are the exception to this rule: they are extremely long, even torrential. This would not surprise friends who knew her in adult life, who often had to endure her astonishing logorrhea. Throughout her life, she seems to have had difficulty distinguishing between conversation and soliloquy.

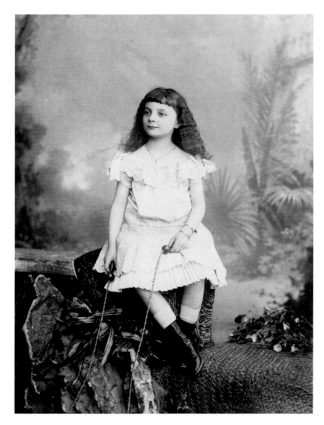

Anna invented fables and fairy tales from the age of five. Her earliest writings date from 1884; as she herself later remarked, "When I was eight I wrote a two-strophe poem inspired by Alfred de Musset that I tried to make correct." Anna received a lot of attention from her parents. Although her father inspired "great love and extreme fear" in her, her mother, who sensed her gifts, envisioned a wonderful future for her. Anna had a brother, Michel-Constantin, born a year earlier than she, and a sister two years her junior, Catherine-Hélène. The family divided its time between a house in Paris and a Romanesque-Byzantine revival chalet overlooking Lake Geneva that had belonged to Count Walewski, the illegitimate son of Napoleon I. For Anna, who spent her vacations there, the chalet was a paradise. Here she learned to love nature, discovered life, received her first lessons, and marveled at the world. This is the principal subject of a letter she sent her brother from Paris on April 28, 1884. She already had a knack for imagery ("The three of us make up a single clover"), but she was prepared to acknowledge that spelling was not her strong point. As she noted, "but you understand that when one writes so fast without a first draft and without help there have to be. And then you are learning more French than I am."

Top left and above:
These two photographs of the young Anna de Brancovan were preserved in the same elegant album as the three-part manuscript letter shown here.

Opposite:
First page of a long letter written on April 28, 1884, by Anna in Paris to her brother, who was away on vacation. (For complete text, see appendix)

Mercredi le 26 Avril 188?

1ᵉ

Mon cher frère.

C'est avec le plus grand plaisir, tu peux t'imaginer que j'aie reçu ta lettre d'hier soir. Je suis heureuse de te savoir heureux, car nous trois nous ne formions qu'un trèfle. Il est vrai qu'une des trois feuilles s'est détachée (de la tige) pour aller bien loin, mais j'espère avec bonheur que le vent ~~~~ la repoussera auprès de nous. J'ai vu avec bonheur que ton papa t'a fait un petit et qu'il en fera un autre. Il t'avait bien soin, pré parer un place où tu monter. Il nouveau née et il déjà grand, tu me disais dans ta lettre que

"To Sister Agnes of Jesus"

THÉRÈSE MARTIN, LATER SAINT THERESA OF THE INFANT JESUS
(1873–1897)

Thérèse at thirteen,
February 1886

It is reported that Thérèse Martin, who would one day be canonized as Saint Theresa of the Infant Jesus, gave signs of her religious calling as early as the age of two. Born in the Norman town of Alençon on January 2, 1873, the daughter of a clockmaker/jeweler and a lacemaker, she lost her mother at age four. As a result, she was cherished by her four older sisters. In Lisieux, where the family moved two months after their mother's death, Thérèse's sister Pauline served as a surrogate mother for five years, after which the girl was bereft a second time when Pauline took her vows as a Carmelite nun under the name Sister Agnes of Jesus. In fact, Thérèse's early experience of religion, apart from her five years as a part-time boarder at a Benedictine school, was painfully colored by loss. While she was still a child, no less than three of her sisters—Pauline, Marie, and Léonie—left home to join religious orders.

According to her account, on Christmas night in 1886, at age thirteen, Thérèse received the gift of divine grace, and with it a feeling of serenity and fulfillment that never left her. From that time her dearest wish was to withdraw from the world. She wrote the letter published here to her sister Pauline (Sister Agnes of Jesus) when she, Thérèse, was fifteen years old, only twenty days before she was to enter the Carmelite order. The letter reveals the controlled impatience of a devout adolescent who thought that she had persuaded her family to allow her to take the veil four months earlier, but whose extreme youth was still causing them some uneasiness regarding her vocation. It was, however, not piety but a desire to save paper that prompted Thérèse to continue her text crosswise on the letter's verso.

Thérèse's life was rich in expectation—for new dispensations of divine grace; for an ever-closer proximity to heaven; and for union with Christ. Unfortunately, she died at the young age of twenty-four in 1897, a victim of tuberculosis.

To Sister Agnes of Jesus
March 18, 1888

My dear little Pauline,

I would have liked to write you immediately to thank you for your letter, but that was impossible; I had to wait until today.

Oh Pauline, it is quite true that every chalice must contain a drop of gall, but I find that trials help us to detach ourselves from earthly things; they make us look higher than this world. Down here, nothing can satisfy us; only by being prepared to do God's will can we find momentary repose.

My little gondola is having difficulty reaching port. Although I've been able to see the shore for some time, I still find myself a certain distance from it. But it is Jesus who guides my little boat, and I am sure that when the right day comes he will see me safely into port. Oh Pauline, when Jesus has delivered me to the blessed Carmelite shore, I will give myself over to him entirely. Oh no, I don't fear his blows, for even in the bitterest suffering I always feel that it is his sweet hand that strikes me. I certainly felt this in Rome at the very moment I might have thought the earth was disappearing beneath my feet.

When I am in the Carmelite convent I will have but one desire: to suffer always for Christ. Life passes by so quickly that it is truly more worthwhile to have a very beautiful crown and a little pain than to have an ordinary life without pain. And then, for a suffering borne with joy, when I think that for all eternity one will love Dear God better! And by suffering one can save souls. Ah! Pauline, if at the instant of my death I could have a soul to offer up to Jesus, how happy I'd be! It would be a soul wrenched from the fires of Hell and that would bless God for all eternity.

My beloved little sister, I see that I still haven't said anything about your letter, which gave me so much pleasure. Oh Pauline, I am so happy that the Good Lord gave me a sister like you; I hope that you'll pray for your poor little girl, that she might answer to the graces that Jesus wants to bestow on her; she is in great need of your help for she is VERY FAR from what she'd *like* to be.

Tell my dear Godmother that I think of her quite often; we would very much like to know when she will make her final profession.

Céline sends you a big hug. This poor little sister has a sore foot; I think she won't be able to go to vespers. Almost everybody is sick at my uncle's; life really isn't easy, it's hard to become attached to it.

Farewell my beloved Pauline, my confidante. Until Easter Monday but above all until April 9. Embrace my Beloved Mother for me.

A letter from Thérèse Martin to her sister Pauline, who preceded her into the Carmelite order

A Prodigy of the Franck Group

GUILLAUME LEKEU

(1870–1894)

When we contemplate the untimely death of a gifted person, we can hardly help asking ourselves what he or she might have created if death had not come so soon. Such questions certainly come to mind when we consider the rich and expressive music of Guillaume Lekeu, who died of typhoid fever at twenty-four.

An extremely personable young man, Lekeu was educated in Poitiers and Paris before studying with a composer who cleared a new path for French music: César Franck. Together with Ernest Chausson, Henri Duparc, and Vincent d'Indy, among others, Lekeu belonged to the "Franck group." He was certainly its youngest, and perhaps also its most gifted, member.

Talented and precocious, influenced by his teacher, Lekeu began to write for violin and piano, producing at age fifteen an *Andante and Variations* and a *Sonata in D Minor* for these instruments that attest to his promise as a composer. Two years later came a *Tempo di Mazurka*, which was followed the next year by a sublime *Sonata for Violin and Piano*. Between the ages of twenty and twenty-four—during the last three years of his life—he produced his most accomplished work, a sublime *Sonata for Violin and Piano*, a tribute to Franck commissioned by the great violinist Eugène Ysaÿe. Written when Lekeu was twenty-two, this piece, together with his *Ophelia, or Symphonic Fantasy on Two Popular Songs from the Anjou Region*, amply demonstrates the imaginative vitality and melodic invention of which this young composer was capable.

Although Lekeu's work is not well known today, the thirty scores—some of them incomplete—that he bequeathed to us cannot fail to leave us with an irreparable sense of loss.

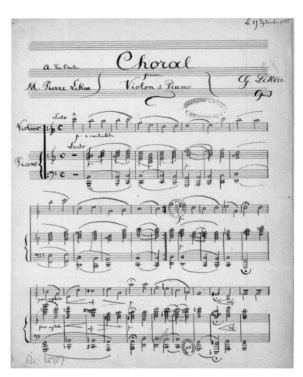

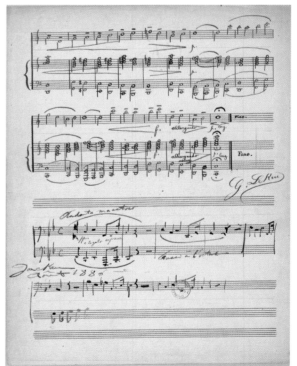

Top left:
Guillaume Lekeu as an Adolescent. Verviers, Conservatory of Music

Above:
Chorale for Violin and Piano, a handwritten score with a dedication to the composer's uncle, Pierre Lekeu. Paris, Biblothèque Nationale de France

Opposite:
Sonata for Violin and Piano in D Minor, first page of a handwritten score with dedication to Marcel Guimbaud and the following inscription: "Pain overwhelms me / Misfortune seems to stalk my steps / And life has become a torment for me / Which is why I summon death, / why I want to plunge anew / into the abyss whence I came." Paris, Bibliothèque Nationale de France

Comic Sketches

PIERRE LOUIS, KNOWN AS PIERRE LOUŸS

(1870–1925)

On both his father's and his mother's side, Pierre Louis—who later changed the spelling of his name to the more sophisticated "Louÿs"—was descended from a family of lawyers. He was also the great-great-nephew of Andoche Junot, an impetuous general in the army of Napoleon nicknamed "Junot the Tempest," who died insane. But the center of the family knot lay elsewhere: it appears that Pierre may have actually been the child of the man who passed as his elder half-brother Georges, the son of their putative father's first marriage. Although there is no unequivocal proof that this was so, there is considerable circumstantial evidence to support the theory. When Pierre was nine years old, his mother died of intestinal tuberculosis. At that time it was Georges, rather than the child's supposed father—who was then sixty-seven years old—who assumed responsibility for the boy's care and education. Pierre's warm affection for his elder "half-brother" and his tense relations with the man thought by the world to be his father lend credence to this theory, the truth of which will probably never be known for certain.

Pierre was educated in some of the finest schools in Paris, where he made excellent marks. In 1882, at age twelve, he began to keep a diary. On its first pages we read of his enthusiasm for the work of Victor Hugo, which never flagged: "Today Georges let me read *Hernani*. God it's beautiful! . . . I love this play." Poetry, novels, indeed everything literary interested him. At school, one particular student always dreaded the moment when the French teacher returned assignments, for he invariably took second place to Pierre's first. One day, to Pierre's professed indifference, first place was awarded to the other boy, who himself would later become famous for his writing, André Gide.

Some of Pierre's compositions for school already hint at his gifts, despite the severe judgments of his teachers. One remarked, for example, that an essay showed "Still too much enthusiasm, but there is feeling and a degree of observation." As the boy grew older the level of his scholastic performance tended to decline. The notebooks from his final year of secondary school are dense with humorous drawings, songs, and raillery of all kinds, which suggests that his self-discipline was giving way to reverie. But Pierre, who had just acquired Hugo's *Légende des siècles* (The Legend of the Centuries), had no doubts about his future. As he wrote later of Hugo's book, "My 'ferocious need' to write—and my vocation—began there."

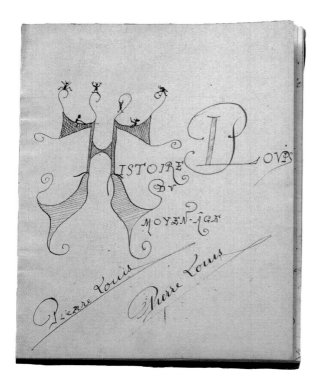

Above, opposite, and following pages:
Pages from notebooks dating from Pierre Louÿs's secondary schooling. Filled with drawings and playful cartoons, they suggest the degree to which he allowed his imagination free rein. Collection Édouard and Christian Bernadac

Papa Grévy.

1. Papa et maman Grévy pioncent consciencieusement.

2. Papa Grévy ayant bien fait dodo se lève tout seul et sans chandelle à 10h 1/2.

3. Papa Grévy fait sa prière

4. Papa Grévy voyant sur le calendrier que c'est aujourd'hui le [2] jour du mois, voit qu'il faut se laver les pieds

5. Papa Grévy prend un bain de pieds

6. Papa Grévy profitant du sommeil de sa dame boit la goutte

7. Papa Grévy constatant un commencement de constipation contemple avec terreur l'instrument.

10. Cryoscope de papa Grévy nouvelle invention brevetée S.G.D.G. à musique jouant la Marseillaise ou "Partons pour la Syrie" selon les opinions politiques du patient.

11. Papa Grévy ayant lu dans St Simon que Louis XIV donnait audience sur la chaise percée, veut imiter le grand monarque et donne audience à l'ambassadeur de Russie pendant l'opération (la bienséance bien comme du dessinateur l'a seul empêché de reproduire cette scène)

Maman Grévy voulant imiter aussi la reine des [?] introduit l'usage du bain annuel. Le 1er janvier elle lave et asperge le corps diplomatique avec l'eau sainte qui a lavé son corps auguste et respecté.

15. Papa Grévy se fâche tout rouge contre Mr son gendre qui a cru devoir lui faire observer qu'il y a quelque différence à voir dans son bain une présidente gaga de soixante dix ans ou une petite reine de 22.

16. Papa Grévy toujours en [?]

17. Dans le foyer, le petit Wilson rentre sous terre

K. Papa Grévy fait sa [conjointe?] avec la petite fille

Papa Grévy fatigué de ses occupations si peu [?] charme des loisirs dans la saine lecture des Attrapeurs de l'Arkansas

19. Le soir, grande réception à l'Elysée. Maman Grévy permet à son époux d'y assister et de rester jusqu'à 8h 1/2 à la condition de ne pas être trop aimable avec les belles dames et de ne pas mettre ses doigts dans son nez.

18. Papa Grévy ayant été bien sage, son épouse lui permet par exception de prendre du dessert et il va surveiller lui-même à la cuisine la confection des confitures

M. Grévy étant resté au bal jusqu'à 9h mais un grand [?] le [?].

Papa et maman Grévy repioncent consciencieusement.

FIN.

Drawings of Children

PABLO PICASSO

(1881–1973)

Picasso's reputation as a great twentieth-century artist is so overwhelming that we tend to forget his youthful work in Spain. The son of Don José Ruiz Blasco, an art teacher who specialized in paintings of doves, young Pablo learned early on how to handle the crayon and the brush. At age ten he began to take drawing lessons from his father at a school in La Coruña, on the Atlantic coast. The class was dedicated to drawings of ornament, plasters of ancient statues, and the live model. His father also introduced him to oil painting.

In 1895, when Pablo was sixteen, the family moved to Barcelona, where he enrolled in the Academy of Fine Arts. He now began to produce a prodigious number of portraits, drawing and painting without cease, thinking all the while of the great masters whose work he had admired in the Prado, especially El Greco, Velázquez, Ribera, and Goya. Their influence is visible, for example, in *Barefoot Girl*, which hints at both the beggars of his Blue Period and the statuesque women of his later, neoclassical work. Picasso's favorite model during these years, apart from his father, whom he represented in myriad ways, was his sister Lola. His tenderness for her is readily apparent in *Going to School*, where she is shown accompanying their younger sister Concepción, who died shortly after the drawing was made. It was in Lola that Picasso first became aware of the grace of the female body, of the female body, a central theme in his later work.

Above:

Pablo Picasso, *Head of Conchita Maria de la Concepción Ruiz Picasso,* 1894. Barcelona, Picasso Museum

Top left:

Pablo Picasso, *The Young Painter,* made at Mougins on April 14, 1972. Paris, Musée Picasso. Picasso once remarked that "I never knew how to paint like a child." He produced this disarmingly fresh image a year before his death.

Opposite:

Pablo Picasso, *Barefoot Girl,* 1895, an oil painting dating from the artist's fourteenth year. Paris, Musée Picasso

Pablo Picasso, *Going to School: Lola and Concepción, the Artist's Sisters*, 1895. Barcelona, Picasso Museum. Concepción, Picasso's younger sister, died shortly after this drawing was made.

First Poems

WILHELM DE KOSTROWITZKY, KNOWN AS GUILLAUME APOLLINAIRE
(1880–1918)

Fleeing his native Poland to escape Russian oppression, Apollinaire Kostrowitzky arrived in Italy, his wife's native land, in the 1860s. He wanted Angelica, his only child, to obtain an education worthy of a young woman of good family, which was available at the convent of the French nuns affiliated with the Church of the Sacred Heart in Rome. Despite her given name, however, the girl was anything but angelic, and at age sixteen she was expelled. She began to frequent Roman salons, where she met an Italian twenty-three years her senior, Francesco Flugi di Aspermonte, with whom she eloped. In 1880 their union produced a male child, initially declared to be of unknown parentage. Some weeks later, on the occasion of his baptism, Angelica acknowledged Wilhelm de Kostrowitzky as her son; apparently, a fairy passing over his cradle had added the particle "de" to imply noble connections.

The boy divided his first years between Rome and Bologna, in the company of his mother and Albert, a brother two years younger than he. Italian, then, was the first language of one of the greatest of French poets. Soon, however, the young mother moved with her two sons to Monaco, where between her many travels she spent much time in the casino. Wilhelm, an excellent student at boarding school, was deeply religious, even becoming the secretary of a religious society, the Congregation of the Immaculate Conception. In 1895, when he was fifteen, he placed first in his class in French composition, literature, Latin composition, Greek, and drawing and was given commendations in mathematics, history, geography, German, recitation, and piano. This same year saw the emergence of his passion for literature; he wrote his first poems, including *Pan est mort* (Pan Is Dead), a fitting subject for a boy of mystic inclinations who at night sometimes prayed in the school chapel. During the day he drew copiously, combining his gifts for drawing and writing in illustrated poems. In these early works, drawings and verses are woven together in ways that anticipate his later "calligrams"—poems that used words to draw lines and form images.

Poem by the young Apollinaire. Paris, Bibliothèque Nationale de France

PAN IS DEAD
To Ch. Tamburini

Flora and warm Phoebus returned to earth,
Roaring waves still broke on Cythera,
And blonde Venus, adored in that place,
Listened in her temple to pious hymns.

Olympus was full; the master of thunder
Summoned all his children, who approached their
 father:
Something strange was happening in the heavens,
The powerful immortals had grown old.

. . . But suddenly the sky plummets through space
And in an instant the divine race disappears.
A voice cleaving the air cries to a confused world:

"Jesus will finally be born and his reign begins
He is born poor in Bethlehem, his power is immense
Pan, the great Pan is dead and the gods are no more!"
W. de K.
July 3, 1895

Above:
Wilhelm de Kostrowitzky—sitting at the table, pen in hand—as secretary of the Congregation of the Immaculate Conception

Top left:
Wilhelm de Kostrowitzky on the day of his first communion, May 8, 1892

~ Pan est Mort ~

A Ch. Tamburini

Flore et le chaud Phébus revenaient sur la terre,
Toujours les flots grondants se brisaient sur Cythère
Et la blonde Vénus adorée en ces lieux,
Dans son temple écoutait le chant des hymnes pieux.

L'Olympe s'emplissait; le Maître du tonnerre
Mandait tous ses enfants qui venaient vers leur père:
Quelque chose d'étrange était alors aux cieux,
Les puissants immortels étaient devenus vieux.

--- Mais tout à coup le ciel s'abîme dans l'espace,
Et la race divine en un instant trépasse.
Une voix fendant l'air crie au monde confus:

« Jésus va naître enfin et son règne commence
« Il naît pauvre à Béthlem, son pouvoir est immense
« Pan, le grand Pan est mort et les dieux ne sont plus! »

N. de K. 3-7-95

"Dear Mama"

JEAN COCTEAU
(1889–1963)

Jean Cocteau had the comfortable and carefree childhood typical of the late nineteenth-century Parisian upper middle class. In Paris and at nearby Maisons-Lafitte, where he spent vacations (and smoked for the first time, chewing on grass afterward to obliterate the smell), he led a tranquil existence with his parents, his brother, and his sister. He was passionately attached to his mother, whom he watched dress for the theater in a state of rapture. His father, never much of a presence in his life, died when he was ten.

Cocteau's earliest surviving letter to his mother dates from the winter of 1898, when he was nine. As fate would have it, it describes a snowball fight, although not the one of a few years later that was to inspire a famous scene between Paul and the student Dagelos in his novel *Les Enfants terribles* (The Terrible Children, 1930).

As a student at the Lycée Condorcet in Paris, Cocteau's performance was rather mediocre. As he himself later put it, he won prizes in the "dunce subjects": drawing, gymnastics, and German. Nonetheless, it was during his stint there that he emerged as a child prodigy, thanks to the actor De Max, who placed a theater at his disposal for a reading of his first poems. The event was an unqualified success. Thereafter the young Cocteau began to move in exalted social and artistic circles, associating with the most fashionable and advanced of the Parisian cultural elite. His first volume of poetry, *La Lampe d'Aladin* (Aladdin's Lamp), which he later disavowed and even prohibited from being reprinted, appeared in 1909, when he was twenty years old.

Opposite:

"André, Péronne, Philippe, Wehrlé, the little Péronnes and me, presenting arms to some officers"

Letter from Jean Cocteau to his mother, 1898. Paris, Bibliothèque Historique de la Ville de Paris

Dear Mama,

I write you a short letter because Grandma told me you would rather have a drawing, which is why I seize the opportunity to write to you. Marianne finally comes tomorrow morning and she will sleep in Marthe's bedroom to be close to us; Pierre is feeling better. When you return don't forget to buy the seal, choose a pretty one *but not like yours*.

Farewell my dear Mama. Joséphine asks me to send you and Marthe her regards. I embrace you with all my heart.

Your son who loves you
Jean

Top left and left:
Drawings by the young Jean Cocteau. Note the hilarious face of the clown Foutit on the sheet at left. Private collection

Above:
Drawing of the Cocteau house by a member of the family. Private collection

166

André Péronne Philippe Wehrlé et toi moi et les petites Péronnes. Présentant les armes à des officiers.

Ma chère maman

Je t'écris une courte lettre parce que grand-maman m'a dit que tu voudrais bien encore avoir un dessin c'est pourquoi j'en profite pour

t'écrire. Marianne vient enfin demain matin et elle couchera dans la chambre de Marthe pour être près de nous; Pierre va mieux, à ton retour n'oublie pas d'acheter le cachet choisis le joli mais **pas comme le vôtre**

Au revoir ma chère maman, Joséphine me charge de ses amitiés pour toi et Marthe. Je t'embrasse de tout cœur.

ton fils qui t'aime

Jean

"Go Away!"

FRANÇOIS MAURIAC

(1885–1970)

"I've never gotten used to the misfortune of not having known my father," remarked François Mauriac. From the time this last of five children was twenty months old, he was raised in a household dominated by two women: his mother, widowed at age twenty-nine, and his grandmother. The family, bourgeois and Catholic, lived in Bordeaux.

Unfolding under a cloud of grief, François's first years were not his happiest; at age seven he was enrolled in a religious school that he detested, and where he learned to master anguish and solitude. His first communion, which took place when he was eleven, coincided with another important event in the family: his mother's decision to cease mourning her late husband. Increasingly, the puny child, teased by all his schoolmates and useless at sports, sought refuge in reading; as his rare aptitude for French, Latin, history, and music became apparent, his self-confidence grew. He was commended above all his schoolmates for his first composition assignments; in the evenings, he kept a diary—later destroyed—and secretly wrote poems that he later published in *Les Mains jointes* (Clasped Hands). Perhaps he had already embraced a literary vocation. He certainly understood that he should take precautions regarding *Va-t-en!* (Go Away!), the "large unpublished novel" he wrote when he was thirteen. When he entrusted the manuscript to his sister Germaine, seven years his senior, he instructed her: "Please don't let anyone read this novel which might upset people." He explained its genesis in a cover letter: "My dear Germaine! You have won the bet. What to give you? My purse is empty and I was at a loss. But when you asked me for a novel, I was awash in intense joy; only an author can understand the happiness one feels when someone expresses interest in one's work. As for my own work, it is quite modest, and the hand that wrote it belongs to a thirteen-year-old without experience or talent. But I'm sure you will be indulgent, and then in these more or less worthless pages you will be able to read: 'My sweet Germaine I love you with all my heart because you are good and beautiful, because you are a model older sister.'"

François Mauriac, *Va-t-en!*, 1898, which he presented to his sister Germaine as her prize for winning a bet

VI

Vision dans une chapelle

Une jeune fille en deuil

Ludovic reçut son portefeuille des mains des mission-
naires et prit voile pour L'Europe avec son
serviteur.

Un mois plus tard le jeune homme était à
Paris. Il loua un petit appartement quai des
Grands Augustins et s'y installa. Un matin
selon sa pieuse coutume il alla entendre la messe
dans la chapelle d'un couvent de religieuses
qui se trouvait à côté de chez lui
Or il aperçut agenouillée près de l'autel une jeune
fille ravissante mais en deuil qui priait avec
ferveur. Tout le temps de la messe il fut distrait
et lorsque les fidèles quittèrent le lieu saint
il resta encore pour tant que la jeune fille fut
agenouillée. Lorsqu'elle rentra dans la sacristie, il
revint chez lui songeur. Tous les matins il
revit la belle apparition de cette jeune fille.
Un amour ardent brûla dans son cœur
Il fut demander des renseignements au sacristain
par Chalcave, qui avaient fait connaissance
avec lui

Early Works

At age sixteen, Egon Schiele had himself photographed in Vienna, palette and brushes in hand, his gaze somber and still, his thick hair combed back. There is an air of defiance in his eyes, a striking blend of assurance and calm provocation. He was sure he would be a painter.

The same message is conveyed by his earliest self-portraits, which were so accomplished that his teachers encouraged him to pursue an artistic career. One need only see his first drawings to understand their reaction: from the time he was ten, Egon drew trains, railway cars, and locomotives with an engineer's precision. Admittedly, railroads were quite familiar to him; his grandfather had been inspector general of the railways in western Bohemia, and his father was the manager of a railroad

station. Unfortunately, the father's career was thwarted by mental problems. Three years before he died, he placed his son under the guardianship of his brother, the boy's uncle. The uncle was a stern man, who frowned upon his nephew's artistic ambitions. However, Schiele was accepted into the Academy of Fine Arts in Vienna and arrived in the Austrian capital in 1906.

Financial difficulties and conflict with his professors cast a pall over his life there; "there is only shadow in Vienna, everything is black," he lamented. Nonetheless, he made several acquaintances pivotal for his future, notably Gustav Klimt and Anton Peschka, a fellow student with whom he founded, at age nineteen, the Neukunstgruppe (New Art Group), which stood for the complete artistic independence from tradition. Schiele wrote its manifesto.

Above:
Egon Schiele, *View of the Apartment of Leopold and Marie Czihaczek*, 1907. Vienna, Belvedere, Österreichische Galerie

Left:
Egon Schiele, *Portrait of Leopold Czihaczek*, Schiele's uncle, 1907. Private collection. Czihaczek became Schiele's guardian three years before the death of the boy's father in 1905.

Opposite:
Egon Schiele, *Self-Portrait*, 1906. Vienna, Graphische Sammlung Albertina

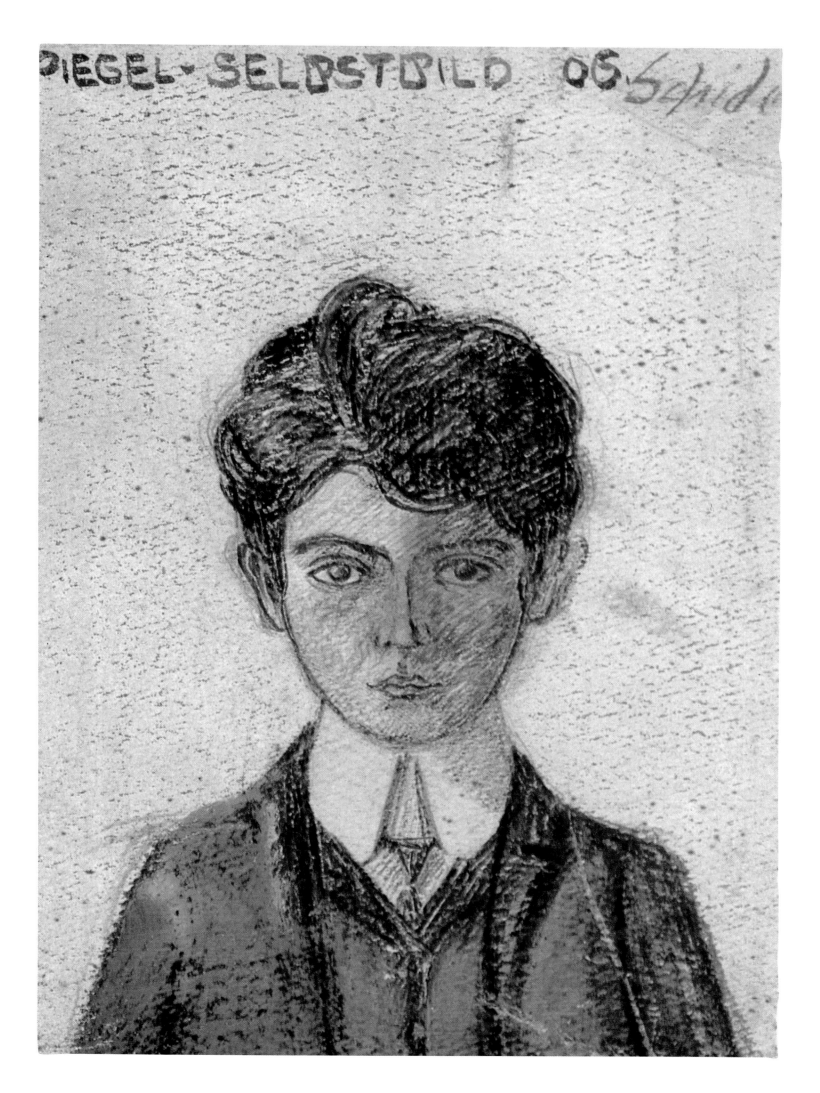

SPIEGEL-SELBSTBILD 05. Schiele

"I juggled with a brush and a lens"

JACQUES HENRI LARTIGUE
(1894–1986)

"When I was little, I juggled with a brush and a lens. Then I confused my brush with a tennis racket. After which I juggled with the racket, the brush, and the lens—while balancing a pen on my nose," wrote Jacques Henri Lartigue, evoking in a playful image youthful enthusiasms that he would continue to cultivate throughout his long life: tennis, painting, photography, and writing.

In his pursuit of the last three, he sought to fix the ephemeral, to hold back time, whose images and sensations the little boy, in an excess of anxiety, was determined to retain. To this end, he devised an odd stratagem that was part memory enhancement and part white magic: "While looking at what I wanted to catch, I blinked my eyes three times, opened them wide, did a somersault, and presto! The image was caught!" His memory became a storehouse of a thousand impressions, noted on sheets of paper intended to become part of a diary, but this project was soon rendered moot by photography. For Jacques began to use his father's "black box" when he was six. The next year, 1901, he received his own camera as a Christmas gift, together with some "large, yellowish-green glass plates" and "all sorts of complicated things too heavy for a little boy less than four feet tall." No matter. Now he could capture everything: family portraits, vacations, beloved faces, the countryside of his dreams. He developed all his own negatives, discovered the technique of double exposure, and played at photographing "ghosts" by passing so quickly before the camera that the plate recorded only a transparent reflection of his silhouette. At age eight he marveled at the stereoscopic technique (binocular exposures that create the illusion of relief), which his father had learned; experimented with autochrome (an early color process); and unwittingly invented the rayograph by placing his hand on a sensitized sheet of paper exposed to light.

Although shape, value, relief, and color were all within his grasp, something important was lacking: movement, a quality to which the early twentieth century was especially partial. Automobiles and aviation were subjects that Jacques captured on the fly, with drawing pencil or from behind the lens. By the time he was ten his career had scarcely begun, but his accomplishment was already substantial.

Left:
April 3, 1904, at Merlimont:
"Zissou says: 'I can fly just like Gabriel Voisin.'"

Top left:
"Grandmother, Mama, and me with my glass-plate camera," taken in the Bois de Boulogne, Paris, 1903

Above:
"First photo taken absolutely alone. Aunt Yéyé, little Dédé, Uncle Auguste, Papa, Zissou, Mama, Marcelle"

Opposite:
"My nanny, Dudu," June 1904

A Letter to His Parents

JEAN GIONO
(1895–1970)

Doubtless it was because he was born into poverty that Jean Giono soon began to cultivate a rich inner life, a capacity for wonder, and an ability to refashion the world as he saw fit, starting from the meanest details of reality. The son of a shoemaker and an ironer, he came into the world March 30, 1895, in his father's shop in Manosque, in the south of France. The grandson of an Italian revolutionary who had fled his country to escape execution, the son of an artisan with a gift for corporal and spiritual healing, Giono himself remarked in *Présence de Pan* (The Presence of Pan) that he had inherited a hapless look from his father. "Mine was an awkward figure, tall and thin, remarkable only for its tender eyes." "I was extremely sentimental," he later admitted in a vivid description of himself as a young boy.

At age sixteen, Giono left school to help out his parents, taking a post in a bank from which he earned ten francs a month. The following year, the director of the bank assessed his performance: "Work: diligent. Punctuality: good. Character: compliant. Conduct: good. Likely to become a good employee," entering as his final judgment: "rather good." The director clearly had no inkling of the genius that was incubating within his apprentice.

One day the young man found himself on a train to Marseilles, where he had been sent on business. He was reading Kipling's *Jungle Book*, which he had just bought, when he came across a sentence that was to change his life: "It was seven o'clock of a very warm evening in the Seeonee hills." He later remarked, "This simple sentence started everything. I sensed that I myself could have written 'It was seven o'clock of a very warm evening in the Seeonee hills' and continued it in my fashion."

Only in 1927, at age thirty-two, did Giono begin to write. In the interim he had experienced the horrors of the 1914 war, had been promoted at the bank, had married and become a father. In all likelihood, even he did not realize at the time of the publication of his first book, *Naissance de l'Odyssée* (Birth of the Odyssey), that it had inaugurated his own great literary adventure.

Postcard from Jean Giono to his Italian cousin (written in Italian), December 1902. Musée de Manosque, Jean Giono Collection

Top left:
Jean Giono as a child. Musée de Manosque, Jean Giono Collection

Cher Papa, chère Maman,

je vous aime,
je vous souhaite une
bonne année. Ma petite
main n'en peut tracer

davantage; lisez le reste
dans mon cœur, et répon-
dez-moi par un doux
baiser.

Notre chéri,
jean Giono.

Manosque, 24 x.bre, 1900.

Above:
Letter from Jean Giono to his
parents, from Manosque,
December 24, 1900. Musée
de Manosque, Jean Giono
Collection

Dear Papa, dear Mama,

I love you, I wish you a happy new year.
My little hand cannot write any more; read the
rest in my heart and answer me with a gentle
kiss.

Your beloved
Jean Giono

A Catalan Turtle

JOAN MIRÓ
(1893–1983)

It may seem glib to find—many years later—the seeds of greater things to come in juvenile artistic efforts. Looking at the first works of Miró, however, we can hardly resist recognizing in them something of the poetry and color that would characterize the master's mature work.

Joan Miró was born on April 20, 1893, into a family of artisans. His mother, originally from Palma de Majorca, was the daughter of a cabinetmaker, while his father, a Catalan, was a goldsmith and jeweler. The family lived in Barcelona, in the heart of the old town. Between Catalonia and Majorca, where his grandparents lived, the boy exercised his eye in contact with nature, perusing landscapes saturated with color, and the animals and insects so abundant in the nearby countryside. Many pages of his sketchbooks resemble bestiaries, for example the drawing of a turtle dating from 1901 (opposite), when he was eight years old. The same year, the boy also made simple drawings of picturesque scenes that he must have chanced upon, completing them with watercolor after returning home, as in this charming depiction of a pedicure. Even at this age, Miró never left the house without his crayons. He chose his vocation early; in 1907, when he was only fourteen, he enrolled in the Lonja art school in Barcelona. There he studied with Modesto Urgell, an artist of romantic temperament who had known Gustave Courbet. Urgell may have been the first person to speak to the boy of Paris, where the teacher had lived for a time. Painting not being a proper craft, at his father's insistence, Joan obtained a license in accounting. Bookkeeping was not to get the better of him, however. In 1912, after a nervous breakdown, he convinced his father to allow him to enroll in the academy of Frencesc Galí in Barcelona. His true apprenticeship had begun.

Joan Miró, *Pedicure*, 1901.
Barcelona, Fondación Joan Miró

Above:
Joan Miró, *Montroig: The Church and the Village*, 1919. "Everything started in Montroig," the artist said on several occasions.

Opposite:
Joan Miró, *Turtle*, 1901.
Barcelona, Fondación Joan Miró

Photograph of the young Joan Miró.

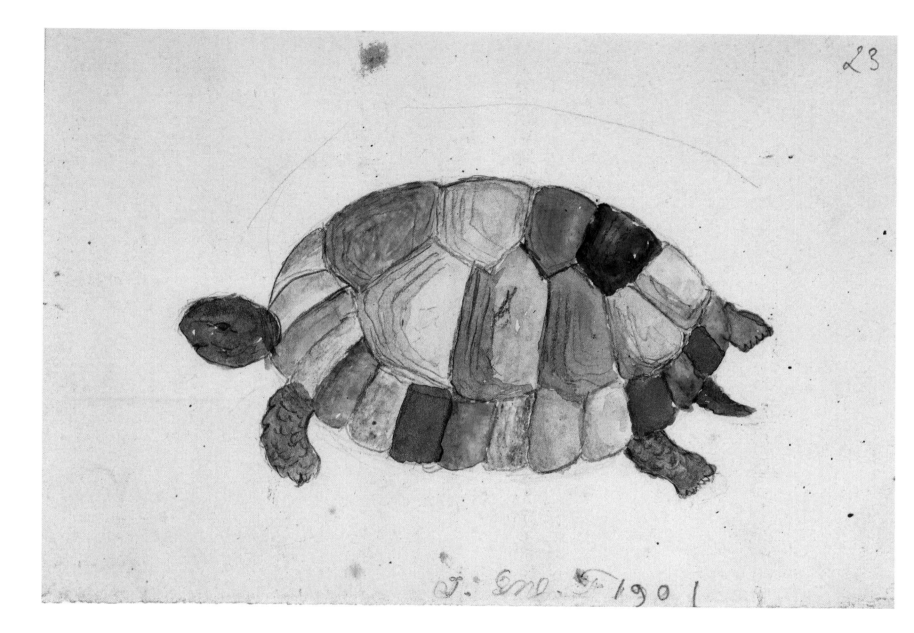

J. Ens. F 1901

"This Mean and Shallow Life"

HENRI ALBAN FOURNIER, KNOWN AS ALAIN-FOURNIER

(1886–1914)

"Garrets; trunks in attics; the smells of school; women passing by under their umbrellas; peasants' sabots scraping the street; hawthorn hedges; childhood secrets; the buzzing heat of summer afternoons; little houses in the Sologne Forest; checkered tablecloths; the smell of posters; bottled fruits and vegetables stored in basements for winter; mysterious gardens; shined shoes; autumn scents; capes hanging under porch roofs; chestnut trees in courtyards, linden trees in public squares; roads that are dusty in dry weather and muddy when it rains . . ." Such were the sights and sounds of rural France that gave Alain-Fournier's remarkable single novel its flavor and beauty.

The son of two schoolteachers, Henri Alban Fournier was born on October 3, 1886, in a small town in the Loire Valley. When he was five, his father was transferred to Épineuil-le-Fleuriel, not far away, where the boy started school. Épineuil was less than six miles from yet another town called Meaulnes, which the young novelist would later adopt as the name of the autobiographical hero.

In Épineuil's school for boys, in a countryside "without picturesque qualities, backward, unsullied, and bountiful," Henri passed the next seven years of his life. Here his "immense and vague infantile life" unfolded, providing him with a store of sensations, memories, feelings, and moods that would nourish the atmosphere, descriptions, and evocations in the novel he would later write, *Le Grand Meaulnes* (usually called *The Lost Domain* in English). At age twelve, Fournier was torn from the "gentle and luminous garden of his childhood" to commence a peripatetic series of stints at boarding schools, first in Paris, and then, at several provincial schools.

These early forays into what Henri, under his pen name of Alain-Fournier, would later call "this mean and shallow life" occasioned his earliest writings, letters to his friend Jacques Rivière, which described his literary ambitions as early as 1905: "I am beginning to sketch in my head a project based on my childhood days in the countryside."

Alain-Fournier never completely recovered from the loss of his childhood. *Le Grand Meaulnes* is both the story of impossible love and the account of the traumatizing fall into the real world of the author, who was determined to memorialize in its pages the secret garden that had once been his. Tragically, he was killed in action in World War I.

Above and opposite:
Various drawings and the draft of a letter from the school notebooks of Alain-Fournier

Top left:
Photograph of Alain-Fournier during his enrollment at the Lycée Voltaire in Paris

Mercredi.

Nous ne sommes que 14 où 15 dans tout le grand lycée, à cette... Tout semble vide et grand -- dortoir réfectoire. C'est triste!

Cependant je ne m'ennuie pas, je potasse mes Math. Je lis avec d'autres camarades car la discipline est, en ce moment, beaucoup plus relâchée.

J'attends de vous, d'Isabelle en particulier, plusieurs lettres avant la rentrée fixée au jeudi soir, 8 h 1/2.

Un bon baiser à tous,

Fournier

"What a Divine Soul!"

LOUIS ARAGON

(1897–1982)

In 1924, Louis Aragon published *Le Libertinage* (Libertinage), a collection of writings that included a story only a few pages long entitled "Quelle âme divine!" (What a Divine Soul!), a rather chaotic account of a trip to St. Petersburg taken by a party of five. On the occasion of its republication in 1964, a few careless critics suggested that it was a fictionalized account of the author's own sojourn in the Soviet Union. They had failed to notice, despite its having been clearly indicated, the date of its composition: 1904, when its author was only seven years old. Although certainly precocious, Aragon had not yet become a Marxist. He had just read a novel set in Russia, which had filled his young imagination with visions of that country.

Many years later, Aragon remarked: "I can't remember a time when I wasn't writing, for the truth is I have always written, even when I didn't know how to write; I dictated texts to my aunts that are now lost." Much the same note was struck by Henry de Montherlant (a schoolmate of Aragon's), who remembered that at age twelve "this skinny little boy with soft eyes" wrote a play in classical alexandrine verse and spoke effusively of Racine.

Doubtless this early interest in telling stories originated in the saga his family, whose incredible history shaped the future writer's identity. Indeed, Aragon's very birth was based on a fiction: his parents of record, Jean Aragon and Blanche Moulin, were invented as a cover for an adulterous liaison between Marguerite Toucas-Massillon and Louis Andrieux, married and the father of three children, the French ambassador to Madrid. Placed at first with a wet nurse and then reclaimed by his mother's family, the child grew up having been stuffed with lies. Until 1914, he thought he was the adopted son of Claire Toucas-Massillon, his grandmother, that his true mother was his sister, and that his father was merely his godfather. Thus, it is not surprising that the boy should have grasped the expiatory virtues of literature early on, and proceeded to construct an oeuvre of which "Quelle âme divine!", dedicated to his "sister," is the touching foundation stone.

Top left:
Photograph of Louis Aragon taken in 1904.
Collection Jean Ristat

Above and opposite:
Louis Aragon, autograph manuscript of "Quelle âme divine!", 1904. Aragon-Triolet Archives, Paris, Centre National des Recherches Scientifiques

180

dit René, à dit
Alfred :) en
effet, dit
Monsieur de
Noissent, oui,
dit Madame
de Noissent :))
XX

II
en route
Victor! voici
un wagon,
venez-vite,
Marie! Alfred!
Robert! René!

VII
le passage
de l'Irtiche,
tout en parlant
on traversa Zara;
bientôt on arriva
au bord de l'Irti-
che. l'Irtiche ce
jour là a-ec il
été complétement

Marie mis le
pied sur la Gla-
-che, et s'enfon-
-ça jus'quau gen...
nous bientôt
on hu, traversée
l'Irtiche; sans
d'autre incident,

181

First Poems

HENRY DE MONTHERLANT
(1895–1972)

"The most remarkable act of my youth was my having managed to be born on an April 21, which is to say on the anniversary of the founding of Rome," Montherlant once remarked. In fact, Henry Millon de Montherlant had been born on April 20. But the writer later chose the date of his birth as he would the date of his death.

At the time, the Montherlants were living in Paris on the elegant Avenue de Villars, dominated by the dome of the Invalides. "One evening after nightfall, a procession of students passed below our windows heading toward the Invalides and chanting 'Spit on Zola! Spit on Zola! Spit!' I was aware of civil war and racism from the beginning." The boy's mother's family—the Camusat de Riancey, from Troyes—was dominated by his grandmother. Monther-lant paid tribute to this mystical and sensitive woman in the character of Mother Angélique de Saint-Jean in his novel *Port-Royal*.

Henry's father had trained to become a civil servant, but he believed that office work was tantamount to imprisonment—a notion that he shared with his son. According to the author's biographer, Pierre Sipriot, he loved "the world, beautiful religious rituals, the nobility, English engravings." When the boy turned ten, the father gave his son a gold ring on whose interior was inscribed: "Honor above all."

But Henry's fondest attachment was to his mother. Gravely ill from the time of his birth, she divided her life between a chaise longue and her bed, in which, until he was twelve, the boy snuggled up to her for a time each night before retiring. "The drama of the last ten years of my mother's life was her sense that I didn't love her as much as she loved me," Montherlant later wrote, and threw his correspondence with his mother, as well as the diary he had kept as an adolescent, into the Seine.

In 1903, he resolved to devote his life to literature, after reading an abridged version of Henryk Sienkiewicz's historical novel *Quo Vadis?*, whose deft fusion of antique beauty and modern fiction enchanted him. At the same time, Henry began to study Latin, which brought the revelation of ancient Rome and its pagan culture. He also began to write, producing, either alone or with a collaborator, short texts accompanied by illustrations drawn by himself or, on occasion, by his mother. In 1908–09, there followed *Herold et Sylvaine*, likewise illustrated, in which the young author listed his other "publications."

Above:
The château de Montherlant, near Méru in the Oise Valley north of Paris. It had not belonged to the family since the mid-19th century, but in July 1910 young Henry copied an 18th-century image of it.

Top left:
Henry de Montherlant in Neuilly, 1907
"It takes a long time for a young modern bourgeois to become a man; it never ends. He is superior, in this regard, to the people."
(Montherlant)

Left and opposite:
Two unpublished poems by Montherlant. Left: "Petits Chats" (Little Cats), written when he was eleven. Opposite: "Ballade orientale" (Oriental Ballad), dated "April 25, 1907"

— Ballade orientale —

Harems mystérieux où brûle l'encens sacré !
O nuits langoureuses du monde continental !
Terrasses parfumées et jonchées de safran
où les femmes, le soir, récitent le Coran,
Accroupies, deux à deux, près de l'autel nacré,
Sous le voile azuré du ciel oriental !

Une rose fleurit sans cesse sous vos pas :
Ou bien vous l'écrasez ; alors, bourgeon cassé,
Pétale desséché, senteur évanouie... —
ou vous vous arrêtez, et la rose épanouie
Vous charme pour un instant — Mais dans les deux cas
Elle est pour un autre quand vous êtes passé...

La nuit sous la lune, le jour sous le soleil,
Dans le palais, dans le harem, dans le désert
On retrouve partout le même fruit vermeil.

O Eden enchanteur, extatique séjour,
Ou partout et toujours sous le feuillage vert,
On n'a qu'à se baisser pour cueillir de l'amour...

25 Avril 1907

Éluard's First Story

EUGÈNE GRINDEL, KNOW AS PAUL ÉLUARD

(1895–1952)

"And there he remained, motionless, with the dogs' howls for his funeral oration." Such is the strange concluding sentence of *Volé*, a story whose title in French means both "flown"—a reference to the young protagonist's attempted escape from gypsies—and "stolen," an allusion to his abduction as a child. It is the earliest known manuscript of Eugène Grindel, written when he was twelve (and a half, as he carefully notes after his signature). In January 1958, six years after the death of the poet who had since become famous as Paul Éluard, the text of this rediscovered manuscript was published. Its appearance occasioned the following pronouncement by Jean Marcenac: "There is no perfection in these lines penned by a schoolboy. But there is something much more striking: the first stutterings of greatness."

The son of an anticlerical white-collar worker and a seamstress, Eugène, an only child whom his parents called Gégène, suffered from ill health from early youth. At age two, he had all the symptoms of meningitis; at his mother's insistence, his father consented to have him baptized. He was so sickly that his parents, who doted on him and feared the worst, resolved to improve their modest lot for his benefit. Very quickly, thanks to astute real estate investments, Clément Grindel achieved the financial success he sought. After spending several years in the working-class suburb of Saint-Denis, the family moved to a middle-class neighborhood of Paris, where Eugène began school. At Sunday dinners, the little boy would invariably be asked to recite one of La Fontaine's fables, a trial about which he later remarked: "As I had not yet acquired the skill at reciting verse for which I am now well known, I did it by rote and without pleasure; I finished quickly—to get it over with, to be done with these singsong words for good students without much inside their heads." The boy couldn't have known that one day almost all French children would have to recite, either at school or at home, his most famous poem: *Liberté* (Liberty).

FLOWN!

He didn't know his family name, but he vaguely remembered a pretty house and people strangely different from the caravan in which he found himself and from the people around him. He lived with these gypsies who made bears dance, and who were tougher and shiftier than the worst bandits. Ill treated, scarcely fed, living like a wild child, he suffered greatly. He might be fourteen, but in his bruised and toughened soul he wished all these nasty people well. Countless times, the idea of escaping had popped into his head; today the band was camped in a ravine, in an abandoned quarry. . . . It was night, and everyone was asleep. He got up and looked around him; he dressed, a glimmer of hope in his beautiful blue eyes. Carefully he approached the door, took a cane, and, after having assured himself that the others were asleep, jumped to the ground. A stick cracked under his feet, a dog barked; he hesitated an instant and then ran as fast as he could, the dogs barking with more enthusiasm. . . . Suddenly a man jumped in front of him. "Stop right there." Jean recognized the leader's voice. He lifted his cane; the man fell with a loud cry, then remained still. Jean wasted no time. He dropped the cane and fled, but an alarm was sounded and the dogs were released. He left the ravine and entered the forest. There was a great cry of outrage: the gypsies had just found the body of their leader and rushed after him with still greater fury. Jean knew that he was lost; his limbs weakened, large drops of sweat formed on his brow; he ran without seeing, the dogs were approaching . . . Suddenly there was a great shock and Jean was struck down. He had just run into a large branch that barred his way. His skull was knocked in. . . . And there he remained, motionless, with the dogs' howls for his funeral oration. . . .

E. Grindel the younger
12½ years old

Above: Paul Éluard with a group of students at Aulnay-sous-Bois

Top left: Paul Éluard around 1905

Opposite: Four sheets from the autograph manuscript of *Volé*, 1907. Paris, Bibliothèque Littéraire Doucet

5) Les chiens aboient de plus belle,... Soudain un homme bondit devant lui. (Halte-là!) Jean reconnaît la voix du chef. Il lève son bâton, et l'homme s'abat avec un grand cri, puis il ne bouge plus. Jean ne perd pas de temps, il lâche son bâton

6) puis s'enfuit, mais l'éveil est donné on lâche les chiens Jacques ~~s'enfuit~~ il quitte ce ravin d'entre dans la forêt un grand cri de rage s'élève ~~et~~ les bohémiens viennent de trouver le cadavre de leur chef et s'élancent plus furieux encore

7) Jean sent qu'il est perdu; ses jambes fléchissent, de grosses gouttes de sueur perlent à son front, il court sans voir, les chiens approchent.... Soudain un grand choc, et Jean tombe foudroyé, ~~Il vient~~ Il vient de se heurter une grosse branche qui

8) qui barrait le chemin. Le crâne est défoncé... Et il reste là, immobile ~~ment~~, avec les hurlements des chiens, pour oraison funèbre...

El [?] fils
12 ans ½

"I Made Myself A Fountain Pen"

ANTOINE DE SAINT-EXUPÉRY

(1900–1944)

When Antoine de Saint-Exupéry, the author of *The Little Prince*, was himself a boy, he had radiant blond hair. His mother called him the Sun King, indulged his every whim, and never tired of telling him the stories he wanted to hear. His hair darkened and he grew up, but his relationship with his mother did not change; from the moment of his birth, she saw him as the glory of her life.

The third of five children, Antoine scarcely knew his father, who died when he was four. After his death, Antoine's mother moved to her father's estate, the château de la Mole, where she and her children made a life for themselves. The mother, artistic by temperament, painted and played the piano and the guitar. Indulgent by nature, she gave her children the run of the countryside and let them stage the stories she read to them at night. But the death of her own father brought this idyll to an end. The family moved to an aunt's house in Lyon, while the two boys entered a Jesuit school in Le Mans. Discipline was not Antoine's strong suit. His reputation as a dreamer was confirmed by his scholastic performance at the school, where his principal occupation was disassembling and reassembling a new invention that was then all the rage: the fountain pen. So we should not be surprised by the opening of his earliest surviving letter, written to his mother in 1910, when he was ten years old: "I made myself a fountain pen," a portentous beginning for a future writer. With this same instrument, "Tonio" would soon write stories and essays that already bear his individual stamp, launching a short-lived class newspaper and writing *L'Odysée d'un chapeau melon* (The Odyssey of a Bowler Hat), a playful text that won him the prize for best original composition in 1914.

Ma chère maman
je me suis fait un stylographe
je vous écris avec il va très bien
Demain c'est ma fête.
Est que l'Oncle
emanuël a dit qu'il me donnerai
une montre pour ma fête
alors es que vous ne pourrez
lui écrire que c'est demain ma fête
Il y a un pèlerinage jeudi
à notre dame de... je vais avec
le collège il fait très mauvais
temps il pleut tout le temps
je me suis fait un très jolie

une toutes les cadeaux
que l'on m'a donné
Adieu
maman chérie je
voudrais bien vous
revoir

Antoine

c'est ma fête demain

A Child of Genius

PRIMO CONTI
(1900–1988)

"He, too, is a monster," exclaimed Pablo Picasso by way of paying homage to a young Italian painter whom he met in 1917, during the stint of Diaghilev's Ballets Russes at the Politeama Fiorentino. Two young prodigies of twentieth-century art had just come face-to-face.

Primo Conti, born on October 16, 1900, was baptized Umberto after King Umberto I, who had just been assassinated. His father Alfredo, originally from near Empoli, a town on the road between Florence and Pisa, had married a young woman from an aristocratic family, Maria Immacolata Incarnati.

The boy began by studying the violin, on which he made such rapid progress that his family envisioned a musical career for him. But in 1910 his gift for drawing became apparent and he enrolled in a private school directed by a nonconformist artist named Eugenio Chiostri.

In 1911 he produced his first painting, a self-portrait. Two years later he composed a *Romance* for violin and piano, and produced his first work of sculpture. Now thirteen, he established contact with the Futurists on the occasion of the first exhibition of a group of artists associated with the Futurist journal *Lacerba*. That same year, the Futurist Giovanni Papini gave him a postcard of a painting the boy had admired on which the artist had inscribed: "To the youngest and most intelligent visitor to the Futurist exhibition."

The following year, he helped with the work on an exhibition of the sculpture of Umberto Boccioni. The older artist suggested they go to see Michelangelo's *Prisoners* together, ceding to Conti as a souvenir of the experience some Futurist drawings on the pages of his engagement book. In the summer of 1915 Conti almost died from an acute case of peritonitis, but the illness brought with it a new sense of creative urgency: in the rare moments of respite it accorded him, he painted, drew, and feverishly composed verse.

In 1915 he also discovered the writing of Stendhal, and in 1916, produced illustrations for a musical score by Mario Castel Tedesco, which was published. Then he read Baudelaire, studied Cézanne, and deepened his acquaintance with Cubism. Over the course of a single decade, Primo Conti managed to absorb everything that contemporary painting had to offer. At age seventeen, he published his first volume of poetry. His public career had begun.

Above:
Self-Portrait, 1911. Fiesole, Fondazione Primo Conti. Conti's first painting, executed in inexpensive colors mixed with olive oil

Top left:
Primo Conti painting, 1911

Opposite:
Self-Portrait in a Bathing Robe, 1915. Fiesole, Fondazione Primo Conti. This canvas, executed after the artist had his appendix removed in 1915, reveals the degree to which he had absorbed the work of the Fauvists, then little appreciated in Italy.

Comedies, Tragedies

MARCEL ACHARD
(1899–1974)

"My father's great-nephew and my mother's first cousin, I was born by special dispensation of the Pope and the President of the French Republic!" Indeed, Jean Ferréol Achard had married Augustine-Anaïs-Amélie Blanc, his sister's daughter. Such inbred marriages were not uncommon in this period among peasants attached to the land, for their world did not extend beyond their own village.

Grandfather Achard was a horse trader in a rural district near Lyon, but his son, who did not want to work outdoors, moved to a town, where he ran a café. So it was in Sainte-Foy-lès-Lyon, a suburb of Lyon, that young Marcel came into the world in 1899. All his life he regretted not having been born six months later: "Why was I born in the previous century when the twentieth suits me so well?"

In 1901, the Achard family moved into Lyon, rue Simon-Maupin, where they operated two cafés simultaneously. The same year their number grew with the birth of a boy, followed in 1905 by a girl.

The boys enrolled in boarding school and thereafter rarely saw their parents, with the result that as children they received little affection or attention, to the point that Marcel's myopia, as well as his asthma, went undetected for years. He did not receive eyeglasses to correct his short sight until he was thirteen years old.

At age seven he decided to become a novelist. He chose René Dax as his pseudonym and launched *Mon Rêve, le magazine illustré de la famille* (My Dream, the Illustrated Family Magazine), which he "published" himself in single manuscript copies. He was responsible for all of its articles and drawings, including a comic novel, a dramatic novel, and cloak-and-dagger fiction.

In the library of Grandfather Blanc he discovered Alexandre Dumas's *The Three Musketeers,* whose dramatic situations, disguises, and chases delighted him. He embarked upon *Henry d'Auvergne* (Henry of Auvergne), a historical melodrama in three acts dealing with Richelieu's struggle against the rebellious nobility. At school he won he nickname *"Poâte,"* a playfully nasal, Provençal variant of *poète,* poet.

In 1910, when asked "What do you want to do with yourself?" he answered: "I will be an actor, a playwright, or both at once!" He was an unremarkable student whose only interests were French and recitation. "When I was a child, first place in French always sufficed to make me happy," he later remarked.

The fledgling playwright had his first stage triumph on March 14, 1915, when his play *Tartruffe* [sic], a parody in one act after Molière, was performed in the school courtyard for his teachers, fellow students, and their parents.

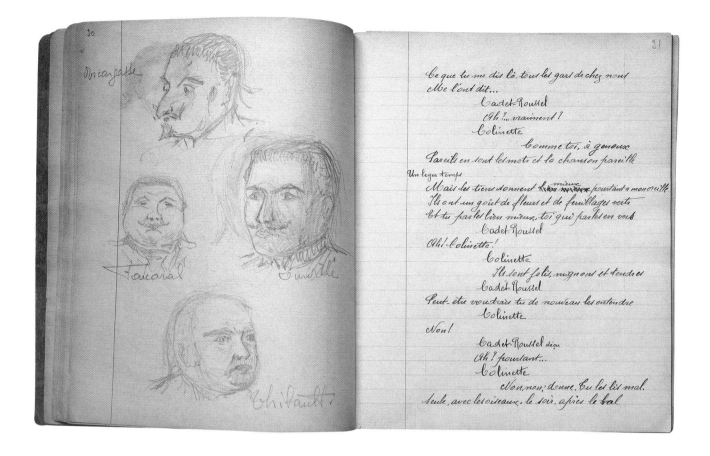

The notebooks of the young Marcel Achard contain about a dozen texts of various kinds: a comic novel entitled *Le Mariage de Plumard* (The Marriage of Plumard); an adventure novel entitled *Frank Wilson*; a one-act play entitled *La Guerre chez soi* (War at Home); a "dramatic comedy" entitled *L'Aîné* (The Eldest Son); *Tournées* (Turns), "a little review aiming at humor like that of the Dumas reviews, by Monsieur Achard, eyewitness," accompanied by little color drawings of the characters; *Tartruffe,* a "parodic puppet show"; *Drame d'amour* (Drama of Love), a "heroic-comic tragedy in verse by Monsieur Achard, known as Totah"; *L'innocent* (The Innocent), a two-act play; *Henry d'Auvergne* (Henry of Auvergne), an illustrated "melodrama in three acts . . . poem and music by Monsieur Achard," written in notebooks printed with the name of the Institution Rollin. Another notebook begins with three pages of class notes, but thereafter is filled with drafts of plays, poems, drawings, and sketches from scenes from *Cadet-Roussel,* a one-act "fantasy in verse" that appears in more developed form in another notebook, dating from 1918–19, along with drawings of the set and the characters. It concludes with poems that already reveal a surprisingly well developed poetic sense.

Left, opposite, and following pages: Pages from the many notebooks filled by Marcel d'Achard while he was at school. This page and opposite: *Cadet-Roussel.* Page 192: *Henry d'Auvergne.* Page 193: *L'Aîné* and *Tartruffe.*

191

MARCEL ACHARD

Institution Rollin — Caluire

(2)

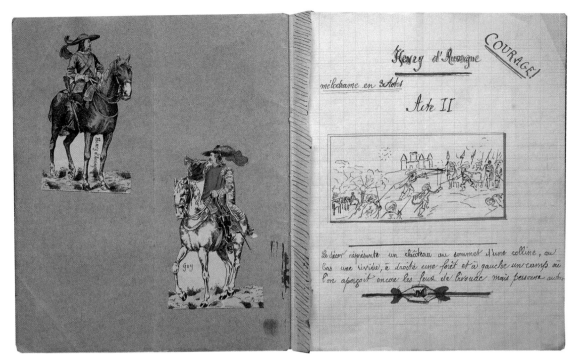

COURAGE!

Henry d'Auvergne

mélodrame en 3 Actes

Acte II

Le décor représente un château au sommet d'une colline, au bas une rivière, à droite une forêt et à gauche un camp où l'on aperçoit encore les feux de bivouac mais personne au...

Acte II

Scène I

Peter assis sur un tronc d'arbre Josebas, debout

Peter.– Il va falloir se sortir du mauvais pas où nous sommes tombés; les gens du château ont dû être lancés à notre poursuite, comment sortir de ce mauvais pas, il faut se cacher.

Josebas.– Mais voyons Peter [1] tu as perdu toute ta décision habituelle. Si on avertit Richelieu nous sommes sauvés. La nuit, nous conduirons Richelieu et sa troupe par la porte secrète que nous avons découverte. Les gens qui ne soupçonnent pas l'existence de cette porte; et je me suis assurée que Guy et Charles n'en sauraient rien et que seul Henri en est connaissance. Ainsi notre plan peut très bien réussir.

Peter.– Tu as raison, mais il faudrait savoir où est Richelieu. Je vais me mettre à chercher des traces. Mais vois donc, Josebas, ce feu de bivouac éteint, Richelieu a sûrement campé ici.

(1) Prononcer Peter Petère

Henry.– Eh! bien Charles je reprends ma parole

Charles.– Si vous retirez votre parole vous êtes déshonoré

Henry.– Non

Charles.– (implacable) Eh! bien l'ordre est donné Guy reprend la nouvelle dans le château. Je vous suis (As sortent)

Scène XIV

Henry d'Auvergne seul

Ah! mes fils. Ils ont sans doute complété quelque chose contre moi. Ils ont pris sur parole mon instinct de bête fauve contre Richelieu qui a fait que je voulais punir mon fils d'un moment d'égarement je savais qu'il serait vainqueur aussi c'est pourquoi que je lui ai fait livrer ce combat avec je misérable eh! si j'aurais pu penser que mon fils, mon fils que j'aime! de tout mon cœur, mon plus jeune fils me prisse sur parole et que pour punir mon emportement il se ferait tuer; et dire que mon fils aîné celui en qui j'avais le plus de confiance l'a soutenu dans cette révolte. Ah! que je suis malheureux, que je suis malheureux ah! que mes fils sont méchants; ce

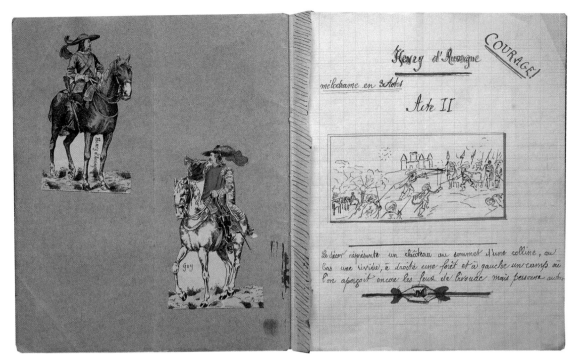

Josebas

les seigneurs

Peter

Josebas.– Je suis un espion de Louis XIII Acte I Scène XII

sont de véritables tyrans, ah! pourquoi! ne suis-je plus de force à me venger! moi-même, car maintenant je suis bien sûr que je ne peux plus me venger avec l'aide de mes fils, eh! bien, soit je me vengerai seul et si je me fais tué Richelieu me précédera sûrement dans la tombe eh! bien partons

192

ACHARD MARCEL

L'Aîné

Comédie dramatique en un acte

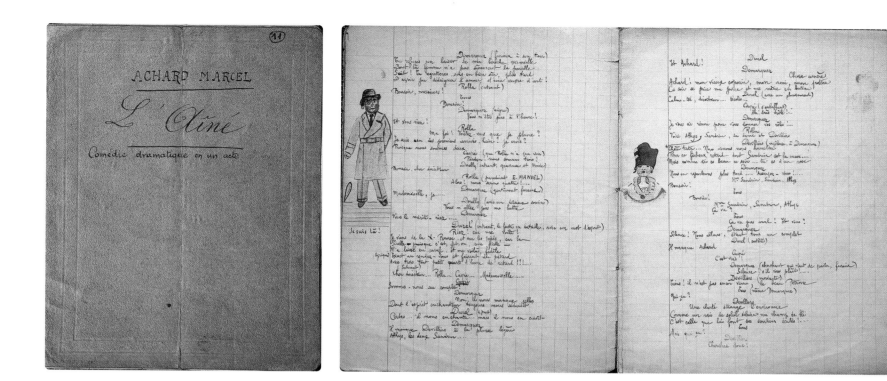

Achard Marcel

TARTRUFFE (Parodie Guignol)

TARTRUFFE

Parodie en deux actes de la comédie classique
par M. Achard

Personnages

GNAFRON (Bon bourgeois) — PANDORE (Gendarme)
GUIGNOL (intendant) — ELMIRE (femme de Gnafron)
TARTRUFFE (Faux dévot) — MARIANE (Fille de Gnafron, aimée de Guignol)

ACTE PREMIER

Un salon, chez Gnafron

Scène Première

MARIANE, ELMIRE

Mariane : Mariane ! (Elle se lève) Voilà deux mois que je ne décolère pas. C'est insupportable ! Notre foyer ne nous connaît plus, notre père ? ne nous parle plus ? Il n'a d'yeux et d'oreille que pour ce Tartruffe. Lui dont la principale occupation était de boire, en est venu à négliger la sève bouteille.

Mariane
La situation est d'autant plus inquiétante, ma mère que ce Tartruffe prend ici une plus grande autorité. C'est lui qui dirige nos domestiques. Seul, notre intendant Guignol lui tenir tête ce qui déplait fort à propre.

An Intense Love

FRANÇOISE MARETTE, THE FUTURE FRANÇOISE DOLTO
(1908–1988)

Nothing about little Françoise-Marguerite Marette, born in Paris on November 6, 1908, seemed to predestine her for the career as the famous child psychoanalyst that awaited her as Françoise Dolto. Born into the upper levels of the industrial middle class, Françoise was the fourth child in a family that would eventually include two sisters and five brothers. It was not altogether good form for a young girl of her day and milieu to receive a proper education, but Françoise was exceptionally gifted, possessing rare powers of analysis and observation even in her youth; at the age of four, she began to understand that part of the adult world was, to say the least, complex.

Two tragedies left their mark on the life of this girl, known to everyone as Vava. First, the death of her uncle and godfather, Pierre Demmler, whom she adored, to whom she even considered herself engaged. During the first two years of World War I, she wrote letters to Demmler of such maturity that, coming from a seven-year-old, they are almost disturbing. Then, having become a "war widow" at seven and a half, Vava lost her older sister Jacqueline after a horrible bout with cancer in 1920, when she was twelve. The death of this eighteen-year-old girl profoundly affected the dynamic between her parents, and her mother, Suzanne Dolto, who never recovered from the loss, treated her surviving daughter dreadfully, accusing her of having failed to save her sister through prayer on the day of her first communion, obliging her to dress like her dead sister and play her violin, and thwarting her education until she was twenty. Nonetheless, Françoise managed to obtain a medical degree, a tribute to her lively intelligence and unshakable resolve. From the age of eight, Françoise Dolto had wanted to be a "school doctor," in which capacity she hoped to bring children the comfort and mental serenity that had been so sorely lacking in her own childhood. She died in 1988, but she remains one of the great figures of child psychoanalysis.

Above:
Françoise Marette's uncle, Pierre Demmler

Top left:
The young Françoise Marette

Opposite:
Letter from Françoise Marette to her uncle, Pierre Demmler, June 30, 1916. Paris, Association Archives et Documentation Françoise Dolto

My dear Uncle Pierre,

I ask you to forgive me for not having written sooner. Prizes were distributed on Tuesday the 27th; I won first prize in analysis and the trimester prize; unfortunately I did not win the prize of honor, but I promise you that I will next year. Papa gave me two francs for these prizes, an umbrella and box of letter paper on which I write you, mama had my watch fixed which I had broken by setting it back too far and breaking the spring, and mademoiselle gave me stamps. The other day I went to see the [re]construction of houses taken by the Germans and I visited them. They were very pretty. I chose one for you and me and our four children. I want two girls and two boys. If you want each of us to have a boy and a girl hurry up and ask for permission for us to marry because I'm leaving for Deauville. I used my umbrella this morning because it was raining. I send you a big hug.

Françoise Marette

30 juin 1916

Mon cher oncle Pierre

Je te demande pardon de ne pas t'avoir ecri plus tôt. C'était le mardi 27 la distribution des prix, j'ai eu le 1 prix d'analyse et le prix du tri-merstre, mais malheureu-sement je n'ai pas eu le prix d'honneur, mais je te promet que ce sera pour l'année prochène. Pour ces prix papa m'a donné 2 francs, dans un parapluie et une boite de papier à lettre avec lequel je t'écri, maman me fait aran-ger ma montre que j'ai casé parce que je l'avait trop remonté et alors j'ai casé le resor, et mademoi-alle me donne des timbres. L'autre jour j'ai été voir les fabricassion des maisons ravaiegu par les boches et je les est visités, elles étaient très jolies, j'en ai choisie une pour toi et moi et nos quatres enfants. J'aurai 2 filles et 2 garçons si tu veux bien nous aurons chacun 1 garçon et une fille, dépêche toi de deman-der une permission pour que l'on puisse se marré parce que je vais partir à Deauville. - Je me suis servi ce matin de mon parapluie parce qu'il pleu-vait. Je t'embrasse très fort. - Françoise Marette

195

Wartime Diary

YVES CONGAR
(1904–1995)

On July 27, 1914, the ten-year-old Yves Congar took his mother's advice, offered earlier that same summer, and began to keep a diary. Its first lines read: "Today there was already talk of war." As this opening suggests, the diary would be less a record of childhood thoughts and experiences than an idiosyncratic almanac of World War I.

The first paragraph describes the international situation with disarming clarity: "A Serb assassinated the son of the king of Austria, which then declared war against Serbia. As a result Germany went to war with France, an ally of Serbia. The wives of military men were anxious and there were lines at the banks and savings banks, for everyone wanted to withdraw their money. Sedan [where the Congar family lived] is uneasy because of false rumors that are circulating in the town." Sometimes sufficiently full of patriotic bluster to call the enemy *boches* and *casque à piques* (piked helmets), standard French terms of abuse for the Germans at the time, at other times distressed by the noise of discharging cannons and by his father's capture by the enemy, the young Yves tried to situate himself through writing, to understand what was happening around him by describing things he had witnessed: a riot in front of a bakery, cavalry officers on patrol, and the like—in short, by keeping a daily record of wartime events.

When the war came to an end, Yves was fourteen. He could close his notebooks, whose pages document a remarkable stylistic evolution. Perhaps he already sensed his vocation. He took religious orders as a Dominican monk, and knew the joy of being named a cardinal a few days before his death in 1995. Two years later, his diary was published, its appearance bringing to pass something the boy had written, in small script and within parentheses, below the title of his first notebook: "for later publication."

Above:
Yves Congar's certificate of identity, dated January 1, 1917

Above and opposite:
Yves Congar, *Journal de la guerre franco-boche* (Diary of the Franco-German War), cover of the first notebook and drawing of Prussian soldiers in their "piked" helmets

Top left:
Photograph of Yves Congar taken to commemorate his first communion

An Unassuming Hero

JEAN MOULIN
(1899–1943)

Jean Moulin at age ten

Born June 20, 1899, in Béziers, in southwestern France, Jean-Pierre Moulin was the fourth and last child of Antonin Moulin and Blanche Bègue. His parents had previously lost their first daughter when she was quite young, and Jean's childhood was troubled by the death of his brother Joseph in 1907. Jean was frail and excitable. He lived in a small three-room apartment in Béziers, which he shared with his parents, siblings, and two cousins. He spent most of his vacations close to the family house in Saint-Andiom, about nine miles south of Avignon.

Jean's early life was strongly influenced by the political activity of his father, a history professor and Freemason whose passionate republicanism led him to espouse radical and anticlerical views. He considered it a point of honor that his son should become an open and tolerant man, a citizen committed to freedom and democracy.

In his youth Jean read little, but he devoured the illustrated children's books that were lent to the family by a bookseller friend. Throughout his schooling, his carefree nature and his propensity to daydream made him a mediocre student, but his drawings were admired by teachers and schoolmates alike. His earliest caricatures date from 1906, when he was seven; like the rest of his drawings, watercolors, humorous illustrations, newspaper cartoons, engravings, and etchings, they are now in the collection of the Musée des Beaux-Arts in Béziers.

Perhaps it was to reassure his mother, distraught by the death of her eldest son, that Jean, after obtaining his undergraduate degree, chose to pursue a career in the law instead of becoming an artist. He worked his way up the ladder of local government and was, after the fall of France, one of the first prefects to be dismissed by the Vichy government. He then became a leader of the French Resistance, opening an art gallery in Nice to serve as his cover.

When his "secretary" in the Resistance, Daniel Cordier, remarked during the occupation: "It's very surprising that you should choose a profession that isn't very serious and that, in the end, might give you away," Moulin answered: "You're mistaken; what is most conspicuous is most invisible." Jean Moulin's artistic production reveals the secret life of a man who, while apparently quite ordinary (he didn't distinguish himself in the eyes of his first teachers), matured into an altogether exceptional individual, a personification of the Resistance and of the suffering of its martyrs.

LA PROMENADE DES ANGLAIS

Left:
La Promenade des Anglais (a street in Nice), drawing by the six-year-old Jean Moulin. Béziers, Musée des Beaux-Arts

Opposite:
Autograph manuscript of a French composition by Jean Moulin, October 13, 1915. Assigned subject: "Your favorite hero." The teacher found that young Jean had placed insufficient emphasis on the *virtues* of Vercingetorix, the Gallic chieftain—defeated by Caesar—whom Jean had chosen to discuss. Bordeaux, Centre Jean Moulin
(The text of this composition is published in the appendix.)

7 1/2

Il y a presque à 7 f[?] sont quelques
fautes d'orthographe sont de graves inadvertances. Les
vues sont de graves inadvertances.
En racontant la vie de Ver. mettez en relief sa
Il fallait mettre en relief qualités.

Composition Française.

Le héros préféré.

Début ag... sujet

Notre histoire est celle qui renferme le plus
de traits héroïques. En effet dès ses origines
la France montre des exemples de courage et
d'abnégation. Et déjà avant notre ère, Ver-
cingétorix, le héros de l'indépendance gau-
loise combattit et se sacrifia pour la liberté de
sa patrie. C'est notre première gloire nation-
nale, c'est lui que je préfère entre tous.

Il employa toute sa vie pour à affranchir
la Gaule du joug écrasant des Romains. Mais
malheureusement des obstacles insurmontables
se dressèrent sur sa route glorieuse et il mourut
en héros dans la fleur de l'âge. C'était un jeune
homme robuste et intelligent de la tribu des

Arvernes

Il se fit remarquer de bonne heure par
son courage et ses qualités et devint bientôt le
chef du parti populaire. Le sentiment de la
patrie gauloise était né en lui. Il voyait avec un
serrement de cœur les Romains victorieux vivre
aux dépens d'eux et il exhorta les siens à s'unir
pour reconquérir leur liberté. Avec ses amis, il
alla de ville en ville, invoquant le souvenir de
leurs gloires et des glorieuses conquêtes qu'ils avaient
faites. Ils disaient aux habitants que leur
devoir était de prendre les armes pour gagner leur
indépendance. Ses paroles, son exemple, son
action enflammèrent les Gaulois qui se levèrent
tous contre l'ennemi. Et César fut cette
fois reconnaître le merveilleux accord de la
Gaule pour ressaisir sa liberté.

Tout ceci était dû à la persévérance et
à la volonté de cet ardent patriote. Vercin-
gétorix avait compris, d'après les expériences
fâcheuses qu'avaient senti les prédécesseurs,
que pour vaincre il fallait l'effort de tous.
Par ses encouragements il communiqua son
ardeur aux Gaulois qui firent taire toutes leurs
querelles, et se rallièrent sous leur jeune chef.

attention !!

Mauvais de
tournure incorrect

Ce n'était donc pas simplement une révolte de
tribu mais bien toute la Gaule qu'il
soulevait. "Chasser l'oppresseur" tel était le
noble but qu'il poursuivait et, comme dit
César lui-même, il ne s'arma jamais pour son
intérêt personnel mais pour le bien de sa
nation.

+ *Pas de transition*

+ Vercingétorix avait à faire à des soldats
bien entraînés et bien armés; leurs chefs avaient
autant de ruses que de sang-froid; aussi malgré
son courage et son habileté et après avoir tenu
un moment la victoire entre ses mains, il
fut contraint, écrasé par le nombre, à se retirer
à Alésia. Il s'enferma donc dans cette
ville avec les débris de son armée et y soutint
un siège mémorable. Réduits à un horrible
famine ils firent des efforts désespérés pour se dégager
de l'encerclement des Romains. Plus de vingt
fois, Vercingétorix, à la tête de ces hommes,
chargea avec un élan admirable contre les
assiégeants. Et chaque fois il se brisa contre
les remparts des Romains. Une armée de secours
venant de l'extérieur vint se faire battre devant
les retranchements de César. Leur dernier espoir

s'étant évanoui, les assiégés se désespérèrent.
Alors Vercingétorix, conservant seul une âme
ferme au milieu de la consternation générale, réu-
nit ses compagnons. Il leur dit que lui seul était
l'auteur de la guerre, que lui seul devait mou-
rir et il alla s'immoler en victime expiatoire.
Et pour conserver, même à la veille de la
mort, cette noble fierté gauloise qui nous carac-
térise, il revêtit sa plus belle armure, monta
sur son cheval de bataille et après avoir
fait caracoler son instant devant le tribunal
de César il jeta son épée, son javelot et son cas-
que aux pieds des Romains, sans dire un mot.
César manqua de générosité et il fit exécuter
son glorieux adversaire.

Vercingétorix avait vécu et était mort pour
rétablir la liberté de son pays.
Sa vie, son œuvre et surtout sa mort font
de ce héros primitif un des plus grands de
notre histoire. De tels ancêtres ne pouvaient
engendrer que des fils comme ceux qui se
battent aujourd'hui glorieusement sur les
coteaux de Champagne ou sur les bords de l'Yser.
A vingt siècles d'intervalle, nous voyons le même Français lutter
pour la même cause. Mais aujourd'hui c'est la
revanche et bientôt nous entendrons le coq gaulois
chanter la victoire.

bonne
conclusion

"The Awkward Age"

RAYMOND RADIGUET

(1903–1923)

Valentine Hugo, *Raymond Radiguet,* 1921

"All the great poets wrote at seventeen. The greatest are the ones that make us forget this," wrote Raymond Radiguet in September 1920. He must be numbered among the greats, but in his case circumstances precluded the mature writer's eclipse of the younger one. However simplified they might be, romantic images of striking destinies are tenacious. Who can forget that Rimbaud wrote *Le Bateau ivre* (The Drunken Boat) at sixteen and Radiguet *Le Diable au corps* (Devil in the Flesh) at eighteen? When he began work on this novel two years earlier, his working title was *L'Age ingrat* (The Awkward Age). Before the book's publication in 1923, he would consider a string of other titles, including *Le Coeur acide* (The Acid Heart), *Aigre saison* (Bitter Season), *La Tête la première* (Head-First), and *Le Blé en herbe* (Young Wheat), which by pure coincidence was used by Colette the very year Radiguet's book appeared.

The novel recounts, with admirable economy, an adolescent's love for a woman whose husband is away at the front, an unconventional love affair that, its author assures us (unconvincingly), was not autobiographical but that provoked scandal nonetheless. It was relentlessly promoted by Jean Cocteau and the publisher, who, proclaiming the arrival of "France's youngest novelist," and saw to it that newsreels disseminated images of the young author throughout the French-speaking world. By the time the novel came out, Radiguet—who began publishing poems and articles when he was fifteen—had already published two collections of his poems, *Les Joues en feu* (Cheeks Ablaze) and *Devoirs de vacances* (Vacation Assignments). Unfortunately, he did not live to see the publication of *Le Bal du comte Orgel* (Count Orgel's Ball), his second novel. He died from typhoid fever at age twenty.

Above and opposite:

Opening pages from the autograph manuscript of an early draft of *Le Diable au corps,* provisionally entitled *L'Age ingrat* (The Awkward Age). Paris, Bibliothèque Nationale de Franc

Je vais ~~encourir bien~~ des reproches. Mais qu'y puis-je ?
Est-ce ma faute si, venant d'avoir douze ans à
la déclaration de la guerre, les troubles qui m'
en vinrent furent d'une sorte qu'on n'éprouve
pas d'habitude à cet âge, ~~et enfin~~ s'il n'en
existe pas d'assez ~~vite~~ forts pour nous ~~on~~
~~les vieillir~~, malgré les apparences. Sans
doute tous mes ~~contemporains~~ camarades en
garderont. ils ~~—~~, à cause de leur ~~époque~~ enfance,
un souvenir qui ne ressemble pas à ceux de
la génération précédente. Mais ~~mon souvenir~~ le charme de cette

époque

~~A moi~~ ~~idées pour moi~~ ~~celui de l'âge~~, je
~~les dons~~ dépasse ~~revient~~ et à la guerre qui
provoqua ~~cela~~ me fut trop distante pour l'~~
atténuer~~. Que ceux qui déjà n'en veulent se
représentent ce que la guerre fut pour tant
de très jeunes garçons : quatre ans de grandes
vacances.

Mes parents, condamnant plutôt la camaraderie
mixte, ~~me qu'il les ne blamissent~~, ~~elle leur~~
~~était assez indifférente. Il ne s'y~~ ~~ne s'y~~
poussaient pas. La sensualité, qui naît avec
nous, et se manifeste ~~avant d'avoir ses~~ yeux
encore aveugle

"The Royal Falily"

BENJAMIN BRITTEN

(1913–1976)

Consensus holds that *Peter Grimes*, Britten's opera of 1945, is one of a handful of great twentieth-century operas, and it is worth considering whether the composer's childhood holds any keys to its success. The entirety of Britten's social and geographic environment in youth reappears in his operas: the Suffolk coast, the violence of storms at sea, nocturnal anxiety, human solitude. Indeed, his entire production is haunted by a single theme: that of the marginal being who violates social taboos and is finally rejected by society.

Even as a child, Britten was fascinated by theater and music, interests encouraged by his mother, a singer who regarded the boy's birth on Saint Cecilia's day as a sign of his destiny. While other children his age played with balls and dolls, he studied piano and composition. Even before he began piano lessons at age seven, Benjamin amused himself by writing theater scenes separated by sung interludes, for example *The Royal Falily* [sic], in which awkwardly delineated lines of dialogue alternate with perfectly legible musical notations of the songs.

The young Britten, self-taught, delighted in devising diminutive "symphonic poems" (only a few seconds long) about episodes in everyday life, from a shipwreck to the making of a new friend. Extremely precocious, he turned out symphonies and songs, producing what might be his first masterpiece at age fifteen: *Four French Songs*.

Such postwar works as *Peter Grimes* (1945), *Billy Budd* (1951), and *The War Requiem* (1961), as well as the creation—with the tenor Peter Pears, his companion in life—of the Aldeburgh Festival in 1948, catapulted Britten to the front rank of British composers, prompting comparisons with Handel and Henry Purcell.

Top left:
Sarah Fanny Hockey,
Benjamin Britten.
London, National
Portrait Gallery

Left and opposite:
Pages from the
autograph manuscript
of Benjamin Britten,
The Royal Falily.
Britten-Pears
Foundation

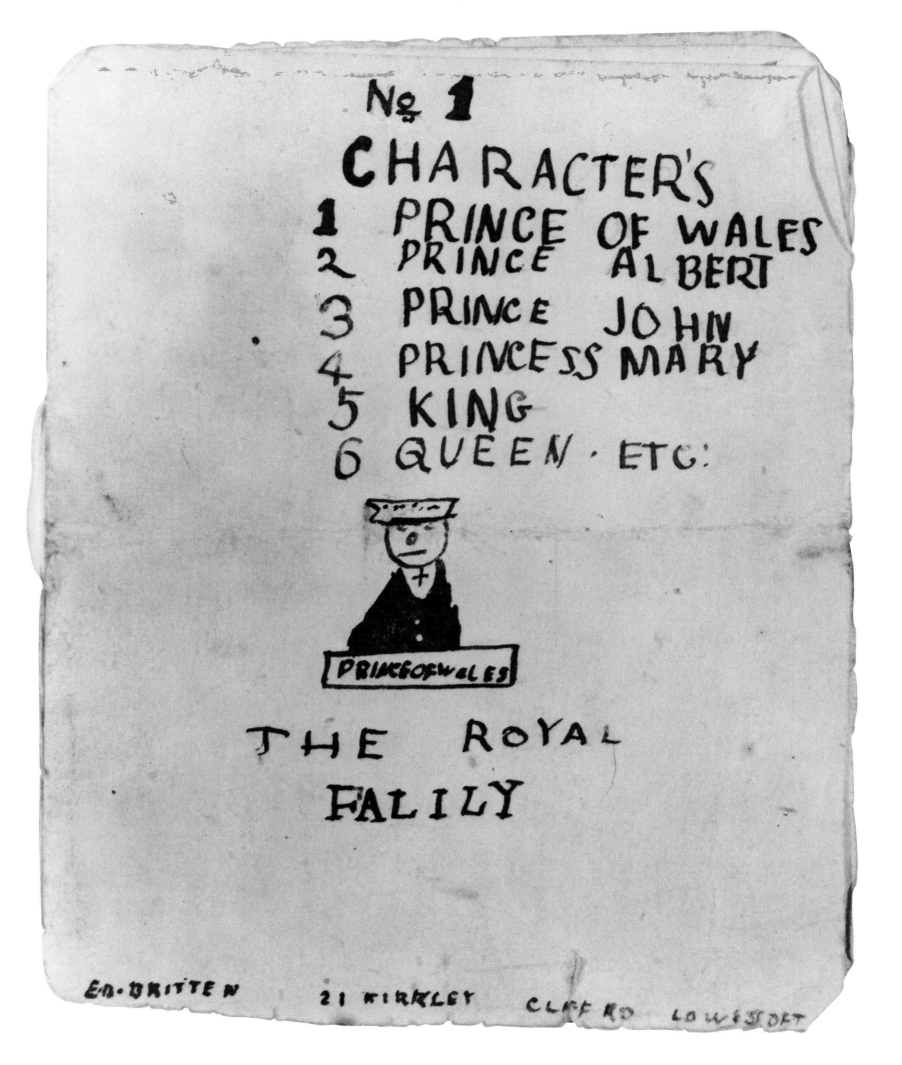

Nº 1
CHARACTER'S

1 PRINCE OF WALES
2 PRINCE ALBERT
3 PRINCE JOHN
4 PRINCESS MARY
5 KING
6 QUEEN · ETC:

PRINCEOFWALES

THE ROYAL
FALILY

E·B·BRITTEN 21 KIRKLEY CLIFF RD LOWESTOFT

203

Painting Against the Grain

SALVADOR DALÍ
(1904–1989)

In his *Diary of a Genius*, Dalí says that his parents named him Salvador because he was destined to "be the savior of painting, which was threatened with death by abstract art, academic surrealism, dadaism, and, generally speaking, all of the anarchic 'isms.'" In reality, they could not have dreamed of such a program, but they certainly adored this child-king, this "messiah" whose primary mission in his family's view was to escape the fate of an elder brother who had died nine months before the artist was born. "My brother was only a first draft of myself, conceived in impossibly absolute terms," Dalí later remarked. He would be haunted his entire life by this ghostly double.

His father was an authoritarian figure. Although he admired the exceptional gifts of his son, who completed his first painting at age six and received his first palette from the painter Siegfried Burmann when he was ten, he did not actually encourage the boy to pursue an artistic career, but at first simply indulged the child's whims. Fortunately for the boy, his parents were close to the Pichot family, all of whose members were artists, painters, or musicians, and they managed to convince the Dalís of the seriousness of his commitment. In all likelihood, it was while looking at the canvases of Ramón Pichot that Salvador first felt a desire to become an Impressionist painter. A few works from this period survive, for example a portrait of the cellist Ricardo Pichot (1920), the free handling and soft, muted scheme of which contrast with an imposing portrait of his father completed the same year. The extent of Dalí's gift, suggested in *Portrait of Hortensia, Peasant from Cadaqués*, painted in 1918 when he was fourteen, was now confirmed. Ferociously independent, taking a perverse delight in doing exactly the opposite of what his teachers asked of him, Dalí was determined to become an artist whose fame would extend throughout the world. He passed his examinations at the school of fine arts in Madrid in 1921, on which occasion his judges noted: "Although the drawing was not executed in the specified dimensions, it is so perfect that the jury has accepted it."

Above:
Salvador Dalí, *Portrait of Hortensia, Peasant from Cadaqués*, c. 1918–19. Private collection

Top left:
Salvador Dalí, *Self-Portrait with the Neck of Raphael*, oil on canvas, 1920–21. Figueras, Fundación Gala-Salvador Dalí. Gift of Dalí to the Spanish state

Opposite:
Salvador Dalí, *Portrait of My Father*, oil on canvas, 1920–21. Figueras, Fundación Gala-Salvador Dalí. Gift of Dalí to the Spanish state. "When I was six, I wanted to become a cook. When I was seven, I wanted to be Napoleon, and since then my ambition has never stopped growing."

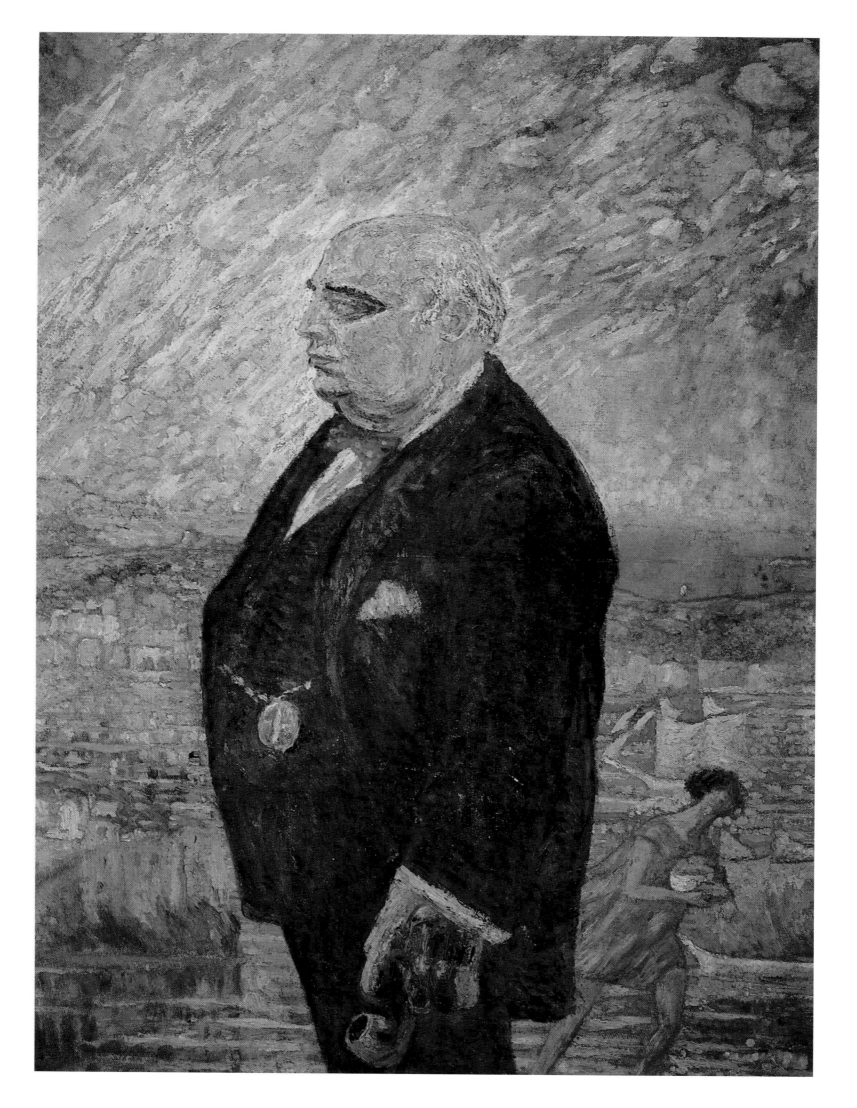

Balthasar's Cat

BALTHASAR KLOSSOWSKI DE ROLA, KNOWN AS BALTHUS

(born 1908)

What could be more natural for a child than to draw, especially when both of his parents are painters? We can be sure that the young Balthasar Klossowski de Rola never asked himself this question, but he nonetheless provided an answer. At age twelve he produced *Mitsou*, a little book recounting in images the "true" story of a cat found, lost, and recovered but finally lost again on Christmas Eve. Its final drawing shows a distraught little boy crying in his bedroom.

These forty ink drawings, which have real narrative force, were published the very next year, 1921. The artist had already found his pseudonym, although he initially spelled it "Baltusz" instead of "Balthus."

The book needed a text. A writer was found, but instead of devising captions he chose to preface the images with a text addressed directly to his young collaborator, whose gifts he praised. Sensing the emotional precocity of these images, he postulated that the boy had already experienced loss and, under its influence, had instinctively grasped the reparative power of artistic sublimation: "You felt it, Baltusz; no longer seeing Mitsou, you arranged to see him some more," suggests the author in French, which was not his native language. For he was none other than the celebrated German poet Rainer Maria Rilke, a friend of Balthus's mother, the famous Merline, with whom he would correspond until his death. Together, the poet and his young collaborator managed to produce an illustrated book that would continue to enthrall later generations.

Six compositions by the twelve-year-old Balthus (here spelled "Baltusz") from *Mitsou: Forty Images*, published in 1921 with a text by Rainer Maria Rilke. The artist, subsequently encouraged by Georges Braque, first exhibited his work at age sixteen.

207

"Drawing is Meditative"

HENRI CARTIER-BRESSON
(born 1908)

Henri Cartier-Bresson in 1924.

"Photography is for me the spontaneous impulse of a constant visual attention that captures an instant for eternity. Drawing . . . elaborates what our consciousness has seized of this instant. Photography is an immediate action, drawing is meditative," wrote Henri Cartier-Bresson in 1992.

Henri Cartier-Bresson was born on August 22, 1908, in Seine-et-Marne outside of Paris, not far—as he once remarked with bemusement—from the present site of Euro-Disneyland. His mother was originally from Normandy; the family settled in Paris, where his father, Parisian by birth, ran a textile business. Young Henri studied at the Lycée Condorcet and the Lycée Fénelon, where he first read Rimbaud, Lautréamont, Dostoyevsky, Proust, Joyce, and Romain Rolland. But he failed to pass his graduation examinations three times, dashing his parents' hopes that he would enter one of the professions.

"Painting became my obsession after my 'mythic father' Louis Cartier-Bresson, one of my father's brothers killed in the war in 1915, took me into his atelier during the Christmas holidays in 1913. There I lived in an atmosphere of painting, I sniffed the canvases. A friend of my uncle's [Jean Cottenet], a student of [Ferdinand] Cormon like [Chaïm] Soutine, introduced me to oil painting when I was twelve." During his summer vacation in Normandy, Henri painted with one of his cousins under the supervision of Jacques-Émile Blanche.

From his youth, then, he frequented artistic circles (Blanche was a friend of the family), befriending René Crevel, Max Ernst, Élie Faure, and Max Jacob. He visited museums and galleries, enthused over the films of Buster Keaton and Sergei Eisenstein, and was attracted by the surrealists, especially André Breton and Louis Aragon, whom he met at Café Blanche. In 1927–28 he studied with André Lhote, the theorist of Cubism, of whom he remarked: "He taught me to look rigorously rather than to identify [with what I saw]." A career as a painter beckoned. Only in 1931 did photography strike him with the force of a revelation, in the guise of Martin Munkasci's *Child on the Shore of Lake Tanganyika*.

Left:
Henri Cartier-Bresson, *Rue des Saules*, 1924. Collection the artist. Camille Corot and Paul Cézanne also painted this street in Montmartre.

Opposite:
Henri Cartier-Bresson, *The Church at Guermantes*, 1924. Collection the artist

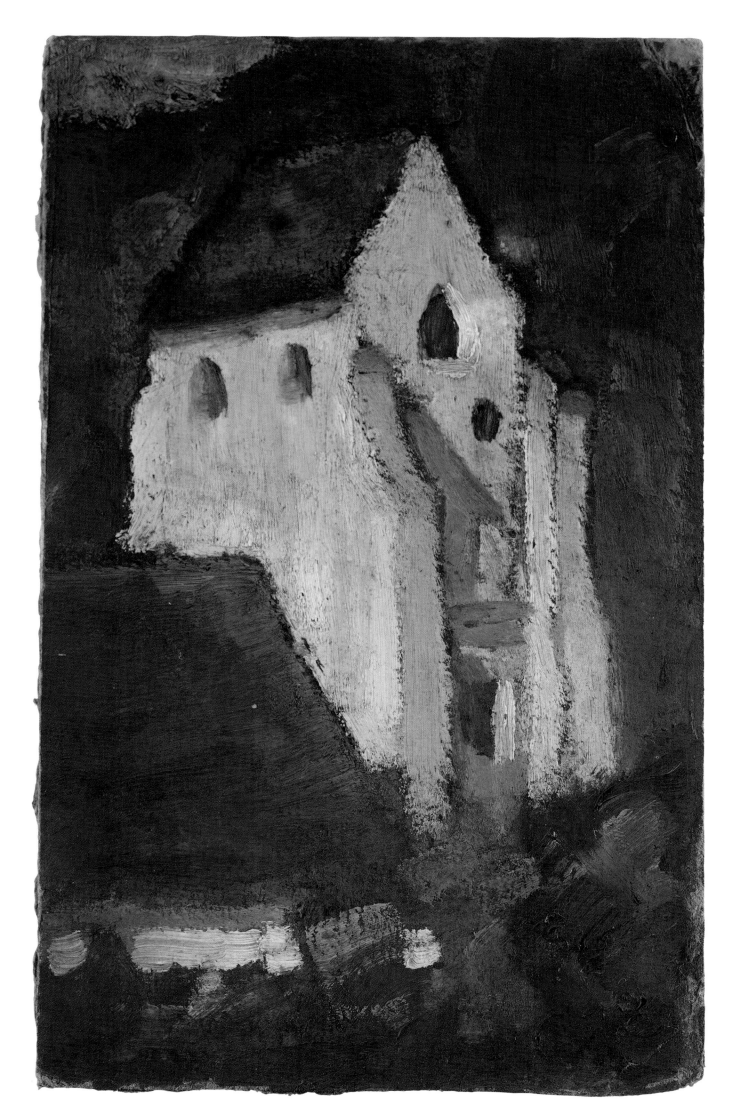

In Hiding

ANNE FRANK
(1929–1945)

On June 12, 1942, Anne Frank, a German Jewish girl living with her family in Amsterdam, celebrated her thirteenth birthday. Her parents gave her a notebook in a red and white binding, equipped with lock and key, that was destined to become her private diary. On its first page, she wrote: "I will, I hope, be able to confess all kinds of things to you that I haven't yet told anybody, and I hope you will be a great support to me."

Anne Frank would need support. By 1942, the situation was already quite difficult in Holland for Jews, who were subject to a host of prohibitions; they were barred, for example, from working, attending school, and even taking public transportation. The noose was tightening: on July 5, Margot, Anne's sister, was summoned to appear before the SS. It suddenly became imperative either to flee or to hide. The next morning at dawn, the family left on foot to find refuge, thanks to friends, in the annex of a business formerly directed by Otto Frank, Anne's father. They would remain in hiding for two years in these rooms, where on a small table Anne wrote the greater part of her diary, an irreplaceable account of the clandestine existence of Jews during the war as experienced by a courageous young girl who never lost hope and never succumbed to hatred. "We make as little noise as mice. Three months ago, who would have believed that quicksilver Anne would be obliged to remain still for hours at a time and succeed?" she wrote on October 1, 1942. Little by little, Anne entered early adolescence within these close quarters; as her body matured (she grew five inches while in hiding), she fell in love with the son of friends of her parents, in hiding with them.

In 1944, hope was renewed by talk of the Allied landing. But on August 4, Dutch Nazi soldiers entered the Franks' hiding place; they had been denounced. Anne's mother would later die at Auschwitz. Anne and Margot, their shaved heads rendering them all but unrecognizable, were sent to Bergen-Belsen, where they died of typhus within a few days of each another, some three weeks before the camp was liberated by British forces. Only Otto Frank survived. When he returned to Holland he was given his daughter's diary, which had miraculously escaped seizure. Published soon thereafter, it was translated into fifty-five languages and sold twenty million copies. Anne Frank, struck down by Nazi barbarity at age fifteen, had wanted to be a writer; the success of the diary realized her dream.

Above and opposite:
Pages from *The Diary of Anne Frank*. Anne Frank Archive, Langendorf, Switzerland

Top left:
Anne Frank with her diary. Anne Frank Archive, Langendorf, Switzerland

Ik begin met de foto
van Margot en eindig
met mijn eigen.
Dit is ook Januari
1942. Deze foto is
afschuwelijk, en ik

lijk er absoluut niet op.

Mej. Anne Frank

Merwedeplein 37

Amsterdam

Dit is Juni 1939.
Dat is de eenige foto van
oma Holländer, aan
haar denk ik nog
zo vaak en ik wou
dat zij nog maar
de huiselijke vrede
bewaarde.

Dit is 1940,
nog eens
Margot en
ik.

Appendix
Complete Transcription of Selected Texts

Published here are translations into English of the complete texts of certain letters that, due to limited space, could not appear with the illustrations. When letters are only partially transcribed in the main body of the text (including several not included in this appendix), ellipses (. . .) indicate that portions of the text are missing. When the complete text of a letter appears in the appendix, a note to this effect appears at the end of the portion published with the illustration. Please note that in the appendix the original punctuation and capitalization have been retained as far as possible.

The original French texts are published in the appendix of the book's French edition.

JULES MICHELET

These lines were written in 1816 by Jules Michelet for Madame Fourcy, whose daughter had just committed suicide.

1816
Heart oversensitive and virtue too severe
Grace, talent, kindness, goodness
Death has consumed all!
Plead a mother's pain,
Maternal love
You are conversant with spells!
Console her by joining in her tears!
Save me from the lugubrious cypress
And the dark-leafed yew
Come and crown this image
Eternal monument of mourning and regret!
But let us not sadden this cherished image.
Wreath it with flowers, decorate it with these lilies
These lilies so pure, an emblem of her life
These lilies, alas! so quickly faded . . .
You who shed so many tears on her tomb
In the name of friendship quiet your pain
Turn your eyes oh unfortunate mother
Upon her who offers you this token of friendship
In her you will again see your much regretted daughter!
Hortense exists still and your comforted heart
In its embraces has already found her once more.

THÉOPHILE GAUTIER
Letter to Pierre Gautier

Maupertuis, July 4, 1825

My dear papa,
I am going to give you, as you asked, an account of everything that has happened to us since we left home; when we reached the Place Royale, mama told Honoré to stop because she thought her gown might be finished. Consequently, Samuel descended from our triumphal chariot and went to Madame Poteau's; after some considerable time had passed, we saw him return not with the gown but with Hélène who bid us farewell. Mama gave her final instructions over the side-rails. We proceeded rather slowly up the rue du Pas de la Mule; there Honoré decided he'd better talk to Huard, so we had to stop. Everything seemed to oppose our departure; only with reluctance did

Paris let us abandon her winding labyrinth. Honoré remained at Huard's at least half an hour. Due to multiple impediments, the countless number of market gardeners making their way to the market, who compounded the confusion, it took us an hour and a quarter to get through the faubourg. Near the guard-house, Honoré began to fall asleep. Morpheus showered down poppies on him; already the columns of the barrière du Trône were disappearing; and the ancient towers of Vincennes lifted their pavilions, gilded by the sun's last rays, into the air; our charioteer was still asleep; in the meantime I performed his functions. We woke him at Vincennes, where at Jeannet's he picked up a sugar-loaf and a jug of oil. These details might seem overly particular, but they were to play a rather remarkable role in our trip of which I was the sad victim. For my sins, this cursed jug was placed beside me; with every jolt of the carriage, this infernal jug threw itself against my legs with terrible violence; it obliged me to abandon the pile of straw in which, immersed up to my neck, I was defying the caresses of the cold north wind. Samuel fell asleep toward Saint-Maur and joined in chorus with Honoré's snores; after having crossed the Saint-Maur bridge, in the middle of which is a small pyramid or obelisk, Zoé felt obliged to join in the ranks of the sleepers. If anyone in Paris should ask you who was driving, be sure to say it was Honoré, but [in fact it was] his horse that recognized with admirable instinct the way it should take. There's only enough room on the paper for me to embrace you and sign

Théophile

P.S.: Don't be surprised if you receive nothing from us; we can scarcely procure a few bad cherries, which we are lucky to have; neither peas nor carrots, neither green beans nor potatoes, in fact no vegetables: thanks to the drought, there's nothing except grapevines and wheat, here there are only [illegible] and [illegible] granted with pain a [missing] were half cooked [missing] to discharge M. . . .

ALFRED DE MUSSET
Letter to Paul Foucher

Château de Congers
September 23, 1827

No, my old friend, I haven't forgotten you; your misfortunes have not alienated me from you and you will find me always ready to answer you, whether you want tears or laughter from me, whether it is joy or pain that you wish to share with me. Could you believe for an instant that your friendship was irksome to me? Then you were wrong, for in your place I haven't had any such idea. So you think I'm more favored by fortune than you are? Listen, my dear friend, listen to what has happened to me.

Scarcely had I completed my examination when I began to think about the pleasures that awaited me here. My bachelor's degree encountered my diligence ticket in my pocket, and neither wanted anything more than the other. Here I am in Le Mans; I run to the house of my beautiful neighbors. Everything's going wonderfully; I'm taken to an old château.—A cursed catarrh forgotten for six months again grips my grandmother, I receive a letter informing me that she is in danger, and eight days later a second letter that tells me to begin mourning. On such things depend the happiness and pleasure of this life. I cannot tell you what frightful reflections this very sudden death prompted in me; I had left her two weeks before in a large armchair, conversing spiritedly and full of health. And now earth covers her body; the tears that her death caused those around her to shed will soon be dry, and there you have the end that awaits me, that awaits all of us! I want none of those condolences-to-order, none of the pain that can be doffed with the mourning clothes; I'd prefer that my bones be thrown to the winds; all these feigned or too quickly dried tears are just a bad joke.

My brother left for Paris; I am alone in this infernal château, where the only person I can speak to is my uncle, who is, admittedly, quite fond of me; but the ideas of a man with white hair are not those of a young man with blond hair. He is over-educated, and when I talk to him about women I like or verse that has made an impression on me, he replies: "Wouldn't you prefer to read all that in a good historian? There everything is always true and more accurate." Having read Shakespeare's *Hamlet*, you know what effect the wise and learned Polonius had on him [i.e., Hamlet]! Yet this man is good, he is virtuous, he is loved by everyone! He's not one of those people for whom a stream is merely running water, a forest merely wood of such and such a species and hundreds of sticks. May heaven bless them! They are perhaps happier than you and I.

I am bored and sad; I don't even

have the courage to work. What would I do? Upset old positions? Could I produce something original despite myself and my verse? Since I've started reading the journals (my only distraction here), for some reason all that seems utterly miserable to me! Maybe it is the quibbling of the commentators or the stupid obsessions of the adapters that disgusts me, but if I can't be Shakespeare or Schiller I'd rather not write at all! I feel that the greatest misfortune that can befall a man with intense passions is to have them no longer. I am not in love; I'm producing nothing. There's nothing to keep me here; I'd sell my life for two sous, yes, if death weren't the only way to leave it.

Such are the sad reflections I cultivate. But I have the French spirit, I feel it:— if a pretty woman arrived, I'd forget the entire system I'd built up during a month of misanthropy; — if only she made eyes at me behind the scenes, I'd adore her for . . . for at least six months. I hope age matures me, for I'm ready to take the plunge.

I'd give twenty-five francs to have one of Shakespeare's plays here in English; the journals are insipid: their criticism is so flat. Make systems, my friends; establish rules, you work only on cold monuments from the past. If a man of genius were to appear, he'd topple your scaffolding and laugh at your poetics. From time to time I feel the urge to pick up a pen and sully one or two sheets of paper; but the initial difficulty repulses me; a sovereign distaste makes me spread my arms and close my eyes. How long I've been left here! I need a pretty foot and a narrow waist; I need to love. — I'd love my cousin, who is old and ugly, if she weren't a thrifty pedant.

So I write to you of my distaste and my boredom; you are my only connection to something rousing and reflective; you are the only thing that awakens me from my nullity and steers me toward an ideal that I've forgotten in my impotence. I no longer have the courage to think. If I were to find myself in Paris at this moment, I'd drown whatever nobility is left in me in punch and beer, and I'd feel relieved. They put sick people to sleep with opium, despite knowing that the sleep will probably prove fatal. I'd do likewise with my soul. Isn't there some boring old geezer in a wig here to tell me: "All that's because of your age, my child. You need a little distraction, not too much; and then you'd get your law degree and enter a solicitor's office." Those are the people I'd strangle with my own hands; nature has made Man

the model of everything that's bad; vipers and owls are horrible creations; but that a being capable of feeling and loving should distance his soul from everything capable of adorning it by making it a hobby, and then make a law degree out to be something important! Anatomists who dissect triglochid valvules, tell me they aren't polyps! You see that I'm writing whatever comes into my head; do likewise, I entreat you, I need your letters; I want to know what's happening in your soul, as you know what's happening in mine; doubtless they are animated by the same breath, why does he who gave it to us leave it imperfect? I cannot endure this mixture of happiness and sadness, this amalgam of degradation and heaven. Where is harmony if the instrument is untouched? I am drunk, weary, oppressed by my own thoughts; only one option is left me, to write them down. But perhaps I will leave in a few days. Where will I go? I've no idea. If I return to Le Mans, I'll find everyone sad, my grandmother dead, my whole family in tears, mama, my uncle, and, in the middle of all that, my grandfather, asking everyone who passes by "Where is my wife?" adding: "I hope she's just indisposed." Isn't that a state worse than death?

My sister, about whom you ask for news, is feeling better. By the way, it seems I've had something of a triumph at Monsieur Caron's. Happy, thrice happy he to whom such a pleasure matters! Why has nature given me a thirst for an ideal that can never be realized? No, my friend, I can't believe it, I have that much pride: we are both destined to be more than estimable or reputedly intelligent lawyers. In the depths of my soul, an instinct cries out the contrary, I still believe in happiness, although I'm very unhappy at this moment. I await your response with impatience and I wish with all my heart that I could hear your voice.

Farewell, my dear friend, and warmest regards

GUSTAVE FLAUBERT
Text presented to his mother on July 28, 1831.

To mama on her name day

Louis XIII

Since Louis XIII was only nine years old, the *parlement* gave the regency to his mother Marie de Medici. Intrigue and meanness reigned at the court,

Sully, the friend of the good Henri IV, was dismissed. Marie de Medici placed her trust in an Italian named [Concino] Concini and his wife. Luynes favorite of the young king and a particular enemy of the queen, tried to get rid of the marshal d'Ancre or Concini by inspiring in the dauphin a desire to reign.

The fall of the marshal d'Ancre

Finally Luynes and several other gentlemen managed to inspire in Louis XIII the most intense desire to break free of the guardianship that had been imposed on him. Under a king conscious of his strength, the government could have been overthrown merely by a disgrace. The marshal d'Ancre would have been exiled and imprisoned and the queen mother would have been quietly denied access to [state] business. But Louis and his confidants were timid, fearing the power of the marshal and problems that might not have arisen had they opted for violence. Luynes's brother Maulus and L'Hôpital de Vitry captain of the guards resolved in the king's presence to attack the marshal in the courtyard of the Louvre when he left the queen mother's apartment. This first attempt miscarried due to a misunderstanding. But on April 24th and 27th according to Anquetil 1617, more precautions were taken. The king on the pretext of going hunting had his guard regiment the only one at his disposal mount their horses to support the enterprise. Vitry went to the Louvre with a few gentlemen carrying pistols under their cloaks and positioned himself on the drawbridge.

The marshal d'Ancre arrived there followed by a rather large retinue. Vitry followed by his men approached the marshal and told him grasping his right arm "the king has ordered me to apprehend your person." "It is mine" the marshal cried in Italian placing his hand on his sword "to defend or to surrender."

Vitry, Duhallier, and Sirray [?] then fired their pistols and the marshal's blood flowed at their feet. Vitry immediately cried "Long live the king" the gates of the Louvre were closed and the guard remained in defensive formation.

When the king learned of the death of his minister he went to the windows of his palace and cried to Vitry "Many thanks now I am king." Vitry was later named marshal of France and obtained from the king letters patent [stating] that the marshal d'Ancre had been murdered

at the express order of the king.

Concini's body was wrapped in a black sheet and buried in Saint-Germain-l'Auxerrois around midnight, but the next day the people went in a crowd to the church where despite the resistance of the clergy the body was exhumed dragged as far as the Pont Neuf and hung from a gibbet that the marshal had built for those who spoke ill of him. Then it was dismembered it was cut into a thousand pieces and the remains were sold, one woman even ate some. That very day the marshal's children were removed from the palace and one of the marshal d'Ancre's children was seen running through the streets of Paris making extravagant gestures he was asked what was wrong and he said I have my father's madness, [Leonora] Galigaï his wife perished on the scaffold accused of sorcery. The Protestants displeased with the court armed themselves and marched against Louis the king surrounded them in Montauban but had the siege lifted. Then Richelieu came to the ministry founded the Académie Française and put France's affairs in order his most glorious monument is the siege of La Rochelle the boulevard of the Huguenots, with a marvelous dike Richelieu closed the port to the English, he commanded the troops himself and the city's inhabitants surrendered. The siege of La Rochelle was the final blow against the Protestants they kept their religion but lost their strongholds.

Louis indicated his bravura in the battle of Mantua against the king of Spain where Richelieu exercised his military talents.

After having triumphed over the enemies of his master this great politician knew how to dispose of his own.

Richelieu's ministry was despotic he taxed the great and in a word prepared the marvels of the reign of Louis XIV. Louis XIII died five months after Richelieu in the year 1642 at age forty-two after having reigned for thirty-three.

Below is a list of "new inventions," death dates of "famous people," and "memorable events."

G. Flaubert

THE PRINCE IMPERIAL
Letter to Ernest Lavisse, August 12, 1871

My dear Monsieur Lavisse,
I received with great joy and intense emotion your letter about Saint-Cloud

and your memories of it, I received your note about the same time you wrote to me a year ago to congratulate me on my baptism of fire. I noticed this coincidence of dates and couldn't help but think about the series of misfortunes that have succeeded one another since a year ago.

I received news of you with great pleasure for your memory remains dear to me.
Your affectionate Louis Napoleon
August 12, 1871
Camden Place (Kent)
Chislehurst

Letter to Ernest Lavisse, March 22, 1872

My dear Monsieur Lavisse,
I read your letter with great pleasure, because the feelings expressed in it are engraved on my heart in letters that neither time nor circumstances can efface. I am happy to see, and every day brings me more evidence of this, that many people in France think as you do, dear Monsieur Lavisse, and that, whatever they say, feelings of obligation, of love of country, are not so rare among us. I close by asking heaven to grant our prayers, may France again become a great nation and my sole ambition is to contribute to this work, toward which every Frenchman should sacrifice a portion of his pleasure and shed every last drop of his blood.

Soon, I hope, dear
Monsieur Lavisse
Your affectionate
Louis Napoleon

MARCEL PROUST
School Composition

[*Editor's Note: "The Trial of Piso" is a French composition written in 1883–84, when Proust was twelve years old. This copy is inscribed at the top Lege, quaeso (Read, I beg [you]), a sign to the teacher that its young author had taken particular care with it.*]

The Trial of Piso before the Roman senate

Not long after having returned to Rome, Agrippina accused Gnaeus Piso, the governor of Syria, of having murdered her husband Germanicus there. Piso was imprisoned and the case referred to the Roman senate.

Agripinna enters the curia and all the old senators bare their heads

before this woman made venerable by her misfortunes, and all of the men in whom servility had extinguished all noble sentiments feel an unknown desire for justice spring up in their hearts. They receive Agrippina with respect and are pleased to hear the people cry outside:

Death to Piso, death to the assassin.

Only a few of Piso's friends rise and ask that in the name of the empire Piso be judged without passion:

"Roman senators, will you allow yourselves to be influenced by the cries of a vile populace or by a woman's tears? Consider that justice is the strength of Rome as well as its glory!

Would you have the courage to condemn without judgment, to punish without appeal? No, you owe it to yourselves, you owe it to the empire, you owe it to the emperor to remain calm in judgment. Let passion play no role in your decision. Listen to the defendant with as much favor as you do the accuser. Consider that a man's life and the honor of an entire family depend upon your decision. Show that Rome has not declined."

Agrippina herself is struck by the wisdom of this speech, and fearing that her prey might escape her, she rises, her eyes aflame, and says vehemently:

"Germanicus is dead and his murderer lives. The villain poisoned him: he dared not engage in armed and equal combat with the victor over the Germans: so he killed him viciously: he is an assassin.

He attacked the emperor when he attacked his heir, he placed possessions of the empire in danger by killing their conqueror, he abused all honest people when he killed Germanicus. So he is above all harmful to the state, and it is the voice of public interest that urges me to sue for his death.

But now consider my situation, oh Roman senators: I who saw my husband emerge safe and sound from the revolts, who saw him remain calm amidst mutinous legions, I see him vilely poisoned.

The sight of me moved to pity soldiers intoxicated by the blood of their chiefs; won't you, Roman senators, demand that she be avenged? Consider whether, if you leave Piso unpunished, you won't be disgraced for eternity.

He is a bad citizen, so remove him from the roll of citizens. You are perhaps considering exiling him? But the traitor who killed Germanicus will

ally himself with the barbarians, who will construe 'assassin of the first general of the empire' as a title to glory! No, no, Piso must be condemned to death, his just recompense for having revolted against the emperor."

Carried away by the intensity of this speech, moved by the view of this woman, whose august beauty was enhanced by anger, they turn against Piso. His death sentence is about to be pronounced.

But they see the emperor remain impassive, and perhaps ashamed of having allowed themselves to be swept into views far from his, they mumble shamefully, speak of Piso's courage, of the services he has rendered, when Sejanus enters, holding a bloody dagger in his hand.

"Here is the weapon," he says, "with which Piso took his own life. When I entered his prison, thinking it was the people who came, he killed himself to avoid falling into the hands of his fellow citizens while alive. When he saw me, recognized his error, he said to me in a dying voice: 'I thought the people were coming and I didn't want them to kill me: I regret this impetuous act for I wanted to explain to the senate that I was innocent and save my name from eternal shame.' I then told him that the emperor would have taken pity on his son in any case and implored him to tell me whether he was guilty. Sitting up, he swore on the Gods that he was innocent, and immediately a bloody flux came out of his mouth and he fell stone dead. So he is innocent for a dying man would never damn himself for eternity by perjuring himself, especially when paternal love had nothing more to fear."

But at these words, Lucius rises, his face purple with rage, and reprimands him, saying in a hoarse voice:

"Oh Sejanus, you are very skillful and the ignorant would be swayed, but my father told me everything: he was guilty but was following Tiberius's orders. The emperor knew he had to hide his secret, and resolved to kill it off with Piso, but as the famous accused would have spoken before the senate, he had him assassinated in prison: in vain, for my father confided his secret to me."

Then, with an ironic inflection: "I'm extremely grateful to the emperor for his having deemed it sufficient for Piso to die without being judged–when all he had done was obey the orders of his ruler–and for having at least wished to restore his memory by

fabricating this story.

But first the truth: my father was guilty but Tiberius is even more so, and when you say, oh Agrippina, that Piso attacked the emperor when killing his heir, you are strangely deceived, for it is the emperor himself who ordered the death of Germanicus.

As for me, having now exposed the emperor's infamy and Sejanus's treachery, I am ready to die."

Whereupon, seizing the dagger from Sejanus's hands, he stabs himself in the chest.

In the face of this sudden revelation, Tiberius knows that his plans have misfired, he sees himself shamed, he feels despised.

He knows that no one will make the slightest sign of contempt, but he also knows that in their hearts people will slander him. His mind, already overflowing with spleen, grows even darker; he is overcome by anger, not anger that is frank and exuberant but an anger that he locks in his heart; the muscles of his face express no feeling but he is aroused to dreadful resolves, and he promises to himself that he will effect the deaths of all these senators, guilty of knowing his secret, and that he will send away this Agrippina, whose forthright character was already unbearable to him, and to whom he had now become hateful.

As for her, without indulging in invective against the emperor, she left, throwing him a glance of sovereign contempt, and went to weep over the body of Lucius; in her eyes, the emperor's treachery had effectively absolved Piso.

And at the same time, the senators left in confusion, not daring to confront the emperor after such an outburst.

[*Editor's note: The first sheet of the manuscript translated below is reproduced on page 145.*]

French assignment

The air is perfumed with the fragrance of fresh lilac. The sun rises gaily. It gilds the countryside with its rays: finally we have before us a radiant May morning. Hidden below the hawthorn is an old cottage, smoke rising from its chimney, that Denis Revolle acquired at the time of his marriage. It bears witness to gentle nights. The tall, dark fellow in white jacket and blue hat who emerges, humming, from the little building is the same Denis Revolle who five years ago was at Saint-André, why we need not say. He seems troubled at the

prospect of leaving; he hesitates, turns, inclines toward the house, then toward the town, and finally remains in his modest residence. After five or perhaps ten minutes (my impatience to know his final decision made the time seem long), he came out again followed by a young blond woman, rather pretty, with blue eyes. She was of course swathed in a cashmere of which one might have said: "and holes in the sheet marked the exploits," with all due deference to Corneille, for Denis would have been less than entirely satisfied if I had left the verse intact as Maxime did in his *Plaideurs*; for the rest, what affinity between an old man and a young girl! Two little boys accompanied him as far as the gate and the little girl, a baby with vermilion lips and hair, might have been made of tow. She cried out to him in a fresh voice that would have reminded a naturalist of the sound of air breaking against vocal cords and a novelist of the nightingale's song but seemed to me, neither naturalist nor novelist but simply an amateur, a pretty voice capable of charming its world, myself excepted. "Goodbye, papa, don't forget the doll." The mother smiled, and she cried out, too, but this time I won't analyze her voice, and for cause . . . "Be careful on the scaffolding; I know you are, but . . . it only takes one time, you know, and then . . . courage is never enough.["] Her features took on a singular cast. Her eyes seemed to try to make out the future as if from the middle of a thick cloud and yet seemed fearful of searching too hard. Her face is forever engraved on my memory. I can still see her pale yet pink coloring and her windblown hair, a prophetic and maternal air, an indeterminate something that has no name in any language. But as I speak of the mother, Denis Revolle, a courageous construction worker, set to work. Having no head for numbers, I will merely say that it was in the faubourg Saint-Germain. After two hours, the house was finished or rather had been finished. See the rectangular windows, the gracious ornament; enter and view the ceilings painted with historical subjects, over here the fresh and well-lit dining rooms [*sic*]. But I stop myself, for fear of meriting a dismissive "These are only festoons, these are only astragals." A flag is placed on the gable and the drunken workers rejoice. They disperse; one recovers his saw, another his pen, a third savors some bread spread with white cheese that he's just taken out of his pocket. These are not people

like the foreign beggars in rags who wear jewelry. They have no showy objects but their clothing is carefully mended. They are perhaps just as poor but less itinerant. In the end they are wanderers, living in the mountains, then in the grasslands, then in the city. Which makes us say "a rolling stone gathers no moss." Two gentlemen passed by wearing gray pants, chestnut yellow jackets, round hats, Tyrolean gloves, fantastic cravattes, and monocles. Here is their conversation. N.: "Whose house is that?" M.: "Count X's." N.: "Rich?" M.: "Yes." N.: "Children?" M.: "A daughter." N.: "How old?" M.: "Eighteen." N.: "Charming." M.: "Ah! Quite a deal for the son-in-law." N.: "And the heir." M.: "Until I next have the pleasure." N.: "Goodbye."

I, too, would have said "goodbye," not "until next time" and certainly not "until I next have the pleasure" if I hadn't been distracted by screaming. "Oh oh oh oh oh oh, the unfortunates. Help, dear god. And the poor dear countess when she hears what a dreadful thing has happened here." And everyone runs, lifts their heads, and sees . . . you'll never guess what. Never. Two living beings, Denis Revolle and a figure who'd just appeared on the scene, a thrifty, clever, serious, and intelligent boy—in a word, Jacques—whom you haven't seen but who had accompanied Denis to work, hanging from a board about to give way under their weight. See their eyes like glowing cinders look fixedly at the ground. One would have to offer himself up to save the other. Jacques thinks of the children, the wife, and almost the mother-in-law of Denis. He severs his cord and throws himself into the boundless infinite. I see this living mass roll on the ground and then nothing. All is silence.

But what are these children's footsteps that I hear? "Hey, my doll, papa," cries a pretty voice. It is the young girl who has already occupied us for half a page, in other words for far too long. Her mother, concerned at not seeing her father return, had waited until noon. No one came. She waited another fifteen minutes, which seemed to her two centuries. No one. Then she got up, frightened, the little one followed her, and they arrived running when these words struck Denis's ears. What shame and sorrow he must have felt. Could he survive Jacques? Should he continue living if it entailed another's death? But what enthusiasm gripped the souls of all those present, that a dead hero should have risked his life in a battle for

which fame would be his reward. But to die in a corner of earth as only the stone that received it and the heart for which he sacrificed his life. Still, he would remember it eternally. Good deeds are obliterated from human memory much more quickly than the resulting benefits.

Conclusion

Well here's what Denis did. One might have expected him to cultivate a pure love for Jacques. Not at all: he detested him. Tacitus says that it is characteristic of human nature to hate those whom one has offended. Denis hadn't offended Jacques, but his self-esteem had been wounded by him. Sad but true. And if one answers by pointing out that Denis Revolle and Jacques' sacrifice are pure fiction, I would counter with this remark by Edmond About: "The truest stories are not the ones that actually happened."

[*Editor's note: The first paragraph below corresponds to the manuscript sheet reproduced on page 144, bottom; the following paragraph beginning "For three days" corresponds to the manuscript sheet reproduced on page 147.*]

Narrative

"All of free Greece could read. After the fall of Corinth, the Roman general, in order to distinguish free children from others, ordered each of them to trace out a few words. One of them instantly wrote these lines from Homer, in which Ulysses regrets not having died on the field of battle and having survived his compatriot heroes: 'Three and four times happy those who died fighting on the plains of Ilion!' This child, on the day of his country's ruin, wrote these lines under the eyes of the victor, and the proud Roman could not forbear a tear." (Sainte-Beuve, after Plutarch)

For three days Corinth was consumed by flames. The walls of this beautiful city fell under the redoubled blows of Roman battering rams, and the works of art it contained were booty for ignorant and barbarian soldiers, the Consul Mummius and his legions. Almost all of its inhabitants were massacred, its women reduced to slavery, and all that remained of this eminently civilized population were its children. The ferocious Mummius had decided on their fate. The noble children would perish, a good example for rebellious cities, but what good would it do to kill the children of slaves? Rome would benefit if he

showed clemency toward them. But how to determine which they were? Mummius remembered that all free Greece could read, and he ordered that all the little Corinthians be brought to him and instructed to trace out a few lines. He waited for them in the public square in the company of a few lieutenants.

Soon all the children arrived, some still quite young, others already large and approaching their fourteenth birthday. Before and behind them, burning houses were collapsing with dreadful crashes. The fire's sinister glow made the shadows of the soldiers and ruined houses resemble frightening phantoms. The streets were stained with blood and strewn with bodies, the sky was ablaze. Many children could see the mutilated bodies of their fathers nearby. Many could hear the groans of their mothers, who were being taken in shackles and chains to serve as slaves in a foreign land, very far from their children and the bodies of their husbands, very far from their sweet country. And lost in the middle of these sinister ruins, the smallest children trembled in all their limbs, begging to be allowed to live. They had seen so many men, some of them old, massacred pitilessly that they had little hope but braced themselves for death. Their anguish was so great that they could not cry. The pain of the older ones was perhaps greater although more controlled. They better understood the danger of their situation and the horror that awaited them if they were to be granted mercy by the victor now that they had lost everything. They uttered not a word and thought they had been brought to hear their death sentence. All that could be heard were sighs, cries, muffled sobs, a few muttered words, the occasional final farewell from a small child to his friend.

So they were quite surprised when tablets were brought to them. One after another, they wrote under the eyes of Mummius and his lieutenants, asking themselves what could be the reason for this strange act; and it was truly touching to see these poor little heads mad with fear and despair, begging on their tablets for mercy from their conqueror or for permission to rejoin their mothers. Tablets had been passed to almost all the children. Only a few remained, and all those who couldn't write had been separated from the others. The soldiers came to a beautiful child who could have been about thirteen, with a pure face and beautiful lines, with a

firm and courageous gaze. All of his comrades had tried to evoke the soldiers' pity. He looked at them with contempt, seized the tablet, and, with a steady hand, alone, abandoned in the midst of these cruel people and this city in flames, wrote these two lines from Homer: "Oh three and four times happy those who died fighting on the plains of Ilion!" Mummius approached him with his two lieutenants to examine what he had written; when the beautiful Greek child had impudently returned it to him, the ferocious Roman could not prevent himself from looking at the little hero with interest; his expression even grew troubled, and a furtive tear slipped from his eye.

The day all Greece succumbed to the blows of a coarse and barbaric enemy, this courageous act was a beautiful example of the moral utility of literary study. True, this child was noble and generous by nature, but what inspired him to this beautiful act was the divine Ulysses, the verses of divine Homer. How many heroic acts are caused solely by admiration! How many proud and generous feelings issue solely from poetry! Literary studies allow us to have contempt for death, they elevate us above earthly things by speaking to us of things of the spirit; they purify all our feelings; and this reasoned, almost philosophical courage is much more beautiful than the courage of the body, than fearlessness of the senses, for in reality it is spiritual courage. And we mustn't consider this a liability. It is with an infinite calm of soul and a legitimate pride that one hovers thus over life and its miseries, and poetry, that brilliant flower, flourishes in beautiful souls as in favorable terrain. It contributes its perfume and grace as well as its brilliance and strength. It makes the air around us purer and healthier; it inflames us with a divine love that is its own reward. And don't we also have a beautiful symbol of the fate of Greece in this beautiful boy, who repeated one last time to his dying country the name of its poet and its heroes and lulled it to its final sleep with harmonious and divine music?

[*Editor's note: The beginning of the following text corresponds to the manuscript reproduced on page 146.*]

CLOUDS
French composition, 1886–87

[*Proust was obliged to repeat the second form, having been absent*

In all times and countries where the sky is not always limpid and blue, clouds must have seduced the imagination of man with their changing, often fantastic forms. Man must always have divined in them the imaginary and real beings already in his mind. Each could find there whatever he liked; the contour of these vapors is so light, so indecisive . . . a breeze transforms them, a puff destroys them. In the evening, when the sun has just disappeared below the horizon and its purple reflections still color the sky, when oddly shaped clouds stand out against the sunset, a man who is religiously moved by the majestic and solemn calm of this poetic hour loves to contemplate the sky; then he can discover in the clouds giants and towers and all the brilliant fantasies of his excited imagination. The beautiful purples and golds will confer upon his dream a brilliance that is magnificent and grandiose rather than charming and gracious, and yet in the tenuous pink vapors that flutter here and there in the sky, one can grasp the poetic contours of a dancing chorus of young girls. Then, giving in almost involuntarily to a reverie that absorbs him, the man gradually forgets the objects around him; seeing nothing, hearing nothing that is close to him, he lends his illusion a real character, gives life to the forms he has bestowed and witnesses a grandiose spectacle that he himself has created. The giants he had complaisantly discovered engage in terrible battles on the vast field of the sky. From time to time, one of the most valiant falls in a shimmer of dazzling colors; soon the victors also evanesce, and these indomitable warriors have been overthrown by a gentle [missing word?] of the earth. Then the illusion is destroyed, the vision gone, and one falls back to earth with the same disagreeable sensation as when awakening from a beautiful dream.

But clouds are not always conducive to such hallucinations, their shapes are not always sufficiently distinct for even the most compliant imagination to be able to discover human forms in them. Yet clouds always foster reverie; if their bizarre shapes do not transport us in imagination to the dazzling realm of dreams, their rapid movement plunges our souls into the most profound philosophical meditation. For man's heart is so closely linked by a secret and slender thread to all of nature's parts that when he discerns a human form in it he feels himself prey to an emotion that, while infinitely varied, is almost always present. He loves to confide his heart's pains to a murmuring brook, to the tree where he often sits. How many times, deliciously moved, have I recounted my troubles to leaves and birds, believing that I was opening my heart to living beings but at the same time to superior and divine beings who gave me poetic consolation. But nothing in nature solicits confessions more than clouds do. Quite often, I have entrusted them with messages that, alas, they never delivered. I confided my sorrows to them and then they fled toward the horizon. Left alone, I feverishly imagined that these beautiful messengers must be endowed with life, that they at least went toward God to ask that he console me in some way, and I clung to this mad hope until another cloud came along to foster another sweet delusion. Oh beautiful clouds, how often have you heard avowals that you never repeated, how often seen sadness that you failed to dispel, witnessed despair that you failed to console. Especially that of men in foreign lands eternally bewailing their wives, their children, their sweet native lands, and who, like Ulysses, miss the thin smoke rising from their homes. Of men who, captive and in chains, remain for years with eyes glued to the horizon, scrutinizing it carefully with uneasy and attentive gaze in hopes of discovering there a sail or signal but seeing only you, buoyant clouds, the sole witnesses to their misfortune, the only confidants of their secret avowals. Oh beautiful clouds, thank you for all the consolation you have given the unfortunate. For your approach has filled them with that dreamy melancholy, with that poetic sadness that alone can mitigate pain which will not be stilled, for it purifies and elevates them, instilling a subtle and divine feeling of legitimate pride in those who experience it, making poets and philosophers of those who had been merely wretched.

HENRI BARBUSSE
At the Seaside, 1884

Saturday the 1st
We're off after having been afraid of missing the 8:10 train.

Our traveling companions a young man about twenty years old and a gentleman and his wife (one from Normandy, the other from Auvergne) who will change trains in Mantes.

The young man got off at Boisset-Pacy, one station before Evreux. There was a two-hour stop in Caen, we spent a little time in the town. Lilly, Anne, and I sick.

Reached our destination at nine in the evening (Sottevast). Monsieur Renaud's hotel, the only one in the place, was closed. A very agreeable peasant woman kindly let us sleep in her home.

Sunday the 2nd
We have our café au lait, climb onto the cart, and head for Briquebec, a large ruined tower. From there by diligence as far as Carterets on a smooth road, we pass Bonneville.

We go to the hotel we find the beach magnificent and picturesque, but at least half an hour from the village.

We talk and decide in succession to go to Beuzeval, St-Brière, St-Aubin.

Finally we settle on this last place. We take a diligence to Bonneville, but we change and head for Port-Bail.

Port-Bail, beach like Carteret's, deserted and far from the town. Inhabitants very curious do nothing but look at us.

We take a little carriage that for six francs transports us to St-Sauveur-le-Vicomte.

We get off at the hotel where we eat:
Milk soup
Cutlet
Cheese
Butter
We spend the night in this hotel.

The hostess charges us ten francs. From St-Sauveur we go to Sottevast then to Caen where we buy a tobacco pouch for papa. We take the train from Caen to the sea. We go to St-Aubin. Lodgings too expensive, or too far from the beach, or too dirty. Had some milk with bread with jam. Slept in an inn.

Tuesday the 4th
Go to Bernières, then to Courseulles, where we take a house. But mama, gone to St-Aubin to collect our luggage, finds a pretty villa, or rather a small house surrounded by a garden in Langrume for 250 francs.

We move in there in the evening.

Wednesday the 5th
Went to the beach.
Visited the bathing hut. We make pools with a little boy from Rouen: Henri Demer.

Met Monsieur Elouis who tells us that the beach at Langrume faces north and is quite chilly at night.

Thursday the 6th
Mama's throat being a little sore, we take a cabin with Madame Roussel's bathing-attendant, named Desaunais.

The bathing-attendant, very nice, begins to give me swimming lessons.

Friday the 7th
We go swimming.
In the afternoon, a photographer arrives on the beach. But we were too far to the side he only saw Annie. Then we played croquet with several children.

Saturday the 8th
We go swimming.
We go to the station to wait for papa, he arrives on the nine o'clock train.
We go fishing with him and Henri.
We catch woolly crabs, crabs, and shrimp.

Sunday the 9th
We go to the fair in St-Aubin.
Ate lunch there.
Just before the fireworks a storm obliges us to leave.
We find ourselves at the station with all kinds of people.
The train comes, there are almost no lights on the platform, there's a rush to board.
We are almost the last to leave the station.
We are among thirteen people in a first class compartment.
We get back to Langrume safe and sound.
Madame Rousseau our neighbor who stayed at home was very concerned about her baby, who was sick.

Monday the 10th
In the morning we go to Luc-sur-Mer, in Daburon we buy a lobster in a box. The way from Luc to Langrume is along a picturesque cliff.
We go fishing.
We catch a lot of shrimp and some crabs.

Tuesday the 12th
Go swimming with Madame Rousseau, still in the house next door, with her son Gabriel, her baby, called the little Menou, and her maid Joséphine.

Wednesday the 13th
To the beach. We play. Go swimming with papa. In the evening Gabriel

Rousseau and the son of a fisherman who lives next door named Joseph Levillain played hide-and-seek with us in the garden.

Thursday the 14th
Went to the beach in the morning and then fishing. Lilly fell into the water. We didn't realize that the tide was coming in. To get back we had to wade through water as high as our waists. In the evening, papa and mama went to Cherbourg.

Played hide-and-seek.

Friday the 15th
Désirée Louise Alexandrine Berthou looks after us. Went to high mass at ten o'clock; I was bored to death. In the afternoon took a quick dip with Desaunais.

In the evening, since the young Levillain had said something that really irritated me (he even repeated it in front of everyone), I was bold enough to say that he was a coarse person and told him not to play with us anymore.

Hearing these words, he became terribly angry and threw a rock at my leg, I countered with another that hit his back (and made him scream like a peacock) and was hit with another one on my right side.

Everybody gathered around us, I jumped on top of him and brought him to ground by pulling on his ear.

Monsieur Elouis saw us.

In the evening we play hide-and-seek with Gabriel.

Saturday the 16th
To the beach.
In the evening Mama and papa return from Cherbourg they went to Grandcamp.

They bring me this notebook, a sparkler that we burned the same night, and a parachute that was damp and torn.

Lilly the same notebook and a parachute.

Annie a kite and a parachute that was carried off by the wind.

We go swimming.

Sunday the 17th
To the beach. Made forts and a big pile [of sand] that everyone looked at.

Go swimming. To the beach in the evening to see a fire of bundles of sea-kale.

Monday the 18th
To the beach, we didn't go swimming. Made an immense pile [of sand] with Joseph Levillain, H. Demert, and his two cousins: the exterminator Robert and his sister Alice Durer. The pile resisted the assaults of the waves a long time.

Tuesday the 19th
We went swimming. Completed seventeen, nineteen, twenty-four strokes.

Went to Lion-sur-Mer, took the train as far as Luc.

Pretty villas surrounded by gardens, beautiful beach, we had lunch in a place called Au Vrai Flambard, we had an omelette cooked in butter, some cold roast beef with romaine lettuce, some cream cheese and little pastry cakes. We returned along the beach where we found some beautiful fossils.

Wednesday the 20th
Went to the beach, went swimming, completed [only] eleven strokes for the sea was very rough.

In the afternoon we went fishing. We caught some crabs, some woolly crabs, lots of shrimp, and a few plies [a non-edible fish].

Thursday the 21st
Went to the beach, completed forty strokes. Went fishing in the evening. Caught some crabs, some wooly crabs, some prawns, and a conger.

Friday the 22nd
Swam thirty-four strokes with the bathing-attendant. Papa went swimming. Had a swimming race with him. In the afternoon, went fishing.

Saturday the 23rd
Went to Monsieur Elouis's, who gave a farewell luncheon. He plans to leave tomorrow. After lunch I went to find Lilly and Annie, played quoits with them and Thérèse, Monsieur Elouis' niece. A lawyer from Caen was also there. We had:
Prawns
Bass with caper sauce
Gigot
Green kidney beans
Pears, peaches, shortbread cookies, cakes
In the evening went fishing for shrimp with mama.

Sunday the 24th
In the morning I swam fifty-one strokes. Got a large hairpin stuck in my foot.

Monday the 25th
Stayed in the house, it rained. Worked on building the locomotive.

Mama broke papa's watch.

Tuesday the 26th
My foot is healed. Big waves. Didn't go swimming. Bought a shortbread at the beach. Went to the beach. The photographer came to pose us: me, Lilly, and Annie but Lilly and I are not in the picture because we were too far to the side.

Wednesday the 27th
Didn't go swimming.
Went to the beach in the morning and the afternoon.

In the house we heard the screams of the son of the bathing-attendant Levellain, whose mother was beating him into a jelly. They went to get the mayor.

Song of Farewell
Long live vacations
Denique tandem
And penitence
Hidebunt finem

Magus barbaro
They'll go to the devil
Gaudis nostro

Down with bell-flowers
O parva mala
Which always repeat

ANNA DE BRANCOVAN
Letter to her brother Constantin

April 28, 1884

My dear brother,
It was with the greatest pleasure, you can well imagine, that I received your letter last night. I am happy to know that you are happy, for the three of us make up a single clover. It's true that one of the three leaves has broken away from the stem to go far away, but I hope with luck that the wind will blow it back to us. I was happy to read that your sheep gave you a little one and will do so again. Of course your sheep owed you some pleasure. Is the new-born already big? You told me in your letter that you went to a deserted island like Robinson. As for your natives, I think my dear that you needn't be afraid on their account, and that natives are not very common around Lac Leman since your island was deserted, or if you had rather captured, like the inhabitants of that island, birds and grasshoppers. Yesterday, my Constantin, was for me, morning and evening, a happy day, for I received upon waking the letter from papa which I answered and your own at bedtime. I thank you for having prayed for us, I never forget you in my prayers, but they don't always last half an hour. I think of you more than once in this short space of time. Truly my dear brother, we love one another so much from afar, and my only desire would be that our love should last just as long if we were close. Now, my dear Constantin, I will change your first sentence to read: It is very dull not having you in Paris. I am content that the rabbits are doing well. I see that the fishing wasn't good for that great fisher my brother. I am very unhappy for you. Let's pass, if you will, from water to land. I also read in your dear letter that you went to visit the mirror and then spent an agreeable time at the Villa. You have already been on a podoscaphe [a one-person double-hulled boat] and had much fun. If I told you about our life in Paris it wouldn't take much paper. We go almost every day with Marthe to the Bois [de Boulogne] we often go the Catalan meadow we amuse ourselves a bit in the Bois and then come home where the professor is waiting for us or we play. Give my regards to Monsieur le Curé and to Monsieur Janin. You tell me that he gave you, as well as Monsieur Dejean and Monsieur Frizac, some white wine to lift your spirits, that must have gotten you going. You also passed by the garden of Baron Blanc where you saw some green foliage. I too, my dear brother, am very impatient for the month of August that is so dear to all three of us. It is in this beautiful month that we take pretty excursions and go the seashore. The rest in another letter.

Part Two
I also send you dear brother some of the blue wild hyacinths that we have been gathering lately in a more or less deserted place in the Bois de Boulogne. It is really very beautiful at present. The grass is full of daisies. When we go to the places where we used to go with you some of them lower their heads and are sad not to see you. You might tell me that they're not the same daisies, that the ones that used to be there no longer exist. But their parents told them they'd seen you, and that's why the good-natured ones are sad. The villa is upside down right now, you say, but when everything is in place I assure you that it will be beautiful. Did you see the cows, and is the beautiful chestnut tree in bloom? I beg you my dear Constantin, if you have the time and it doesn't bore you too much, to send a little answer to your sister. Hélène wrote you, she sent her letter to you in the same envelope as I did.

Didn't you get it? We are all quite well, and I hope that Papa and you and everyone at the villa are in good health. You made your little sailboat work and you didn't fall into the water. You tell me that Papa has arranged an orchard with fruit trees. I'm really very impatient for the month of July for we have a much better time as three than we do alone, even if we can't get punished for getting into fights. The weather in Paris is still beautiful as it is at the villa, according to what you tell me. The lake is also splendid and Romainia [*sic*] in good shape. All of this makes me more impatient to again see the villa, the sheep, the rabbits, and all the other quadrupeds. Have the flowers already sprung up? The lawn must be very beautiful. How much fun it will be for the three of us when we go together to Romania [*sic*] my dear brother and walk together. How much fun that will be. And to eat pears, apples, cherries, and figs. That will be really lovely, and to go swimming with Papa. And to take lovely outings on foot or in the boat. To gather flowers in the mountains. To feed the rabbit and take the sheep to pasture, and listening all the while to the sweet chirping of warblers and finches reveling in the pure air around beautiful Lac Leman, where from the top of the beautiful sky blue clouds, black flies, and birds of different colors are reflected in this mirror. I'm astonished that you went by podoscaphe as far as Évian, that's really very far, and that you weren't afraid. Then you went to have a bite at Madame Claret's, then you returned to the Villa. If only you could be with us. I dream about it at night. How much fun you must be having. The rest in the third letter.

Part Three
You must be very tired at the end of the day and you must sleep well and wake up every morning very happy and only work that much better. My letter is a real diary and I hope you will be able to read it. But I still don't want to end it. There are plenty of misspellings, but you understand that when one writes so fast without a first draft and without help then there have to be. And then you're learning more French than I am. Right now I'm only taking piano, solfeggio, and German. What I love so much is to write to you as well as to Papa. Say hello to the rabbit for me and for Hélène. How much more I'd like to say. Now I say goodbye to you, dear brother, and I embrace you tenderly as well as Papa. Your sister who loves you.

Anna Elisabeth
Best regards to Monsieur Frizac

HENRY DE MONTHERLANT

Oriental Ballad

Mysterious harems where incense burns!
Oh languorous nights in the continental world,
Perfumed terraces strewn with saffron
Where women, by evening, recite from the Koran,
Crouching two-by-two near a mother-of-pearl altar,
Under the azure veil of the eastern sky.

A rose is blossoming under one of your feet:
You either crush it, making of it a smashed bud,
A dried remnant, a vanished scent . . .
Or you stop yourself, and the blooming rose
Charms you for an instant—but in either case
It laughs for another after you have passed.

By night under the moon, by day under the sun,
In the palace, in the harem, in the desert,
Everywhere one finds the same rosy fruit.

Oh enchanting Eden, ecstatic sojourn,
Where everywhere and always below the green foliage,
One need only choose to gather love . . .

Little Cats

Dedicated to my cat

One has muscular thighs and the grace of a goat,
Ebony black with a flat mouse's coat
Peppered here and there with tiny gray hairs;
A drop of milk runs from his mouth.

Another sneezes, yet another coughs
With a little noise that isn't very deep;
Close to their basket another heads off
With fitful gait. And gently,

The energetic one joins his brothers.
Another stumbles, frightened by a fly,
While games, spats, frolics, caressing licks
Indicate their pleasure at being together.

But suddenly the young mother

arrives.
The little ones join her and begin to drink
While she, pensive and lying on her side,
Listens, eyes closed, to the sound of their suck.

JEAN MOULIN
French Composition
October 13, 1915
First form, class B

My Favorite Hero

Ours is the history that boasts the most heroic deeds. From its origins, France offers examples of courage and sacrifice. Already before our era, Vercingetorix, the hero of Gallic independence, fought and sacrificed himself for the freedom of his country. He is our first national glory, he is the one I prefer above all.

He used his life to free Gaul from the crushing yoke of the Romans. But, unfortunately, insurmountable obstacles rose in his glorious path and he died a hero in the flower of youth. He was a robust and intelligent young man of the Averne tribe. He was noticed early because of his qualities and soon became head of the popular party. The sense that Gaul was a country was born in him. It made him sick at heart to see the victorious Romans living off of them and he exhorted his own to unite and reclaim their liberty. With his friends, he went from town to town, invoking the memory of their ancestors and the glorious conquests they had made. They told the inhabitants it was their obligation to take arms to win back their independence. His words, his example, his actions inflamed the Gauls, who rose up against the enemy. And this time Caesar had to acknowledge the wondrous unanimity with which Gaul reclaimed its liberty.

All of this was due to the perseverance and determination of this ardent patriot. Vercingetorix had learned from his predecessor's failed attempts that winning would require the effort of all. With such words he communicated his ardor to the Gauls, who put aside their differences and rallied behind their young leader. This was, then, no mere tribal revolt but an uprising of all Gaul. "Drive out the oppressor," such was his noble goal and, as Caesar himself said, he took up arms not for personal gain but for the good of his country.

Vercingetorix was dealing with well-trained and well-armed soldiers whose leaders were as clever as they were ruthless; despite his courage and skill, and after having briefly had victory within his grasp, he was obliged by the [Romans'] superior numbers to withdraw to Alésia. He locked himself inside the city with what remained of his army and withstood a memorable siege. Reduced to dreadful famine, they tried desperately to break loose of the Roman encirclement. More than twenty times, Vercingetorix, at the head of his men, charged the besieging forces with admirable enthusiasm. Each time he came to grief on the Roman ramparts. Relief forces from outside were defeated in front of Caesar's entrenchments. Their last hope gone, the besieged army became desperate. Then Vercingetorix, the only one whose soul remained firm amid the general consternation, called a meeting of his companions. He told them that, since he alone had rallied them to war, he alone should die, and that he was going to sacrifice himself as an expiatory victim. And retaining our characteristic noble Gallic pride even on the verge of death, he donned his best armor, mounted his battle steed, and, after prancing a moment in front of Caesar's tribune, threw his spear, his javelin, and his helmet at the Romans' feet, without saying a word. Caesar lacked generosity and had his glorious adversary executed. Vercingetorix had lived and died for the freedom of his country. His life, his work, and above all his death make this early hero one of the greatest in our history. Such ancestors can only engender sons like those now fighting gloriously on the slopes of Champagne and the banks of the Yser. After an interval of twenty centuries, we see the same Frenchmen battling for the same cause. But today we are getting our revenge, and soon we will hear the Gallic cock celebrate victory.

Piget labora

Bibliography

General Works
Michèle Sacquin. *Le Printemps des génies. Les enfants prodiges.* Paris: Bibliothèque Nationale de France/ Robert Laffont, 1993.

Marcel Achard
Jacques Lorcey. *Marcel Achard ou cinquante ans de vie parisienne.* France-Empire, 1977.

Alain-Fournier
Isabelle-Rivière. *Images d'Alain-Fournier.* Paris: Fayard, 1989.
Isabelle Rivière. *Alain-Fournier.* Paris: Fayard, 1989.
Jean-Pierre Guéno and Alain Rivière. *La Mémoire du Grand Meaulnes.* Paris: Robert Laffont, 1995.

Guillaume Apollinaire
Album Apollinaire. Paris: Gallimard (Bibliothèque de la Pléiade), 1971.
Guillaume Apollinaire. *Oeuvres poétiques.* Paris: Gallimard (Bibliothèque de la Pléiade), 1994.
Roger Shattuck. *The Banquet Years: The Origins of the Avant-Garde in France, 1885 to World War I: Alfred Jarry, Henri Rousseau, Erik Satie, Guillaume Apollinaire.* New York: Random House, 1968.

Louis Aragon
Louis Aragon. *Oeuvres romanesques complètes,* vol. 1. Paris: Gallimard (Bibliothèque de la Pléiade), 1997.
Jean Ristat. *Album Aragon.* Paris: Gallimard (Bibliothèque de la Pléiade), 1997.
Jean Ristat. *Aragon, commencez par me lire!* Paris: Gallimard (collection a "Découvertes"), 1997.

Duke of Aumale
Raymond Cazelles. *Le Duc d'Aumale, prince aux dix visages.* Paris: Tallandier, 1984.

Jane Austen
Jane Austen. *The History of England,* facsimile edition. London: The British Library, 1993.
Deirdre le Faye. *Jane Austen.* London: The British Library, 1998.

Balthus (Balthasar Klossowski de Rola)
Jean Claire and Virginie Monnier. *Balthus. Catalogue Raisonné of the Complete Works* (English edition). New York: Gallimard/Abrams, 1999.
Rainer Maria Rilke, *Oeuvres en prose.* Paris: Gallimard (Bibliothèque de la Pléiade), 1993.

Honoré de Balzac
Anne-Marie Baron. *Le Fils prodige.* Paris: Nathan, 1993.
Gérard Gengembre. *Balzac, le Napoléon des Lettres.* Paris: Gallimard (collection "Découvertes"), 1992.
Roger Pierrot. *Honoré de Balzac.* Paris: Fayard, 1994.
Graham Robb. *Honoré de Balzac: A Biography.* New York: W.W. Norton & Co., 1996.

Henri Barbusse
Philippe Baudorre. *Henri Barbusse.* Paris: Flammarion, 1995.
Henri Barbusse, catalogue of an exhibition organized by the Bibliothèque Nationale de France on the occasion of the gift of the manuscripts of *Feu* and *Clarté,* 1966.

Marie Bashkirtseff
Marie Bashkirtseff. *Journal.* Paris: Collection Capitale, 1991.
Verena von der Heyden-Rynsch. *Écrire la vie. Trois siècles de journaux intimes féminins.* Paris: Gallimard, 1998.

Charles Baudelaire
Charles Baudelaire. *Correspondance,* 2 volumes. Paris: Gallimard (Bibliothèque de la Pléiade), 1973.
Claude Pichois and Jean Ziegler. *Charles Baudelaire.* Paris: Fayard, 1996.
Album Baudelaire. Paris: Gallimard (Bibliothèque de la Pléiade), 1974.

Georges Bizet
Rémy Stricker. *Georges Bizet.* Paris: Gallimard, 1999.

Louis Napoleon Bonaparte, the Prince Imperial
Jean-Claude Lacnitt. *Le Prince impérial, "Napoléon IV".* Paris: Perrin, 1997.

Anna de Brancovan
François Broche. *Anna de Noailles. Un mystère en pleine lumière.* Paris: Robert Laffont, 1990.
Anna de Noailles. *Le Livre de ma vie.* Paris: Mercure de France, 1976.
Anna de Noailles–Maurice Barrès. Correspondance: 1901–1923, new edition edited by Claude Mignot-Ogliastri. Paris: L'Inventaire, 1994.

Benjamin Britten
Xavier de Gaulle. *Benjamin Britten ou l'impossible quiétude.* Actes Sud, 1996.

Charlotte Brontë
Jane Sellars. *Charlotte Brontë.* London: The British Library, 1997.

Henri Cartier-Bresson
Peter Galassi. *Henri Cartier-Bresson: premières photos. De l'objectif hasardeux au hasard objectif.* Paris: Arthaud, 1991.

Catholic League of Paris, Young Members of
Jean-Pierre Babelon. *Henri IV.* Paris: Fayard, 1982.

Théodore Chassériau
Marc Sandoz. *Théodore Chassériau, catalogue raisonné des peintures et estampes.* Paris: Arts et métiers graphiques, 1974.

Camille Claudel
Anne Delbée. *Une femme.* Paris: Presses de la Renaissance, 1982.
Reine-Marie Paris. *Camille Claudel.* Paris: Gallimard, 1984.
Anne Rivière. *L'Interdite. Camille Claudel 1864–1943.* Paris: Éditions Tierce, 1987.

Jean Cocteau

Jean Cocteau. *Lettres à sa mère,* volume 1, 1898–1918. Paris: Gallimard, 1989.
André Fraigneau. *Cocteau.* Paris: Seuil, 1957.
Roger Lannes. *Jean Cocteau.* Paris: Seghers, 1945.
Arthur King Peters. *Jean Cocteau and his World.* London: Vendôme, 1987.

Yves Congar

Yves Congar. *Journal de la Guerre 1914–1918.* Paris: Éditions du Cerf, 1997.

Primo Conti

Il Museo Primo Conti. Verona: Electa, 1987.
Primo Conti. *La Gola del Merlo.* Milan: Sansoni, 1983.

Georges Cuvier

Brianchon. "La Jeunesse de Cuvier," *Revue des Publications de la société nationale havraise d'études diverses,* 1876.

Salvador Dalí

Robert Descharnes and Gilles Néret. *Salvador Dalí.* Cologne: Taschen, 1998.

Eugène Delacroix

Charles Baudelaire. *Eugène Delacroix: His Life and Work,* Translated by J. Bernstein. New York: Lear Publishers, 1947.
Arlette Sérullaz and Annick Doutriaux. *Delacroix, Une fête pour l'oeil.* Paris: Gallimard (collection "Découvertes"), 1998.
Maurice Sérullaz. *Delacroix.* Paris: Fayard, 1989.

Françoise Dolto

Françoise Dolto. *Correspondance, 1913–1938.* Paris: Hatier, 1991.
Françoise Dolto. *Enfances.* Paris: Seuil (collection "Points Actuels"), 1999.
Françoise Dolto. *Autoportrait d'une psychanalyse: 1934–1988.* Paris: Seuil (collection "Points Actuels"), 1992.

Gustave Doré

Gustave Doré dans les collections du musée de Brou, exhibition catalogue. Brou: Musée de Brou, n.d.
Annie Renonciant. *La Vie et l'oeuvre de Gustave Doré.* Paris: ACR Éditions et Bibliothèque des Arts, 1983.

Albrecht Dürer

John Berger. *Dürer.* Cologne: Taschen, 1994.
Erwin Panofsky. *The Life and Art of Albrecht Dürer.* Princeton: Princeton University Press, 1948.

Paul Éluard

Violaine Vanoyeke. *Paul Éluard, le poète de la liberté.* Paris: Julliard, 1995.

Gustave Flaubert

Gustave Flaubert. *Correspondance,* volume 1. Paris: Gallimard (Bibliothèque de la Pléiade), 1984.
Gustave Flaubert. *Oeuvres,* volume 1. Paris: Gallimard (Bibliothèque de la Pléiade), 1989.

Anne Frank

Anne Frank, une vie. Fondation Anne Frank–Casterman, 1992.
Une histoire d'aujourd'hui, Anne Frank. Maison d'Anne Frank, 1996.

Théophile Gautier

Théophile Gautier. *Correspondance générale,* edited by Claudine Lacoste-Veysseyre, eleven volumes. Paris: Droz, 1987–1996.
Anne Ubersfeld. Théophile Gautier. Paris: Stock, 1992.

Jean Giono

Album Giono, edited by Henri Godard. Paris: Gallimard (Bibliothèque de la Pléiade), 1980.
Jean Giono. *Oeuvres romanesques complètes,* three volumes. Paris: Gallimard (Bibliothèque de la Pléiade), 1971–1974.

Grand Dauphin, Le, *see* Louis of France, Duke of Burgundy

Victor Hugo

Sophie Grossiord. *Victor Hugo, Et s'il n'en restait qu'un.* Paris: Gallimard (collection "Découvertes"), 1998.
Victor Hugo. *Correspondences familiale et écrits intimes,* introduction by Jean Gaudon, 2 volumes. Paris: Robert Laffont (collection "Bouquins"), 1991.
Victor Hugo. *Oeuvres poétiques,* volume 1. Paris: Gallimard (Bibliothèque de la Pléiade), 1964.
André Maurois. *Olympia ou la vie de Victor Hugo.* Paris: Robert Laffont (collection "Bouquins"), 1993.

Jean-Auguste-Dominique Ingres

Georges Vigne. *Ingres,* translated by John Goodman. New York: Abbeville Press, 1995.

Jacques Henri Lartigue

Florette Lartigue. *Jacques Henri Lartigue, La Traversée du siècle.* Bordas, 1990.
Jacques Henri Lartigue. *Mémoires sans mémoire.* Paris: Robert Laffont, 1975.

Guillaume Lekeu

Luc Verdebout. *Guillaume Lekeu: introduction, chronologie et catalogue des oeuvres.* Mardaga, 1990.

Pol and Jean de Limbourg

François Avril and Nicole Reynaud. *Les Manuscrits à peintures en France (1440–1520).* Paris: Flammarion / Bibliothèque Nationale de France, 1993.
Erwin Panofsky. *Early Netherlandish Painting: Its Origins and Character.* Cambridge, Mass., 1966. Reprinted by Icon Editions, 1971 (paperback).

Franz Liszt

Ernst Burger. *Franz Liszt.* Paris: Fayard, 1988.
Serge Gut. *Liszt.* Éditions de Fallois / L'Age d'Homme, 1989.

Pierre Loti

Lesley Blanch. *Pierre Loti.* Seghers, 1986.
Alain Buisine. *Pierre Loti, l'écrivain et son double.*
Tallandier, 1999.

Louis of France, Duke of Burgundy (Le Grand Dauphin)

Catalogue des autographes Bossuet de la collection Rothschild.
Paris: Bibliothèque Nationale de France, n.d.
Jean Meyer. Bossuet. Paris: Plon, 1993.

Louis XIII

Journal de Jean Héroard, edited by Madeleine Foisil with a
preface by Pierre Chaunu, two volumes. Paris: Fayard, 1989.
Madeleine Foisil, *L'Enfant Louis XIII. L'éducation d'un roi
(1601–1617).* Perrin, 1996.

Pierre Louÿs

Jean-Paul Goujon. *Pierre Louÿs. Une vie secrète.* Paris: Seghers,
1988.

Stéphane Mallarmé

Stéphane Mallarmé. *Oeuvres complètes,* volume 1. Paris:
Gallimard (Bibliothèque de la Pléiade), 1998.
Jean-Luc Steinmetz. *Stéphane Mallarmé. L'absolu au jour le jour.*
Paris: Fayard, 1998.
Mallarmé et les siens. Musée de Sens, 1998.

Marie-Antoinette, Queen of France

Jean-Chalon. *Chère Marie-Antoinette.* Perrin, 1988.
Correspondance entre Marie-Thérèse et Marie-Antoinette, Grasset, n.d.

Thérèse Martin (Saint Theresa of the Infant Jesus)

Saint Thérèse of the Infant Jesus (Thérèse Martin). *Une course
de géant. Lettres.* Paris: Éditions du Cerf, 1990.
Pierre Descouvement and Helmuth Nils Loose. *Thérèse et
Lisieux.* Paris: Éditions du Cerf, 1991.

François Mauriac

Jean Lacouture. *François Mauriac.* Paris: Seuil, 1980.

Felix Mendelssohn-Bartholdy

Rémi Jacobs. *Mendelssohn.* Paris: Seuil (collection "Solfèges"),
1977.
Yvonne Tiénot. *Mendelssohn, musicien complet.* H. Lemoine, 1972.

Michelangelo Buonarroti

Howard Hibbard. *Michelangelo,* second ed. Hammondsworth:
Penguin Books, 1988.
Charles de Tolnay. *The Art and Thought of Michelangelo,*
translated by N. Buranelli. New York: Pantheon Books, 1964.
Giorgio Vasari. *Lives of the Most Eminent Painters, Sculptors and
Architects,* translated by G. de Vere, 10 volumes. London: Medici
Society, 1912–15.

Jules Michelet

Paul Vialleneix. *Michelet, les travaux et les jours, 1798–1874.*
Paris: Gallimard, 1998.

Joan Miró

Walter Erben. *Miró.* Cologne: Taschen, 1998.
Juan Punyet Miró and Gloria Lolivier. *Miró, le peintre aux étoiles.*
Paris: Gallimard (collection "Découvertes"), 1993.

Claude Monet

John House. *Monet: Nature into Art.* New Haven: Yale University
Opress, 1986.
Sylvie Patin. *Monet, The Ultimate Impressionist.* New York:
Harry N. Abrams, Inc. ("Discovery" series), 1992.
Virginia Spate. *Claude Monet: Life and Work.*
New York: Rizzoli, 1992.

Henry de Montherlant

Pierre Sipriot. *Album Montherlant.* Paris: Gallimard
(Bibliothèque de la Pléiade), 1979.
Pierre Sipriot, *Montherlant sans masque,* volume 1,
L'Enfant prodigue, 1895–1932. Paris: Robert Laffont, 1982.

Gustave Moreau

Geneviève Lacambre. *Gustave Moreau: Magic and Symbol.*
New York: Harry N. Abrams, Inc. ("Discovery" series), 1998.
Pierre-Louis Mathier. *Le musée Gustave Moreau.* Paris: Réunion
des Musées Nationaux / Albin Michel, 1986.

Jean Moulin

Daniel Cordier. *Jean Moulin.* Paris: Gallimard, 1999.
Pierre Péan. *Vies et morts de Jean Moulin.* Paris: Fayard, 1999.

Wolfgang Amadeus Mozart

Michel Parouty. *Mozart: From Child Prodigy to Tragic Hero.* New
York: Harry N. Abrams, Inc. ("Discovery" series), 1989.

Alfred de Musset

Frank Lestringant. *Musset.* Paris: Flammarion, 1999.
Alfred de Musset. *Correspondance,* edited by Marie Cordroc'h,
Roger Pierrot, and Loïc Chard, volume 1, 1826–1839. Paris:
Presses Universitaires de France, 1985.

Germaine Necker (Mme. de Staël)

Jean-Denis Bredin. *Une singulière famille, Jacques Necker,
Suzanne Necker et Germaine de Staël.* Paris: Fayard, 1999.

Gérard de Nerval

Gérard de Nerval. *Oeuvres complètes,* volume 1. Paris: Gallimard
(Bibliothèque de la Pléiade), 1989.
Album Nerval. Paris: Gallimard (Bibliothèque de la Pléiade), 1995.

Louis Pasteur

Patrice Debré. *Louis Pasteur.* Paris: Flammarion (collection
"Champs"), 1997.

Pablo Picasso

Pierro Daix. *Picasso.* Paris: Éditions du Chêne (collection "Profils
de l'art"). 1991.
Picasso and Portraiture: Representation and Transformation,
exhibition catalogue edited by William Rubin. New York: The

Museum of Modern Art, 1996.
Brigitte Léal. *Picasso et les enfants.* Paris: Flammarion, 1996.
Christian Zervos. *Pablo Picasso,* 33 vols. Paris, 1932–78.

The Prince Imperial, *see* **Louis Napoleon Bonaparte, the Prince Imperial**

Marcel Proust
Jean-Yves Tadié. *Marcel Proust.* Paris: Gallimard, 1996.

Raymond Radiguet
François Bott. *Radiguet, l'enfant avec une canne.* Paris: Flammarion, 1995.

Ernest Renan
Ernest Renan. *Souvenirs d'enfance et de jeunesse.* Paris: Gallimard (collection "Folio") 1983.

Arthur Rimbaud
Alain Borer. *Rimbaud, l'heure de la fuite.* Paris: Gallimard (collection "Découvertes"), 1991.
Arthur Rimbaud. *Oeuvre-Vie,* centenary edition edited by Alain Borer. 1991.
Album Arthur Rimbaud. Paris: Gallimard (Bibliothèque de la Pléiade), 1967.
Arthur Rimbaud. *Oeuvres complètes,* edited by Antoine Adam. Paris: Gallimard (Bibliothèque de la Pléiade), 1996.

Auguste Rodin
Ruth Butler. *The Shape of Genius: A Biography.* New Haven: Yale University Press, 1993.
F. V. Grunfeld. *Rodin: A Biography.* New York: Holt, 1987.
Monique Laurent. *Rodin.* Paris: Éditions du Chêne, 1988.
Hélène Pinet. *Rodin: The Hands of Genius.* New York: Harry N. Abrams, Inc. ("Discovery" series), 1989.

Antoine de Saint-Exupéry
Antoine de Saint-Exupéry. *Lettres à sa mère.* Paris: Gallimard (collection "Folio"), 1984.
Nathalie des Vallières. *Saint-Exupéry, l'archange et l'écrivain.* Paris: Gallimard (collection "Découvertes"), 1998.
Paul Webster. *Antoine de Saint-Exupéry: The Life and Death of the Little Prince.* London; Macmillan, 1993.

Camille Saint-Saëns
Michel Faure. *Musique et société du Second Empire aux années 20.* Paris: Flammarion, 1985.

George Sand
André Maurois. *Lélia ou la vie de George Sand.* Paris: Hachette, 1985.
George Sand. *Correspondance,* edited by Georges Lubin, volume 1, 1812–1831. Paris: Classiques Garnier, 1964.
George Sand. *Histoire de ma vie.* Paris: Stock, 1996.

Maurice Sand
Robert Thuillier. *Les Marionnettes de Maurice et George Sand.*

Paris: Hermé, 1998.
Bernard Tillier. *Maurice Sand.* Paris: Éditions du Lérot, 1992.

Egon Schiele
Wolfgang Georg Fischer. *Egon Schiele.* Cologne: Taschen, 1998.

Franz Schubert
Peter Härtling. *Schubert.* Paris: Le Seuil, 1996.
Brigitte Massin. *Schubert.* Paris: Fayard, 1993.
Rémy Stricker. *Franz Schubert: le naïf et la mort.* Paris: Gallimard, 1997.

Georges Seurat
William I. Homer. *Seurat and the Science of Painting,* reprint. New York: Hacker Art Books, 1985.
John Reward. *Seurat: A Biography.* New York: Harry N. Abrams, Inc., 1990.

Stendhal (Henri Beyle)
Jean Goldzink. *Stendhal, l'Italie au coeur.* Paris: Gallimard (collection "Découvertes"), 1992.

Henri de Toulouse-Lautrec
Bernard Denvir. *Toulouse-Lautrec.* Thames and Hudson, 1991.
Danièle Devynck. *Toulouse-Lautrec.* Paris: Editions du Chêne, 1992.

Joseph Mallord William Turner
Michael Bockemülh. *Turner.* Cologne: Taschen, 1991.

Suzanne Valadon
Suzanne Valadon, exhibition catalogue. Fondation Pierre Gianadda, 1996.

Anthony Van Dyck
Arthur Wheelock, Susan Barnes, and Julius Held. *Van Dyck, Peintures.* Paris: Albin Michel, 1991.

Jules Verne
Jean-Paul Dekiss. *Jules Verne, le rêve du progrès.* Paris: Gallimard (collection "Découvertes"), 1991.
Herbert Lottman. *Jules Verne.* Paris: Flammarion, 1996.

Élisabeth Vigée-Lebrun
Élisabeth Vigée-Lebrun. *Mémoires d'une portraitiste.* Éditions Scala, 1989.
Louis Hautecoeur. *Madame Vigée-Lebrun.* Paris: Henri Laurens, 1914.
Souvenirs de Mme Louise-Élisabeth Vigée-Lebrun, introduction by Pierre de Nolhac. Paris: Fayard, 1910.

Alfred de Vigny
Alfred de Vigny et les arts, exhibition catalogue. Paris: Musée de la Vie Romantique, 1997.
Nicole Casanova. *Alfred de Vigny.* Paris: Calman-Lévy, 1990.
Bertrand de La Salle. *Alfred de Vigny.* Paris: Fayard, 1963.
Alfred de Vigny. *Oeuvres complètes.* Paris: Gallimard (Bibliothèque de La Pléiade), 1991.

List of Illustrations and Photograph Credits

p. 9: *Helmeted Warrior,* drawing by the young Prosper Mérimée. Collection Édouard and Christian Bernadac. Photo: Georges Fessy.

p. 11: Gerard ter Borch, *Rider Seen from the Back,* 1633, oil on canvas. Boston, Museum of Fine Arts, Juliana Cheney Edwards Collection. Photo: museum.

p. 12: Valéry Larbaud, *Silhouettes,* red chalk. Collection Édouard and Christian Bernadac. Photo: Georges Fessy.

p. 13: Scribbled pages from the exercise book of the young Roland Barthes. Collection Édouard and Christian Bernadac. Photo: Georges Fessy.

pp. 14–15: Pol and Jean de Limbourg, pages from the *Bible moralisée* known as the Bible of the Duke of Burgundy. Paris, Bibliothèque Nationale de France, Département des Manuscrits, Manuscrit français 166. Photos: library.

p. 16: Albrecht Dürer (?), *Portrait of Albrecht Dürer the Elder,* 1484. Vienna, Graphische Sammlung Albertina. Photo: museum. Albrecht Dürer, *View of Nuremberg from the West,* 1496. Bremen, Kunsthalle. Photo: museum.

p. 18: Michelangelo Buonarotti, *Battle Relief,* marble. Florence, Casa Buonarotti. Photo: Alinari-Giraudon.

pp. 20–21: Pages from *Livre d'emblèmes offert par ligueurs au cardinal Gaetani,* c. 1590, a compendium of anti-Protestant allegorical poems written and illustrated by young Parisian members of the Catholic League. Paris, Bibliothèque Nationale de France, Département des Manuscrits, Nouvelles Acquisitions latines 2637. Photos: library.

p. 22: Pendant mirror case with portrait of the young Louis XIII attributed to Jean II Limousin. Paris, musée du Louvre. Photo: RMN–Daniel Arnaudet.

p. 23: Handwritten manuscript of Louis XIII. Paris, Bibliothèque Nationale de France, Département des Manuscrits, Manuscrit français 3815, fol. 14. Photo: library. Handwritten letter from Louis XIII to his sister. Paris, Bibliothèque Nationale de France, Département des Manuscrits, Manuscrit français 3815, fol. 17. Photo: library. Drawing by the young Louis XIII from Héroard's *Journal.* Bibliothèque Nationale de France, Département des Manuscrits, Manuscrit français 4023, fol.

176. Photo: library.

p. 24: Anthony Van Dyck, *An Elderly Gentleman,* 1613. Musées royaux des Beaux-Arts, Brussels. Anthony Van Dyck, *Saint Jerome,* 1615. Musées Royaux des Beaux-Arts, Brussels. Photos: museum.

p. 25: Anthony Van Dyck, *Self-Portrait,* 1613. Vienna, Gemäldegalerie des Akademie des Bildenden Künste. Photo: museum.

p. 26: Anonymous (French school, seventeenth century), *Portrait of the Grand Dauphin as a Young Adult.* Château de Versailles. Photo: RMN.

pp. 26–27: Pages of an assignment in French history written by the Grand Dauphin and corrected by Bossuet, c. 1675. Paris, Bibliothèque Nationale de France, Département des Manuscrits, Autographes Bossuet de la collection Rothschild, no. 320, various folios. Photos: library.

pp. 28–31: Philibert Commerson, *Cahiers botaniques. Recueil de plantes sèches,* 1742–43, several pages. Paris, Bibliothèque centrale du Muséum d'Histoire naturelle, ms. 200. Photos: museum.

p. 32: Krantzinger after Ducreux, *Marie-Antoinette.* Vienna, Kunsthistorisches Museum. All rights reserved. Martin de Meytens, *The Imperial Family,* oil on canvas. Vienna, Kunsthistorisches Museum. All rights reserved.

p. 33: Handwritten letter from the Dauphine Marie Antoinette to Empress Maria Theresa of Austria, July 12, 1770. Vienna, Österreichisches Staatsarchiv Hausarchiv, Sammelbände, K 3/12, fols. 3–8. Photo: Foto-Studio Udo Otto.

p. 34: Carmontelle, *Wolfgang Amadeus Mozart and His Father Leopold.* Chantilly, musée Condé. All rights reserved. W. A. Mozart, *Sonates pour le clavecin qui peuvent se jouer avec l'Accompagnement de Violon, dédiés à Mme Victoire de France par J.G. Wolfgang Mozart de Salzbourg âgé de sept ans,* 1764. Paris, Bibliothèque Nationale de France, Département de la Musique, Rés 866, fol. 2. Photo: library.

p. 35: Wolfgang Amadeus Mozart, *God Is Our Refuge,* handwritten manuscript. London, British Library, K 20.

p. 36: Élisabeth Vigée-Lebrun, *Self-Portrait,* c. 1782, oil on canvas. Fort Worth, Kimbell Art Museum. Élisabeth Vigée-Lebrun,

Portrait of La Camaraga, oil on canvas. Paris, Musée Cognac-Jay. Photo: Bulloz.

p. 37: Élisabeth Vigée-Lebrun, *Étienne Vigée,* 1773, oil on canvas. Saint Louis, The Saint Louis Art Museum. Photo: museum. All rights reserved.

p. 38: Germaine Necker, *The Artist with Her Mother,* pastel. Collection château de Coppet. Photo: château. All rights reserved. Joseph-Siffred Duplessis, *Half-Length Portrait of Suzanne Curchot de Nasse, Wife of Jacques Necker.* Châteaux de Versailles et de Trianon. Photo: RMN.

p. 39: Handwritten letter from Germaine Necker to her mother. Archives of the château de Coppet. All rights reserved. Photo: Art Go.

p. 40: *Devoir de Religion,* autograph manuscript by the young Germaine Necker. Archives, château de Coppet. Photo: château. All rights reserved.

p. 41: *Essai de réflexion politique,* handwritten manuscript by the young Germaine Necker. Archives, château de Coppet. Photo: château. All rights reserved.

pp. 42–43: *Diarium botanicum* (1786), with watercolor illustrations. Paris, Institut de France, Bibliothèque de l'Institut, ms. 3041, fol. XIV, XV and Tab. IV. Photos: Jean Loup Charmet.

p. 44: David d'Angers, *Medallion Portrait of André-Marie Ampère.* Photo: Roger-Viollet. André-Marie Ampère, *Traité des sections coniques,* 1788, handwritten manuscript. Paris, Archives de l'Académie des Sciences. Photo: Jean-Loup Charmet.

p. 45: André-Marie Ampère, *Rectification d'un arc de cercle,* handwritten manuscript dated July 8, 1788. Paris, Archives de l'Académie des Sciences. Photo: Jean Loup Charmet.

p. 46: Cassandra Austen, *Jane Austen,* summer 1804, watercolor. Private collection. All rights reserved.

pp. 46–47: Jane Austen, pages from *The History of England,* handwritten manuscript illustrated by her sister Cassandra. London, British Library. Photos: library.

p. 48: Joseph Mallord William Turner, *View of Traeth Bach on the Snowden with Moel Hebog and Aberglaslyn,* watercolor. London, Tate Gallery. Photo: museum. All rights reserved.

p. 49: Joseph Mallord William Turner, *Self-*

Portrait, 1791. London, National Portrait Gallery. Photo: museum.

p. 50: Jean-Dominique-Auguste Ingres, *Joseph Ingres, His Wife Anne Moulet, and Their Two Daughters,* graphite, pen and ink, and wash, c. 1793–97. Montauban, Musée Ingres. Photo: Roumagnac. J.-A.-D. Ingres, *Landscape with Fishermen* (probable copy after a Dutch print), before 1793, pen and ink. Montauban, Musée Ingres. Photo: Roumagnac.

p. 51: J.-A.-D. Ingres, *Jean Moulet* (the artist's grandfather), copy in red chalk of a red chalk drawing by Joseph Ingres, 1791. Montauban, Musée Ingres. Photo: Roumagnac.

p. 52: Page from a school notebook of the young Henri Beyle. Bibliothèque Municipale de Grenoble. Photo: library. All rights reserved.

pp. 52–53: Handwritten letter from Henri Beyle to his sister Pauline, March 9, 1800. Paris, Bibliothèque Nationale de France, Département des Manuscrits, NAF 12965, fols. 5–6. Photos: library.

p. 54: Portrait of Honoré de Balzac as a child. Paris, Institut de France, Bibliothèque de l'Institut, Fonds Lovenjoul, objet no. 5. Photo: Jean Loup Charmet. Anonymous, *Madame Balzac,* pastel. Paris, Maison de Balzac. Photo: Photothèque des Musées de la Ville de Paris.

p. 55: Handwritten letter from Honoré de Balzac to his mother, May 1, 1809. Paris, Institut de France, Bibliothèque de l'Institut, fonds Lovenjoul, A 276, fol. 2. Photo: Jean Loup Charmet. The first page of this album bears the following inscription in Lovenjoul's hand: "Letter to Balzac's mother written on May 1 [1809]. Balzac was ten years old. This is the earliest known letter written by him. I possess the volume awarded to Balzac for his *accessit* [commendation for exceptional scholastic performance] for the school year 1808-1809. It is Voltaire's *History of Charles XII.* The *accessit* was for his Latin studies. I attach here a letter sent to me in 1886 by the headmaster of the Collège de Vendôme." The letter in question indicates that the school archives from the beginning of the century did not survive, and that the school possessed none of Balzac's scholastic records.

p. 56: *Franz Schubert as an Adolescent,*

print. All rights reserved. Franz Schubert, *Lebensraum,* D. 39, handwritten score. He composed this song when he was twelve. Paris, Bibliothèque Nationale de France, Département de la Musique, ms 281. Photo: library.

p. 57: Franz Schubert, *Der Spiegelritter, singspiel,* D. 11. Overture, autograph score of opening bars. Paris, Bibliothèque Nationale de France, Département de la Musique, Ms 306. Photo: library.

p. 59: Aurore de Saxe, *Aurore Dupin,* pastel. Paris, Musée de la Vie romantique.

pp. 59–60: Handwritten letter from Aurore Dupin to her mother. Paris, Bibliothèque Nationale de France, Département des Manuscrits, NAF 24811, fols. 213–214. Photos: library.

pp. 60–61: Pages from a notebook of Aurore Dupin dating from her days as a boarding student at the Couvent des Augustines Anglaises. Paris, Bibliothèque Historique de la Ville de Paris. Photo: Jean Loup Charmet.

p. 62: François Kinson, *Alfred de Vigny at Age Seventeen,* oil on canvas. Paris, Musée Carnavalet. Photo: R. Briant–Phototèque des Musées de la Ville de Paris.

pp. 62–65: Drawings by the fifteen-year-old Alfred de Vigny. Collection Édouard and Christian Bernadac. Photos: Georges Fessy.

p. 66: Anonymous (English school), *Presumed Portrait of Eugène Delacroix,* watercolor. Paris, Musée Eugène Delacroix. Photo: RMN–Gérard Blot.

pp. 66–69: Pages from a notebook of the sixteen-year-old Eugène Delacroix. Paris, Bibliothèque d'Art et Archéologie Doucet. Photos: library.

p. 70: David d'Angers, *Medallion Portrait of Jules Michelet.* Photo: Roger-Viollet.

pp. 70–71: Handwritten manuscripts by Jules Michelet. Paris, Bibliothèque Historique de la Ville de Paris, Fonds Michelet, Biographie I (A 3741–3746), fols. 42 and 54. Photos: Jean Loup Charmet.

p. 72: Hubert Clerget, *The Birthplace of Victor Hugo,* drawing. Paris, Maison de Victor Hugo. Inscription scribbled by the young Victor Hugo on the manuscript of his *Essais,* 1817–18. Paris, Bibliothèque Nationale de France, Département des Manuscrits, NAF 13438. Photo: library.

p. 73: Victor Hugo, notebook from 1817: history lesson on the Punic Wars. Paris, Bibliothèque Nationale de France, Département des Manuscrits, NAF 13436, fol. 114. Photo: library.

pp. 74–75: Victor Hugo, geometry notebook, 1816–17. Paris, Maison de Victor Hugo. Photos: R. Briant–Photothèque des Musées de la Ville de Paris.

p. 76: Wilhelm Hensel, *Felix Mendelssohn in 1821,* drawing. Private collection. All rights reserved. *Portrait of Carl Friedrich Zelter,* print, all rights reserved.

p. 77: Felix Mendelssohn-Bartholdy, *Die Beiden Pädagogen (singspiel),* trio, autograph score, 1820–21. Paris, Bibliothèque Nationale de France, Département de la Musique, Ms 189. Photo: library.

p. 78: Pastel by the adolescent Théophile Gautier. Collection Édouard and Christian Bernadac. Photo: Georges Fessy.

p. 79: Autograph letter from Théophile Gautier to his father, July 4, 1825. Paris, Institut de France, Bibliothèque de l'Institut, Fonds Lovenjoul, C 742, fols. 3 and 4. Photos: Jean Loup Charmet.

p. 80: *Franz Liszt at Age Sixteen,* pastel. London, Royal College of London. Franz Liszt, *Étude for pianoforte in 48 exercises,* 1826. Paris, Bibliothèque Nationale de France, Département de la Musique, L. 6518 (1). Photo: library. Anonymous, *The Birthplace of Liszt in Hungary,* c. 1856. Private collection. All rights reserved.

p. 81: Handwritten letter from Franz Liszt to his London music publisher, July 20, 1824. London, British Library, Music Library, ADD 33965, fol. 229. Photo: British Library.

p. 82: David d'Angiers, *Medallion Portrait of Gérard de Nerval.* Photo: Roger-Viollet.

p. 83: Gérard Labrunie, *Napoleon and Wartime France,* part of a twenty-seven-page handwritten manuscript. In–8o, bound. Private collection. Photos: Art Go.

p. 84: Alfred de Musset, print. Collection Christiane Sand. Photo: Jean-Pierre Guéno.

pp. 84–85: *Alfred de Musset,* handwritten letter to Paul Foucher, September 23, 1827. Paris, Bibliothèque Historique de la Ville de Paris, Autographes, tome 78, fols. 26 and 27. Photos: Jean Loup Charmet.

p. 86: Branwell Brontë, Anne, Emily, and Charlotte Brontë c. 1834, oil on canvas. London, National Portrait Gallery. Photo: museum. Charlotte Brontë, *Primula,* c. 1830, watercolor. Brontë Society, Brontë Parsonage Museum, Haworth. Photo: museum.

pp. 86–87: One of the earliest known small-format manuscript books by Charlotte Brontë, *The Search after Happiness.* Brontë Society, Brontë Parsonage Museum, Haworth. Photos: museum.

p. 88: Louis Hersent, *Queen Marie-Amélie with Her Two sons, the duc d'Aumale, in the uniform of a light infantryman, and the duc de Monpensier, in the uniform of an artilleryman, with a view of the park of the château de Neuilly* (detail), châteaux de Versailles et de Trianon. Photo: RMN–Gérard Blot. One of the few surviving homework assignments of the duc d'Aumale, handwritten manuscript, 1833. Collection Alain Nicolas. Photo: Art Go.

p. 89: Handwritten letter from the Duke of Aumale to his father, King Louis-Philippe, November 17, 1829. Collection Alain Nicolas. Photo: Art Go.

p. 90: Delaunay, *Gustave Flaubert at Age Fifteen* (detail), Rouen, Bibliothèque municipale. Photo: library.

p. 91: Handwritten letter from Gustave Flaubert to Ernest Chevalier, 1829 or early 1830. Paris, Bibliothèque Nationale de France, Département des Manuscrits, NAF 25892, fol. 1. Photos: library.

pp. 92–93: Gustave Flaubert, *Louis XIII,* July 28, 1831, handwritten manuscript. Paris, Bibliothèque Nationale de France, Département des Manuscrits, NAF 14135. Photos: library.

p. 94: Gustave Moreau, *Landscape (Honfleur). The Garden of Madame Aupick, Baudelaire's Mother,* watercolor. Paris, Musée Gustave Moreau. Photo: RMN–R.G. Ojeda.

p. 95: Charles Baudelaire, letter to his brother Alphonse, late August or early September, 1835, handwritten manuscript. Paris, collection Alain Nicolas. Photo: Art Go.

p. 96: Théodore Chassériau, *Self-Portrait,* 1835, oil on canvas. Paris, Musée du Louvre. Photo: RMN. Théodore Chassériau, *Adèle Chassériau, The Artist's Sister,* 1835, oil on canvas. Paris, Musée du Louvre. Photo: RMN.

p. 97: Théodore Chassériau, *Vénus Anadyomène,* 1839, oil on canvas. Paris, Musée du Louvre. Photo: RMN.

p. 98: New Year's Day poster, 1888, for J. Hetzel, Jules Verne's publisher. All rights reserved. *Diver Searching Wrecks at Le Havre,* illustration to a tale by Jules Verne published in the illustrated supplement to the *Petit Journal* in 1892. Private collection. Photo: Giraudon.

pp. 98–99: Autograph letter from Jules Verne to Madame de Châteaubourg, March 30, 1836. Nantes, Bibliothèque Municipale, manuscrit JV B 18. Photos: museum.

p. 100: Émile Cohl, *Caricature of Ernest Renan,* Photo: Roger-Viollet.

p. 101: Autograph letter from Ernest Renan to his mother, September 8, 1838. Paris, Bibliothèque Nationale de France, Département des Manuscrits, NAF 11474, fols. 2 and 3.

p. 102: Ch. Lebayle, *Louis Pasteur as a Student at the École Nationale Supérieure,* c. 1842, drawing. Paris, Institut Pasteur. © Institut Pasteur. *The Pasteur House in Arbois,* pastel. © Institut Pasteur. *The Mother of Louis Pasteur,* pastel. Paris, Institut Pasteur. © Institut Pasteur.

p. 103: Louis Pasteur, draft of a letter from Louis Pasteur to a friend of his father surrounded by mathematical calculations, handwritten manuscript. Paris, Bibliothèque Nationale de France, Département des Manuscrits, NAF 18076, fols. 217–218. Photo: library.

p. 104: *Portrait of Maurice Sand as a Child.* Paris, Musée de la Vie romantique. Photo: Photothèque des Musées de la Ville de Paris.

pp. 104–107: Pages (details and general views) from a notebook of the young Maurice Sand. Collection Christiane Sand. Photos: Jean-Pierre Guéno.

p. 108: Gustave Moreau, *Self-Portrait,* c. 1850, oil on canvas. Paris, Musée Gustave Moreau. *Portrait of Camille Moreau, the Artist's Sister,* c. 1840. Paris, Musée Gustave Moreau. Photo: RMN–R.G. Ojeda.

p. 109: Gustave Moreau, *Four Landscape Studies,* c. 1840–45. Bayonne, Musée Bonnat. Photo: RMN–R.G. Ojeda.

p. 110: Camille Saint-Saëns. *First Gallop,* dated June 6, 1841, handwritten score. Paris, Bibliothèque Nationale de France, Département de la Musique, Ms 854 (1). Photo: library.

p. 111: Camille Saint-Saëns, *Andante for*

Piano, handwritten score. Paris, Bibliothèque Nationale de France, Département de la Musique, Ms 854 (3). Photo: library.

p. 112: Gustave Doré, *The Adventures of Mistenflûte and Mirliflor,* drawing. Musée de Brou. Photo and ©: Musée de Brou. Gustave Doré, *Festival in Brou,* pen and ink. Musée de Brou. Photo and ©: Musée de Brou.

p. 113: Gustave Doré, *Mythology,* beginning of chapter 10, "Portrait of Jupiter," pen and ink. Musée de Brou. Photo and ©: Musée de Brou.

p. 114: *Georges Bizet,* print after a portrait by Giacometti. Photo: Roger-Viollet. Giuseppe Canella, *The Théâtre de l'Ambigu Comique and the boulevard Saint-Martin,* 1830. Paris, Musée Carnavalet. Photo: Phototèque des musées de la ville de Paris.

p. 115: Georges Bizet, *Barcarolle,* autograph score. Paris, Bibliothèque Nationale de France, Département de la Musique, Ms 422. Photo: library.

p. 116: Auguste Rodin, *Couple after the Antique,* 1854–57, graphite, pen and brown ink on cream watermarked paper. Paris, Musée Rodin, D 5103. Photo: museum. © ADAGP, Paris 1999. Auguste Rodin, *Male Nude with Baton,* 1854–57, charcoal on cream watermarked paper. Paris, Musée Rodin, D 5104. Photo: museum.

p. 117: Auguste Rodin, *Male Nude,* c. 1857, oil on canvas. Paris, Musée Rodin, P.7231. Photo: museum. © ADAGP, Paris 1999.

p. 118: Édouard Manet, *Stéphane Manet,* oil on canvas. Paris, Musée d'Orsay. Photo: RMN–Hervé Lewandowski. pp. 119-120: Stéphane Mallarmé, *Ce que disaient les trois cigognes* (What the three storks said), handwritten manuscript. Paris, private collection. Photo: Art Go.

p. 120: Claude Monet, *Wine from Bordeaux,* 1857. Paris, Musée Marmottan-Claude Monet. Photo: Giraudon. © ADAGP, Paris 1999. Claude Monet, *Groom in a Top Hat,* 1857. Paris, Musée Marmottan–Claude Monet. Photo: Giraudon. © ADAGP, Paris 1999. Claude Monet, *Black Woman in a Madras Headdress,* 1857. Paris, Musée Marmottan–Claude Monet. Photo: Giraudon. © ADAGP, Paris 1999.

p. 121: Claude Monet, *Young Man with a Monocle,* 1957. Paris, Musée

Marmottan–Claude Monet. Photo: Giraudon. © ADAGP, Paris 1999.

p. 122: Photograph of the adolescent Arthur Rimbaud (formerly owned by Paul Claudel). Paris, Bibliothèque Nationale de France, fonds Claudel, fol. 3. Photo: library. Anonymous, *Birthplace of Arthur Rimbaud in Charleville,* watercolor. Charleville, Archives Départementales. Anonymous, *The Place Ducale in Charleville,* watercolor. Charleville, Archives Départementales.

p. 123–125: Arthur Rimbaud, pages from a school notebook dating from his tenth year. Bibliothèque de Charleville–Mézières. Photos: Trptik.

pp. 126–127: Pages from a school notebook of Pierre Loti. Collection Édouard and Christian Bernadac. Photos: Georges Fessy.

p. 128: Jules Lefebvre, *The Prince Imperial,* pastel. Château de Compiègne. Photo: RMN–Arnaudet.

pp. 128–129: Handwritten letters from the Prince Imperial to Ernest Lavisse, 1871 and 1872. Paris, Bibliothèque Nationale de France, Département des Manuscrits, NAF 22 956, fols. 20–22. Photos: library.

p. 130: Photograph of Marie Bashkirtseff. Paris, Bibliothèque Nationale de France, Département des Estampes.

pp. 130–31: Marie Bashkirtseff, pages from her autograph diary. Paris, Bibliothèque Nationale de France, Département des Manuscrits, NAF 12306, fols. 1–3. Photos: library.

p. 132: Henri de Toulouse-Lautrec, *Self-Portrait,* oil on cardboard. Albi, Musée Toulouse-Lautrec.

pp. 132–133: Pages from one of Toulouse-Lautrec's notebooks from his stint at the Lycée Fontanes, 1873–74. Albi, Musée Toulouse-Lautrec. Photos: museum. All rights reserved.

p. 134: Henri de Toulouse-Lautrec, *Artilleryman Saddling His Mount,* oil on cardboard. Albi, Musée Toulouse-Lautrec. Photo: museum.

p. 135: Henri de Toulouse-Lautrec, *Two Horses with an Aide-de-Camp,* oil on cardboard. Albi, Musée Toulouse-Lautrec. Photo: museum.

p. 136: Georges Seurat, *The Parthenon Illissus,* 1875, charcoal and graphite on pink paper. Paris, Musée du Louvre,

Département des Arts Graphiques. Photo: RMN. Seurat's palette. Paris, Musée d'Orsay. Photo: RMN.

p. 137: Georges Seurat, *Male Nude Viewed from the Back,* October 1877, charcoal and graphite. Paris, Musée du Louvre, Département des Arts Graphiques. Photo: RMN.

p. 138: Georges Seurat, *The Hand of Poussin,* after Ingres, 1875–77, graphite. New York, The Metropolitan Museum. Inscribed in the artist's hand (partly illegible): *"voilà le génie"* ("now that is genius"). Georges Seurat, *Head of a Man,* 1877, conté crayon and charcoal. Private collection.

p. 139: Georges Seurat, *Faun with Kid,* after the antique, 1877–18, charcoal and black chalk. New York, Woodner Family collection.

p. 140: Photograph of Camille Claudel in 1878. All rights reserved. Camille Claudel photographed by César in 1913. Camille Claudel, *Bust of Rodin,* 1888. Paris, Musée Rodin. © ADAGP, Paris 1999.

p. 141: Camille Claudel, *Paul Claudel as a Young Roman,* bronze bust. Musée de Châteauroux. Photo: museum. © ADAGP, Paris 1999.

p. 142: Suzanne Valadon, *Adam and Eve,* 1909, oil on canvas. Paris, Musée National d'Art Moderne Centre Georges Pompidou. Photo: RMN.

p. 143: Suzanne Valadon, *Self-Portrait,* 1883, pastel on paper. Paris, Musée National d'Art Moderne Centre Georges Pompidou. Photo: RMN.

p. 144: Jean Béraud, *Leaving the Lycée Condorcet,* oil on canvas. Paris, Musée Carnavalet. Photo: Roger-Viollet. © ADAGP, Paris 1999.

p. 145–147: Pages from various composition assignments by the young Marcel Proust, handwritten manuscripts. Paris, Bibliothèque Nationale de France, Département des Manuscrits, NAF 16 611, fols. 5, 10, 12, 13, and 18. Photos: library.

pp. 148–149: Pages from the diary of the young Henri Barbusse and his sister, 1884–1891, handwritten manuscript. Bibliothèque Nationale de France, Département des Manuscrits, N.A.F. 16 505, fols. 1, 2, and 8. Photos: library.

pp. 150–151: Photographs of Anna de Brancovan and a manuscript letter from

her dated April 28, 1884, all bound together in a commemorative album. Paris, Institut de France, Bibliothèque de l'Institut, Ms 4711. Photos: Jean Loup Charmet. Reproduced by kind permission of Eugénie de Brancovan.

p. 152: Photograph of the sixteen-year-old Thérèse Martin. Library of the Carmelite convent in Lisieux.

p. 153: Letter from Thérèse Martin to her sister Pauline, March 18, 1888. Library of the Carmelite convent in Lisieux. Text of the letter published by kind permission of Éditions du Cerf.

p. 154: *Guillaume Lekeu as an Adolescent.* Verviers, Conservatoire de musique. All rights reserved. Guillaume Lekeu, Sonata in D Minor for Violin and Piano, handwritten score. Paris, Bibliothèque Nationale de France, Département de la Musique, Ms 12 788, fol. 1. Photo: library.

p. 155: Guillaume Lekeu, *Choral for Violin and Piano,* autograph score with dedication to his uncle Pierre Lekeu. Paris, Bibliothèque Nationale de France, Département de la Musique, Ms 12 787. Photos: library.

p. 156–159: Pages from the school notebooks of Pierre Louis, later known as Pierre Louÿs. Collection Édouard and Christian Bernadac. Photos: Georges Fessy.

p. 160: Pablo Picasso, *Young Painter,* April 14, 1972. Pablo Picasso, *Head of Conchita Maria de la Concepción Ruiz Picasso,* 1894, graphite (from a sketchbook). Barcelona, Picasso Museum. Pablo Picasso, *Going to School: Lola, the Artist's Sister,* 1895, pen and ink. Barcelona, Picasso Museum.

p. 161: Pablo Picasso, *Barefoot Girl,* 1895, oil on canvas. Paris, Musée Picasso. Photo: RMN.

p. 162: Pablo Picasso, "La Coruña," pages from an autograph diary dating from September 1894, graphite. Photo: RMN–B. Hatala.

p. 163: Pablo Picasso, "Azul y Blanco," pages from an handwritten diary dating from October 1893, graphite. Photo: RMN-B. Hatala. For all works by Pablo Picasso: © Succession Picasso, 1999.

p. 164: Photograph of Wilhelm de Kostrowitsky commemorating his first communion, May 8, 1892. All rights

reserved. Photograph of the Congregation of the Immaculate Conception. Wilhelm de Kostrowitsky, secretary of the organization, is seated to the left of the table, pen in hand. All rights reserved.

p. 165: *Pan est mort* (Pan is Dead), July 3, 1895, handwritten poem by Guillaume Apollinaire to Charles Tamburini. Paris, Bibliothèque Nationale de France, Département des Manuscrits, Legs Apollinaire, N.A. F.280, fol. 41. Photo: library. French text © Éditions Gallimard.

p. 166: Several drawings by the young Jean Cocteau, including one of the face of the clown Foutit. Private collection. All rights reserved. Member of the Cocteau family, *The Cocteau Family House,* Private collection. All rights reserved.

p. 167: Handwritten letter from Jean Cocteau to his mother, 1898. Paris, Bibliothèque Historique de la Ville de Paris. Photo: Jean Loup Charmet. Reproduced by kind permission of the Comité Jean Cocteau. French text of the letter © Éditions Gallimard.

pp. 168–169: Cover page, preface letter, and text page ("VI, Vision dans une chapelle"), with illustration, from handwritten manuscript of François Mauriac, *Va-t-en!* (Go away!). Paris, Bibliothèque Littéraire Doucet, MRC 13. Photos: Jean Loup Charmet.

p. 170: Egon Schiele, *Portrait of Leopold Czihaczek,* 1907, oil on canvas. Private collection. All rights reserved. Egon Schiele, *Interior of the Apartment of Leopold and Marie Czihaczek,* 1907, oil on cardboard. Vienna, Belvedere, Österreichische Galerie. Photo: museum.

p. 171: Egon Schiele, *Self-Portrait,* 1906. Vienna, Graphische Sammlung Albertina.

pp. 172–73: All photographs by Jacques-Henri Lartigue © Ministère de la Culture-France / A.A.J.H.L.

p. 174: Photograph of Jean Giono as a child. Collection Jean Giono–Musée de Manosque. All rights reserved. Handwritten postcard from Jean Giono to his cousin. Collection Jean Giono-Musée de Manosque. All rights reserved.

p. 175: Handwritten letter from Jean Giono to his parents. Collection Jean Giono-Musée de Manosque. All rights reserved.

p. 176: Photograph of Joan Miró dressed for his first communion. All rights reserved. Joan Miró, *Pedicure,* graphite, watercolor and ink on paper. Barcelona, Joan Miró Foundation. Photo: foundation. © ADAGP, Paris 1999. Joan Miró, *Montroig: Church and Village,* 1919. All rights reserved. © ADAGP, Paris 1999.

p. 177: Joan Miró, *Turtle,* 1901. Graphite and watercolor on paper. Barcelona, Joan Miró Foundation. Photo: foundation. © ADAGP, Paris 1999.

p. 178: Photograph of Alain-Fournier at the Lycée Voltaire. Collection Jacques Rivière. Photo: Jean-Paul Guéno.

pp. 178–179: Drawings and notebook page from school notebooks of the young Alain-Fournier. Collection Jacques Rivière. Photos: Jean-Paul Guéno.

p. 180: Photograph of Louis Aragon in 1904. Collection Jean Ristat. All rights reserved. Photograph of Marguerite Toucas-Massillon, Louis Aragon's mother. Private collection. All rights reserved.

p. 181: Louis Aragon, *Quelle âme divine!* (What a divine soul!), handwritten manuscript, 1904. Fonds Aragon-Triolet Paris-C.N.R.S. Photo: Art Go.

p. 182: Photograph of Henry de Montherlant in Neuilly in 1907. Private collection. Drawing by Henry de Montherlant of the château de Montherlant in the Oise, July 1910 (probably copied from an eighteenth-century image). Private collection. *Petits chats* (Little cats), handwritten poem by Henry de Montherlant. Private collection.

p. 183: Henry de Montherlant, *Ballade orientale* (Oriental ballad), handwritten poem by Henry de Montherlant. Private collection.
All documents regarding Henry de Montherlant reproduced by kind permission of Jean-Claude Barat. All rights reserved. Reproduction prohibited.

p. 184: Photograph of Eugène Grindel (the future Paul Éluard) c. 1905. All rights reserved. Photograph of a group of school children, including Eugène Grindel, in Aulnay-sous-Bois, postcard. All rights reserved.

p. 185: Eugène Grindel, *Volé!* (Flown!), handwritten manuscript, 1907. Paris, Bibliothèque Littéraire Doucet. Photo: Jean Loup Charmet. Text of handwritten tale published by kind permission of Mme Cécile Éluard-Boaretto.

p. 186: Photograph of the young Antoine de Saint-Exupéry. Photo: Sygma. Photograph of Madame de Saint-Exupéry. Photo: FA-Viollet.

p. 187: Handwritten letter from Antoine de Saint-Exupéry to his mother, June 11, 1910. Paris, Archives Nationales. Photos: Archives nationales. Text of the letter © Éditions Gallimard.

p. 188: Photograph of Primo Conti painting. Fiesole, Fondazione Primo Conti. Primo Conti, *Self-Portrait,* 1911, oil on canvas.

p. 189: Primo Conti, *Self-Portrait in a Bathing Robe,* 1911, oil on canvas. Fiesole, Fondazione Primo Conti.

pp. 190–193: Pages from several of Marcel Achard's notebooks dating from his enrollment at the Institution Rollin, handwritten manuscripts. Collection Édouard and Christian Bernadac. Photos: Georges Fessy.

p. 194: Photograph of Françoise Marette at age six. Association Archives et Documentation Françoise Dolto. Photograph of Pierre Demmler, the uncle of Françoise Marette, to whom she was "engaged." Association Archives et Documentation Françoise Dolto. Both photos: Art Go.

p. 195: Handwritten letter from Françoise Marette to her Uncle Pierre Demmler, June 30, 1916. Association Archives et Documentation Françoise Dolto. Text of the letter published in Françoise Dolto, *Correspondance,* volume 1, *1913–1938* (Hatier, 1991). New edition forthcoming from Éditions Gallimard. Photos: Art Go.

pp. 196–197: Yves Congar, pages from *Journal de la guerre franco-boche* (Diary of the Franco-German war), handwritten manuscript. Reproduced by kind permission of Éditions du Cerf.

p. 198: Photograph of the adolescent Jean Moulin. Collection Suzanne Andrée and Henri Escoffier. Photo: Jean-Pierre Guéno. Jean Moulin, *La Promenade des Anglais,* drawing. Béziers, Musée des Beaux-Arts. Photo: museum.

p. 199: *Le héros préferé* (My favorite hero), French composition by the young Jean Moulin, handwritten manuscript. Bordeaux, Centre Jean Moulin. Photo: center.

p. 200: Valentine Hugo, *Raymond Radiguet,* 1921. Paris, Bibliothèque Nationale de France, Département des Imprimés. Photo © ADAGP, Paris 1999.

pp. 200–201: Cover page, title page, and first text page from the first notebook of *L'Age ingrat* (The Awkward Age), handwritten manuscript. Paris, Bibliothèque Nationale de France, Département des Manuscrits, NAF 18765. Photos: library.

p. 202: Sarah Fenny Hockey, *Benjamin Britten.* Courtesy of the National Portrait Gallery, London.

p. 202–203: Benjamin Britten, *The Royal Falily,* handwritten manuscript. © Trustees of the Britten-Pears Foundation. Photos: Nigel Luckhurst.

p. 204: Salvador Dalí, *Self-Portrait,* 1920-21, oil on canvas. Given by Dalí to the Spanish government. All rights reserved. © ADAGP, Paris 1999. Salvador Dalí, *Portrait of Hortensia, Peasant from Cadaquès,* c. 1918–19, oil on canvas. Private collection. All rights reserved. © ADAGP, Paris 1999.

p. 205: Salvador Dalí, *Portrait of My Father,* 1920–21, oil on canvas. © ADAGP, Paris 1999.

p. 206–207: Balthus, six compositions from *Mitsou, quarante images* (Mitsou, forty images). Paris, Bibliothèque Nationale de France, Département des Imprimés, Réserve mZ 573. © ADAGP, Paris 1999.

p. 208: Photograph of Henri Cartier-Bresson in 1924. Collection Henri Cartier-Bresson. Henri Cartier-Bresson, *The Rue des Saules,* 1924, oil on cardboard, collection of the artist.

p. 209: Henri Cartier-Bresson, *The Church at Guermantes,* 1924, oil on cardboard. Collection of the artist.

p. 210–211: Photo of Anne Frank and pages from her diary reproduced by kind permission of the Anne Frank–fonds, Langendorf, Switzerland.

Key to Authorship of the Entries

Patrick Barbier, a musicologist and writer, is professor at the Université Catholique of Angers.
Pascale Heurtel is curator of manuscripts, Bibliothèque Centrale du Muséum National d'Histoire Naturelle.
Laure Murat, a writer and journalist, is the author of books on literature, architecture, and other
cultural topics.

Pol and Jean de Limbourg
Roselyne de Ayala

Albrecht Dürer
Laure Murat

Michelangelo Buonarroti
Roselyne de Ayala

**Young Members of the Catholic
League of Paris**
Roselyne de Ayala

Louis XIII
Roselyne de Ayala

Anthony Van Dyck
Laure Murat

Louis of France, Duke of Burgundy
Roselyne de Ayala

Philibert Commerson
Pascale Heurtel

**Maria Antonia Josepha of Lorraine
(Marie Antoinette)**
Roselyne de Ayala

Wolfgang Amadeus Mozart
Laure Murat

**Élisabeth Vigée
(Élisabeth Vigée-Lebrun)**
Roselyne de Ayala

Germaine Necker (Mme. de Staël)
Laure Murat

Georges Cuvier
Laure Murat

André Marie Ampère
Roselyne de Ayala

Jane Austen
Laure Murat

Joseph Mallord William Turner
Laure Murat

Jean-Auguste-Dominique Ingres
Laure Murat

Henri Beyle (Stendhal)
Laure Murat

Franz Schubert
Patrick Barbier

Aurore Dupin (George Sand)
Jean-Pierre Guéno

Alfred de Vigny
Jean-Pierre Guéno

Eugène Delacroix
Laure Murat

Jules Michelet
Roselyne de Ayala

Victor Hugo
Laure Murat

Felix Mendelssohn-Bartholdy
Patrick Barbier

Théophile Gautier
Roselyne de Ayala

Franz Liszt
Laure Murat

Gérard Labrunie
Laure Murat

Alfred de Musset
Jean-Pierre Guéno

Charlotte Brontë
Laure Murat

Henri of Orléans, Duke of Aumale
Roselyne de Ayala

Gustave Flaubert
Laure Murat

Charles Baudelaire
Laure Murat

Théodore Chassériau
Roselyne de Ayala

Jules Verne
Laure Murat

Ernest Renan
Laure Murat

Louis Pasteur
Laure Murat

Maurice Dudevant (Maurice Sand)
Jean-Pierre Guéno

Gustave Moreau
Laure Murat

Camille Saint-Saëns
Patrick Barbier

Gustave Doré
Laure Murat

Georges Bizet
Laure Murat

Auguste Rodin
Laure Murat

Stéphane Mallarmé
Laure Murat

Claude Monet
Laure Murat

Arthur Rimbaud
Laure Murat

Julien Viaud (Pierre Loti)
Roselyne de Ayala

Eugène-Louis Napoléon Bonaparte
Roselyne de Ayala

Marie Bashkirtseff
Laure Murat

Henri de Toulouse-Lautrec
Laure Murat

Georges Seurat
Laure Murat

Camille Claudel
Jean-Pierre Guéno

Suzanne Valadon
Laure Murat

Marcel Proust
Laure Murat

Henri Barbusse
Roselyne de Ayala

Anna de Brancovan
(Anna de Noailles)
Laure Murat

Thérèse Martin (St. Theresa
of the Infant Jesus)
Jean-Pierre Guéno

Guillaume Lekeu
Patrick Barbier

Pierre Louis (Pierre Louÿs)
Laure Murat

Pablo Picasso
Laure Murat

Wilhelm de Kostrowitzky
(Guillaume Apollinaire)
Laure Murat

Jean Cocteau
Laure Murat

François Mauriac
Laure Murat

Egon Schiele
Laure Murat

Jacques-Henri Lartigue
Laure Murat

Jean Giono
Jean-Pierre Guéno

Joan Miró
Laure Murat

Henri-Alban Fournier
(Alain-Fournier)
Jean-Pierre Guéno

Louis Aragon
Laure Murat

Henry de Montherlant
Roselyne de Ayala

Eugène Grindel (Paul Éluard)
Laure Murat

Antoine de Saint-Exupéry
Laure Murat

Primo Conti
Roselyne de Ayala

Marcel Achard
Roselyne de Ayala

Françoise Marette
(Françoise Dolto)
Jean-Pierre Guéno

Yves Congar
Laure Murat

Jean Moulin
Jean-Pierre Guéno

Raymond Radiguet
Laure Murat

Benjamin Britten
Patrick Barbier

Salvador Dalí
Laure Murat

Balthasar Klossowski de Rola
(Balthus)
Laure Murat

Henri Cartier-Bresson
Roselyne de Ayala

Anne Frank
Laure Murat

Index

Numbers in **bold face** indicate that the person after whose name they appear is the subject of the article on those pages.